50 MAIN STREET

50 MAIN

STREET

THE FACE OF AMERICA

PIERO RIBELLI

 | CAMERON + COMPANY

For information address Cameron + Company Publishers

Library of Congress Control Number: 2012931515

ISBN: 978-1937359157

Cameron + Company
6 Petaluma Blvd. North
Suite B-6
Petaluma, CA 94952
www.cameronbooks.com

CONTENTS

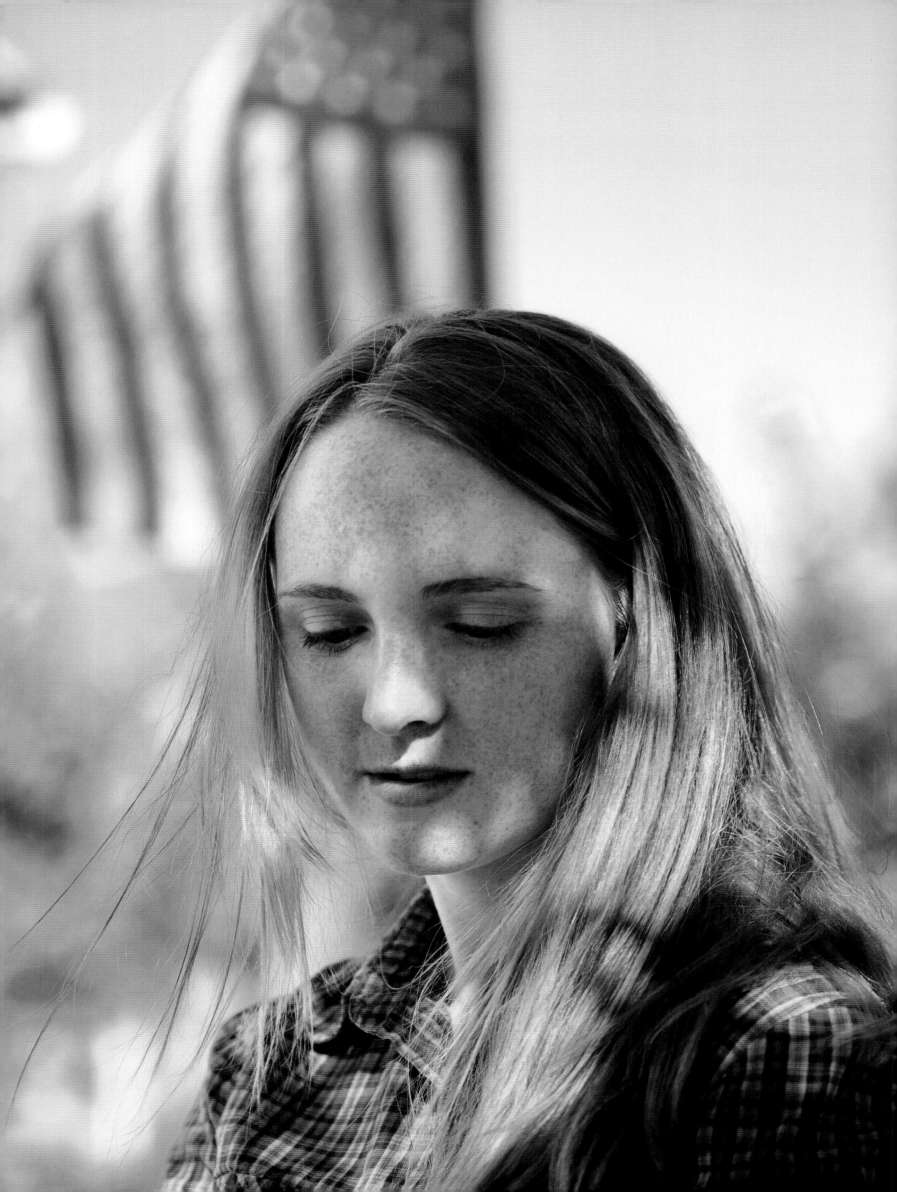

FOREWORD

If there is one name synonymous with American life, it is Main Street. Ever since the Pilgrims and the cod, as Westward Expansion became the New World creed, Main Streets were named everywhere from forlorn Appalachian hamlets to Bostontown, from adobe Santa Fe to the isolated log outposts along the Continental Divide, from the white-sand beaches of Gulf Florida to the dazzling San Juan Islands of Washington State, onward to fog-shrouded Maine, and to the borderlands of Texas—almost every American community has a Main Street.

I grew up in Perrysburg, Ohio—a suburb of Toledo—where Main Street was our principal drag. Everyone in the U.S.A. has a Main Street in their lives. Sometimes when writing history books I've used phrases like "Main Street values" or "Main Street America" to describe the archetypical citizen of this gorgeous land.

So when Piero Ribelli sent me his *50 Main Street* manuscript, I was immediately captivated. It is a brilliant, well-executed plan (not to mention an audacious one). Ribelli, with camera in tow, photographed 50 U.S. citizens (actually more) who live at 50 different 50 Main Street addresses. It's the kind of project that Ed Ruscha so masterfully completed back in 1963 with *Twentysix Gasoline Stations*. Like Ruscha's odyssey, Ribelli's seven-year road trip has produced fine art.

Ribelli grew up on the coast of Lake Garda, in northern Italy. His friend Peter used to call him an "Italian hillbilly." Imbued with a Thoreau-like spirit, Ribelli used to wander the woods hunting mushrooms, tracking down wildlife, even clearing a meadow to make room for a soccer field. He relished the pastoral lifestyle.

When Ribelli moved to New York in 1985, he discovered an urban world vastly different from his own rural Italy. Nevertheless, he also noticed how similar human desires were. Like many immigrants to America, Ribelli fell in love with our country. But in recent years, the political divisiveness corroding our republic disturbed him. It seemed that America was becoming ever more fractured, not united. That's why he decided to write *50 Main Street*: as a healing gesture. This book doesn't point fingers or apportion blame. It just attempts to remind people where we came from and how diverse we are as a nation.

To make this book, Ribelli became a vagabond in the Woody Guthrie and Jack Kerouac tradition. He flew over 31,000 miles on planes and drove another 16,000 by car to meet these fine folks at their Main Street locations—a wonderful immersion exercise. Although he is a newly minted U.S. citizen, Ribelli has seen more of America than most of us ever will. Ralph Waldo Emerson used to say, "Only truth in transit." There are real truths about the American character in these pages that you won't find in *Time* magazine or on YouTube.

We live in an age of cynicism, but *50 Main Street* is a work of heartland sentiment. All of the Americans in this book exude the utmost dignity. Whether it's a truck driver, pool player, hardware store owner, fireman, or hair stylist, Ribelli treats his subjects honorably, somehow bringing out the better nature of their spirits. It is impossible not to feel a patriotic uplift from this book.

Douglas Brinkley
American historian and author

Dedicated to the memory of my parents, Linda and Gino, my guiding lights;
and to the spirit of my friend Peter, my American mentor.

A special thank-you to my biggest fan, my producer and my inspiration:
my wife Rose.

This is a book about people.

Fifty people in fifty towns across the fifty states, all found at the same address. In telling the stories of people with something undeniably in common, the book inspires us to focus on the fundamental similarities we experience as humans, rather than dwell on our differences.

Growing up in Italy, I was inspired by the lessons of my parents; I was taught to look at the world as one big painting combining many different shades and colors. Sadly, my father passed away when I was just a teenager. I felt compelled to help my mother and sister and went to work as an electrician. My work schedule didn't allow for much dreaming, but I was fascinated by American icons like Clint Eastwood and Marlon Brando; I was intrigued by the writings of Ernest Hemingway and Jack Kerouac and captivated by the music—from The Doors to Jimi Hendrix, from Otis Redding to Johnny Cash. Even the classic Coca-Cola song: "I'd Like to Teach the World to Sing in Perfect Harmony."

I was entranced by the young people of all races and religions singing together on a hilltop, and I longed to experience such a multicultural society.

That dream eventually took me to New York City, the ultimate melting pot, where I had a chance to start a new career, learn a new language, and embark on a new life adventure. I found a liberating spirit and a feeling of belonging that made me fall in love with it instantly. I was no kid anymore but, at the age of twenty-seven, I felt like I was given the chance to reinvent myself, in a vibrant, diverse, and fair world. Instead of prejudice and judgment I found interest and curiosity. The more I learned the new language, the more I understood the mechanics of the place. All the American myths and legends that were etched in my mind through music, books and movies, became more familiar as soon as I became more comfortable with the new environment.

I was missing my family but I found a strong support system in all the new friends that seemed to be in the same boat that I was trying to navigate. My world seemed ever-expanding. My new friends were from places that I had only heard about in my youth: Wisconsin lawyers, Brazilian mathematicians, Chinese designers, Californian photographers, Iranian economists, Floridian architects and, of course, New Jersey actors.

I started to hear new and different points of view or religion, politics, economics, race, gender and sexuality issues; while noticing how enriched these experiences made me feel, I also realized how similar our histories had been.

I still chuckle thinking about the time when, at a typical reminiscing dinner, Miki, a Romanian friend, showed me her childhood album. The photos taken on the Black Sea looked just like the ones that my sister Nora took of me on the beaches of Lake Garda. I saw the image of my very Catholic mother when my friend Shari described to me the guilt trips that make Jewish mothers so infamous. It was emotional to meet Muhammad Ali, my father's greatest hero; I wished I could share the moment with my dad, and I was moved finding out that my Indonesian girlfriend felt the same way about her own father. And then I took a trip out west.

My friend Peter invited me to meet up with him in Texas and drive back to New York. He picked me up at the airport, we spent a couple of days around Dallas, eating at barbecue joints, listening to blues music in smoky bars and learning line dancing with people wearing cowboy hats. I still carry in my wallet a Good Luck Winner coin from Billy Bob's Honky Tonk in Fort Worth.

The locals tried very hard to understand my heavy accent, just as hard as I struggled to understand their Southern drawl. People welcomed and embraced me with curiosity and generosity —and I loved it!

On a seemingly endless highway out of Texas and into Arkansas, an immense landscape was in front of us, huge dark clouds hinting at the storm looming ahead. Yet, I was in a great mood. "This is the real America," I told Peter, still excited from the previous night at the honky tonk.

His reaction seemed a bit over the top at the time, but it soon became a life lesson that stayed with me ever since.

"That's nonsense!" he said firmly. "America is made as much of the desert of Arizona as of the forests of Vermont, as much of the cowboys of Wyoming as the Wall Street brokers in New York. The BBQ in Texas, the jambalaya in New Orleans, and the mojitos in Miami. America is all these things; that's why America is so great!"

Looking at it from my newly acquired point of view made me appreciate the country and its people even more. It made me realize that, in America, doing things differently does not mean doing them wrong. I learned how important it is to maintain your own identity and, at the same time, how important it is to continually learn from others. I discovered how enriching it is when different cultures combine. I realized that, no matter our origin, upbringing or race, we all share the same basic principles. We all have a personal profile and history—we might have different religions, different skin color and speak different languages, but what we have in common in our lives as humans is much more fundamentally important than what separates us. And America is the country that, more than any other, has been able to assemble people from all over the world.

And what could represent America more than Main Street?

Main Street is the heartbeat of the American small town, the place where the country's pulse is measured. The mythology of Main Street has for generations fed the social, economical, moral, and political discourse in America. It is often lauded as the home of a sensible majority, and the country's moral compass. At times it is also disparaged as the home of like-minded thinkers who resist change and progress.

Regardless of one's ideological position, Main Street serves as a symbol that is central to the ethos of the nation; it is the frame of reference most often used to weigh the vices and virtues of our society. Tinged with nostalgia, Main Street's imagery, architecture, the mom-and-pop shops and its close-knit communities came to embody the spirit of moderation between the extremes of the chaotic urban jungle of the metropolis on the one hand, and the shallowness of strip malls and suburban sprawl on the other.

On a personal level, the six years that I spent working on this book have been a tremendous growth experience. I made it a goal for myself to visit all fifty states before I turned fifty years old. I am proud to have achieved that goal, and most of all I am proud to call all the people in the book my friends. They are now part of my life, and I often refer to them in my conversations and reflections. I still wear and cherish the turquoise pendant that Kevin gave me after our hike in Utah. I felt a connection with Jack in Arizona, a fellow music lover and Jim Morrison fan. I understood the pain of Tony in Minnesota, who lost his wife to breast cancer, and I thanked God for helping my sister and my wife survive the same experience. The portrait of a young soldier that left the plains of North Dakota to sacrifice his life in World War II brought tears to my eyes; I remembered my mother's stories about life during that war and, all of a sudden, the price of freedom had a face.

In addition, marrying into an African-American family has given me a chance to experience first hand just how similar our lives are, as we share, ultimately, the same fundamental needs, despite the differences in culture and upbringing.

We all strive to express ourselves freely, practice our religion, find a decent job and an opportunity to provide a better future for our children. Whether it be the thrill of the first day of school, the happiness of graduation, the excitement of a wedding, the joy of the birth of a baby, or the pain of the loss of a parent, I realized that what we have in common is more important than our minor differences—that the fundamental aspects of our life that we share as humans are much deeper than the individual necessities or beliefs that sometimes become our main priority.

This book is another addition to the wealth of contributions that immigrants have provided to this country. Some of us have been here for only a couple of decades, like Prasop Kiewdara in New Jersey, while others, like Angela Fischer Brown in Rhode Island, are sixteenth-generation Americans—and in California, George Silva's Yaqui ancestors have a connection to the land that is older still. In all our individualities, we each offer our own testimonial to the global aspect of the American spirit, that unique spirit built from a common human experience of people from all sorts of backgrounds.

These fifty stories are an honest observation of who we are as Americans, a reminder of our roots, values and history, based on immigration, opportunities and hard work. They are windows into the lives of everyday folks, representing the soul of that Main Street that is much discussed but is rarely given a face. The landscapes and the architecture in these pages might be distinctly American, but the experiences of these people reflect universal sentiments. Though the small moments that make up their lives are often humble and ordinary, they indeed do become exceptional when viewed as a whole.

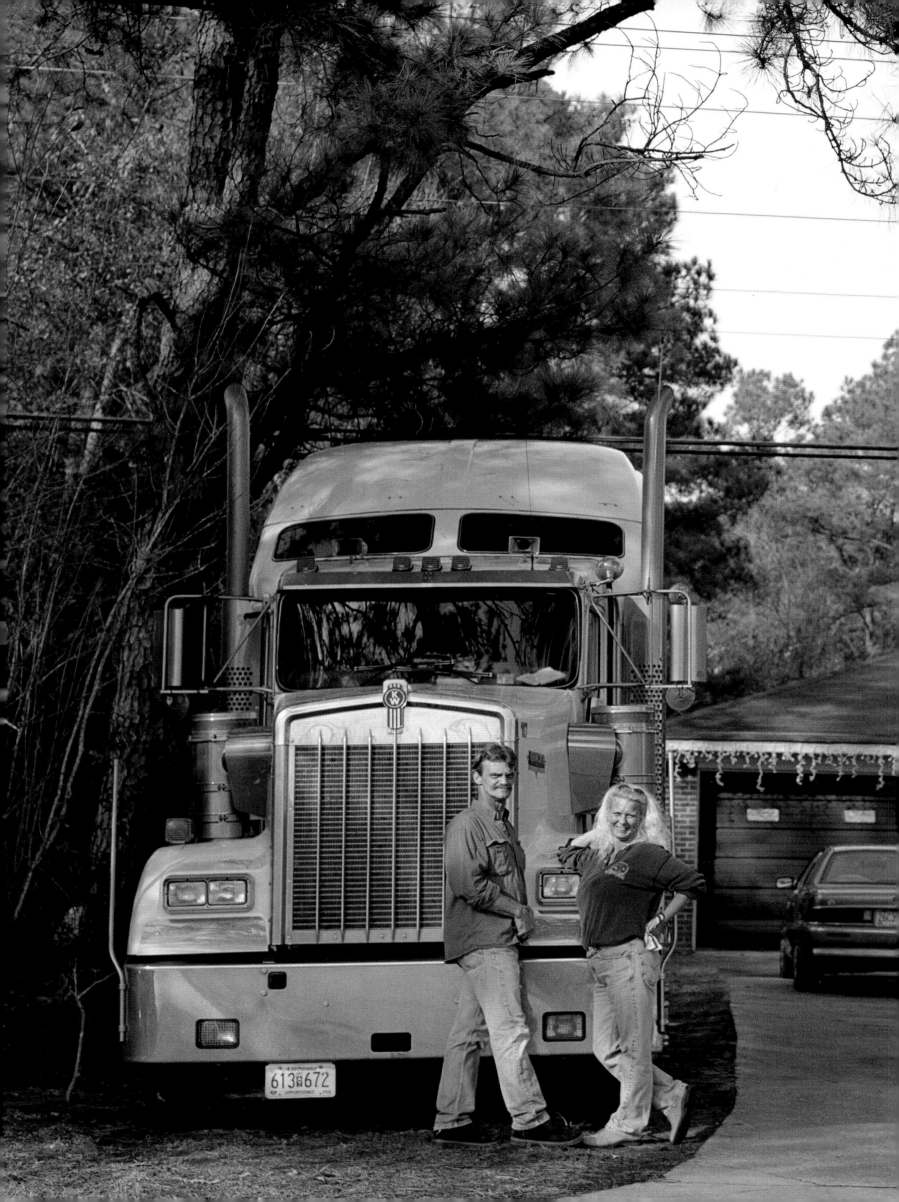

ALABAMA

HELENE & STEVEN BARNES

CLAYHATCHEE

Peanut and cotton plantations line the roads as I cross into Alabama, driving north from the Florida Panhandle. Some of my favorite music from my youth comes to mind; I remember playing air guitar and bobbing my head without understanding the words. I smile within myself realizing that, after speaking English for twenty years, I can now grasp the lyrics of Neil Young's songs of social critique of the South in the '70s, and the proud response of Lynyrd Skynyrd in "Sweet Home Alabama," the quintessential classic rock homage to the state.

I am humming these songs when I arrive at West Main Street in Clayhatchee. As I pass the police station, I notice a sparkling white eighteen-wheeler, the king of the American road. My heart fills with excitement when I see that it is parked a few feet from the mailbox that bears the number 50 on the side facing oncoming traffic. The rig is almost bigger than the house!

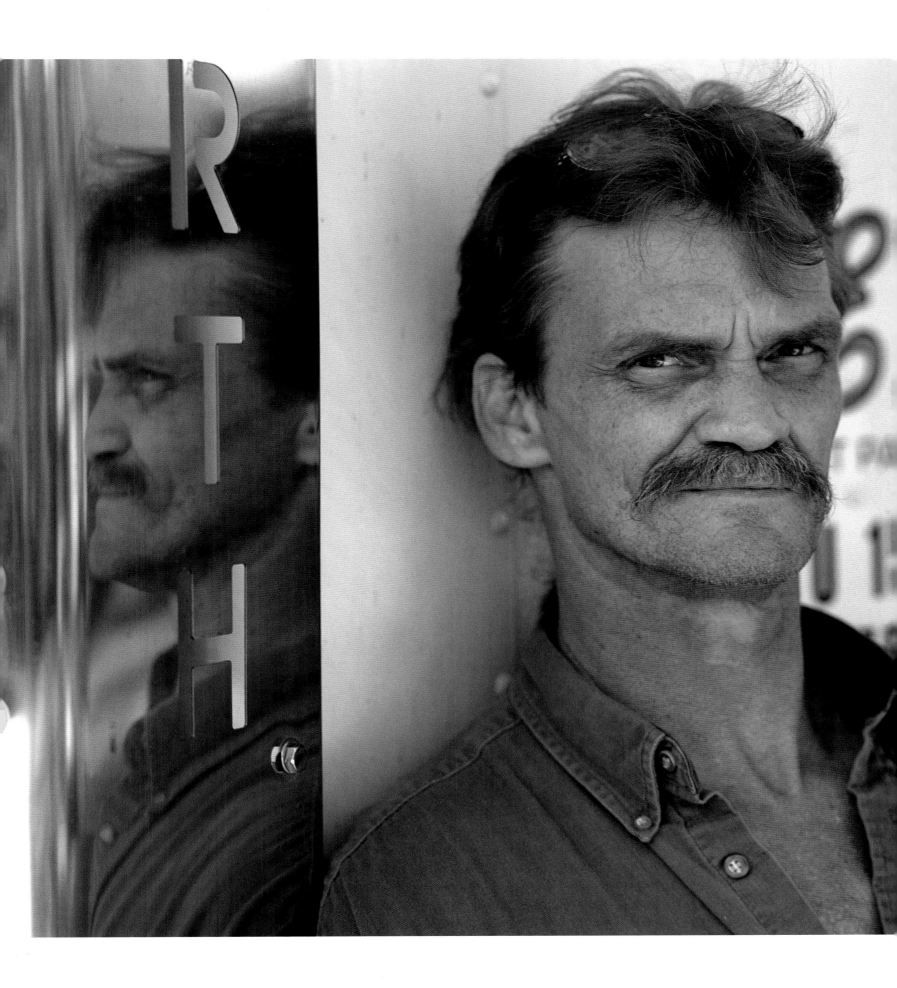

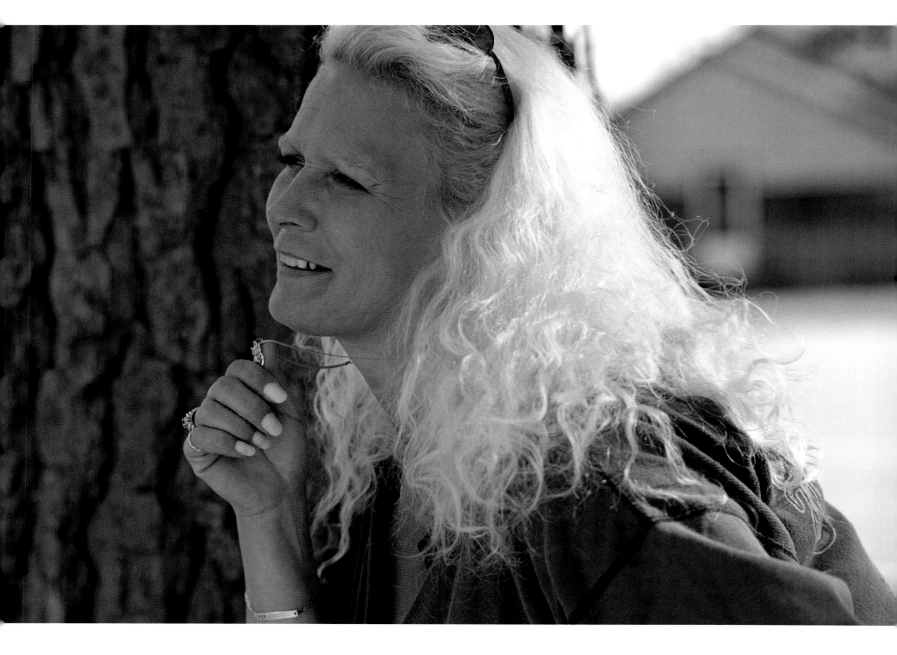

Steve and Helene giggle when I express my excitement about the truck. Helene is warm and welcoming, while Steve is more silent and suspicious at first. "I was born in Ft. Stewart, Georgia, where my father was stationed with the military, and then we moved to the Panama Canal. I come from a family of Army brats," she says laughing. "My mother was born in Panama, her father was in the Army as well and her mother was a native." She doesn't remember much of those days. "It was warm all year round, we had rainy seasons and dry seasons." They eventually moved back to the States. "When I was a teenager, my dad was transferred to the base in Fort Rucker, just a few miles from here. Never had a chance to pick up Spanish in the few years I lived in Panama." Helene recalls the relocation was a mix of fear and anticipation. "I didn't know what to expect, but it was exciting going somewhere new." She adapted quickly. "After I graduated high school, I stayed in the area, doing a little bit of this, a little bit of that until I met Steve, in 1999."

Steve jumps into the conversation. "Helene grew up in Panama but she kept good old American values." He recalls meeting her at a bar through another friend. "Well, I had to meet three of her girlfriends and get their approval before she would agree on going out," he says, warming up to me while I take pictures of him by the truck.

Soon after they met, Helene decided to join Steve on his travels across the United States. "We were on the road for all but about six weeks of the year," she says. "It was a permanent vacation. I got to see a lot I've never seen before, but you never really get to experience it," she explains. "I've seen the St. Louis arch three times, but at seventy miles per hour."

Four years after they met, Steve and Helene tied the knot, and continued their life on the road. "We had fun traveling, especially when we got our first dog, Sasha," says Steve. "Helene doesn't care a bit for camping—her idea of camping is the Holiday Inn. The dog gave us a reason to enjoy the outdoors." After six years of cruising with Steve, Helene decided to take a job as an office manager for a local construction company. "I miss her a lot," he says, "her companionship, her conversation. I call her at least twice a day, in the morning to briefly check on her and in the evening for a couple of hours. She usually has to tell me what she is planning to do. Just to warn me." Helene feels like she has to explain: "I like to go to Las Vegas, that's what he means!"

Their house is just a quarter of a mile from her office. "I don't like the hurry-hurry, rush-rush. I like having a big yard and a lot of space to help me dealing with our three Rottweilers: Sasha, Bruce, and Precious." They don't have any children of their own, so the dogs somewhat fill the role. Helene even bought a vehicle more suited for the family. "I had a T-bird," she says, "but I had to switch to a Jeep to get them around." Steve has a son and daughter from a previous relationship. "I am a grandfather already," he says, smiling. "They are all in Kentucky. Unfortunately I don't get to see them much, but I try to stay in touch any way I possibly can. I love my kids."

Helene enjoys life in Clayhatchee. "There's not much to tell," she says. "There's not a single traffic light or restaurant, just Annie's Convenience Store and one bar, The River Lounge."

While Clayhatchee might not have many sights, its people are the main attraction. "Annie," she explains, "lets you buy on credit, and will happily order something you want, if it's not in stock. You just don't find places like that anymore. I can sum it up in one single word: hospitality! Everybody knows everyone and most of them are related," she says, laughing at her own joke.

Their landlord lives next door and comes over to check on things. After a few questions, mostly related to the events of 9/11 in New York, he leaves me to my picture-taking. He returns a few minutes later with a full bag of freshly roasted peanuts. "These are from my fields; they'll give you energy for the road." I taste the best peanuts I've ever had and look at Helene. She smiles back. "That's Clayhatchee for you."

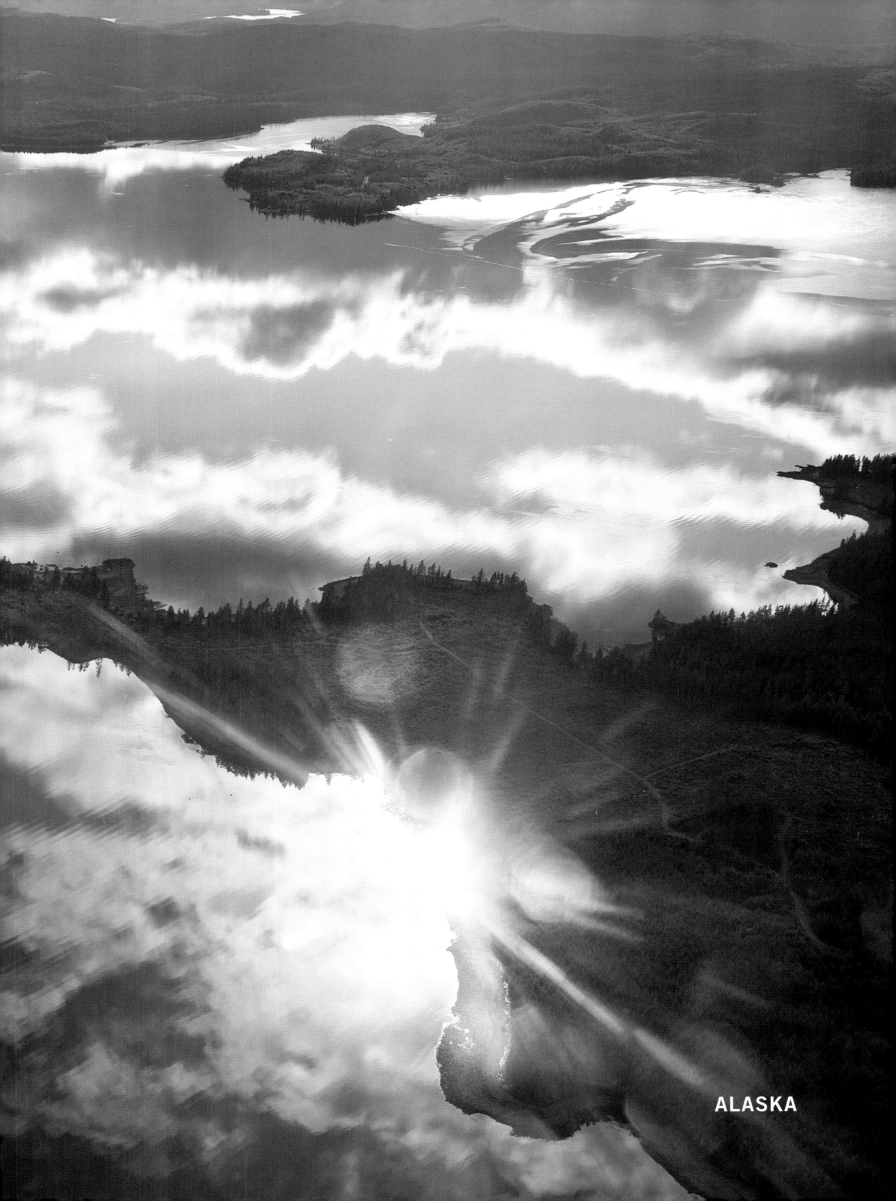

ALASKA

TIMOTHY FISHER

KETCHIKAN ✈

Love at first sight. For me it is love at first sight with Raven; I have no idea what it means but I am fascinated by the stylized design of the Native American symbol depicted on the napkins of the Alaska Airlines flight from Seattle. I arrive in Ketchikan on a rainy afternoon and Tim welcomes me at the airport, enthusiastically ready to introduce me to his recently acquired hometown. "Ketchikan is connected to the rest of the world via this small airport," he says. "It is only accessible by boat. This is the location where the infamous Bridge to Nowhere was supposed to be built." He explains the logistics of the town, stuck between the mountains and the ocean. "Well, that would have been the bridge to everywhere for me; I need the airport to get to the Lower Forty-eight." I quickly learn the locals' name for mainland USA.

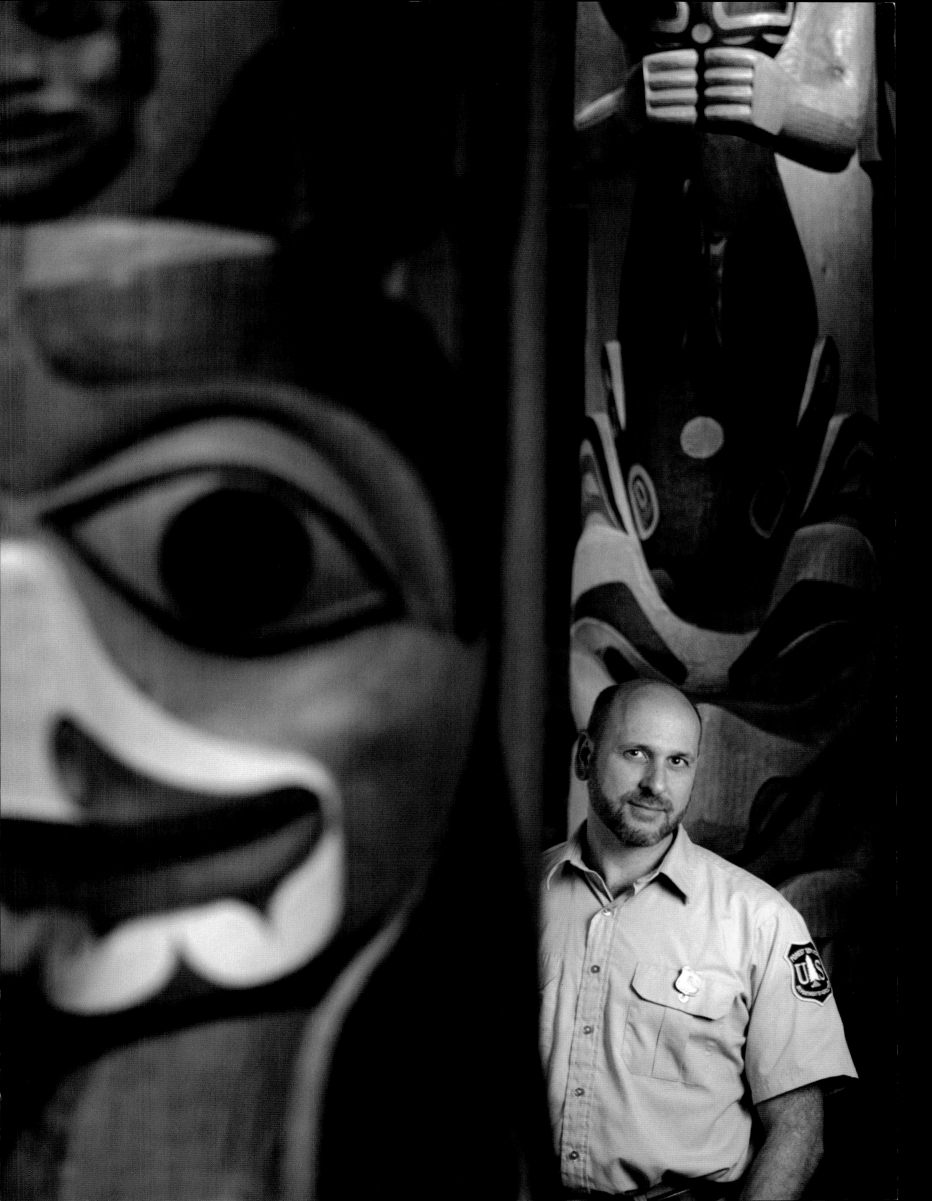

"I grew up in the countryside, in New Hampshire. It was the quintessential American childhood," he shares. "Me and my brothers were always outdoors. My mom would open up the door and kick us out and we were not supposed to be back home until lunchtime."

Tim has moved between many states for work, stationed most recently in Florida and Montana, and is now working as a park ranger at the Southeast Alaska Discovery Center. I am amused and feel lucky when he tells me that the Center was built just a few years earlier, making it the first and only 50 Main Street in the whole state. Working with nature has always been Tim's passion. "I got lost in the woods with my brother when I was a child," he tells me with the slight enthusiasm that we all have when describing our youth adventures. "It was very cold; we were lost only for a few hours but enough to get frostbite. I think that getting lost in the wilderness intrigued me even more to go out there, discover things and places, find challenges."

The rain lets up, reduced to only a light drizzle, so Tim takes me for a hike in the Tsongas National Forest, the largest in the United States. His passion for his job is clear during the hike, as Tim points out different kinds of plants and flowers, abundant in an area that I expected to be very cold but is instead surprisingly temperate.

"Keep your eyes open for bears," he says, warning me. I am intrigued at the possibility of seeing my first bear. He understands my excitement. "I saw one on the first day I arrived in Ketchikan," he says. "I went for a walk and I bumped into my first bear. The first week, the first day!"

Disappointed that we couldn't encounter one in the forest, Tim takes me to a couple of spots known for bear sighting and, sure enough, we spot a mama bear and her two cubs just at the outskirts of town, feeding on the exhausted few salmon left at the end of their run season.

Tim's curious nature pushes him to look out for "first" experiences, so he is now planning a trip to Denali National Park in the hope of seeing his first Grizzly bear. "I saw my first Northern Lights here in Alaska, on Halloween night. I also just had my first fishing expedition in the ocean." Of course I am curious about the catch. "I caught two Budweisers and a couple of Jack Daniel's," he says, betraying his sense of humor.

It is mid-October and light rain sprinkles on and off for the first four days of my stay. Four days that allow me to visit the town and get to know some of the local people. I get to visit the hatchery where the salmon begin their journey to the ocean, just to mysteriously return three years later to lay their eggs and die in the same river where it all started. I visit the carving studio of Brita Alander, the only female Tlingit totem pole-maker; she gives me a crash course on symbol-ism and storytelling of the three Native tribes, Tlingit, Haida and Tsimshian. I especially enjoy hearing about Raven—the rebel, the rascal, the mischievous bird that stole the sun, the moon and the stars and put them in the sky. My fascination with the symbol grows even stronger.

On the fifth day, Tim shows up at the Black Bear Inn, where I am staying, at the crack of dawn. "It's going to be sunny today; we set you up to go on a mail run." I look at him perplexed so Tim explains that the seaplane is the only way to reach some of the communities on the islands north of Ketchikan.

The takeoff is very smooth; the water is calm, resembling an immense mirror. The plane makes a few stops, always landing on water, and every time is a breathtaking experience for me.

The archipelago of islands dotting the ocean, the humpback whales, the sea lions, the snow-capped mountain peaks and the lakes that lie in the valleys make for a mesmerizing flight.

When we return, Ketchikan in the sunlight looks like a garden in bloom, the colorful houses punctuating the green hills surrounding the harbor.

I am sad to leave the following morning but I cheer up when I run into Brita Alander on the plane. We embrace like old friends and I realize that, after only six days, I am in love with Alaska.

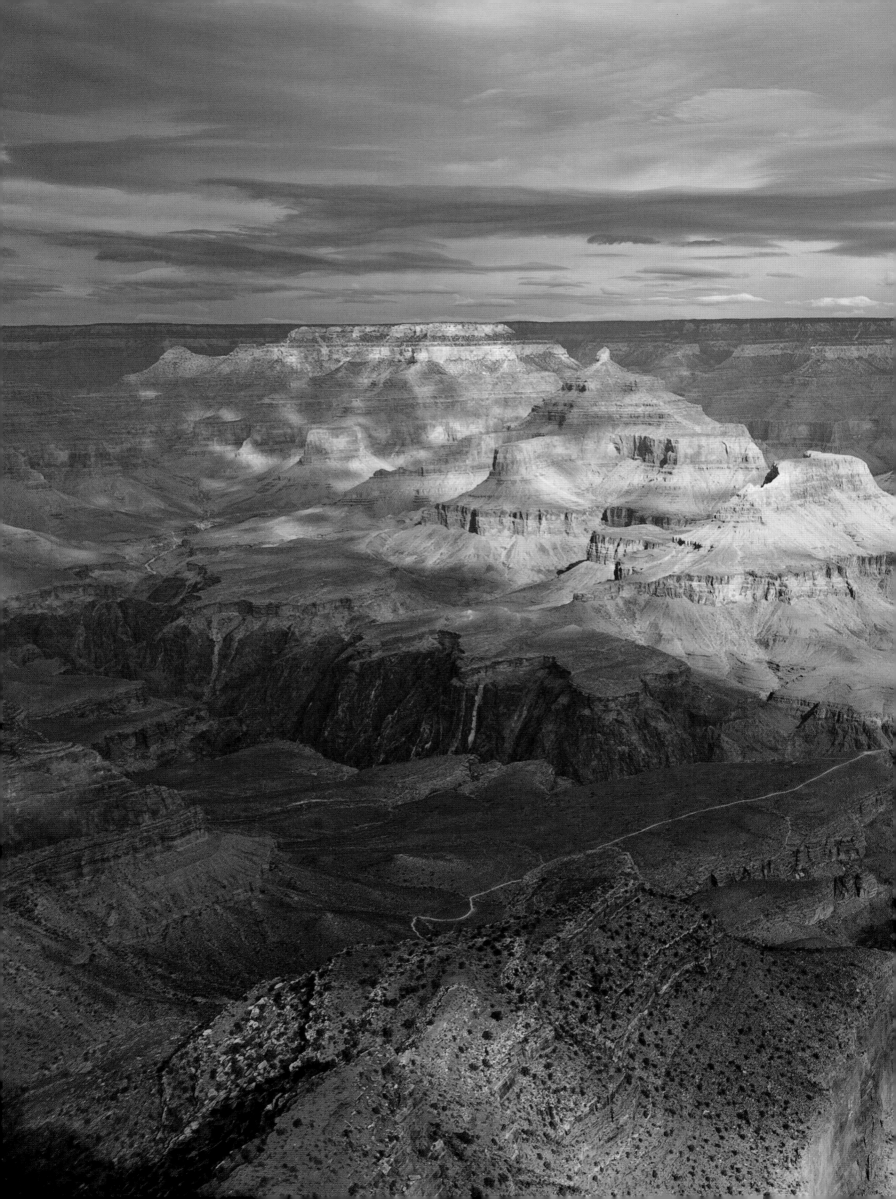

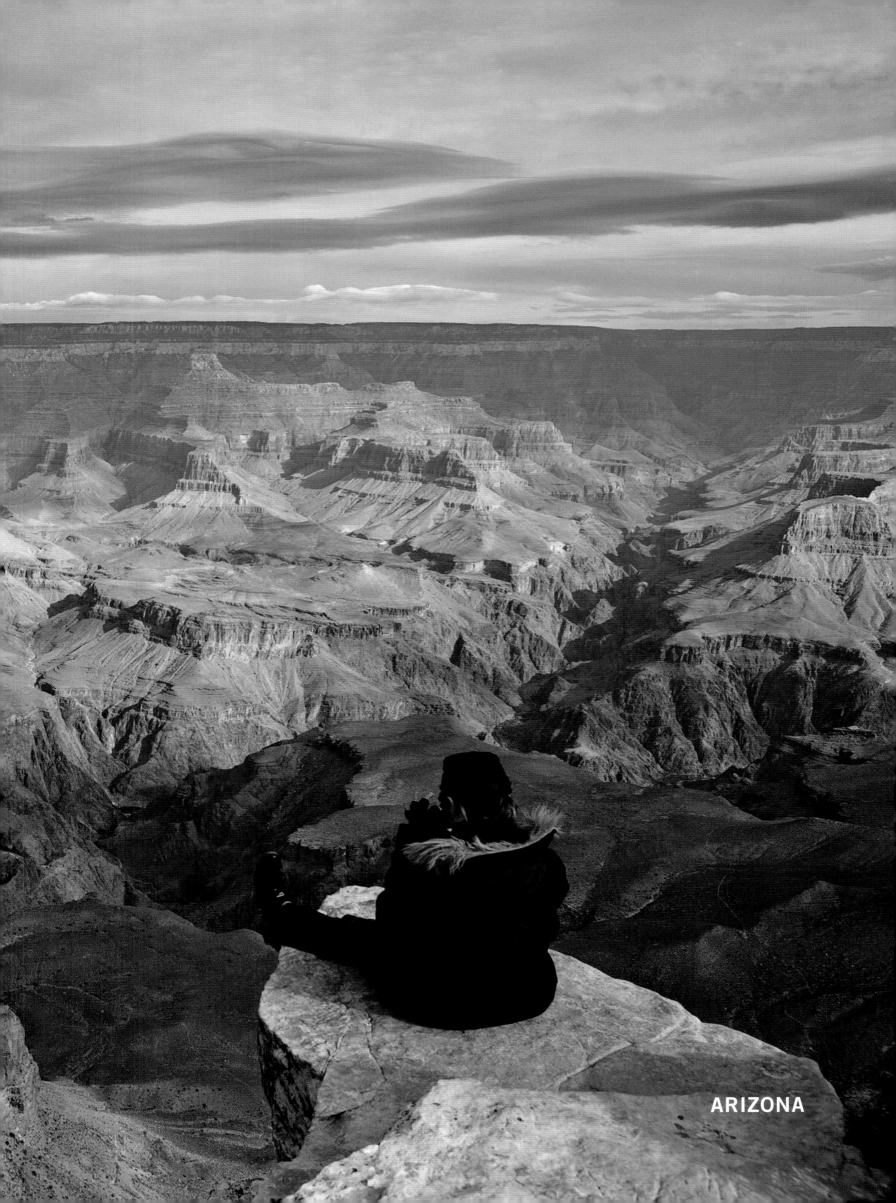

ARIZONA

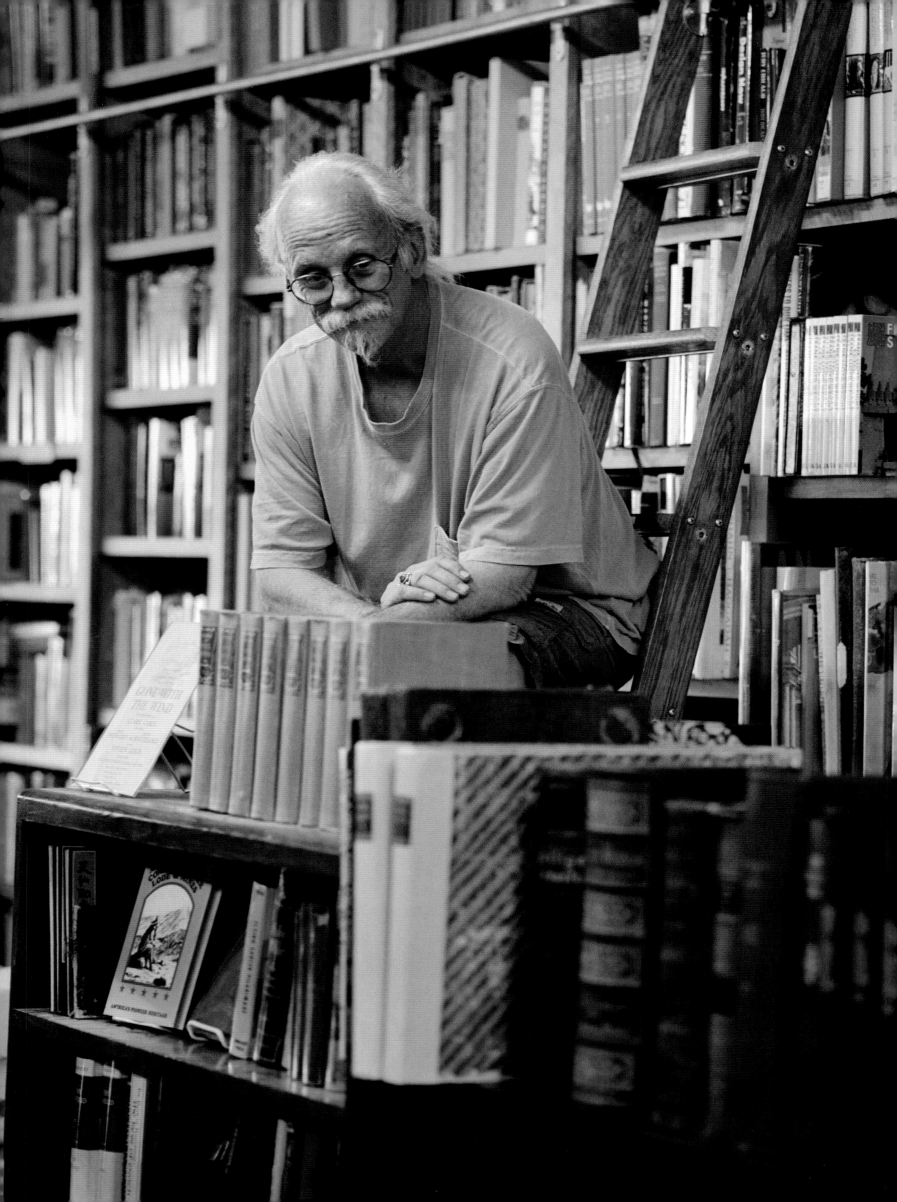

JACK ELLWOOD

MESA +

"I am sixty-four now," says Jack, acting a lot younger than his age in his casual outfit. I laugh when he expresses the same trouble I have been experiencing with aging. "Every time I get to those years that end with zero, something gets in my mind. I have a hard time registering. It literally takes me a year to get used to it. So when I turned sixty-one I went, that's OK!"

I meet Jack at the Book Gallery in Mesa, where he works two days a week. "It pays for my books," he says quietly. It's funny to realize how close the circle of life is for him, spending his money in the same place where he earns it. "I have been a reader all my life, ever since I was old enough to read." Jack has lived his entire life with a book by his side, but only recently started collecting rare and antique ones.

"To me it's a real charge, to hold a book that is seven or eight hundred years old and think of all the people that might have held it. It's like holding something sacred. I own about four thousand books at the moment." As an apartment dweller in Manhattan I express my amazement about where anybody could keep so many books. "In many, many bookcases—two rooms could practically be considered libraries," he says with an open smile and a sense of gratification.

"My father was in the Army so we had to move every couple of years. I learned to love traveling. When my father was transferred to Germany I decided to move out on my own." Jack had just finished high school and decided to join the service instead. "I wanted to learn how to fly so it was between the Navy Aviation and the Air Force; I picked the Navy." The four years in the Navy allowed him to travel and enjoy the world but also took him to war missions in Vietnam. "I loved Saigon at the beginning of the war. It was like the Paris of the Far East back then." He enjoyed the first couple of years but the situation changed rapidly. "The good memories went away by '65, when they started shooting at our planes. That changes your mind quickly!"
After leaving the Navy in 1966, he made San Francisco his base. "I would travel for six months around the country and go back to San Fran," he says, evoking images of a magic era in my mind. "In 1967 and 1968 I stayed in San Francisco permanently in a house that I shared with my girlfriend and many, many visitors, right in the middle of Haight-Ashbury." The commonalities between the two of us start piling up when we talk about the music scene of those days. "There were the Grateful Dead, Airplane, Big Brother…" I have to ask about my teenage hero and he lights up: "Jim Morrison was my favorite."
I am fascinated by his closeness and direct exposure to such a defining moment in American culture. "I am lucky I was there when so many things were happening!" he says humbly. "They even shot an episode of *The Streets of San Francisco* in my house. I had a chance to meet Michael Douglas when he was just starting out." I was an avid watcher of that show and I am flabbergasted that I might have seen Jack's old house on TV, many years before I met him!
After leaving the Navy, Jack worked as a technician in the medical records and radiology department in various hospitals. "I was in Honolulu for about three years, working mostly nights and going to the beach during the day. It was a tough life!" He laughs out loud. "I lived in Waialae, on the side of the mountain. I became friends with my neighbors. When you become friends with a Hawaiian, you are friends with the whole family. I would get invited to luaus or family parties." A big smile comes to his face. "At times I would hear a knock on my back door; there would be a little boy with a bag of fruit or the local pakalolo—here, this is yours."
His parents retired in Arizona, so Jack would visit periodically, eventually moving there permanently after they passed away.

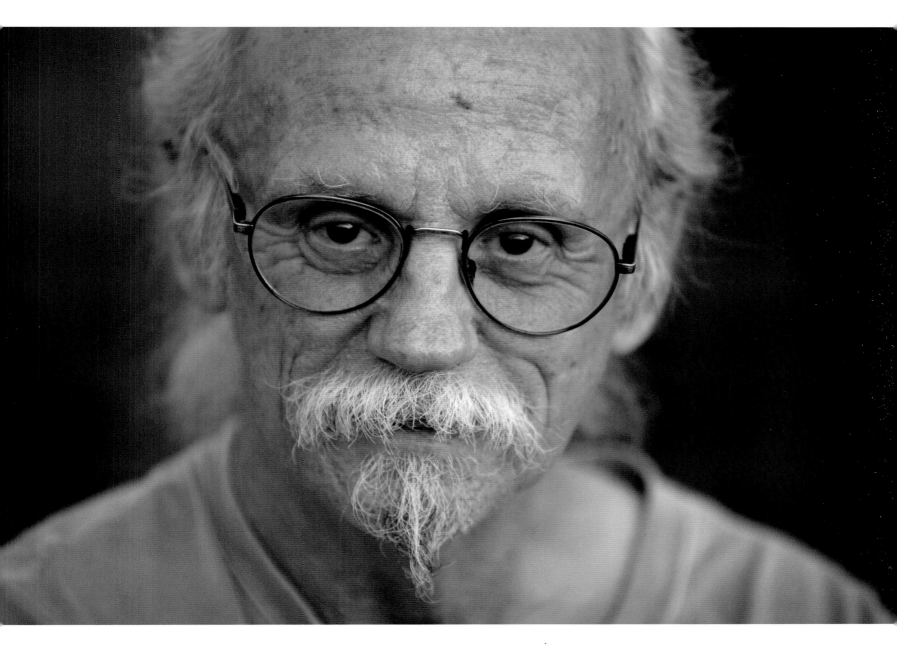

"I am the oldest in the family; my younger sister is mentally handicapped so I came to take care of her. She is fifty-one now but she behaves like a teenager, basically. I have known all my life that she would become my responsibility."

Jack has a long-distance relationship with a woman fifteen years younger than he is, the same age difference I have with my wife Rose—another uncanny coincidence. "We've been together twenty-five years," he says, almost apologizing. "There have been times when she wanted to get married and times when I wanted to get married but it never happened at the same time. She lives in western Arizona and we get together a couple of days a week. That way we don't get on each other's nerves," he says, laughing.

A sense of accomplishment is palpable when he sums up his life. "I had great experiences, visited all the places I desired and lived my life to the fullest. I haven't missed much."

I leave Mesa hoping I will feel so at peace with myself when I am sixty-four.

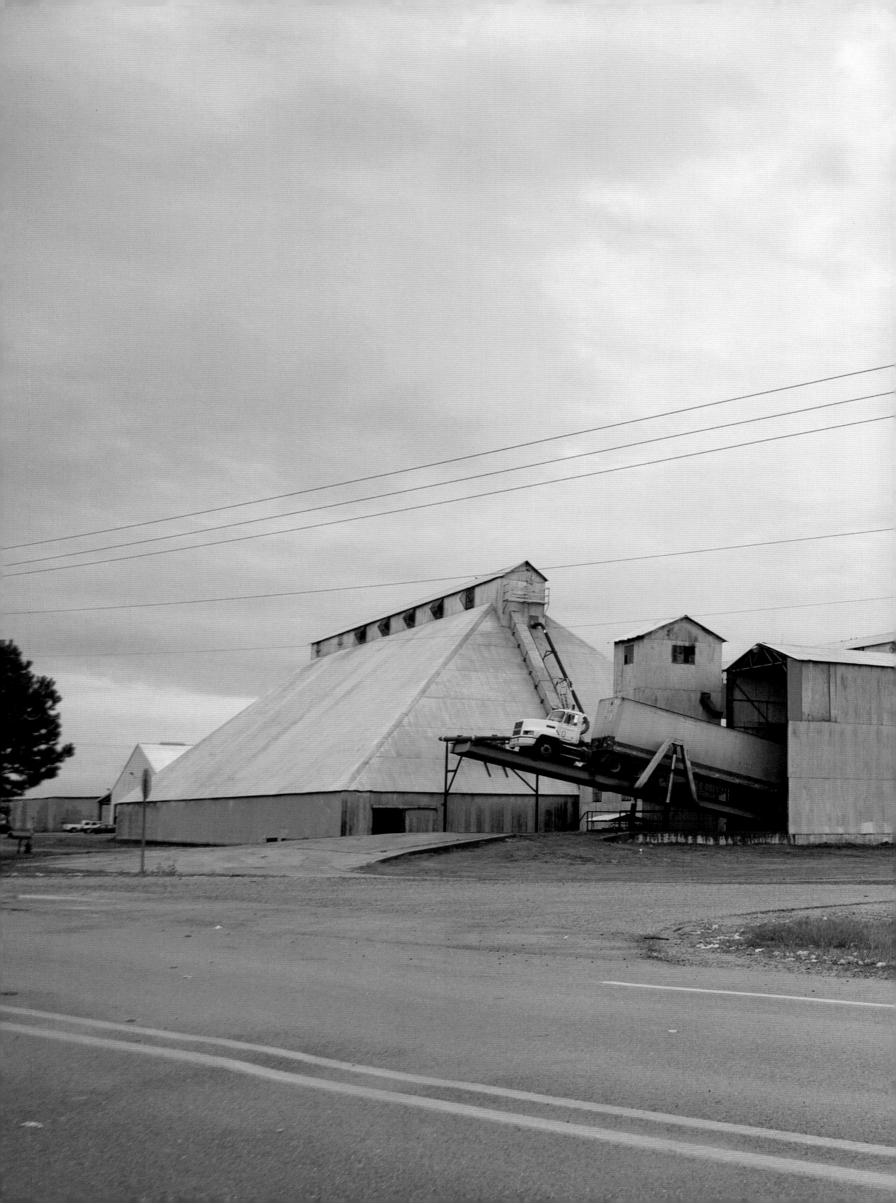

ARKANSAS

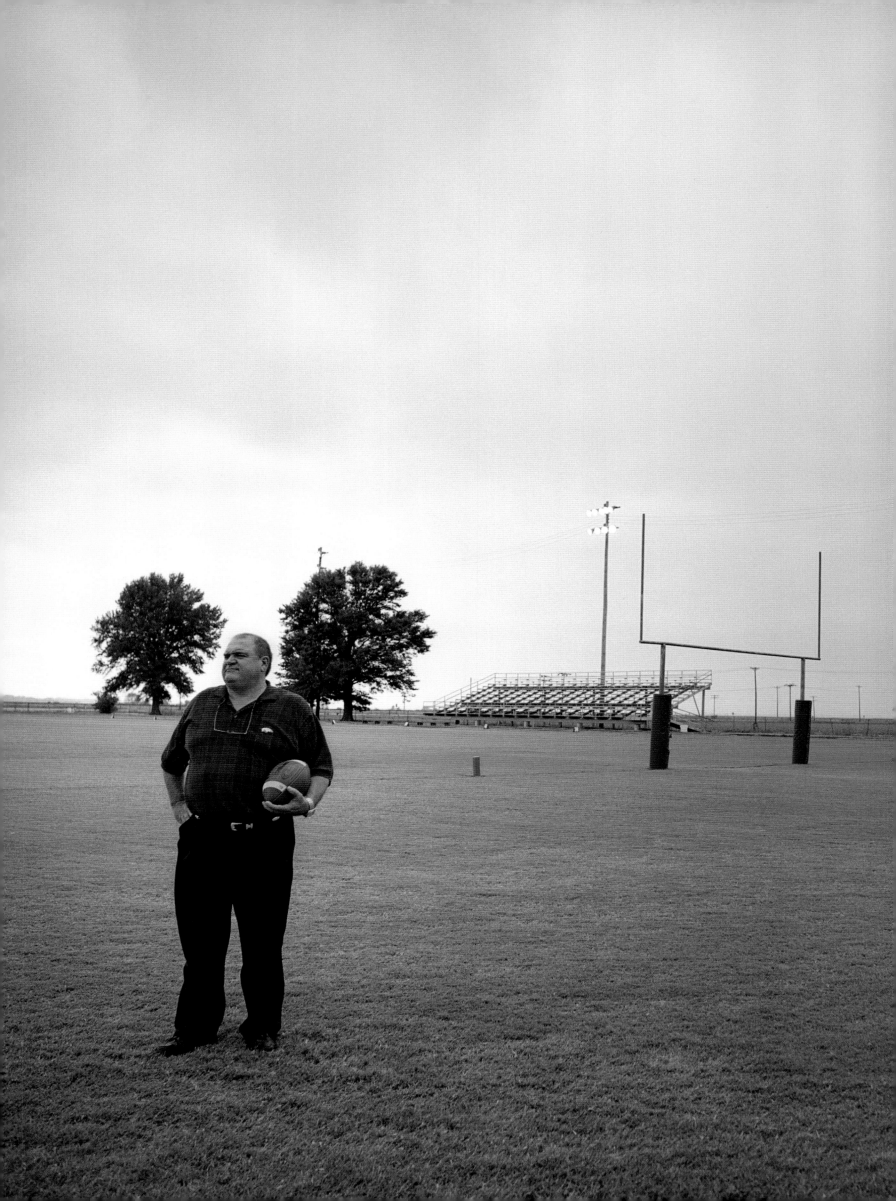

RON PARNELL

WILSON +

"I've always lived in Arkansas, always
around Wilson…" Ron Parnell is a local kind of
guy and spent all his life in the northeast area of
Arkansas. "We were farmers, my parents, their
parents and their grandparents—as far back as I
know about." A reserved, stocky man, he likes to
share his family history.

"My ancestors came over from Ireland; we can
trace them back to the 1800s. They first stopped
in North Carolina and through the generations
they made their way to Alabama, moved on to
Mississippi, and eventually settled in Arkansas.
My grandfather was already in the farm where I
was raised. We all worked with my family growing
soybeans, cotton, wheat."

But the romantic images we all have about farm
life are not really part of Ron's life story.

"When I was growing up I didn't enjoy the farm. It was before all the modernization. You had to do it all with your back. It was tough working the fields every day. When it rained, you couldn't get in the fields. That kind of work breaks your back, and if you get bad weather, you might not even make anything." He does have some good memories of his childhood. "I consider myself fortunate for my childhood, but it was a really hard life, especially as a teenager. I couldn't wait to get out of the farm and go to college."

Ron is a tough nut to crack and doesn't like to talk much, but I notice the New York Yankees memorabilia in his office, always a good ice-breaker. "Mickey Mantle was a hero of mine when I was younger," he says. "Now I follow our local college teams; I went to Arkansas State but I love the Razorbacks too."

Sports have been a passion for Ron all his life. "I've always wanted to be either a teacher or a coach. I think that educating our children is the best thing we can do for their future, and sports keep them healthy. I graduated in social studies and history. I did a few years of high school coaching, and then I went back to get a Master's degree in administration. I took this job as principal on a temporary basis. That was twenty years ago," he says, laughing for the first time.

A dark sky looms over us so I feel pressured to take my pictures, but Ron has other priorities. "My kids are leaving now, I have to coordinate the school buses and make sure they are safe." After he has finished directing the buses, I request to photograph him on the football field. School budgets are really tight these days so Ron expresses some doubts. "Those lights are expensive. I'll have to ask." Luckily the football coach is understanding and cooperates, turning on the lights for ten minutes, just enough time before the rain makes us run back to the office, where we continue our conversation.

"This is my last year. I am going to retire in a few months. I'll have a chance to play more golf." He loves fishing as well. "Here in the Ozarks we have trout in the rivers, and lakes with bass, carps, bream, and catfish, of course. We love catfish in Arkansas. I think we eat more catfish than anybody else in the country." He hopes his wife will be able to join him, especially on the golf course. "I've been married my whole life," he says with a smile. "I met Robbie in church while I was still in high school. We attended the Pentecostal Church. Her dad was the pastor." I have to comment about him having the guts to ask out the preacher's daughter. "That's right!" he says assertively in his thick Southern drawl. "I remember when we first started dating. I still lived on the farm and drove to town to pick her up in my used Ford Falcon. It was a small car but I bought it with my own money. I was in my senior year in high school; I was working a second job at the grocery store on weekends." The story reminds me of how I bought my first Vespa as a teenager. "We've been blessed by a son—he works at the Federal Building in Jonesboro—and a daughter that practices law in Little Rock," he continues.

"We have a granddaughter now; we are look-ing forward to moving closer to her." He looks at me with a straight face. "I just realized recently that I have been married to a grandmother." We both laugh at the joke. "She is a reader and a homebody, that's how we match up so good. I like to read about history. We have to learn from our past to make sure we don't make the same mistakes. I read everything that Steven Ambrose wrote on World War II. It fascinates me, all those people putting up their lives for democracy."

Following his readings, Ron made a point to travel to Bedford, VA. "It's a very small town, but they lost more boys than any other place in the country on the invasion of Normandy. Now they have a National D-Day Memorial there. It's really something that people should see."

Retiring is going to be an adjustment for Ron. "I have loved working with children in this school," he says. His pragmatism prevents him from getting too mushy, but his feelings are hard to hide: "I am going to miss my kids."

CALIFORNIA

GEORGE SYLVA

VENTURA ✦

"We do have to be proud of it, man," says George, pointing at the huge flag hovering over Sylva's Boxing Gym. He is proud of being American and he wants to impress the importance of the flag as a symbol on the young boxers that find refuge in his gym. "I want to remind them that they have choices and they have the power to make those choices, in this country of ours." He takes a short pause. "I am very proud of having Indian blood, too. My mom was Yaqui-Mexican and my father was Mexican-Portuguese. I grew up in East Los Angeles, the oldest of four siblings. It was a tough environment, not a very happy childhood." George doesn't remember much of it. "I got struck in the head by a golf club when I was ten years old. I have no clear recollections of my life before then…I might have gotten lucky, after all," he says sarcastically.

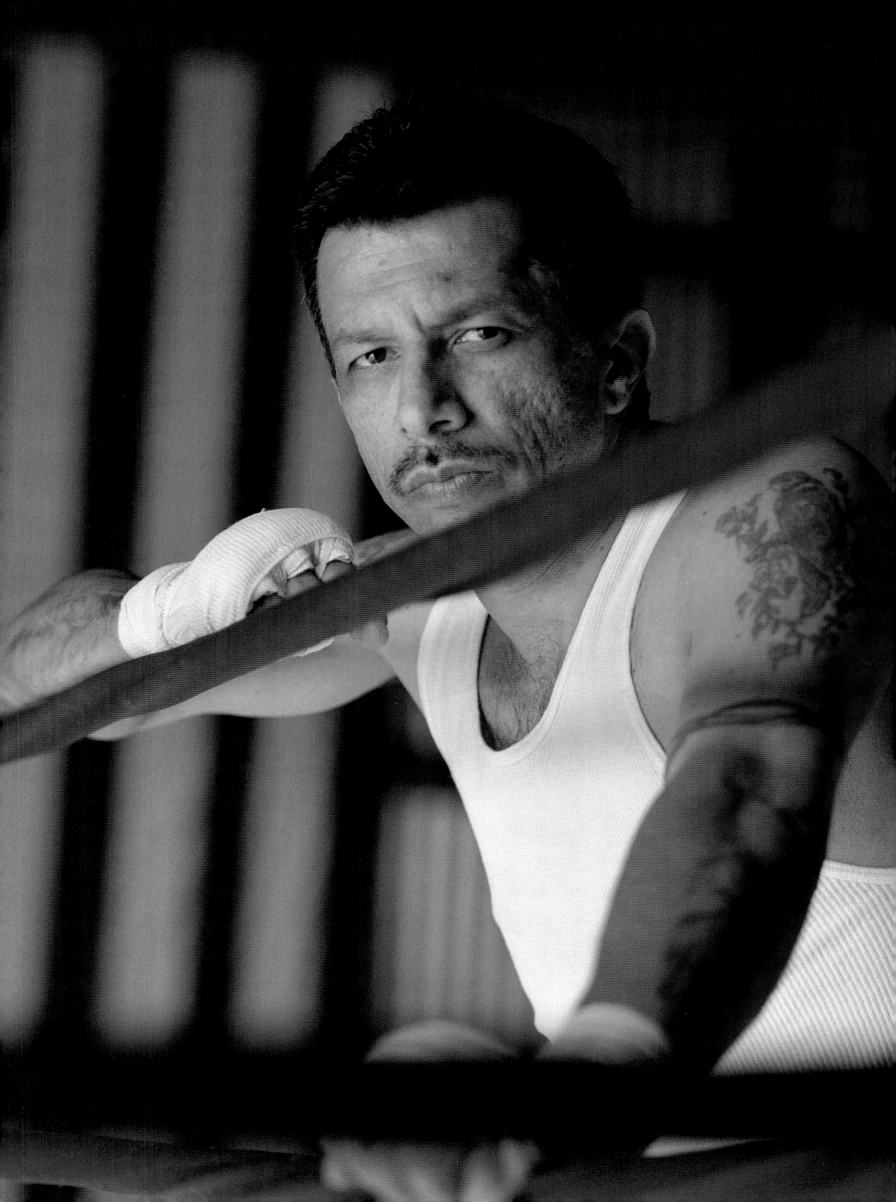

He does remember the teachings of his grandmother, Raphaela, a full-blooded Yaqui Indian. His voice changes when talking about his abuela. "She was the most spiritual person in our family and she really influenced that side of me, really pushed me to trust my instincts and develop my spiritual side." He fondly remembers their conversations. "She used to tell me that, in our bloodline, I was more Indian and more akin to that culture than anybody else, and that's why she decided to pass down a lot of that stuff to me. She just felt it." He smiles. "I was so exited about it, even as a kid."

At age seventeen, George joined the Navy and took a successful path as a combat cameraman. "It was absolutely fascinating. I traveled all over the world, I saw so many things, discovered so many adventures. When I was stationed in San Diego I even had a chance to work on the movie *Top Gun* as part of the Navy crew that helped shooting some of the aerial footage."

That experience inspired him to try something different. "What better place than Los Angeles to start a career in films?" he says, thinking back. "I was kind of an open book. I have always known that I would accomplish whatever it was that I wanted from life," he says with the confidence that military training must have given him.

"I started working on fitness videos even before I quit the Navy, when a friend asked for help on evening sessions." Discipline and hard work ethics helped George work his way up the ranks in the entertainment business just as fast as he did in the military, working on camera, grip, and lighting until he became director and producer. His passion and experiences eventually brought him to fulfil his dream and open Sylva's Gym.

"I am the trainer of the boxing Navy team these days," he says, mentioning the success his team has had in recent years. "I myself just won a title at the Ringside World Championship, at the age of forty-two." He gets humble for a second. "It's only an amateur tournament, but it's the World Championship, in Kansas City."

His generous side quickly comes through. "My life passion is really about the kids, though," he says, recalling his grandmother's teachings. They come in handy dealing with troubled youths that might share his own early experiences. "I think about her all the time. I even catch myself talking like her." I smile, as I feel the same way often.

The palm trees, the beautiful beach and the surfers make Ventura an idyllic place to my eyes. "Ventura is a great town. It's all about the beach, lots of surfers. It's a great life, but not for everybody. Unfortunately gangs are finding roots in here as well. The kids that we want to most influence are the ones that don't have such a great life at home or don't have a lot of money; that's where I want to be." He doesn't even require payment if they can't afford it, as long as he can apply his teachings. "My goal is to give these kids enough confidence and enough skills where they can go out there and do it for themselves, where they don't have to rely on anybody else—build their own lives and take responsibility."

It takes hard work and energy. "It is frustrating at times to live in such a powerful country as ours and still have to endure these many problems, but I try to stay focused on what I am doing right here locally. I watch the kids on a daily basis improve and get better, themselves and their attitude. So I think, 'OK, if I can affect one kid then I've made a difference.'" He brings it back to his work at the gym. "I use boxing as sort of a metaphor for life. I think life teaches you how much you are putting into it right away," he explains.

"And boxing does that same thing. When you get in the ring and you are in a competition, you know how much you have put into your own training and you can see what you get out of it." He really cares about the results of his work. "I get kids in here that, sometimes, are from the probation department and they are in trouble. With time I see them get back into school, bring their grades up, and make themselves better people. To me that's great success!"

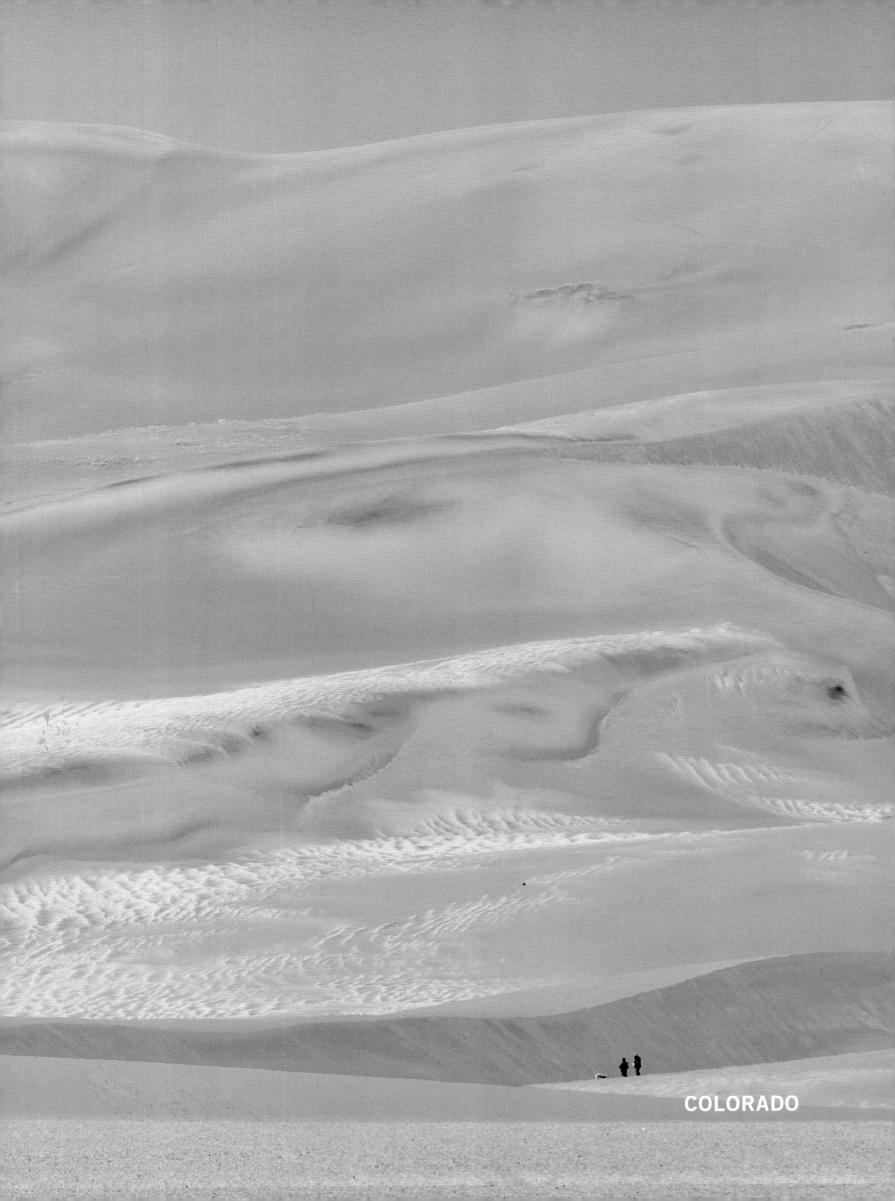

COLORADO

ELAINE CASEDY

KEENESBURG ✦

"We were really poor, but we lived on a ranch. It wasn't ours—my dad rented it. He did some farming and we helped with the hay, to put up for the horses and the cows, but basically it was taking care of the cattle and moving them from pasture to pasture during the spring and fall. Riding horses all the time. Taking care of bucket calves."

Elaine is happy to explain. "That's when you have a young calf, and the mother doesn't take care of it so you have a bucket with a nipple on it, and you feed them." She laughs at me. She must see me as a total city slicker. "I started riding a horse when I was five years old. All of us, me and my three sisters, we all started riding very young. Nobody really taught us, we just got on and started riding. You got thrown off a few times, but you just get back on. I was nine years old when I started milking the cows."

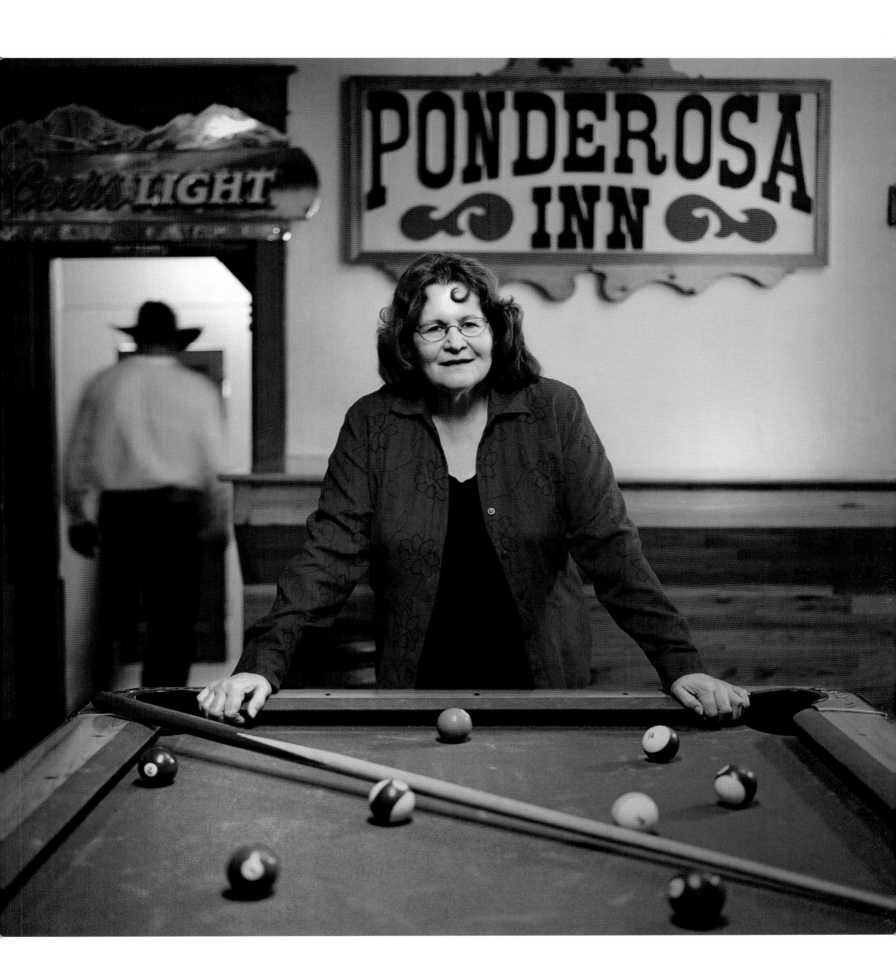

Elaine's childhood sounds like so much fun. "My fondest memories as a child are of animals. Riding the horses, playing with the calves. I thought of it as playing, but actually we were feeding them and stuff, helping dad. My favorite was Flame, my own horse. I loved her; I never knew what to expect. My sisters and I would be out galloping in the pastures or something and if I tried to tell her to run and she wouldn't want to do it, if she decided that she was going to stop, she would put her head down and her feet out and I'd slide right off of her neck. Right down in front of her." She lights up thinking about those days. "The ranch was fenced but if we wanted to go someplace else, we just opened the gate and went right through, closed the gate behind, and went further." She sounds a little melancholic. "My sisters and I still think of it as our favorite house. It was a big two-story house. It had hardwood floors, a bay window. Big trees outside, a nice lawn, very green. At the foothills of the Rocky Mountains. We just loved it."

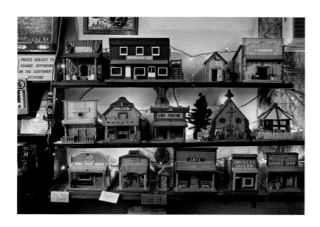

She never had a chance to win her battle with Flame. "My dad got hurt. A bull charged at him and ran him into the back of a pickup, and it broke his tailbone. He couldn't work on the ranch anymore so we moved to Golden and he started driving a truck."

A few years later her father moved the family to Nebraska. "He started a business building head gates." Again, I must look like a deer in the headlights to her. "It's the gate where you put the cows in, and close the gate on them, so that you can give them shots or whatever you have to do to them," she explains.

Elaine married right after graduating high school but divorced five years later. "I had a little girl that died," she says calmly. "After she died, I guess I was just very unhappy, you know. I just wanted to go and see the world and do something different. A couple of months later I got a divorce and moved to California."

I don't know what to say so she continues. "I think I was just a spoiled brat. If I couldn't have my girl, I didn't want anything, you know." Her tone becomes sad. "She was three days old. She had respiratory distress syndrome, the same thing as President Kennedy's youngest child, I think it was a boy, the one they lost." She takes a moment, thinking back: "I thought about it later, I mean, how can I be so upset about my baby, when even the Kennedys lost theirs, and they had all the money in the world."

She didn't last long in California. "I was working as a waitress. I missed my family and friends and I was spending all my money on phone calls," she says, laughing. After returning to Colorado, she ventured on many different career paths; she worked a few years in a factory, opened her own restaurant and remarried. Two children came to add to the family until tragedy struck again and Elaine found herself a widow. "It was a freak accident. He fell down some steps and hit the back of his head; it killed him instantly." It's been a long time but her voice still cracks. "He was forty years old. We were devastated."

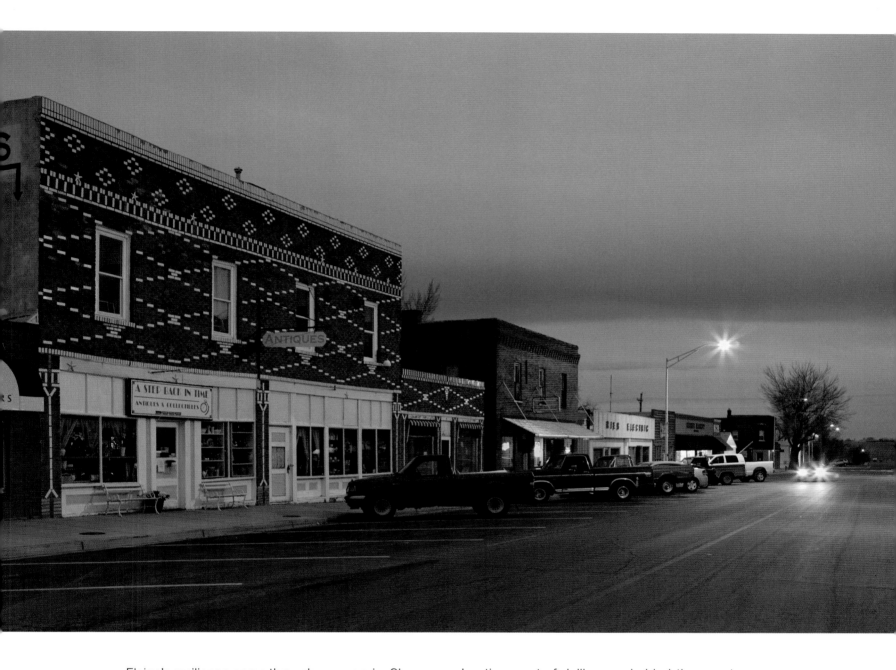

Elaine's resilience came through once again. She decided to get a real estate license and start a new career. "One day, in 1985, I took a couple of clients to Keenesburg to show them a house, never been here before." She fell in love with the small town and decided to buy the Ponderosa Inn, the bar at 50 Main Street. "It felt good right away. I met a lot of really nice people. I felt like I found a new home," she says happily. "This is where I raised my kids, and now I am happy to help raise the grandchildren."

I notice a set of dollhouses behind the counter. "Our customers, John and his wife Emma, used to come in all the time. I told them that my parents were so poor when we were kids that I never had a dollhouse. A week later he comes in and brings me a dollhouse. And a week after that, he comes in with a wooden version of the bar, and a couple weeks later he brings me a church, until I have a whole town." She is still touched by the gesture. "Those are the kinds of things that make a person feel good."

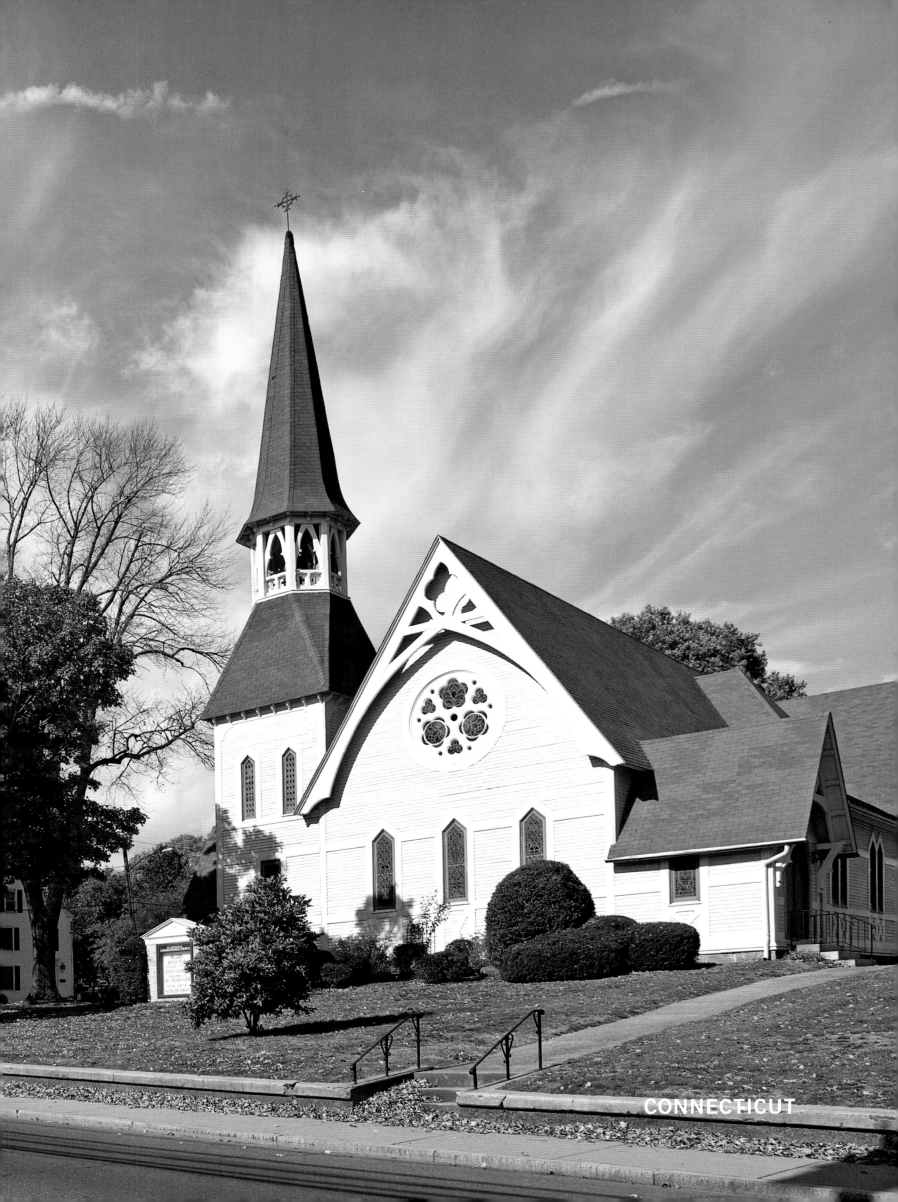

CONNECTICUT

CYNTHIA JONES

NEW BRITAIN ✦

"I figured I could make it anywhere I'd go," says Cynthia, telling me of all the places she has been before settling in New Britain.

"I was born in Chattahoochee, Florida, raised on a farm," she says. "I had a great childhood. We were poor but we didn't realize it. We were outdoors playing in the sun all the time, we went fishing, we had big outdoor cookouts. I was just an old-fashioned country girl." She laughs now.

"My father worked in a hardware store hauling lumber and then took a job at the post office as a janitor until he was seventy-five years old, when he retired. There will never be another one like my father—he was a rock."

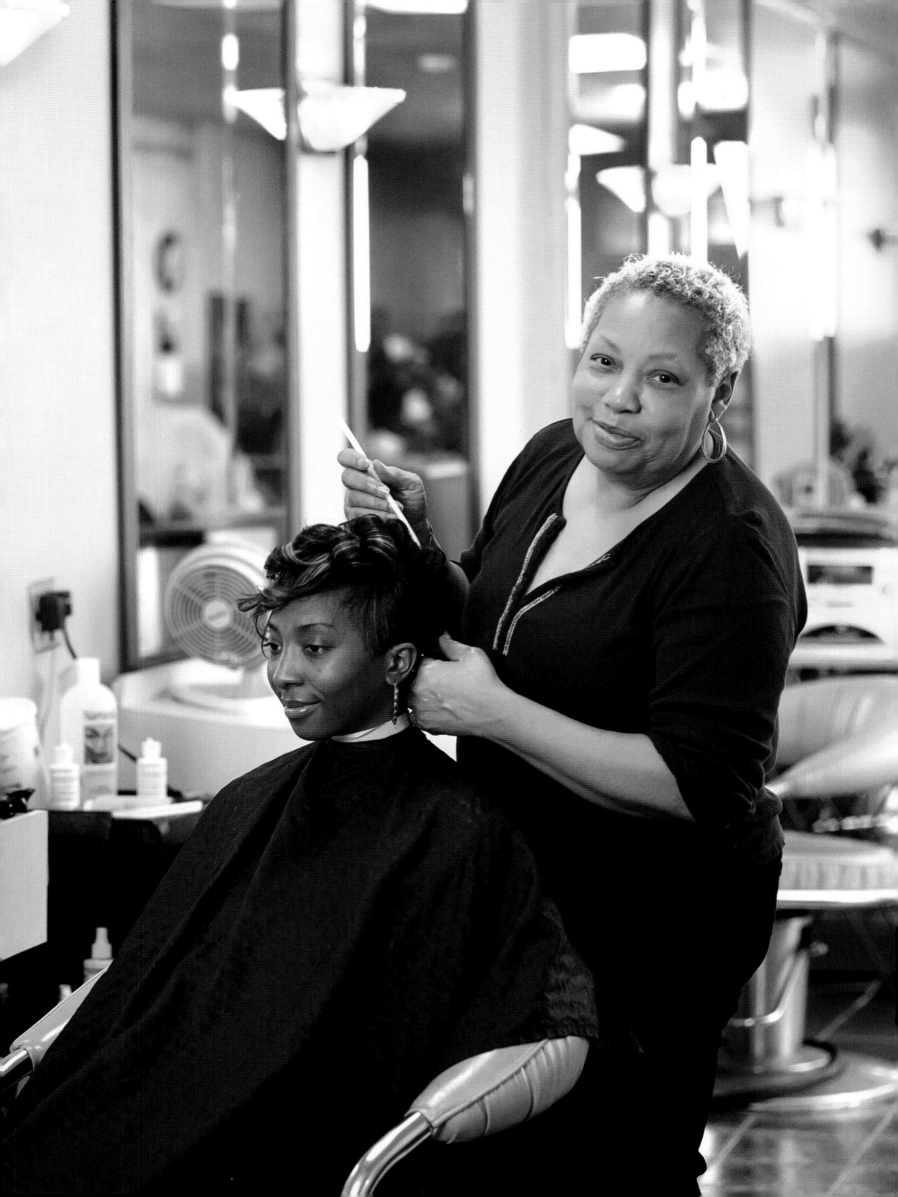

Her mother passed away just a couple of years ago and Cynthia still misses her. "Mom was such a delicate woman. She only had a ninth grade education but she raised us with great values. We are all entrepreneurs: restaurants, dry cleaners, catering..." Cynthia has seven sisters and two brothers. "My dad raised chickens and grew vegetables so we had slaughter days and we had canning days. I know all that stuff. I didn't know anything about boxed food when I went to Los Angeles." She joined one of her sisters in California in the '70s, where she studied and worked as a dental assistant for a while, moved on to do retail and then drycleaning. "My boss was such a great guy. He was a Jewish man. He used to call me Josie. He told me, 'Josie, I am going to allow you to go to beauty school. I'll give you Saturdays off with pay. You need to be your own boss.'" She passed the State Board exam with flying colors. "I will always be thankful to Mr. Parks for believing in me. He changed my life."

She loves that era. "The '70s were the best—the music, the energy, the way people dressed." She was a young mother and her daughter's name is indicative of Cynthia's stage in life. "I named her Chenyere, from the Ibo tribe in West Africa. It means 'God's gift.' I was an independent, young black woman then," she explains.

"I had a lot of growing up to do," she says, looking back. "Don't get me wrong, I was a very good person, but bitter—I wouldn't take any crap from anybody. It was pretty rough being raised in the South as a black person. You had a place and you knew you had a place but there was a lot of stuff going on, outside and inside of you." She doesn't like to linger in those thoughts. "I started a salon with my friend Ruby. Her husband was Ernie Terrell, a famous boxer. He owned a barber shop next door to our salon so we got a lot of famous clients spilling over: actors, dancers, entertainers, athletes."

Two more children joined the family, this time twin brothers, but Cynthia's relationship with their father never went to the next level and they separated. After a quick stint in Atlanta, Cynthia and the kids moved to Connecticut, close to many relatives. "It is really quiet and pleasant here, and a lot of my family had already migrated to this area. There's a good support system."

Her younger sister comes to visit from Florida regularly, helping out at Mahogany 2000, the salon Cynthia opened at 50 Main Street. "Juanita is a beautician too. She comes up here often. Everybody knows her; every time she comes back she picks up from where she left off." Cynthia likes having her sister around, especially when they go to the casino. "We have a good time together but I go by myself too. Sometimes I just have to get away. It's the most relaxing thing in the world for me." I am surprised at her approach to gambling, but it turns out that she has a long connection with casinos. "I used to go to Las Vegas often with my friend Ruby when I lived in Los Angeles. We knew the road manager for Sammy Davis, Jr., so we would drive up over the weekend. We were always treated as VIPs at his shows."

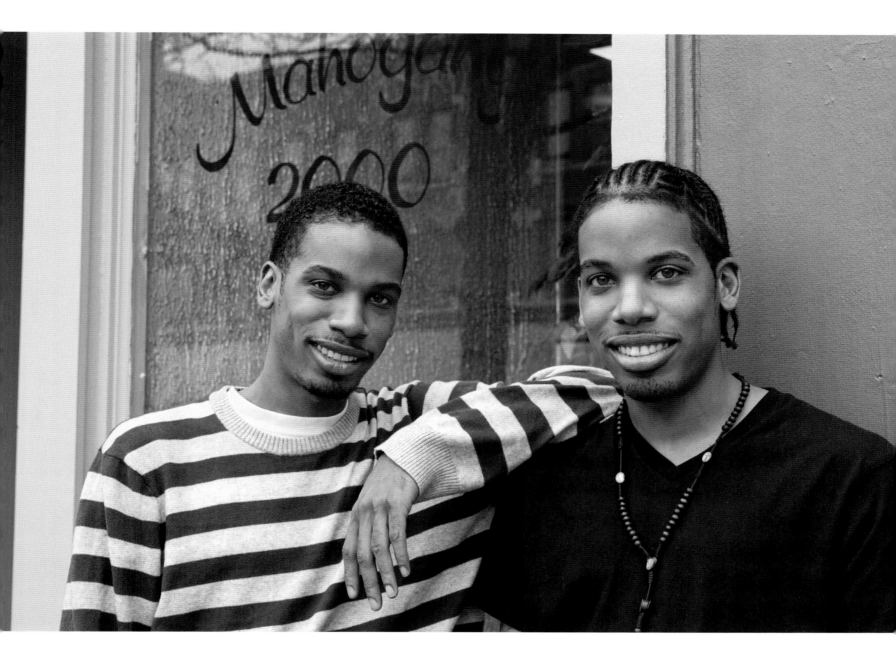

She doesn't like to brag so I almost have to force a story out of her. "Sammy loved to cook, to the point that he always traveled with his own pots and pans. He cooked for us all the time."

She smiles, reminiscing. "I don't have that kind of energy anymore. I was diagnosed with diabetes a few years ago and that's taking a toll on me. I can keep it in check with medication, diet and exercise, but the salon is hard work. It tires me out. Chenyere is going to beauty school herself. Hopefully she'll be able to help me with it soon."

The twin sons live in town as well; Kevin works in a barber shop, just down the road from Cynthia. "I can't get him to work with me. He likes to work with his boys, I guess," she says, a little disappointed. "Starling has a sixteen-month-old son and works in a hotel. He is hardworking, a real family man." I'd never met anybody named after a bird. She smiles. "'Not just a bird, Mom,' he always says to me, 'a very intelligent bird.'"

DELAWARE

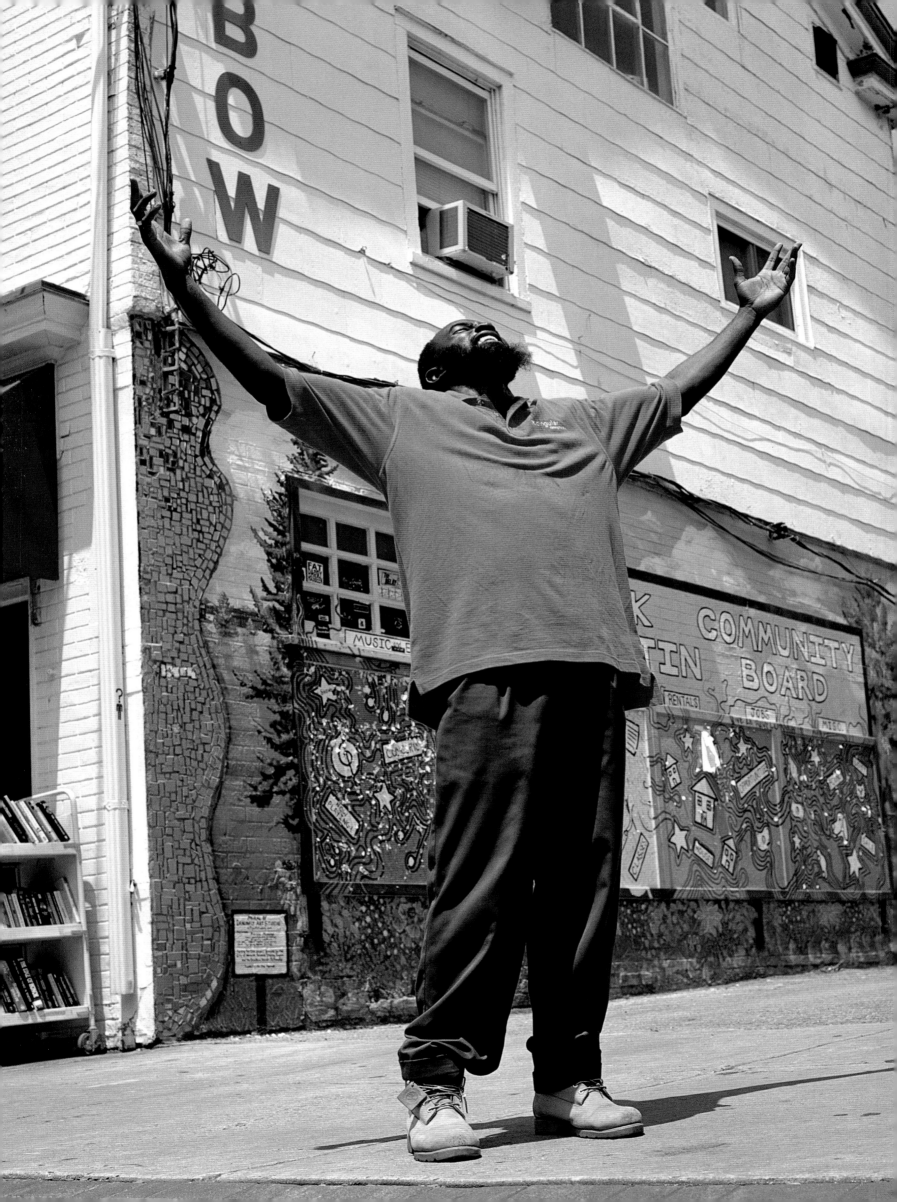

FALAH KHATIB

NEWARK ✈

Falah's life story has an uncanny similarity to Will Smith's fictional characters. He first makes me smile when he mentions moving from Philadelphia to Los Angeles, reminiscent of *The Fresh Prince of Bel-Air*. And then again when he talks about his childhood experiences, evocative of *The Pursuit of Happyness*, the inspiring movie based on a true-life story.

"Yeah, man, that movie reminded me so much of my dad! Like the main character, he also was a door-to-door salesman. I lived with him in the Jordan Downs housing projects in Watts." He remembers the time spent at home. "My dad was trying so hard to raise a family. It was school first for me—I didn't have time for sports. At one point Dad had a shop for a little while so I helped him with that."

I meet Falah on a Sunday morning at the mobile phone store at 50 E Main Street, where he is putting his father's teachings to work. I wait for him to take care of a customer on the sunny sidewalk. The drive from Maryland took just a couple of hours so I am well rested and I enjoy the look and freshness of the young people running around Newark. "It is pronounced 'Noo-Ark,' not to be confused with the one in New Jersey," he says immediately. "It's a college town, it's home to the University of Delaware. New students come in at the beginning of every school year. It makes the place a constant revolving door of young, enthusiastic people." He seems to enjoy that aspect. "When the summer comes to an end, there is all this excitement," says Falah with a smile on his face, thinking about all the new young students that will be arriving in a few weeks—maybe with a vested interest. "I don't have a girlfriend yet, still looking for the right one."

A friend from the pizzeria next door drops off a couple of slices and Falah is generous enough to share his lunch with me. Like any good salesperson, he can talk your ear off and he goes on and on, discussing everything from relationships and work to religion and marriage. When I dare to define him as a philosopher, he smiles. "Well, my online name is indeed Falahsophy."

Maybe because of the heartache he experienced when his parents divorced, or maybe because of his strong religious beliefs, Falah, at the young age of twenty-seven, has a very traditional perspective on relationships. "Religion comes first in my life. It teaches you to get married, no fornication, no premarital sex." He senses my doubts. "The lack of a relationship does not worry me as much as it would others my age. It keeps me safe; it helps me evaluate myself a lot better." The way he experienced relationships around him has left a deep mark on his personality. He touches upon his past in the projects of Los Angeles very briefly and slightly mysteriously, as if he'd rather not think of those days. "That wasn't a good place. A lot of my statistics, my upbringing in the projects," he pauses for a second, "lots of poverty, ignorance, violence; there was a lot of negativity there, man!" Falah had a chance to reinvent his world in Newark, but all the moving around left him without any really close friends. "That's one thing I wish we did as a family. I wish we stayed in one city, built real friendships. I meet a lot of people that grew up in one place and they have the same friends, even a relationship with their grandparents. I envy that." The lack of family support took a big toll on his school curriculum as well. "I had a terrific freshman year, but then my grades dropped. I wanted to go to medical school, become a surgeon, but I took on too much, more than I could chew." He tries to find an explanation for dropping out of college. "I missed my dad's support and stimulation to do well with my grades; living so far from him was almost like taking a class online versus being in the classroom with the best professor." His personal experiences took him down a path of soul-searching, especially relating to his religion.

Being Muslim in a small town has gotten more difficult in recent times, and Falah wants to help other Islamic immigrants. "I want to welcome them to this great country of ours. This is a country that embraces everybody. I want to teach them about its history and I want to let them know that everything is going to be all right." Reading the Koran helps him keep his life on track. "The Koran is the most comprehensive guide that I have seen in my life. It's like one hundred self-help books bundled up into one."

Falah likes to educate himself about African American leaders as well. "It keeps me in touch with my ancestry. Dr. Martin Luther King, Jr., W.E.B. Du Bois, and Malcom X are among my heroes. I am proud of what my people have been able to achieve in America," he says, turning patriotic. "I will never forget who I am and where I come from—and I am aware of where all this happened. I would not have much history without America."

FLORIDA

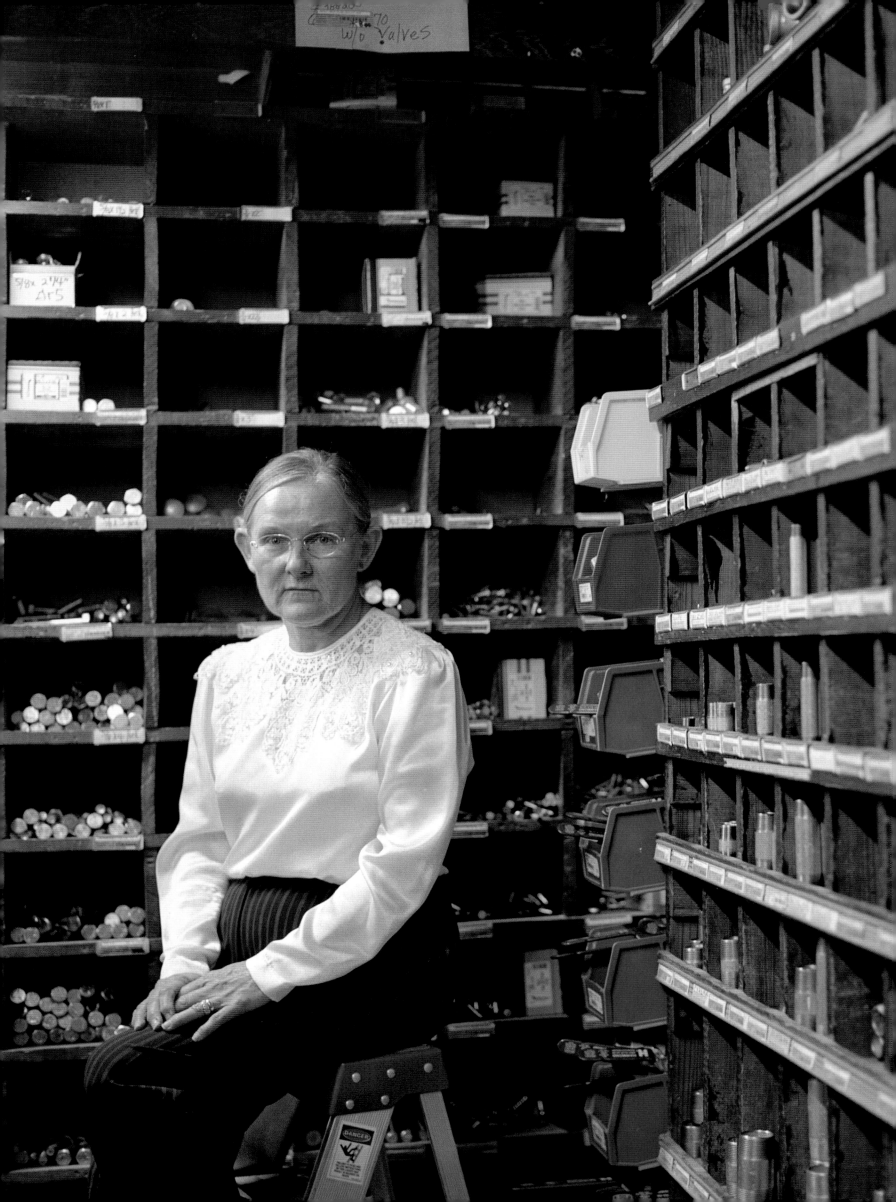

JANICE SHEFFIELD

HIGH SPRINGS ✈

"Just ask for the Sheffields' table when you get to Sonny's." Janice is giving me directions on the phone when I call her on Sunday morning on my way to High Springs. When I arrive at the restaurant, the hostess knows exactly who I'm looking for and she walks me through the bustling restaurant famous for its barbecue.

Janice, her husband Bobby, and a couple of friends are already halfway into their meal and still dressed in their Sunday best after their regular church service.

Bobby's accent makes me realize how Deep South the northern part of Florida actually is; I can hardly understand him. Luckily I communicate better with Janice.

"I never went to the ocean," says Janice when I tell her about my trip from Clearwater. "The only time I went to the ocean is when I took my kids to St. Augustine once to meet their friends for school break. I just dropped them off, didn't stay," she says. "I think I was forty years old."

"We grew up very poor. We didn't buy groceries from the store. We ate the vegetables we grew in the garden, berries we picked in the bushes, and squirrels." She notices my surprise. "Yes, Daddy wouldn't shoot rabbits, but he didn't mind shooting squirrels. He died when I was sixteen. He had a brain hemorrhage." She still feels sad thinking about that tragic moment and I join in her sorrow as I remember losing my dad at the same age, for the exact same reason. "I couldn't quit crying. My aunt had to come in, read some verses from the Bible, and talk to me," she says, "I cried for two days." Her faith helped her. "We are very religious. I grew up Baptist but now attend the Church of Christ. We are conservatives," she says. "We follow what the Bible says."

They now have a farm, and Janice runs the only movie theater in town, open on weekends and Mondays, and a well-established hardware store, open every day except Sunday, of course. "We go to church on Sunday for morning and evening services. And Wednesday," she says.

They took over the store thirty-seven years ago, from Mr. Palmer. "He was very generous; he really helped us out at the beginning when we had a hard time with payments." The hardware store has become her life. "I love serving people and being able to work out their problems." She gets emotional about it. "The old-timers, the ones that came almost every day, have all passed away. There was Daddy McDougal, Lum Stewart, Reese Markham. And Papa; he wasn't our papa but we called him Papa Golden." They shopped the same way I used to shop as a child in Italy, back in the '60s. "They all had accounts with us. They would come in almost every day and pay at the end of the month. They always paid."

The community has become more of a suburb of Gainesville than the farmland it used to be. "Dad used to raise corn, tobacco, peanuts, and cows, and we had a few hogs." Janice started helping early. "I was handing tobacco when I was four years old." I am fascinated by the process she describes. "They cut the leaves off the tobacco stalks, brought it to the barn, and put it on a shelf. You had to pick up three leaves with one hand, put it in the other hand and pass it to the stringer, an older girl, and while she's getting it out of your hand, you pick up three more leaves." Her memory is clear. "Back then, apples came in a wooden box and I had to stand on an apple box to reach the table." She was still in school. "Tobacco is a summer crop so it didn't interfere with the school schedule." She loved school and she still remembers the only time she almost skipped it. "Daddy wanted me to stay home to help plant the tobacco and I wanted to go to school. I argued with him and he whipped me; that was the only time in my whole life. And then he let me go to school. I was ten years old."

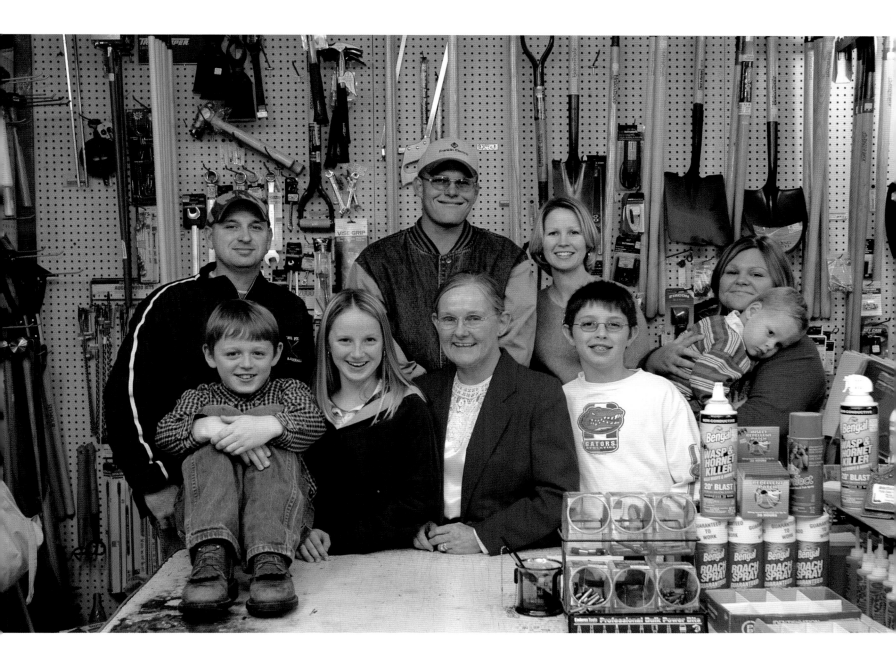

Janice went back and finished high school after her father's death. "Mama was only thirty-nine years old; she remarried after two years and I found myself living with my four siblings and five new ones that came with the stepfather. I was miserable. There were twelve of us in a three-bedroom house. I didn't get along with my new siblings." She doesn't resent her mother. "I loved Mama," she says. "She passed away four years ago. I was devastated. I cried for two years." Once again I relate to her grief.

Her husband saved her. "I met Bobby working on my uncle's tobacco farm, where we worked together as teenagers. We got married when I was seventeen and he was nineteen," she says with a warm smile. She now has her own extended family, with a growing number of grandchildren. "The most important thing is that, living just minutes apart from each other, we get together as a family on a regular basis," she says laughing. "Every day is a holiday at the Sheffields'!"

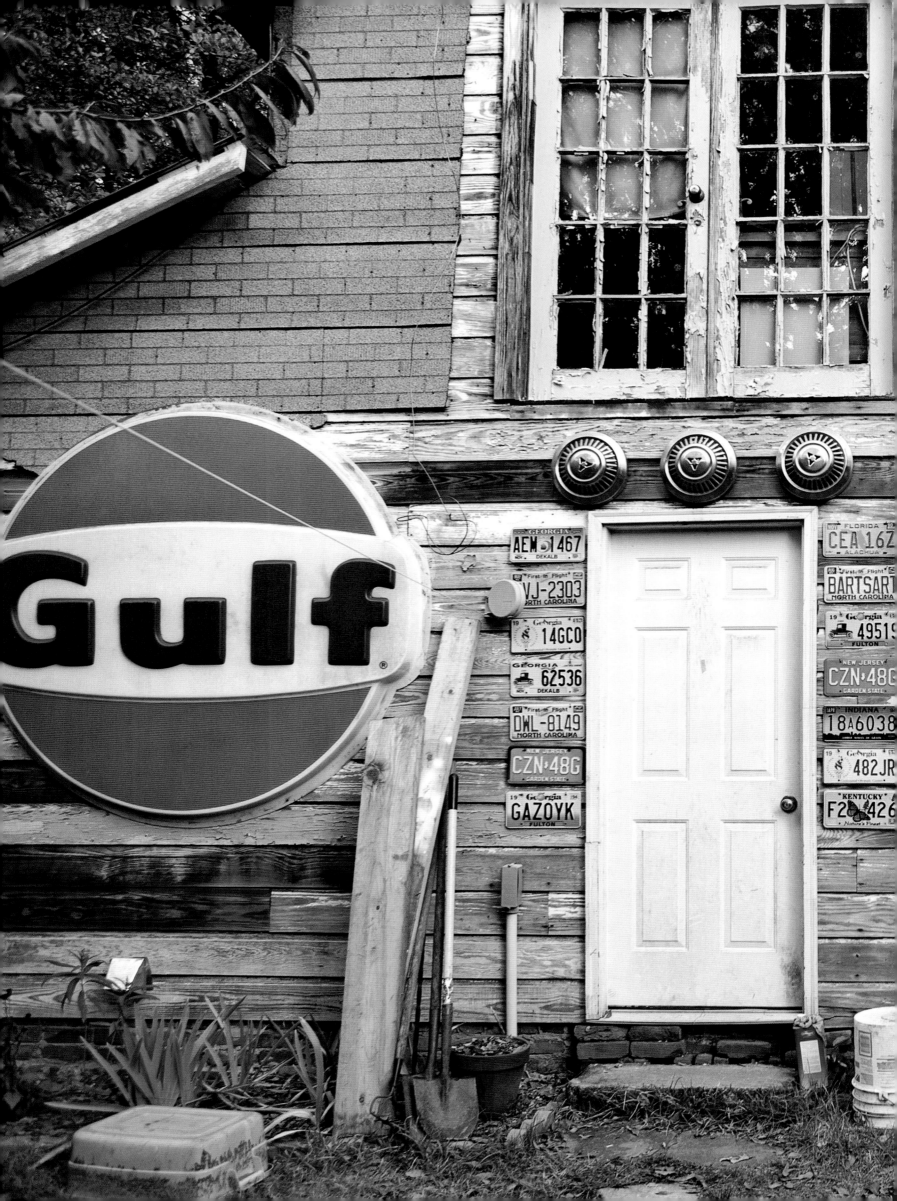

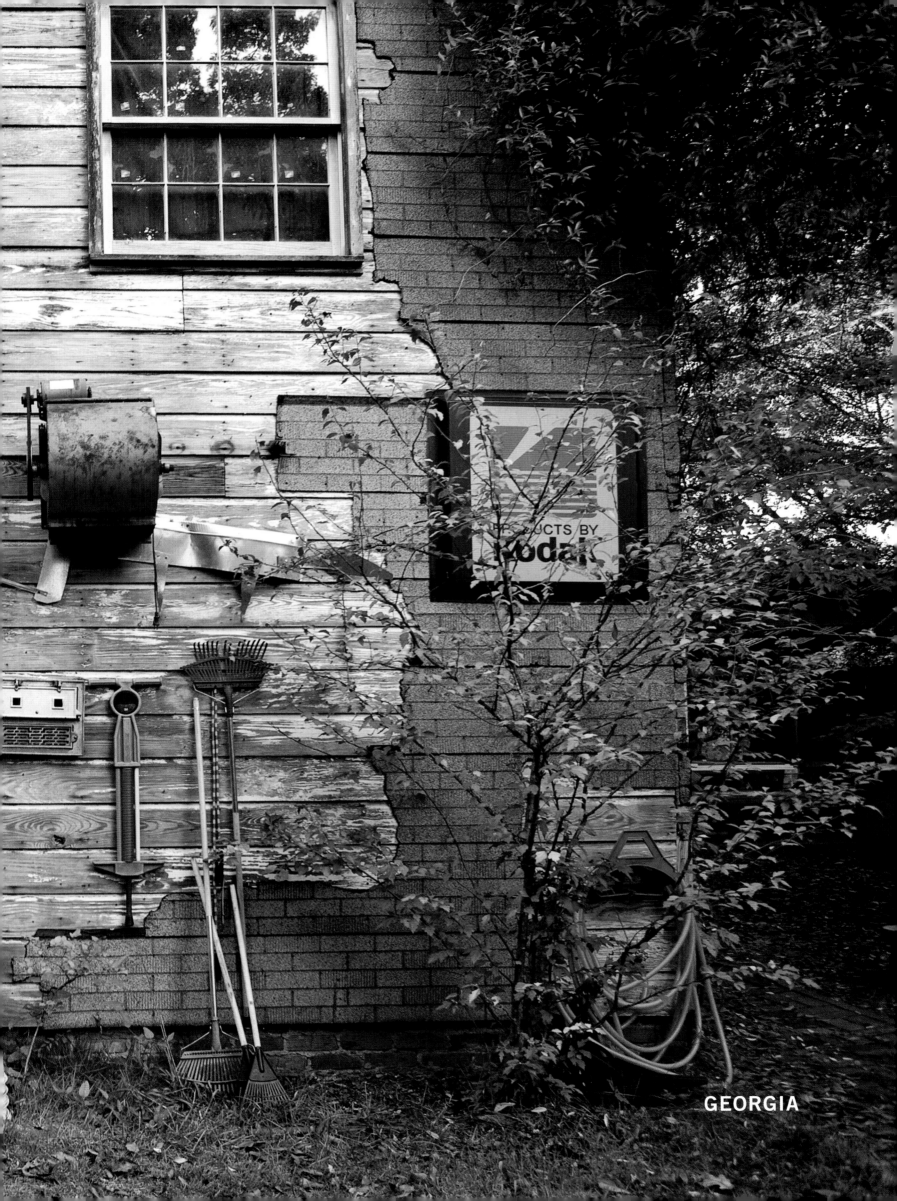

GEORGIA

BOB MILLER

ALPHARETTA ✦

"Hey, where have you been, Bob?" The waitress at Dockery's Café hasn't seen him in a while and is not shy asking about his whereabouts in the last few days.

"I took my wife to Florida for a long weekend. She loves Regis; we had to go see his show down there," he says with a typical husband tone.

"He wants sweet tea," is Bob's next order to the waitress, except he is ordering for me. "You want the peach cobbler, it's their speciality here," he continues a few minutes later. I can tell right away that I am dealing with a strong personality. I get to Alpharetta on my way up from Florida and Alabama, after spending some time with my friends Jennifer, Bart, and their three wonderful children in Atlanta.

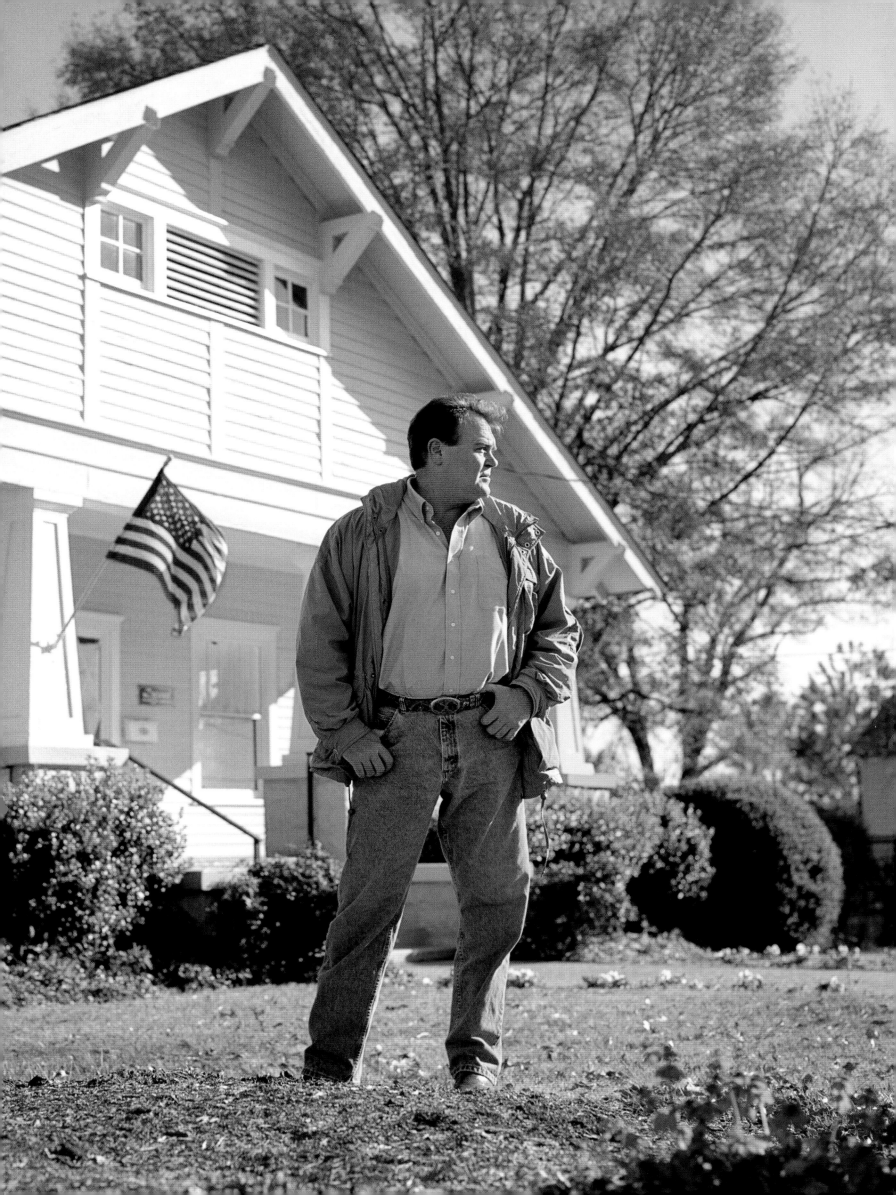

"My great-aunt Ozella Hembree Youngblood purchased the property in 1962. The house was beautiful but needed some work done." Bob launches into a history lesson about the building at 50 Main Street, where he now has his office. Let alone talking about his beautiful wife and the two lovely children portrayed in the photos all over his desk, or getting into fascinating stories of his numerous big-game hunting trips, which took him all over the world and left him with all the trophies that hang on the walls of every room. Business, and the trouble related to it, is always on his mind, but he wants people to know about the house. He is still friends with the original owner, Mr. Jones, and he loves to recollect the stories that the old man has been sharing with him over the years. "He was born here and lived an amazing life. The house was built in 1914 at the cost of $520, including labor. It had a water well on the back porch and a big front porch with Brumby rocking chairs." He starts showing his sentimental side when talking about his old friend.

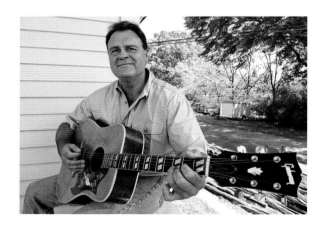

"I was always fascinated by Mr. Jones' stories," he says in a soft tone. "He was a retired captain of the Marine Corps. He would tell me of catching rabbits and his mother frying them for the whole family. The sweet recollections of bathing in a tub on the back porch. The Model T Ford parked in the barn in the back of the house. The .410 shotgun he used to shoot at chimney swifts," he says, laughing. "I don't think he ever killed one." All these stories conjure up memories of the much smaller Alpharetta of Bob's youth.

"After graduating from Mercer University with a B.A. degree, I was lured away from the curse of affirmative action and into the insanity of self-employment by Aunt Ozella." I don't have to agree but I do appreciate his honesty. "It was 1979. Aunt Ozella had started two successful real estate companies and could use the help of a young lad like myself. Alpharetta in those days was a sleepy village and deals were few. We held on by doing a lot of rental and residential deals. And then came I-400, the interstate that connects Alpharetta to Atlanta." He is not a fan of big government but benefited from the money that the project injected into the local economy. "The work went on for twenty years and it defined my life," says Bob with a great sense of pride for his perseverance. "I eventually bought all the shares in my aunt's company. The business did very well, but through the years I had to endure some personal tragedy, as both my mom and Aunt Ozella passed away. That was the hardest part." We change the subject as I notice a guitar and a couple of banjo cases in his office. I invite him to play some music out on the porch.

Bob manages to surprise me once again with a virtuoso rendition of a couple of classic American songs from his '30s jazz repertoire. A little disappointed that I am not familiar with that kind of music, he proceeds to play a Beatles tune, obviously trying to please me. We start exchanging stories of our travels and we find a common place we both have been; Wyoming. "I went elk hunting there, when I was young and stupid!"

The hunting story is almost tragic at first. "We got caught in a snowstorm, thirty degrees below zero. We couldn't see anything. It was so cold my boots were frozen and our rifles couldn't even fire." It turns comical at the end. "When we woke up in the morning, we realized that we had camped forty yards away from a cabin, with a stove, beds, and everything," he says, laughing. Bob owns eight hundred acres of land, where he has a tree farm he is developing as a wetlands restoration project and keeps a hunting cabin.

"I still go hunting with friends or my son very often. We love it out there—no water, no electricity and no shopping," he jokes. "That's how you keep the wives from coming."

When we move back into the house he pauses for a moment and gets serious. "I have spent more living hours in this house than in any other house I have ever lived in," he says. "I have made many decisions, most good, a few not, in this house. I have been determined to be a good steward of the property and remain so until this day."

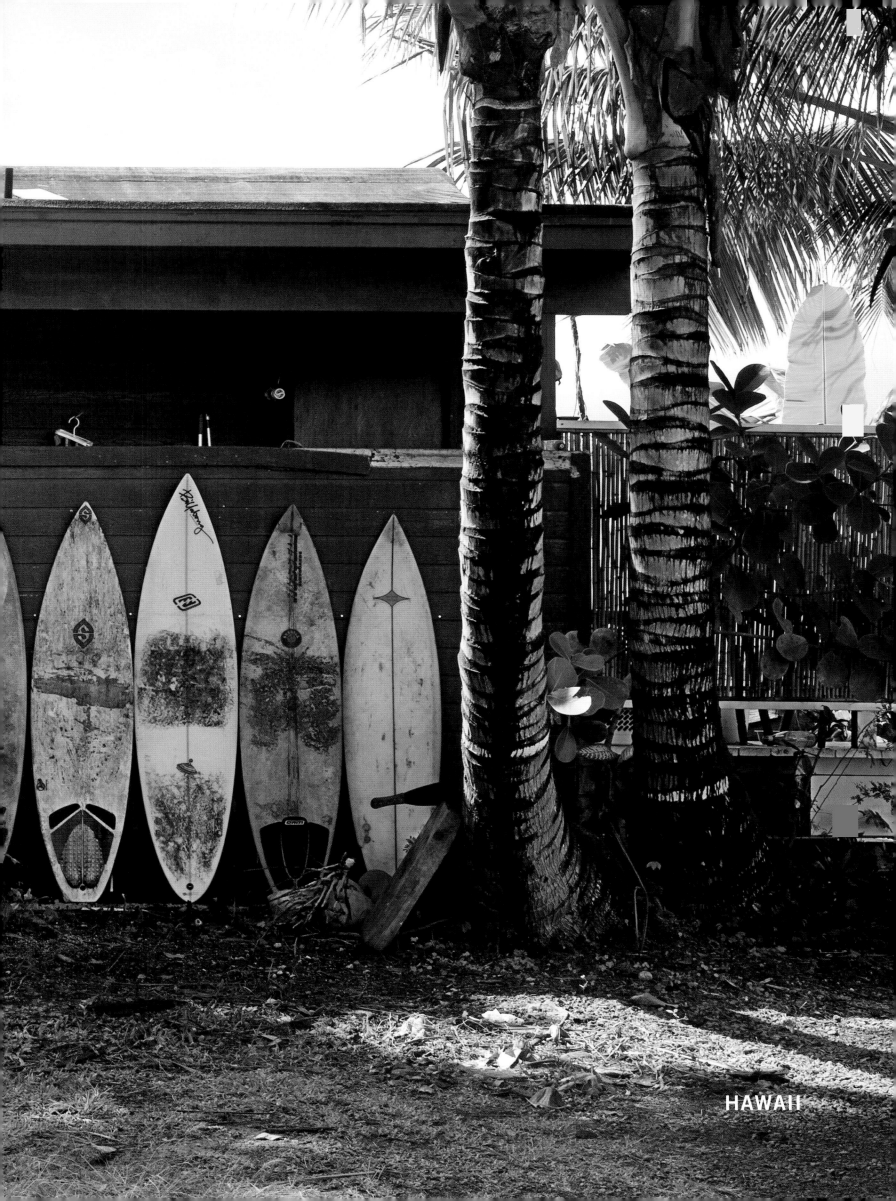

HAWAII

ROBIN TUPA

✈ PEARL HARBOR

My wife Rose and I chose Hawaii as our honeymoon destination. We loved the place so much that we made a promise to ourselves to return for our tenth wedding anniversary.

We survived a few bumps in our relationship and were happy to be able to fulfill our promise to ourselves. The trip was even more special, as it coincided with the last shoot of the book.

Hawaii is the newest of the fifty states and it maintains a lot of street names in the native language; it turns out that there are only two Main Streets in all the eight islands.

"I think number 50 was destroyed. We are the lowest number on the street," says Robin when we meet at her office, located at 174 Main Street, in Pearl Harbor. "The attack of December 7, 1941, is still impressed in the minds of people here, especially military families like ours."

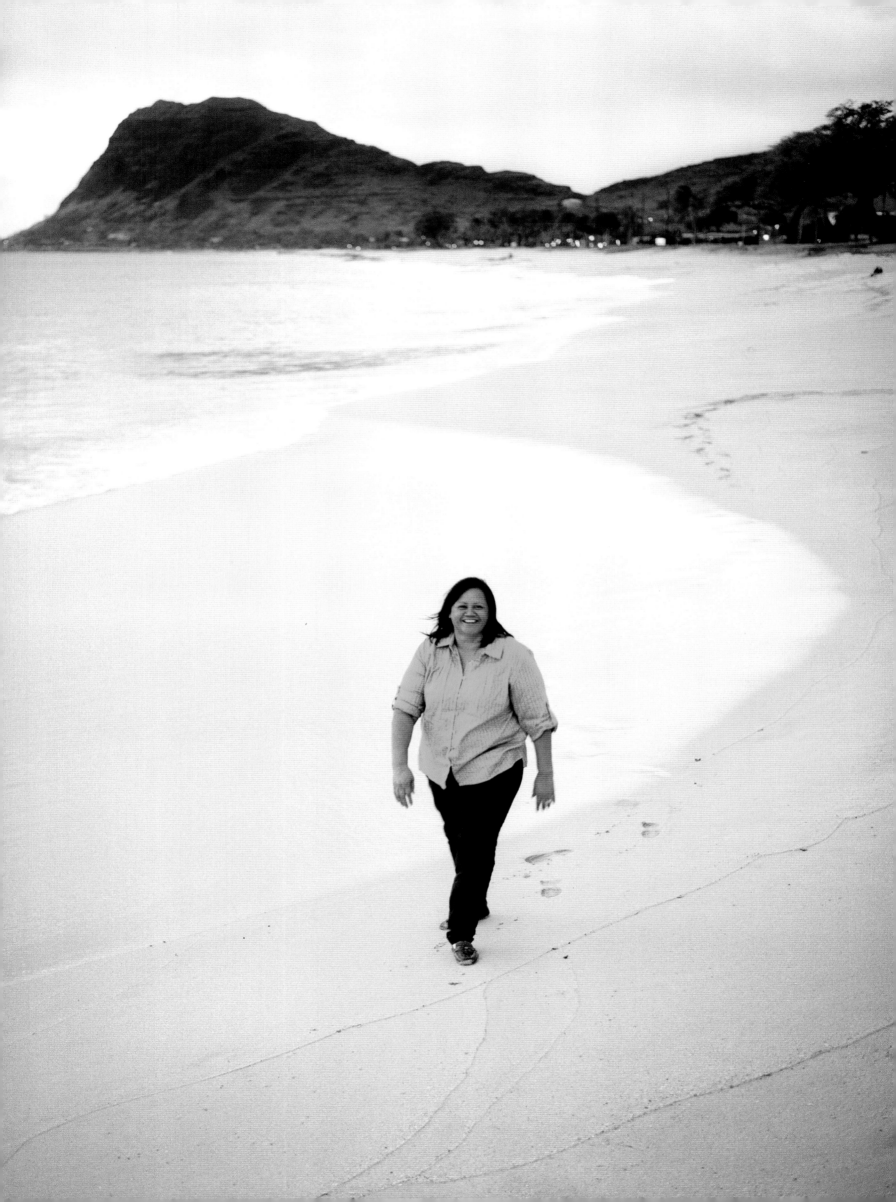

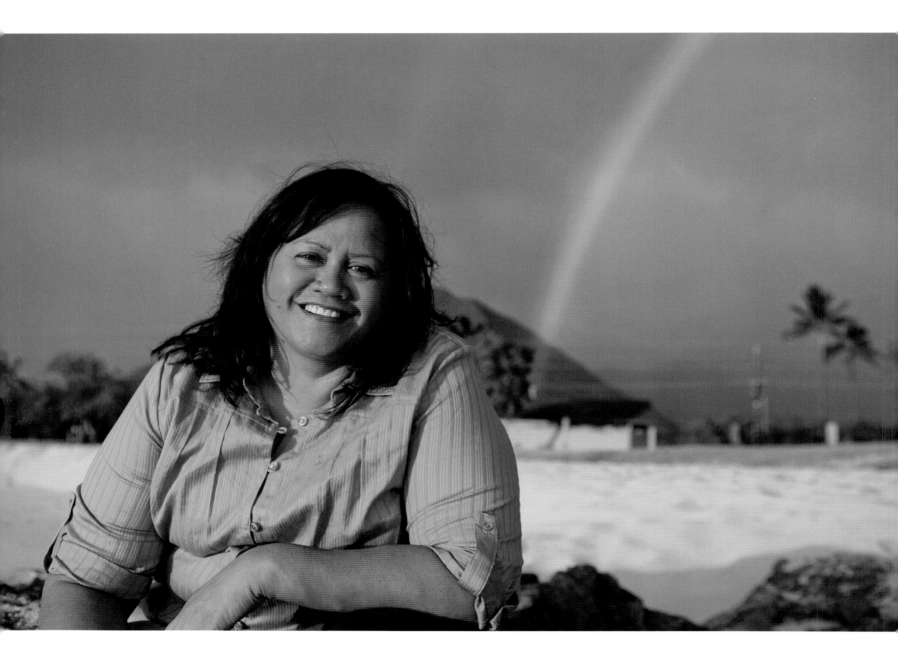

"My dad was in the Army so we traveled around a lot," she says with her soft accent. "It's kind of funny because I am a Native Hawaiian but I was born in Orleans, France." She is happy the family moved back home in 1969. "I love the Aloha spirit of Hawaii's life—it's hard to understand if you don't live here. People are so warm and friendly." She has a hard time explaining so she looks it up: "Aloha is the essence of relationships in which each person is important to every other person for collective existence." She smiles.

"Father was always stationed somewhere, so it would be only Mom and us children. The older ones had to take care of the younger ones." Her mom was working as a telephone operator, so each child had a couple of younger siblings to watch over. "I started baby-sitting when I was in second grade. I had to grow up fast."

They even had jokes about their father's visits. "We would joke about a new baby coming soon, every time he came home on leave," she says, laughing about the eleven siblings in the family.

Robin's household is just as crowded now. "My daughter Kristina got divorced, so she moved in with her five children. My youngest one, Crystal, lives with us, with her boyfriend and baby boy." I am afraid to ask about the middle daughter. "Melissa is still in school; she is going to get a Master's degree in human resources from Central Washington University. We are all so proud of her. She has cerebral palsy but she doesn't let it affect her life. She is very independent."

Family is the most important aspect of Robin's life. "I fell in love with my husband's music before I fell in love with him," she says about her marriage of thirty-five years. "He works as a medical technician now, but he has been a musician all his life." He even wrote a song for Robin. "'Luana' —it means joyous, happy," she explains. "It's my middle name. He wrote many songs, including 'Ululani' for our youngest daughter; that's also her middle name. It means fruit of paradise."

She suggests we take photos at her favorite beach, next to Nanakuli Park, after she gets off work. I love the location and we are blessed by one of Hawaii's famous rainbows, appearing in the sky right in the middle of the photo session. Robin is used to the beauty surrounding her but doesn't take the beach for granted. "We come here very often. We like to camp in our tents for a few days." I look at her. "I know," she says, laughing, "my husband complains that he has a much more comfortable bed at home, just five blocks away, but the children love it. They all have their own tents and sleeping bags. They have to clean up and take care of their own space. It makes them responsible and they feel independent." It's not all work, though. "It's nice and peaceful here. We get up and jump in the water, and then we go eat breakfast. It's just relaxing."

The weekend expeditions are a monthly experience, but twice a year they organize big family reunions. "We have one in July for my dad, and one on Labor Day for my mom's side. Every five years we have a brother/sister reunion."

She feels a mix of pain and pride mentioning her parents. "We lost my dad to leukemia ten years ago; my mother lasted two years longer. She is the one that instilled the importance of family in us. I now volunteer to organize the reunions and everybody comes from all over the place." She laughs. "You should have seen my brother's kids last year. They didn't want to go home. They were begging their father to let them stay. And they live in Las Vegas!" Everybody gets involved and contributes. "My husband and some cousins play guitar and ukelele, others sing and dance. My daughter Kristina is a natural hula dancer so she teaches the kids." I am afraid to ask how many people attend these reunions. "About one hundred and fifty," she says with satisfaction.

I look at the beautiful ocean, I hold my wife's hand, and we both wish to be able to attend the gathering some day. As I put my cameras away, I get startled by something falling on my head and abruptly wipe it off. I look at Rose and we smile when we realize it is a red flower. Only in Hawaii.

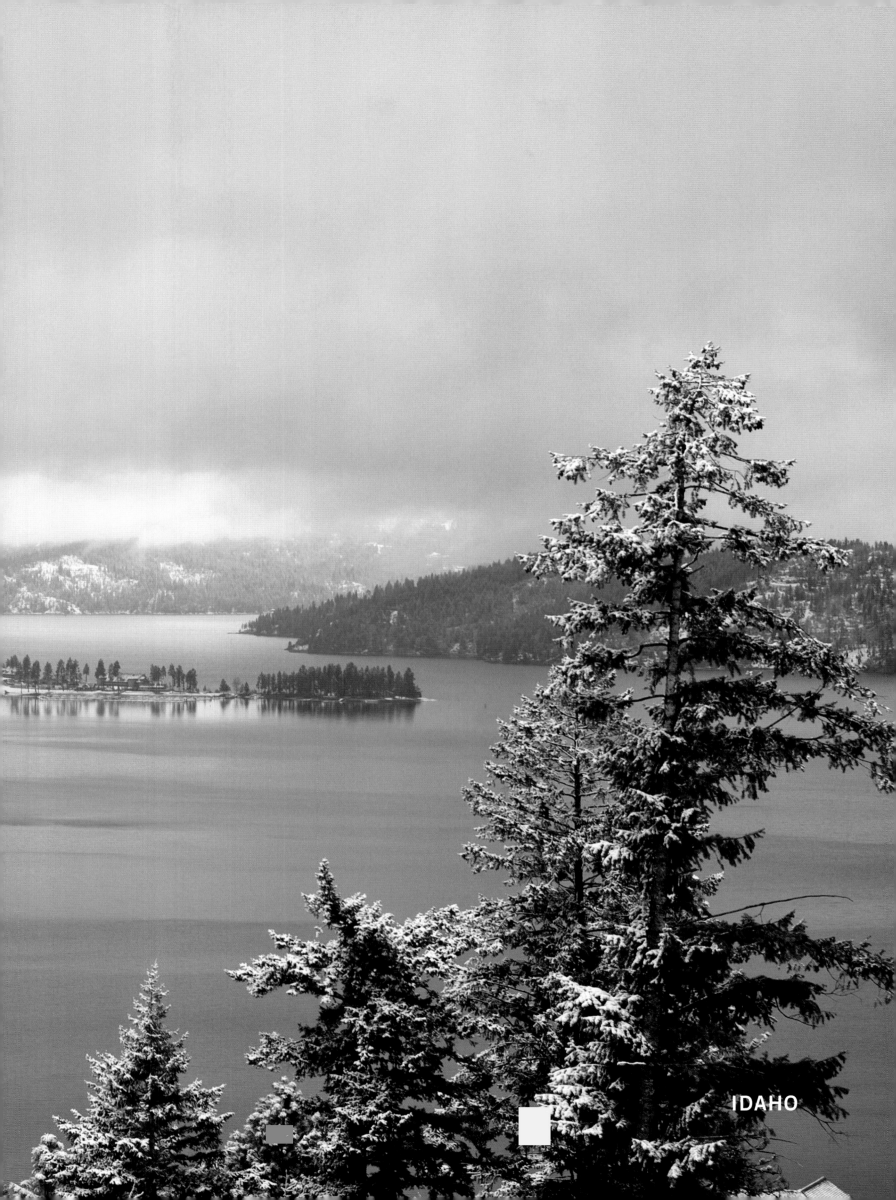

IDAHO

BRAD STANERSEN

LAVA HOT SPRINGS ✈

"The seasons are so expressive here in
Idaho," says Brad when I describe the different
landscapes I witnessed on my way to Lava Hot
Springs. "It's just amazing. It's like a new canvas
every day, and you never know what's going to
be painted on it."

He describes himself as a desert rat. "I grew up
in Arizona. I ended up in Idaho as a kid when my
family moved to Twin Falls." He likes to recount
the annual Christmas trips back home. "I loved
those vacations. That's where I learned to hunt."
His peaceful demeanor doesn't match the image
I have of hunters. He laughs. "Everybody hunts
out West; we all have guns and we all know how
to use them."

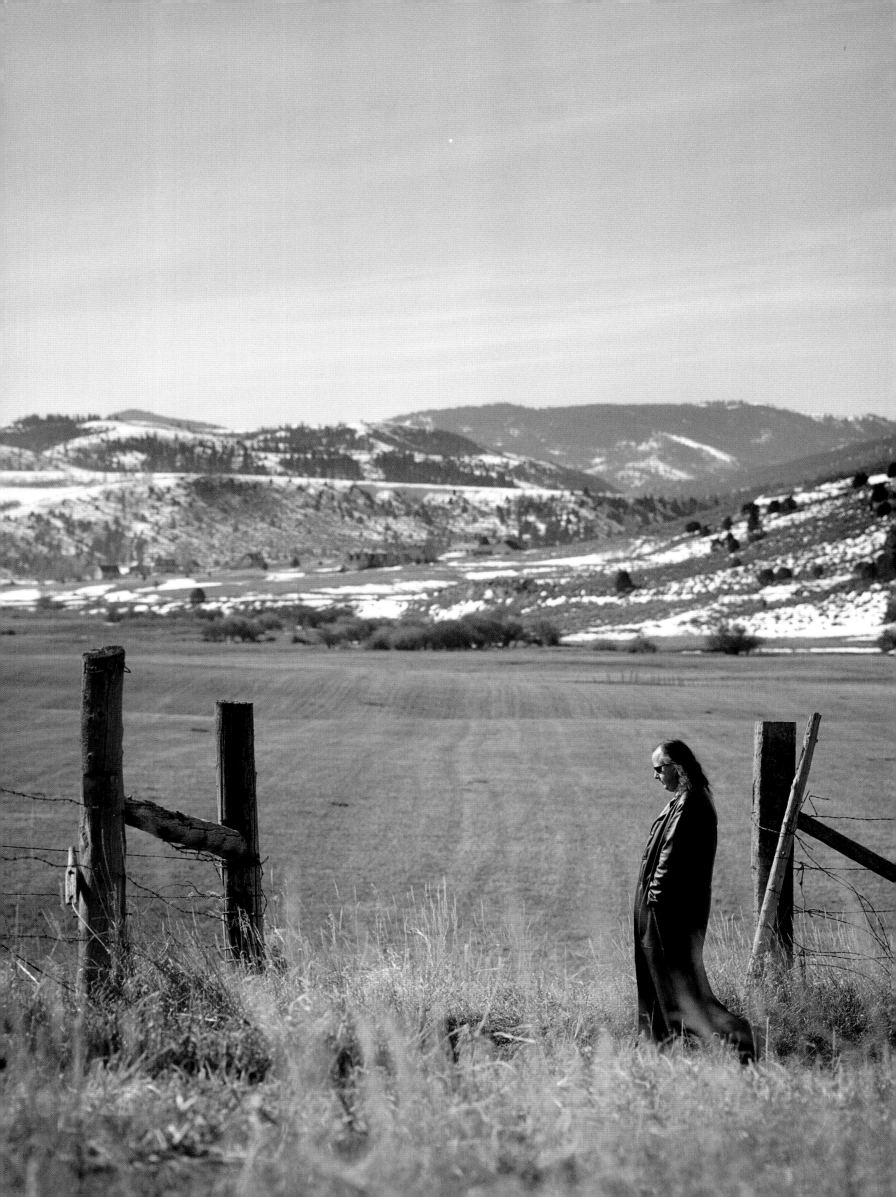

Brad's looks are deceiving, especially considering the Buddha carvings and the crystals on the shelves at Purple Moon, the esoteric shop at 50 Main Street. "It's very eclectic," he says. "We carry items from all over the world. We get really unique things that you just can't find at other places. The town is home to only about five hundred people but we get thousands of visitors year-round. We have the hot springs and a lot of water activities and river rafting." He is very grateful. "Life is amazing," he says with enthusiasm. "We lived in Pocatello ten years ago. We had the chance to stay at a friend's cabin in Lava Hot Springs and we fell in love with it. I cannot tell you how many wonderful things happened to us over the last ten years. We found a house we liked but we had no money. The gal that owned it, Jan, was incredible—she helped us in any way possible. If it wasn't for her, we wouldn't have been able to get a home."

After the house came the job. "On my first interview Sam told me that I was the Purple Moon guy." Brad is almost emotional now. "He must have known something, because eight years later I am still here and now own it with him." He is still touched by their generosity. "These people have been awesome. Without them we never would have dreamed of the opportunities that we had."

He's not using the royal "we" when talking; he always includes Charlotte, his wife of fifteen years. "I never felt for anybody else the way I feel about her. We are the best of friends and we spend all our time together. It's awesome. We work together and we play together." Charlotte also is in partnership with Sam and working at the Trading Post, another store just down Main Street.

He smiles, thinking back on their beginnings. "When I picked her up on our first date I forgot to open the car door for her. Her kids didn't like that at all." He laughs out loud. "Liz still never lets me forget that one. I open it now, though."

Charlotte's two children instantly became family for Brad. They all love science-fiction movies and that passion took them to Las Vegas a couple of times. "We went down to see the Star Trek Experience at the Hilton. It was so cool! It was totally awesome. They took a part of the casino and decorated the whole thing as a battleship. They had people dressed up as Ferengis and Borgs walking around, and the Klingons would sing ballads at your table in their own language. We had a great time." It wasn't always peaches and cream, though. "Charlotte has been very, very patient with me. She's put up with a lot of nonsense over the years," he says honestly. "I used to drink real heavy when we first got married. I was too young in some ways. I did not know what it was like to be a dad, to be responsible." He is not looking for excuses, but he admits his addictive personality. "There was no middle road for me. It was all or nothing." No alcohol at all was the best way to go for Brad, and now he can afford to crack a joke. "It was never a problem for me, as long as there was plenty of wine around."

We decide to go for a walk where Brad likes to pick rocks and I have a chance to take photos.

I admire his necklace. "It's amber," he says peacefully. "It's just like a happy thought. Amber is one of the oldest stones that have been used for healing or metaphysical purposes."

The people passing through the store and the trips they took exposed them to different cultures and religions. "To me, a lot of the ancient principles that even predate Jesus are still valuable today. Having integrity, taking responsibility for your actions, and being compassionate towards others. It's just as important today as it ever was.

At the end of the day it all really starts with the individual. There's not a darn thing that I can do about everybody else, but I can try to do something about myself."

Charlotte has been instrumental in his growth. "She's been so good to me. I mean, everything that I've done that's worth anything is because of her. Like they say, behind every good man stands a better woman. If it wasn't for her, I don't even want to guess where I would be. She has really just been awesome."

ILLINOIS

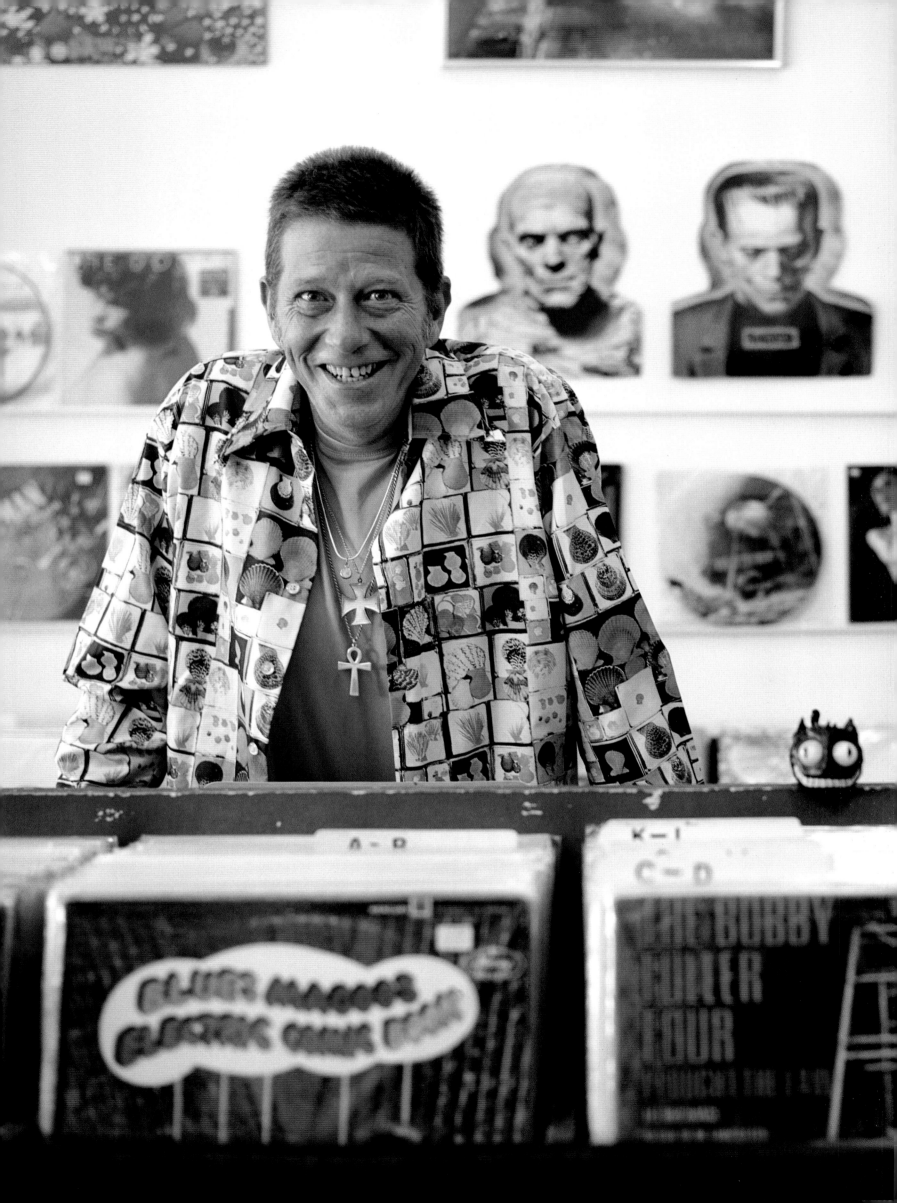

ROBERT SLUYTER

CARPENTERSVILLE ✦

First things first. I meet Bob at his store
right at lunchtime. He is hungry so he drives me
immediately to Benedict's, his favorite restaurant,
a couple of towns away. "I try to put a smile on
people's face," says Bob, handing a smiley-face
pin he retrieves from his pocket to the hostess
that seats us. "It doesn't always work, but I try.
Nice work if you can get it!" We take a seat in
a beautiful, comfortable room with a large tree
growing in the middle; it's a first for me and it
makes for a good conversation piece.

Bob is my same age and we both love music.
"The first record I bought was *Run Joey, Run*.
I paid nine cents for it. It was a bubblegum/ga-
rage/stomp single by the Kasenetz-Katz Singing
Orchestral Circus. I think it was 1968." I smile
to myself; I was still trying to learn how to ride a
bicycle when I was ten years old.

"My father liked to take me places. He was a pilot and air traffic controller. I was born and raised in Ft. Wayne, Indiana. Dad took me to visit many places, including the Ford factory. I got to see the Mustang being built." But his favorite memories are about music and his first shows.

"I remember being at the outdoor theater in the zoo and this band plugged in. I don't think my dad was ready for them to be that loud. Boy, did they plug in—it was really something. Another time he took me out to a place, it was a movie theater on a Saturday morning, and for some reason all these people were dressed in gold lamé and screaming outfits. I thought, 'Oh my God, they are made out of gold!' I was just a kid but I felt it was very cool."

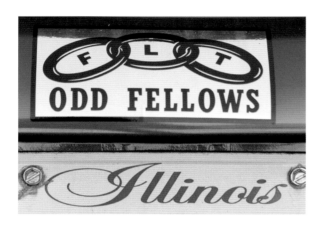

Bob has been in love with music ever since. "I still like bubblegum rock. It kind of stuck with me." He laughs at the pun. "I went through many phases in taste for music. I loved music so much that I wanted to work in the business." His first jobs are typical of boys growing up in Indiana. "I cut grass and raked leaves as a kid. My first official job was parking cars at the Notre Dame football games." He first started trading records at fairs and then opened a store in Algonquin, IL. "We had a problem with the dam. I got flooded out. It was the day of my birthday, July 19, 1993."

His friend Andy came through for Bob and offered to let him move into the building at 50 E. Main Street in Carpentersville. "That worked out for the best because that's how I got to meet the Odd Fellows." The Century Lodge 492 of the Independent Order of Odd Fellows owns the building where Bob runs his records and memorabilia store. "We have been here in this building for one hundred and eight years," he says with a sense of belonging. "IOOF was started in 1819, I think, by a fellow named Thomas Wildey. Back when the masons and other workers would form their alliances to work together to help each other out, the Odd Fellows were a mix bag—they were shoemakers, freelancers or whatever. They called them odd because it was an odd collection of fellows, not just one category." Bob is very proud and honored to be part of the IOOF. "They are my brothers, from a different mother."

There are about 150 members in his lodge and almost as many in the adjacent Rebekahs' Lodge, the female branch of the fellowship. "We were the first fraternity to include women," Bob says with enthusiasm. "We are based around a program of community service. Common working people banding together to help each other in times of distress and illness. We do a lot of work with disabled children, helping orphans and the elderly. Our symbol is made of the three rings. —Friendship, Love, Truth—and they are linked together. Those are the principles I embrace. Nice work if you can get it!"

The business and his involvement with the lodge keep Bob busy and he doesn't have much time for socializing and dating. "I have been engaged in the past but called it off, didn't feel ready. I am pushing fifty now, getting tired of being single. Especially on Valentine's Day," he jokes.

"Unfortunately not many women come into my shop. It's a male-dominated business," he says, taking a drag from his cigarette, "and I am not a male-dominated man!" He has a raspy, contagious laugh. He is much more comfortable talking about music and his passion for live shows. "I managed a shoe store in Clifton, NJ, for a short while. I would go into New York City as much as I could. It was wild then." I wish I had seen as many shows as he has and he is jealous of the concerts I have attended at places like CBGB.

We finally bond for good when we realize that we both attended the same Bruce Springsteen concert at the Meadowlands; a hug is in order. Just like myself, Bob's love for music is not accompanied by any musical skill of his own. "I wanted to play guitar when I was a teenager but then I ran into the problem that I don't have any music ability—so much for that. I appreciate music more than I can make music. I do have a guitar but nobody ever accused me of ever playing it. Nice work if you can get it!"

INDIANA

JAMES STAPLES

GREENWOOD ✛

A handwritten letter in the mail is a novelty these days. I haven't received one in ages, so Jim Staples' polite response to my query is a very pleasant surprise.

"I only use the good old snail mail," he says when I meet him at 50 Main Street in Greenwood. The modest house is finished in the same vinyl siding color of my own place in the Poconos. Standing at six feet, six inches, he makes the house look small. His size and baritone voice prompt me to immediately call him Gentle Giant. He smiles at my corny joke.

"My brother owns the house, but I have been living here for the last forty-five years," he says as he takes me on a tour of the town. "When I was growing up my grandfather had a farm up by Lafayette, about twenty miles from Purdue. I used to spend my summers and free time up there. He taught me all the basic things about farming."

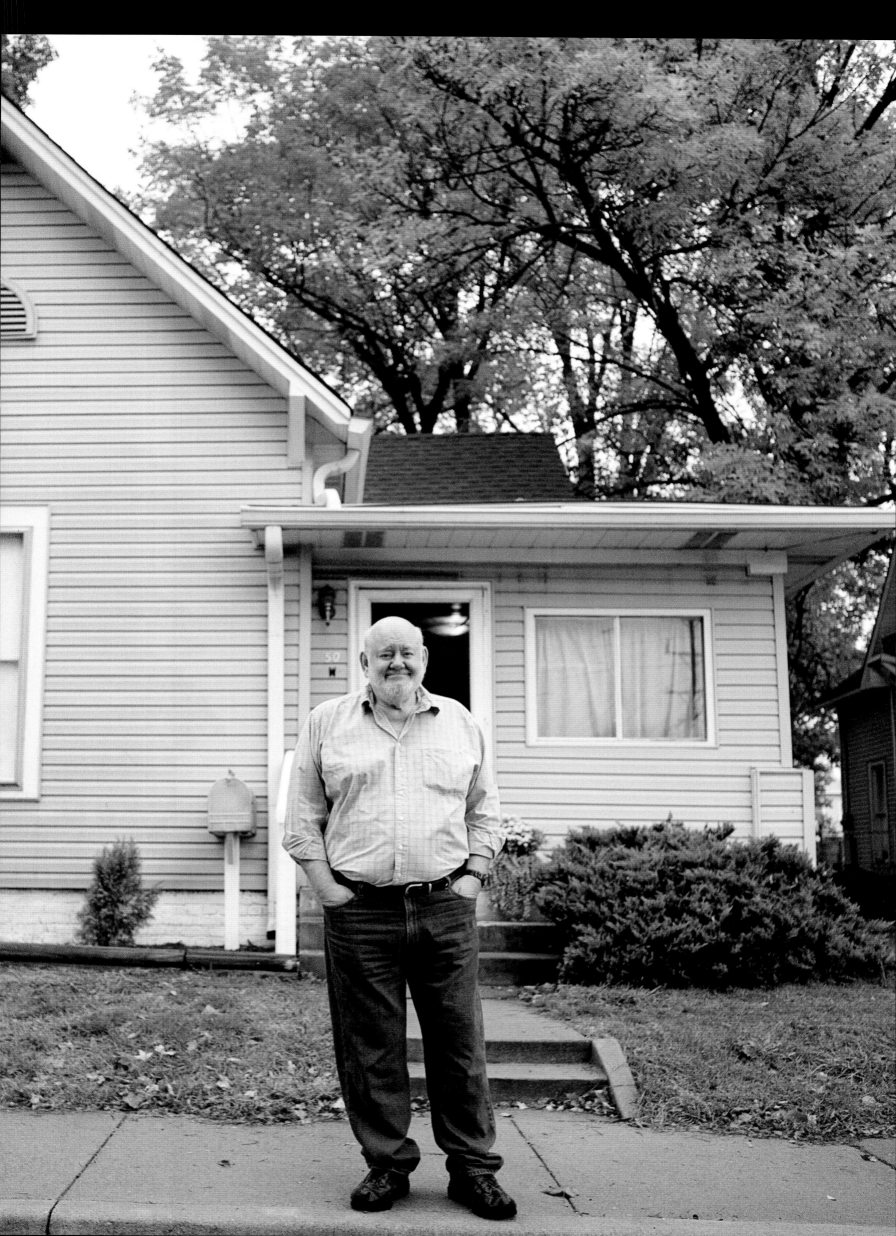

I ask him if farming is his passion. "I love reading books," he says, smiling in response, "ever since I can remember. When I was just a young kid in grade school, I'd go to the library and try to take out three or four books, every chance that I got." All because of his mother's influence.

"My mother was a very intelligent woman. She only graduated from high school and had six children but she went on to open her own real estate firm, which she started when she was middle-aged. She read all the time. She introduced me to it." His father was different. "I can't remember him ever reading a book in my life. He just liked working on cars and doing things like that. The intellectual side of life never appealed to him at all. Mama was just the opposite. She was always wanting to learn, read, and understand things. Just two totally different people, but they were complementary to each other. It worked." Jim pauses for a moment. "He was a very good father. He worked every day driving a truck on short routes. He was around all the time and he was fine, he just didn't share my interests."

"He came to my college graduation, the first one. I think he was sort of mystified; it was such a different world for him. He just never quite understood what was going on, I guess, having only gotten to the fifth grade himself."

I think back to my own parents and imagine their equivalent in the Midwest. "My mom was an awfully good writer," he continues. "She wrote letters to editors all the time. She just had a real sense of being a good, clear writer. Probably for that, I have always loved writing and literature. I majored in English all the way through."

We arrive at a park bench that is special to Jim. "I had my parents' names engraved on it. I paid the city—it's part of a fundraiser for the Parks and Recreation department. The money goes to help building trails around town," he says. "I walk on this trail almost every day. It's a two-and-a-half-mile loop." We start talking about sports and he quickly reminds me where I am. "This is Indiana. Of course I love sports, especially football and basketball, but things are getting out of hand." He is not very happy with the ways of professional sports. "Way too much money involved these days," he says, "but I still love college ball and I still follow my alma mater, Franklin College."

When we head back to the house I enter a book shrine: books everywhere, and a whole section dedicated to President Roosevelt. Jim's memory goes back to his childhood summers. "The times were tough back then—I was born in 1938, at the end of the Great Depression—but in the '40s and during World War II, my grandparents used to tell me about it all the time. I remember Franklin Delano Roosevelt very well. I was only about seven years old when he died in 1945, but I remember hearing his voice on the radio." He remains attached to his first impression. "Roosevelt is still my favorite president," he says. "Argument would be made for Lincoln being the most important president, but for someone who really helped people in need, Roosevelt did more than anybody did as a single president," he says.

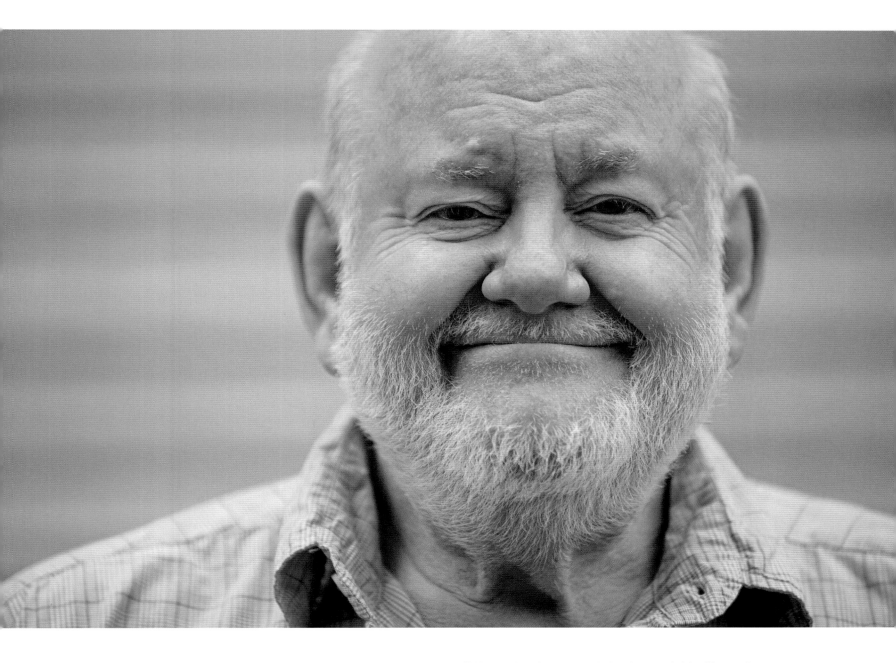

"We had a 25% unemployment rate back then and Roosevelt's Public Works Administration, the Civilian Conservation Corps, all those different programs that created jobs went a long way to getting this country back on its feet." Jim takes a few seconds to describe his hero in detail.

"What was unique about him is that he was a rich man who really helped poor people. He had polio and had to learn to wear leg braces and get around holding onto others and everything. He was paralyzed below his waist," he explains.

"When that happened, it changed his life and probably his views, once he saw what some other people had to live through." His admiration for President Roosevelt guided Jim into a career in politics, working for the legislature in the Indiana State Capitol for twenty-five years. "Legislation is kind of like sausage," he says, laughing. "You don't want to know what goes in it!"

Jim retired a few years ago with no regrets. "I get to read as many books as I can," he says with a hint of glee in his eyes. "I love it!"

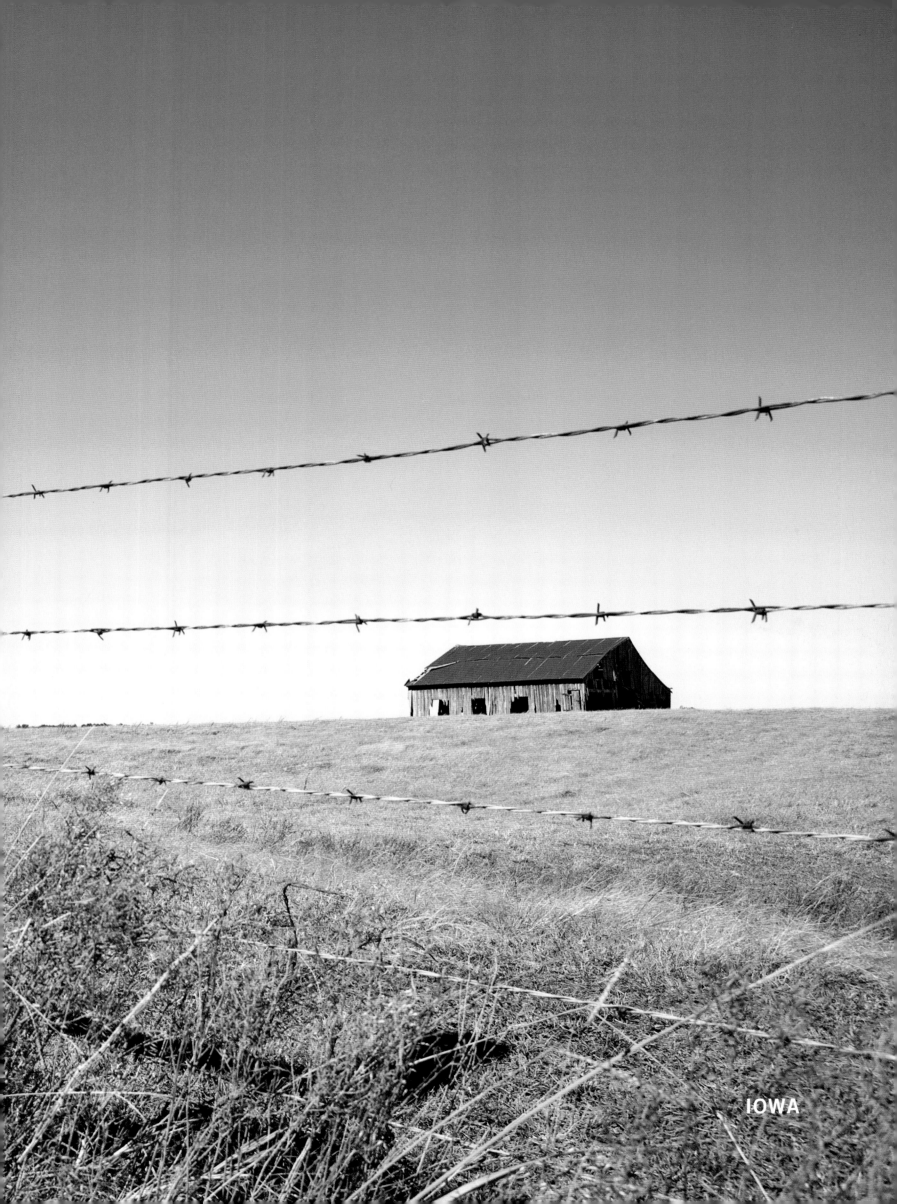

IOWA

KAREN RUBEY

FAIRFIELD +

Karen is busy with her clients at Jacob's Ladder, the antique and vintage store at 50 S. Main Street, when I arrive in Fairfield, so I head out for lunch. Traveling as a vegetarian in the Midwest is a tough quest, so I am very happy to find an Indian vegetarian restaurant, right on the main square of town. "It's because of the meditation center," says Karen when I return and express my surprise. "I actually graduated there, when it was still called Parsons College." She gives me a quick description of the town. "As most places in the Midwest, Fairfield's economy has always been based on agriculture but, because of the school, it also has a unique mix, a special character. You can even see it in the architecture of some of the buildings."

"When Parsons College went out of business, the school was taken over by meditators, as the locals call them. The followers of Maharishi Mahesh Yogi bought the old Parsons campus and opened what is now called The Maharishi University of Management, back in 1974." The name rings a bell in my head. "Maharishi was the guru that influenced The Beatles, a very old, wise man. He just died recently," she says.

The University is still thriving and keeps attracting people to Fairfield. "They come here to study transcendent meditation, it's the technique the guru developed," Karen explains.

She seems pleased by the diversity they add to the population. "At least half of my customers are meditators," she says. "Many of them decide to stay. A lot of people just move into Fairfield after they've graduated or their kids come here for school, and they come to visit and decide to move here because they like it."

She becomes a little apologetic. "Well, the town has had some trouble accepting the Center," she says. "I would say for the first fifteen years, the locals were kind of uptight about it. Suspicious of the newcomers, I guess. But as meditators have come and moved into the community and started businesses, contribute and pay taxes, we realized that it has in fact helped the town grow."

She feels the benefits directly. "They seem to like the vintage clothing I sell in the boutique I run in the back of the store. Sometimes people bring dresses in to me, but I also travel around the nearby counties to find good stuff at auctions."

She is a local and she witnessed the changes taking place firsthand. "I always lived in this area; I grew up in Pleasant Plane, a town of two hundred people just north of here. My father was the mayor," she boasts. "I went to high school in Fairfield and have been living here for more than twenty years." She is now an integral part of the community, not only through her store but also because of her activities. "I was appointed to the library board," she says proudly. "We have the first Carnegie Library west of the Mississippi. When I was in high school I really wanted to be a librarian, so this is really good for me." She remembers well. "I was part of the Librarian Club. We helped shelve the books and put the Dewey Decimal System that they used back then on the books and everything. I just thought that was the neatest thing; I got to handle books and I could read everything I wanted."

The library keeps her busy. "We have a circulation of about 290,000 pieces a year. We do more circulation than any other part of Iowa. There's always something about the building. We have to look at the existing collections or buy new ones. We might have to be a guide, if the librarian needs to buy some more stuff or update things. It's really an interesting job and I enjoy it." Karen likes the changes. "Nowadays libraries are so much more than it used to be," she says happily. "They now have DVDs, CDs, cassettes, they run workshops, they give computer classes, and they have programs for toddlers and senior citizens. It is literally the center of the community."

I wonder when she gets to rest. "I sponsor a bowling team," she responds, "all girls. We meet every Monday night." I smile at her, as it actually is Monday. She is happy to invite me to the gathering, but first we stop at the local VFW lodge. "My dad was a World War II veteran, in the Philippines," she explains over a cold beer. "There's a whole bunch of us that get together after five every day and play cards."

Karen has been married for forty years. "I have a thirty-nine-year-old son and a thirty-seven-year-old daughter. She is an oral surgeon in Iowa City and he is a Master Gunsmith." I'm surprised. "He lives down in Kentucky. He repairs guns for the area's main Remington dealer. They love guns down there. He is very busy," she says, laughing. "My husband used to work for the Army National Guard here in Iowa," she says, pointing at photos on the wall. I ask her if he has ever been deployed outside of the country. "No, he hasn't," she says, joking, "although there were times when it would have been nice to send him off!"

KANSAS

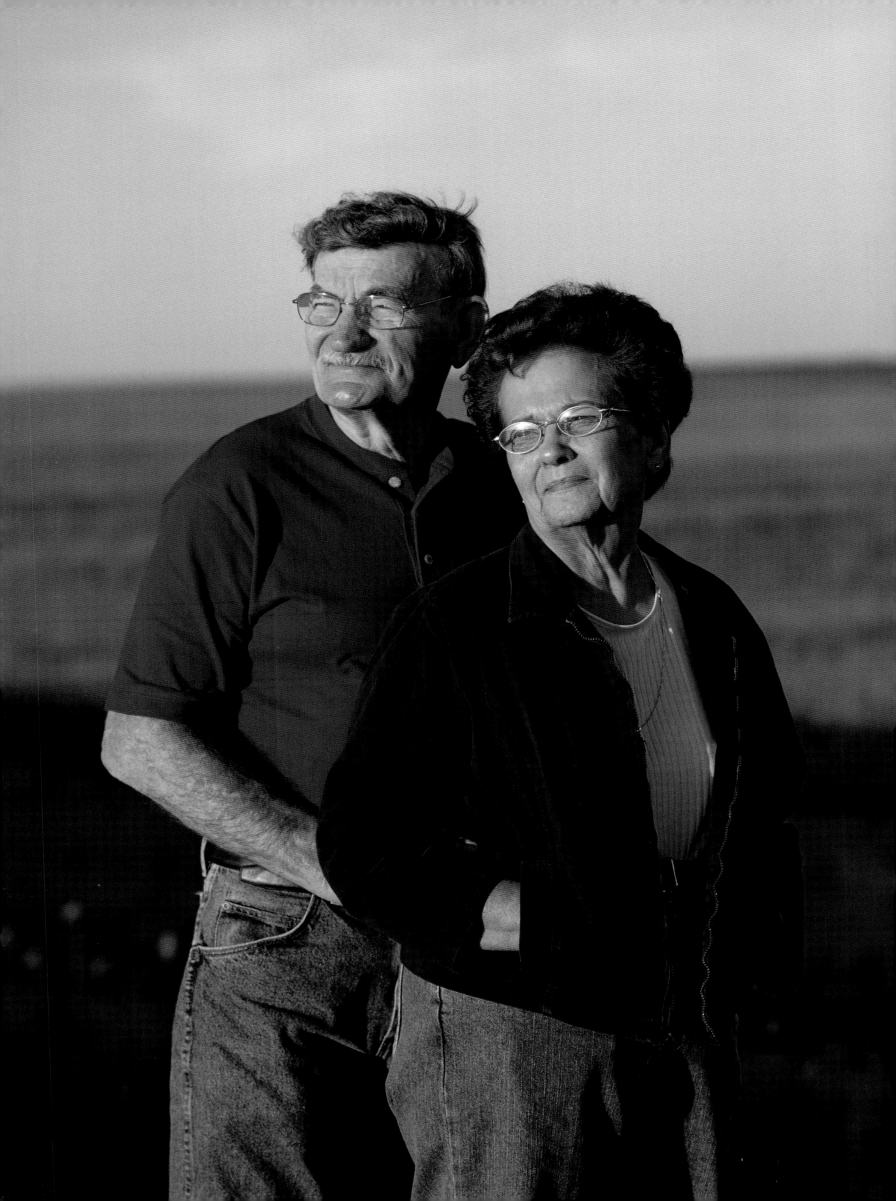

MARY FRANCES & JOE HUNDLEY

SABETHA ✈

"Oh no, no, no! You can't park there, go around the corner." The smiling local policeman warns me as I pull over on the wrong side of the street, when I first arrive in Sabetha. "You are not in New York anymore," I tell myself, paraphrasing Dorothy in *The Wizard of Oz*; it's nice to get help instead of an instant ticket.

"Joe and I both went to school here," says Mary Frances, when I meet her in front of the Midtown Building. "This used to be the high school, at 50 Main Street," she explains. "Now it's the town's fitness center; and the office of Big Brothers Big Sisters. They do a lot of good for our children."

"We grew up together," she explains, "just two houses apart from each other. I was here only for a couple of years; I had my first baby when I was fifteen." My thoughts go to my mother; she also had her first baby at that age with a boy that lived just down the street from her.

"My parents weren't too happy about the news but I felt ready. I was probably forty when I was born. I was very mature for my age," she says. "I didn't really enjoy hanging out with girls my age. A lot of it seemed like foolishness to me," she says, referring to her high school days. "I was more interested in making a home." She is aware of how young she was when she became a mother. "We got married very young. We had three kids by the time I was eighteen."

Only a couple of years older than Mary Frances, Joe went to work in a mechanic shop right after school. "He was the star football player. He was short but very fast," she says proudly. When their five children got old enough, Mary Frances decided to finish her education. "I went back and got my GED," she says in her assertive tone. "I was thirty-seven years old!" She is very glad of her decision. "It made a huge difference when I went out looking for a job."

She recalls the early days as a young married couple: "We've had some hard times. We were young. $50 a week was top wages and we had kids, but we got through it." The relationship had its ups and downs as well. "We are survivors, we truly are. We are not different than many other couples, we went through some bad times between us, but we got over it." She is not a quitter.

"You work things through, you don't give up. We have to be committed to what we think is right. Sometimes it's hard but we do the best we can." Her religion has helped her greatly in overcoming difficulties. "I have a strong faith. I think that's very important. It doesn't mean my life is going to be perfect, but it means that I can always draw on that." She shows her strength again when she makes sure to establish her priorities. "I attend the Protestant Church and I respect other people's beliefs—but it doesn't matter where I go to church, I belong to Christ."

At four feet, ten inches, Mary Frances barely makes it over the mailbox but, seventy-one years of age, she is still full of energy. "We decided that we needed a house without steps so we got a new place, again." They are going to renovate it by themselves, as they have done many times in the past with other houses. "We do 99% of the work ourselves," she says with great pride. "I just finished the tiles in the kitchen last weekend."

They both hold regular jobs, work on the house in the evenings and weekends but somehow find time to restore cars as well. "I'm reupholstering the seats of a 1983 convertible Chevy Cavalier these days—just what two old people need, ah?" she says, laughing, "Joe does the body side of it. We enjoy the work and love the gratification you get when you are done."

They do find time for relaxation. "We like to go to Branson; we used to go with the kids all the time. We would stay at a resort on the lake and we would water ski and stuff." It's almost like their second hometown. "We like the atmosphere there; we love the nature, the views are so beautiful." They don't go with the kids anymore, so now they enjoy their own company. "We just love old, down-home Country and Western shows."

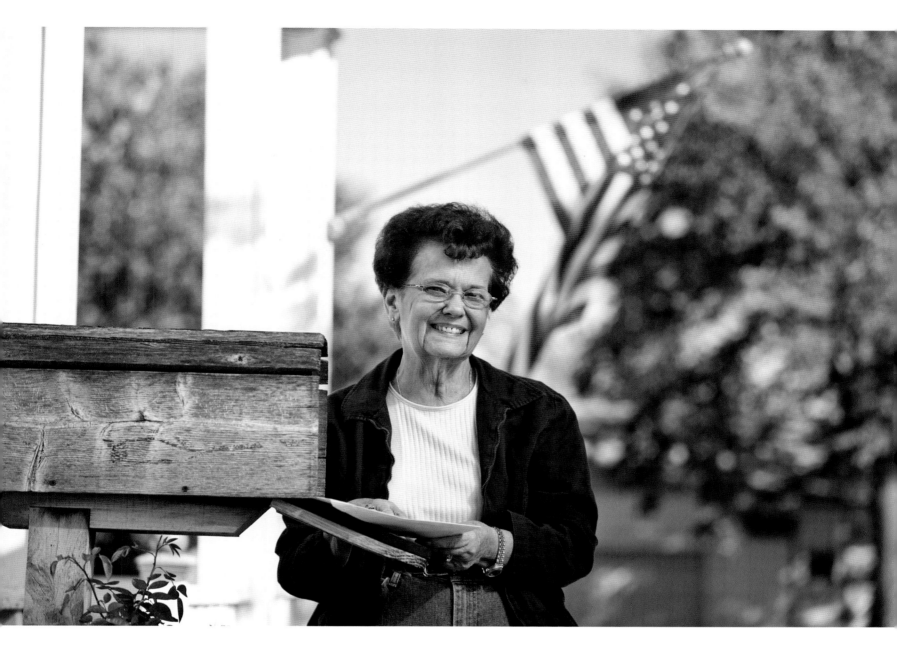

The family is ever growing, and they now have twenty-nine great-grandchildren. "We lived most of our life with either our parents or our children, until 1981, when all the kids finally were out of the house. That was the first time Joe and I ever lived alone," says Mary Frances, smiling. "We had to learn to live together, just the two of us, for the first time." Her honesty is remarkable. "That was a challenge, for sure." Their strong faith helped them through it, and again more recently, when Mary Frances had to face serious health issues.

"It's something in my digestive system—now I have to eat small meals several times a day." She is positive in her assessments, even after having had to endure several operations on her stomach and esophagus that made her lose seventy pounds. "I keep in shape working on the yard. It saves money on the gym and tanning salon," she laughs. Her energy and optimism are contagious. "I am very thankful that I am in good health. I don't have time to be sick. No point in dwelling in the past: I have too much living to do."

KENTUCKY

JACK ROUSE

WALTON +

"My brother and I are the oldest men
left in Walton," says Jack only a few minutes after
I meet him. "I was born in 1929, at the begin-
ning of the Great Depression. I am considered
the town historian." And for good reason.

"I grew up here, my father did, my grandfather
did, and my great-grandfather did. I haven't
moved very far. My family has been here since
1875. I live within one city block from where my
great-grandfather had his mill. We can trace our
family history back to the Revolution."

The Rouses are still very local. "We have two
daughters, grandchildren and great-grandchil-
dren. They all live in the area and we can gather
the whole family within twenty minutes."

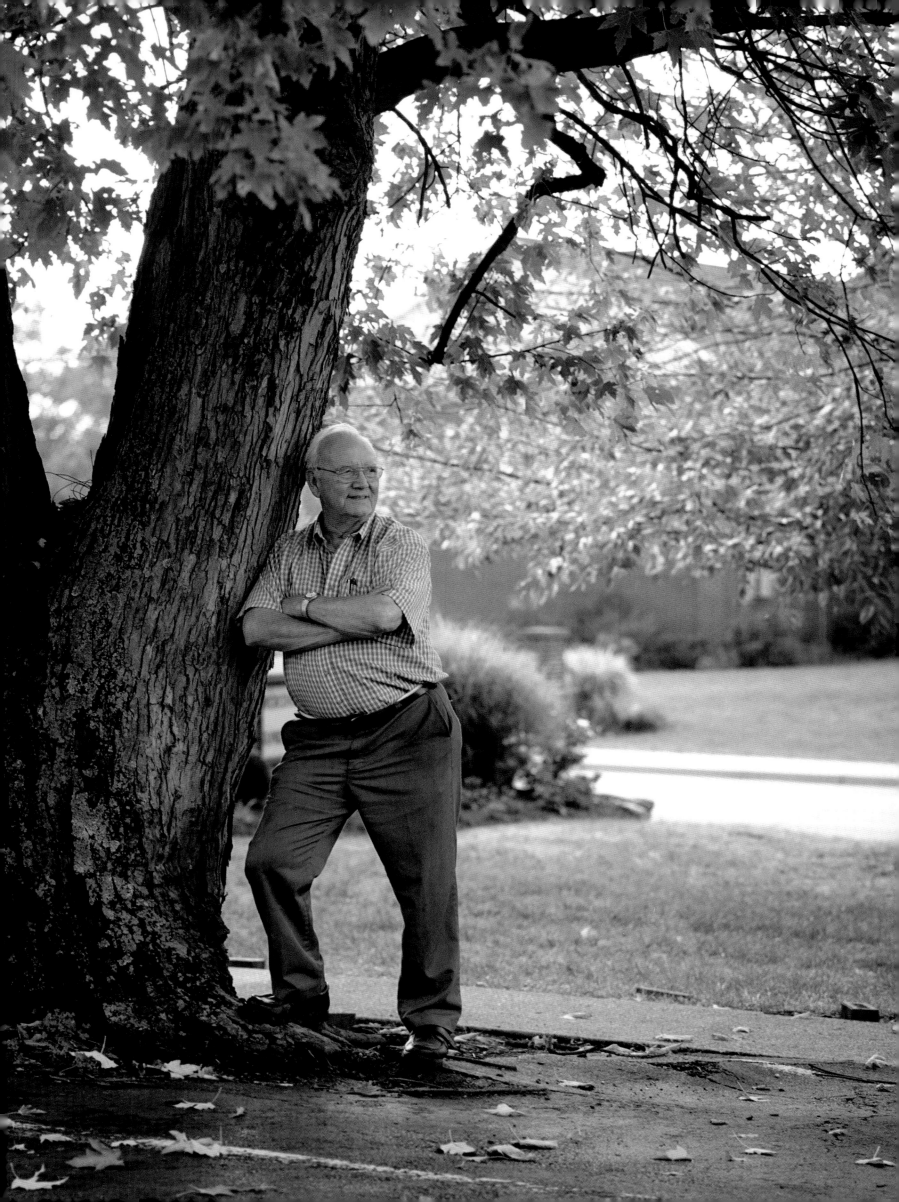

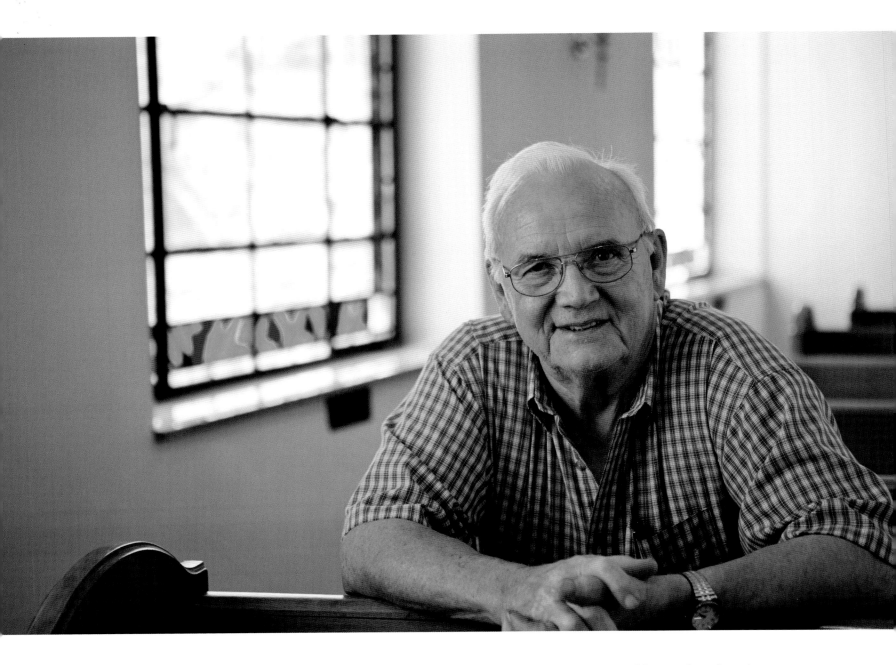

He took over his father's business. "I started working on outdoor advertising when I was still a teenager. I worked on the high risers on the interstate, the signs that stick up in the air; I worked for myself for nineteen years here in Walton and then I went to Cincinnati to work for somebody else to get a steady paycheck. I was doing gold leaf and lettering on trucks, all handcrafted. It's all computerized now, all plastic stick-on. I worked all over the place but never further than sixty miles from home."

He turns the subject to his passion, American history. "My interest awakened in 1965, on the anniversary of the end of the Civil War. One day I found a letter in an old family Bible. It was sent by one of my great-grandmother's brothers. He was a soldier in the Confederate Army. He was captured and imprisoned in Camp Douglas outside of Chicago. He wrote certain things in the letter that I didn't understand. It kind of piqued my imagination; I thought about it for a while and then decided to look more into it."

His excitement is still palpable. "I couldn't stop—I was kind of curious about what happened within our little county. I decided to focus on Boone County and found out that four hundred soldiers served in the Civil War, for both the North and the South." He now starts to sound more like a history teacher to me, especially since he senses my ignorance on the subject.

"My great-grandmother had two brothers that both were with General John Hunt Morgan in 1863. They ran on the longest cavalry ride in the Civil War, all the way from Tennessee to Northwestern Ohio. They got within nine miles of Pennsylvania before they were caught. They took on this responsibility to try to relieve the pressure that the North was putting down south in Tennessee. They refer to it as Morgan's Raid. I ended up publishing a book; it's called *The Civil War in Boone County, KY.*" It's nice to share the enthusiasm of a fellow author and we find another common passion in his new hobby, woodworking. "I like making Shaker-style furniture. Cherry and maple. I have all sorts of tools. I make tables, chairs, drawers. I like the attention to detail. I love the simplicity; there is so much beauty in simplicity."

We are standing outside the church where I met him, at 50 S. Main Street. "I used to be the secretary of the official board and a deacon at the church," he says. "Now I just attend it. Don't have much time for church or woodworking lately; I dedicate myself to being a nurse for Evelyn, my wife. She has been diagnosed with acute leukemia." I am stunned by the news and it must show, as he starts telling me about their love story, inserting some history, of course.

"I am of German descent and Evelyn is Irish. Our families primarily were Lutheran, broke away from the Catholic Church many, many years ago. We switched from Lutheran to Methodist; Evelyn was attending the Disciples of Christ when I was courting her, so I just fell into that denomination." He lights up. "We started when we were fifteen years old. We were the same age and graduated at the same time."

Of course I am curious about their courtship. He likes to reminisce and smiles. "She was raised on a farm, while I was in Walton, a very small town back then. We would meet and we would go to the shows, typical high school times. There was a show house, roller-skate rink, in town. Our dates were kind of low-key; you have to remember that we were in the middle of World War II. We never had any big party or anything like that. Just ordinary folks."

Young Jack and Evelyn must have been so cute. "I used to skate backward and did acrobatics and spins. Just to impress her. I never competed or anything. It was just for fun!" His tricks worked.

"At the age of nineteen I asked her to marry me and she was foolish enough to say yes."

My wife's birthday is an important date for Jack and Evelyn. "On September 14th we will celebrate our sixtieth wedding anniversary. I feel very fortunate. She is my whole life."

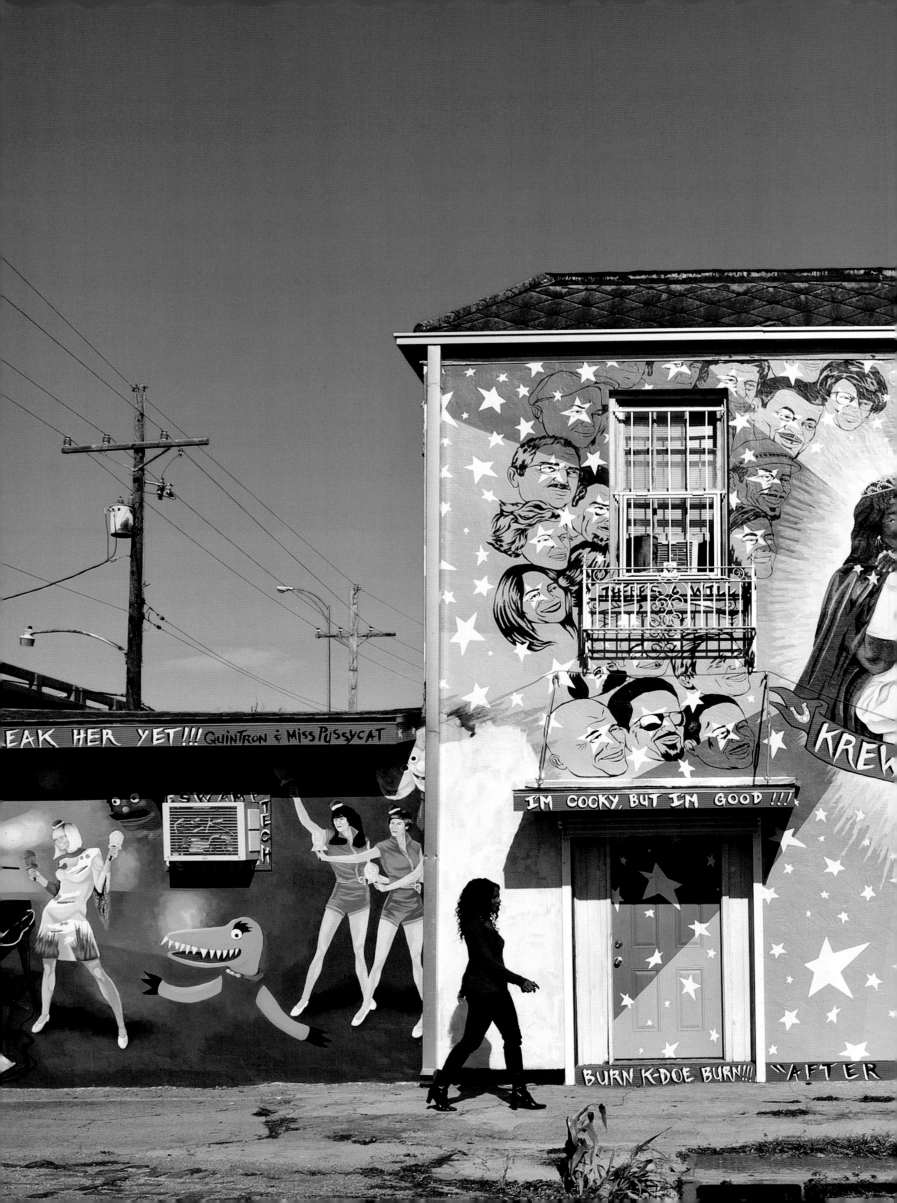

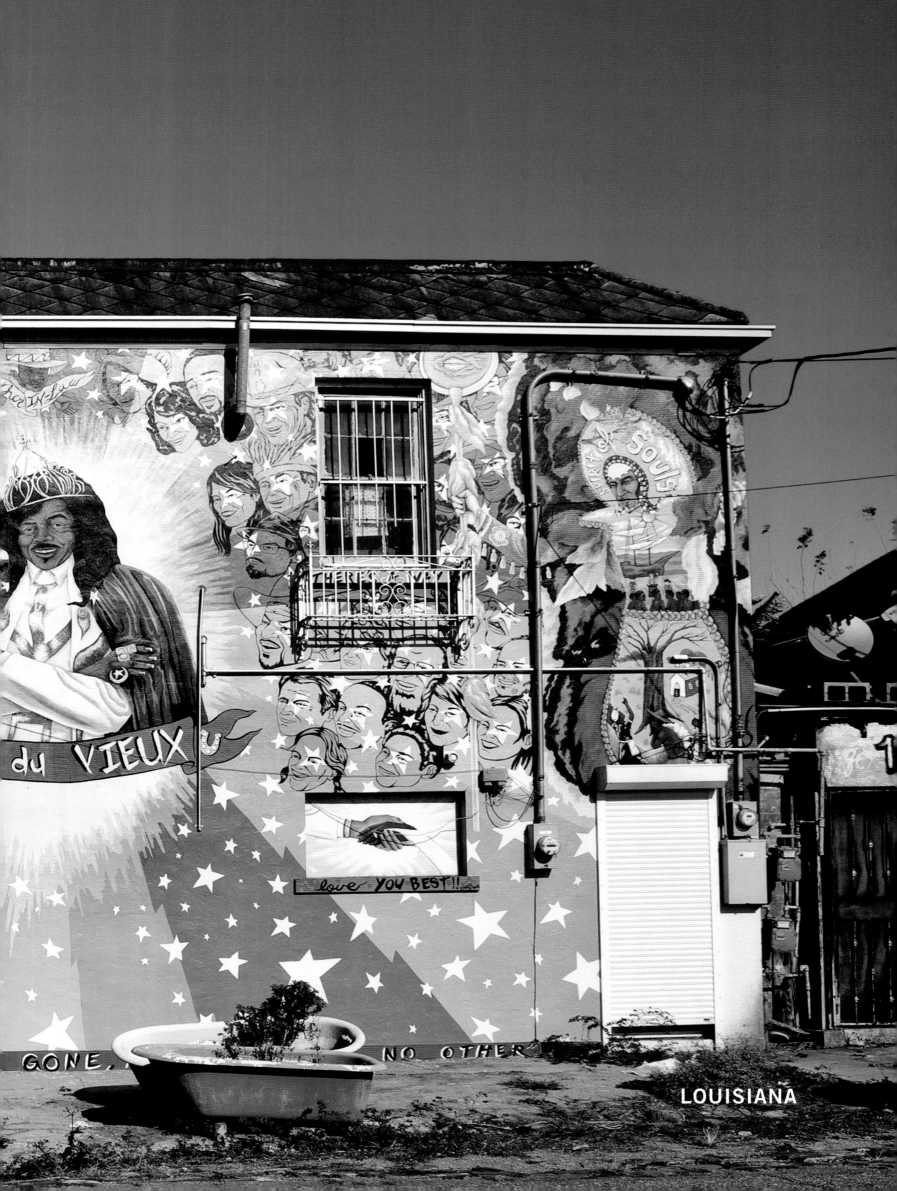

LOUISIANA

DONALD JR. & DOLORES HAHN

FRANKLIN ✈

The sun, the heat and the humidity are almost unbearable when I exit my car and meet Don Hahn. "We are in the middle of the Cash Bayou," he says when I describe the drive from New Orleans, through miles and miles of elevated roads seemingly floating over the water. "This lot was used as a summer camp for the family. My father named it Hondarosa."

We are only two hours away from the Big Easy, where I soaked in the diverse culture, the spicy cuisine, and the energizing beats of jazz, zydeco and Cajun music, but it feels like another world. "Franklin has a rich history based on sugarcane plantations, and the sugar industry is still an important part of the economy, especially now that all the manufacturing is gone," explains Don. During our conversation I hear the buzzing sound of a small vehicle in the background. "Those are my kids, Dolores and Donald, Jr.," he says with a mix of pride and aggravation.

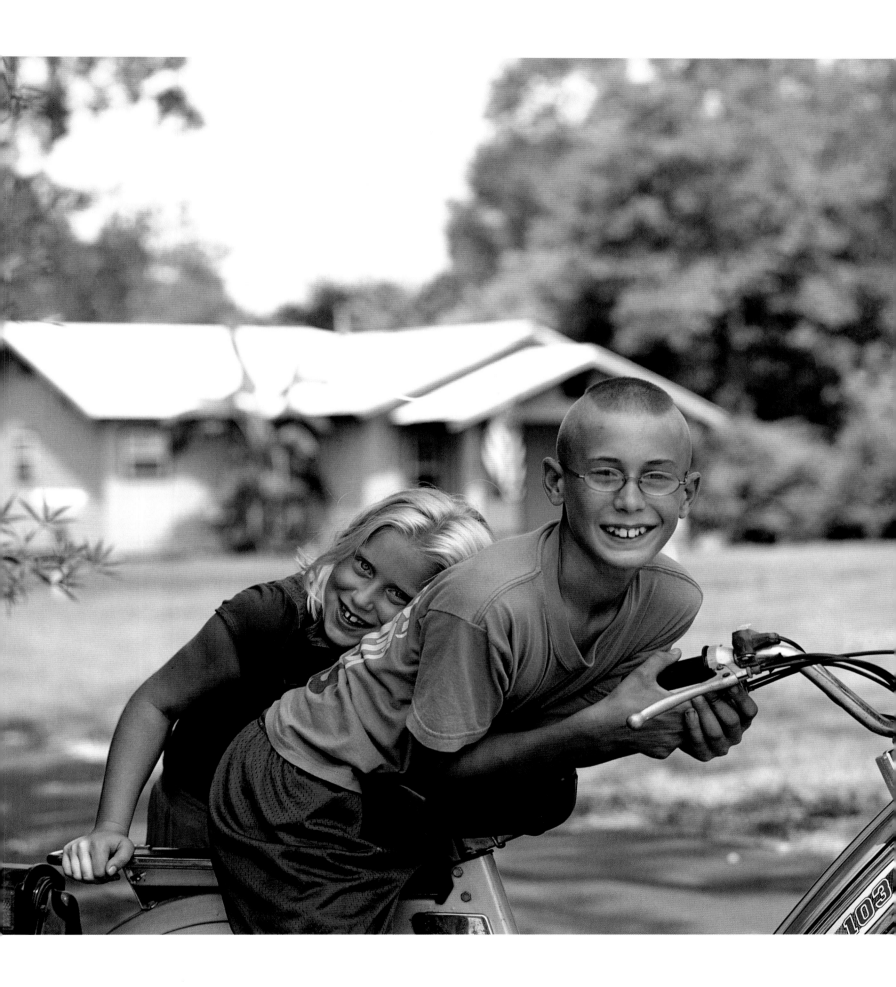

The scooter comes to a stop and Don introduces me to his children, very polite and shy. The conversation with eight-year-old Dolores is limited but to the point. "I like spelling and math, would like to be a teacher when I grow up. I like to swim in the pool—never liked to swim in the bayou," she says. "I like the bayou, when the weather is hot I just jump in!" says Donald, Jr. He is more adventurous and has more to talk about. "I like to fix anything that needs fixing." He has been repairing the scooter and is taking it for a spin.

He is a typical thirteen-year-old country boy when it comes to school: "I rather cut the grass than going to school." Not so average when it comes to playing: "Don't like playing video games much, I rather run around on my four-wheeler." His mother just got him a new all-terrain vehicle, and he takes advantage of it anytime he can. "It's the cheapest, but still runs good. I ride it in the cane fields. I couldn't get lost around here—I know where everything is. I have many friends and we all ride four-wheelers."

"I like having sleepovers with my girlfriends. We play on the trampoline and jump rope, but my favorite is when they stay over. I have a big bed and we all sleep in it," says Dolores, trying to establish herself, but Donald, Jr., wants to go back to talking about his machines.

"When Rita hit a few years ago, we had the storm surge; the water was a few feet high and I had to get the tractor out of the mud and then I pulled the four-wheeler out as well," he says proudly. Hurricane Rita hit the region a few days after the more well-known Hurricane Katrina. While Katrina left longer-term changes in Franklin, in terms of accommodating people from other affected areas, Rita had more immediate devastation. "My four-wheeler died when it was in the mud, but I cleaned it up and fixed it," he insists. The one thing that Donald, Jr., can't fix is tearing him apart. His parents separated just a year earlier and he has had a hard time accepting the new circumstances. "I've seen a therapist but she hasn't helped me very much," he says. "We are doing the seven and seven now," says Dolores, inserting herself in the conversation. They learned to accept sharing their time shuffling between the two parents. Donald, Jr., is more upset about the situation, especially the relationship with his father. "He has been very hard on me—he expects too much from me. He sees me as a grown-up, but I am only thirteen." He shows a mature side now: "I think it's because that's the way his father raised him." Donald, Jr., is going through the phase when frustration is rampant. "Dad doesn't understand that I know right from wrong now," he says. "I have ADD and mild ADHD; we used to work together all the time but I was always misplacing the tools and Dad would get upset." He loves working with his father.

"We have our separate toolboxes, one large for him and one small for myself." The thought makes me smile. "Dad went to trade school. He can fix anything." His tone is so full of pride that I feel like he's talking about his hero.

The kids enjoy spending time with their mother, but when the parents first split up, Donald, Jr., chose to stay with dad. "I love him too much; I was worried about him, and I didn't want him to be alone." I am not sure what to say. "Mom moved to Centerville, about five miles away from here. I ride my four-wheeler to go back and forth." And he does it with his teenage energy. "I broke my collar bone once," he says, almost boastfully. "Mom didn't want me to ride my four-wheeler again, but life is not fun if you don't take risks." He can't even think about life without his four-wheeler. "That's very important to me; it's the only time I really like to do stuff—riding and cutting the grass. I can get my mind off of everything else, and I can think about what I want. It just makes me feel good. It's one of those stress relievers," he says seriously, "I guess like smoking cigarettes, or one of those habits that put your stress down. That's how I feel when I ride the four-wheeler." He finally finds the right words. "I feel free."

MAINE

SHERRY & BOBBY
WHEAR

DAMARISCOTTA

"Bikers used to live here before we bought the place. They told us that they would ride their motorcycles up the front and down the back stairs. Fifteen guys and two German Shepherds." Sherry laughs telling me about the history of the Mill Pond Inn, the bed and breakfast she owns with Bobby at 50 Main Street. "We stumbled upon it. We lived in Massachusetts back then. We were out for a drive," she says. "We fell in love with it as soon as we saw it." They moved quickly. "We got married here, three weeks after we bought it." She is still excited. "It's been a wonderful adventure. The first day we were here, Bobby and I were sitting on the deck with our feet dangling, holding a bowl of cereal, looking at this beautiful pond. Bobby looked at me and said, 'You know, even if it doesn't work out, Sherry, this is going to be one hell of a year,' and we laughed and we kissed. And here we are, twenty-five years later."

It was March and they had to get the place ready for the season. "Our first customers came when we were still painting, cleaning and fixing up the yard. They had never stayed at a B&B and we never had a guest before, so we just invited them in and treated them like family. We are still friends with Judy and Bernie to this day."

It's lunchtime and Bobby wants to take me out for local specialities. "We have the best oysters in the whole world here," he says boisterously.

I am no expert so I defer to Bobby's experience.

"I was a seafood chef for eleven years before the inn," he says. "Besides oysters, Maine has fantastic haddock, flounder, swordfish, mussels, steamers. I do the cooking for functions here now—I set up a kitchen and a tiki bar in the backyard so we can have the events overlooking the pond." Their white Labrador is getting impatient. "His name is Jagger; we love the Stones. We've seen them in concert about sixteen times." Jagger wants to leave so they take me to the Damariscotta river. "This is where the alewives

run up from the ocean." Sherry points to the rustic-looking, man-made fish ladder. "Every year in May, the alewives come to mate in the lake. Our pond is fresh water, right between Salt Bay and the lake, forty-seven feet above sea level." I am reminded of the salmon run in Alaska.

"It is much like that," she says, "but some of our herrings actually return to the ocean after they lay the eggs. We have a big festival here for the occasion, around Memorial Day. There are millions of fish running, the eagles come in to feed and the seagulls are so many that they line the roofs of houses. It's just fabulous." It's the height of the season for their business. "We are basically married to the inn," says Sherry, "but we do take four days off to go to the Frozen Four, the college hockey national championships." Bobby appreciates the athletics side of it. "It's very competitive, very fast, very exciting." Sherry appreciates the choreography. "The teams bring the college band with them and the fans wave banners. It's very cute. It really is." She wasn't always a fan. "I converted her, about twenty years ago," says Bobby proudly. "I converted him to art instead," responds Sherry. "He got me to watch hockey and I got him to go to the museums." I love her art-related anecdote. "I got to meet Salvador Dali, a million years ago, when I lived in New York." I push her to tell me more. "Oh, I was very young. A friend told me that Dali was setting up an exhibit in a gallery so we went and met him. It was very brief, but he extended his hand; he wanted me to kiss his ring. He was a very eccentric man," she says, laughing.

While Bobby's accent is clearly New England, Sherry sounds more familiar. "I grew up in Long Island. I am a Jewish New Yorker," she says. "My parents were not thrilled when I married Bobby.

I have two daughters of my own and they now think of him as their father. They really love and respect him, and he loves and respects them." She smiles, thinking back. "Shortly before passing, my mom looked at me and said, 'Did you ever think I would love my Bobby the way I do?' That was a precious moment."

They had many other precious moments at the inn. "We had a family of classical musicians that came for the parents' fiftieth anniversary. It was New Year's Eve. They got dressed in their formal attire and played a piece for us. Another time, we had a guest that came with a bagpipe. He played Amazing Grace in the backyard. Nobody around, not a sound. Well, you should see the backyard in the spring, it's absolutely magnificent. It was so beautiful, so moving. I was crying." She has more stories. "We had a woman from Kentucky, she had a handmade dulcimer. It's an old country instrument from Appalachia. She played for me, Bobby and my daughter; she had a voice that was like a songbird, so magical. It was a moment, you know. It was just beautiful."

She pauses for a second. "We've had people from all over—China, Alaska, Dominican Republic, you name it," she continues. "We don't get to travel much, but the world seems to be coming to us."

MARYLAND

MARGARET POWERS

WALKERSVILLE +

Margaret Powers is sitting on her front porch, as she usually does at the end of the day, when I arrive at 50 A Main Street. The sun is moving so quickly behind the trees that I hardly say hello before taking my photos.

"I'm not busy today, just finished working on a quilt," she says to make me feel better about my sudden invasion in her life. "I guess I am sort of addicted to working on quilts. It's something I enjoy doing and I feel like it will be helpful to somebody that needs a nice, warm cover," she says. "A quilt is any kind of cover that is made with love and caring. We feel like we can call them quilts because there is a lot of time and effort put into them. You have to feel like you are doing something that is needed and will tell somebody else that somebody cares for them."

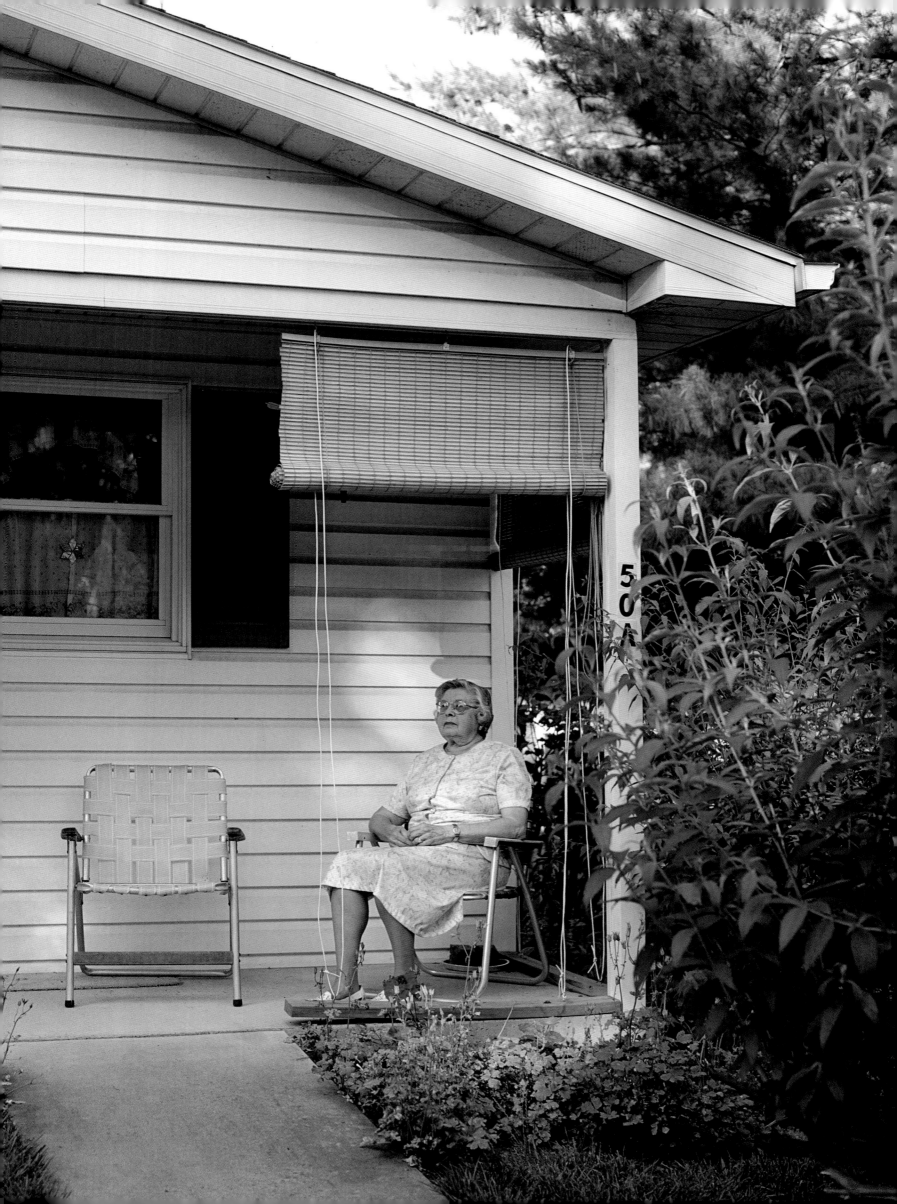

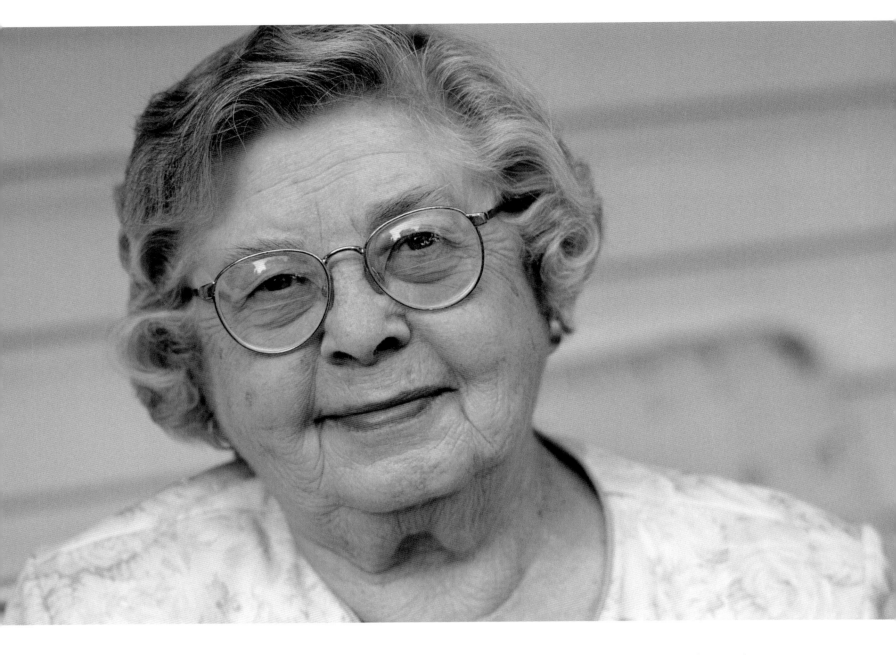

"I work on the quilts with the other ladies at the church," she says, recognizing all the efforts everybody puts in at St. Paul's Lutheran Church. "Today we had a picnic in the afternoon; there are committee meetings and there are different organizations, so I am at the church practically every other day for one reason or the other. And then I have two Sundays coming up when I am going to be the organist for the church, substituting for our regular organist that is going on vacation." I enjoy her quiet demeanour and soft voice.

She started playing as a teenager. "I was about eighteen years old when I started playing piana. I started with the piana, then I switched to the organ. I play maybe eight times a year, so you kind of forget what you did before. The feel of playing the organ is quite different from the piana because you have a couple of keyboards that you play on, and then you also got foot pedals that you use, so I need to practice a lot before I feel that I am prepared for a service." She also plays in nursing homes and for senior citizens.

"Usually twice a week. There are four others that alternate with me playing the piana." I smile at her accent every time she says "piana."

She has always been involved with the church, since her mother moved to Walkersville. "My parents separated because my father liked alcohol more than anything else—he was an alcoholic proper. I never got to know him too well. Mother worked very hard to keep things going. It wasn't easy with us three children, back in those days when people didn't make a lot of money. She worked at a sewing factory and also took on many odd jobs on weekends. Unfortunately there wasn't a lot of social help like there is today."

Even with that family experience she decided to give marriage a try. "I was married for fifteen years, to Alan Powers. They were fifteen good years. And then one day Alan said that he needed to get his head cleared. He feared that the next fifteen years would not be as good. That didn't make much sense, really!"

She has come to terms with her divorce. "He was a bit younger than I was. He said that age was not that important, it was the people that were involved. He had two children from the first marriage so I thought that he would know what he wanted out of a marriage. I had more pep and energy than he had. At least I feel that I haven't rusted out; I kept busy. I've been wearing out but I don't rust out. That was a bad period in my life, for about a year, but somehow through friends, lots of tears, and prayers, I got through it. I kept connected with the church and I think that was a big help too."

The divorce at least allowed her to reconnect with her mother. "Mom was getting older. Her health was beginning to fail so she moved in with me until she passed away." She sounds nostalgic.

"She was one hundred years old, and a half. She died on a Good Friday. It was also April Fool's Day that year. Her service was on Easter Monday. Those dates will stick with me forever."

She married a little late in life. "I was home with my mother until I got married, age forty-five. I had a chance to get closer to her than either my sister or my brother, because they had gotten married and left home much earlier. I was kind of responsible for getting her to different places." She remembers their vacations. "We would go to Ocean City or up to Pennsylvania. I had two friends who came down from Cumberland. The four of us would go to the Cape Cod area, or over to St. Paul, Minnesota, and up into Canada. I did a lot of driving then. As long as I had a navigator, I would drive anywhere." I love imagining young Margaret taking her friends around in her classic green-and-white 1957 Plymouth Belvedere.

"I am still driving. I have an Oldsmobile now," she says proudly. "I am the Hallmark Cards specialist for two CVS stores here in Walkersville and in Frederick, so I drive back and forth quite often." I am shocked when she tells me how long she has been working at the same place.

"I started on April 24, 1944. I was eighteen years old. I started with one company and I am still with them—it must be some kind of record!"

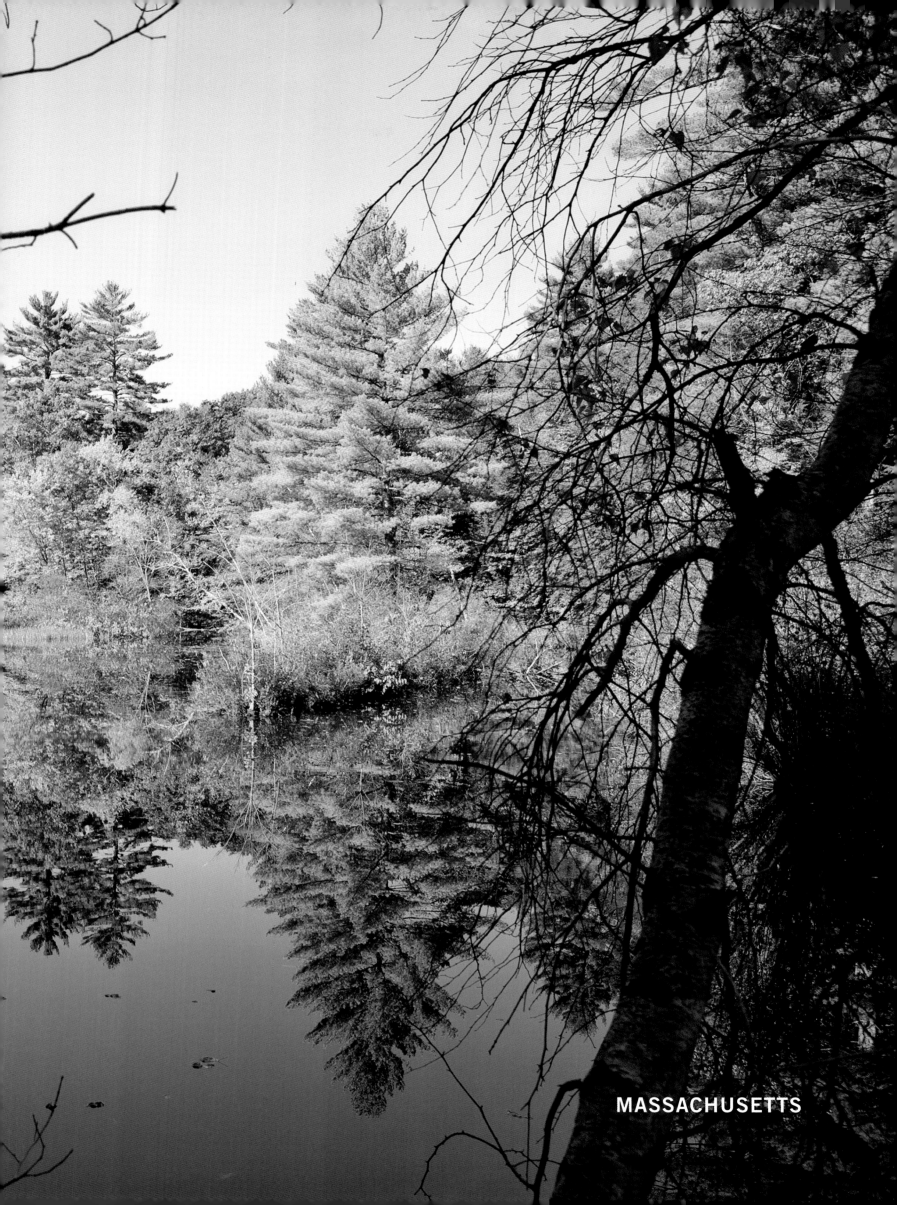

MASSACHUSETTS

ANGEL MORALES

WEST SPRINGFIELD

Doctor Morales is seeing patients when I arrive in West Springfield, so I have time to scout the house that hosts both his office and his home. The wall with pictures of his little patients seems the most appropriate spot to photograph him. "It feels like an extended family," he says about the children. "They grow up with me, some I get to see from birth to age eighteen."

Despite his Latino name, Angel doesn't have a Spanish accent. "I was born in Puerto Rico but I have lived in the U.S. since I was five," he says to explain. "My father came over first. Only after he found a job my mother followed. I lived with my grandparents in Puerto Rico, it seemed like forever, until they gathered up a little money to send for the children to join the family."

Angel doesn't remember much of his native home. "The town is called Junco. It was Puerto Rico back in the early 1950s, late '40s. It was still pretty backwards. They were lacking a lot of the niceties of the United States. For instance I was born in a house, with the help of a matrona, a midwife." He laughs when I tell him that I was born at home with a midwife as well, and that I grew up thinking that all midwives had bulging eyes, just because mine did. I found out many years later that she had thyroid problems.

"My parents had eight other children after me, and my dad decided to look for better opportunities in America," he continues. "When my father first came, he worked in the tobacco fields of Massachusetts and then he found his way to New York. He worked in a laundry for ocean liners—very big back then. He worked there, seemed like forever, but it was about fifteen years."

Life didn't get much easier for little Angel when his mother became ill. "I think all those babies back to back stretched her immune system, so she got tuberculosis. It was like the AIDS of the day: contagious, except it was transmitted by air. She was sent to a sanatorium." The father couldn't raise the family by himself. "We were all put in orphanages. The sanatorium was off limits so I didn't get to see Mother for a whole year.

They were experimenting with a new antibiotic; it was called INH. It turned out that my mother was given that new antibiotic and she survived." Eventually normal life resumed. "When she came out, she took me out first and it seemed like forever before she took out my brother. It took three years before we were all together." Angel learned English in the orphanage. "There was this little black boy in the orphanage that helped me out with my English. I used to ask him, I would point to something, and say, 'How do you say,' head, nose, ear. I'll never forget, I didn't know how to say butt, so I asked him, 'Come se dice cullo?' and he said, 'Oh, you mean aaassss!' He was a real New Yorker, you know. So I learned all my body parts from my little friend there. The nuns taught me the rest. When I came out of the orphanage in a year's time, I was fluent in English." He has a small regret. "I wish I could remember his name. I would love to find and thank him."

Angel always focused on being a good student. "I liked science as a child. Mother was too busy and my father was not around much—he was always working—but I went on a school trip to the Museum of Natural History and I grew an immediate love for it." His parents were supportive. "I was always coming home with A's so my parents were always encouraging me. I think that it helped me and pushed me to do my best."

The support and sacrifice paid off, allowing Angel to be the first in his family to attend a university and the first to become a doctor.

His wife, Kathy, comes over from the house next door for a quick hello. "We have been married almost forty years now," he says when she leaves. "We met the first week in college, at my first freshman party. I thought she was very cute and had a pretty smile but we didn't get to talk much.

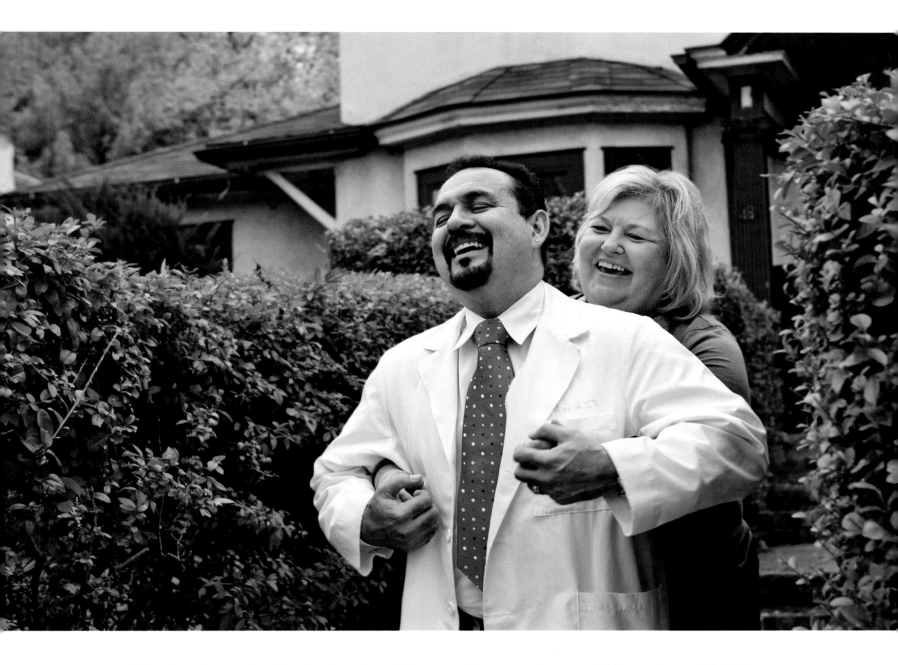

When I saw her again a few days later, I couldn't remember her name so I said, 'How are you doing, Massachusetts?' I guess she found it cute because we started eating breakfast and lunch together, and before you know it, we were an item. We got married right after graduation."

The university was only the beginning for Angel and Kathy. "We survived medical school and I did my residency in New York City. Kathy was always very patient, but after Nathaniel was born, we decided to move closer to her family."

He eventually opened his practice at 50 Main Street. "It's a special place for us; our second boy, Zachary, was born here, and this is where all my schooling finally came to fruition."

Angel's a long way from his days in Puerto Rico. "My niece is actually graduating from medical school so, soon, we will have two doctors in the family." He might have started a trend. "I think, well, I know that I influenced her, because my sister told me. I am proud of that."

MICHIGAN

RACHEL LAZO

CLAWSON ✈

It takes me quite a long time to reach

Clawson, MI. A full day's drive from New York to Birmingham, a few miles outside Detroit, and I arrive just in time for dinner with my friend Holly. She briefs me on the economic hard times that the automotive industry and all the related businesses around the Motor City area have been experiencing recently, but still finds time to show me around the affluent, residential suburb before I finally crash on her couch.

The following morning, nice and fresh, I make my way to meet Rachel at her beauty salon, just a few miles away. When I hear her story I realize that I can't complain. Her journey to Clawson has been much more complicated than mine.

"My family left Iraq when I was still a child," she says. "We went to visit London. It was 1980. The war between Iraq and Iran started while we were there and we were afraid of returning home. My parents decided to go stay with my two brothers that were studying in Sweden. A couple of years later my father had to undergo heart surgery, so the whole family moved to Michigan, where the doctors recommended a hospital for him." That was a different Rachel. "I remember getting off the plane and not even being able to understand 'hello' and 'goodbye.'" She was nine years old and only spoke Arabic and Swedish. "After six months I spoke English like I'd lived here my whole life." She put herself to work immediately. "I think it was survival. I went into third grade when I arrived. I had to learn fast!" All her family spoke Arabic. "Actually my father's family spoke Chaldean and Assyrian—that's the language closest to how Jesus spoke. My family lived in the countryside in Iraq. My dad learned Arabic when he moved to Bazra, where he met my mom and where I was born and went to school."

"I see my family three or four times a week," she says. "If I don't, I have to hear it." Visiting family means seeing brothers, uncles and aunts from both sides. Her dad passed away four years ago so Rachel spends a lot of time with her mother.

"She has her own place but she stays with me a lot, and my nieces and nephews love to spend time at my house." Especially the girls, who love taking advantage of Rachel's skills doing hair. "They better—I wouldn't let them get theirs done anywhere else," she says, waving her finger.

Her aunt Warina started it all. "I used to sleep on the roof when visiting her in Baghdad. I loved looking at the stars. The city had fireworks, it was beautiful. We used to have bunnies. They were pets but they were also..." She pauses. "In Iraq people raise animals in the backyard. We had chickens and rabbits and sheep but then eventually my parents ate them. I didn't!"

Her favorite memories, though, are about hair. "Aunt Warina was a hairdresser in Baghdad and I loved looking and learning from her. She has always been my inspiration." Rachel opened her own business at the early age of eighteen, after apprenticing for a couple of years. Things didn't work out the first time around, so she went to work for somebody else until she felt ready to have her own salon again, this time at 50 Main Street. "I've been here ten years now. The place was a disaster when I moved in. I got all the work done myself. Now it is beautiful." She seems very pleased with her accomplishments.

Family and the Chaldean community are intermixed in Rachel's life. "It's a very large community and a close one too. There is always something going on—a wedding, a party. Even when you just go shopping you run into people. If you don't do anything with them, they do something with you," she says, laughing. "I used to think that my parents were too strict on all of us and it's funny 'cause now that I am getting older..." She stops herself. "I just hope I'll never have daughters because I would make them miserable."

She is more old-fashioned than she would like to think. "I am very proud of being an American citizen but at the same time I am proud of where I come from, the culture, the values and beliefs that my family taught me." She sums it up in one word: "Respect. Respect is big for me." I laugh, remembering my previous visit to Michigan, photographing Aretha Franklin many years earlier.

"I like the fact that when you go to an Iraqi house, they are very hospitable," she says seriously. "They give everything they have. And if an older person comes into the room, you stand up and give them your seat. That's the kind of things that I appreciate in our culture. If I ever have children I would want to teach them things like that."

Rachel is still single "It's not so easy to meet Mr. Right when you work ten hours a day, six days a week and dedicate so much time to your family," she says. "I believe in faith and destiny. If it's going to happen it's going to happen when the time is right." She is very confident in her beliefs, even when it comes to love. "He'll find me, one day."

MINNESOTA

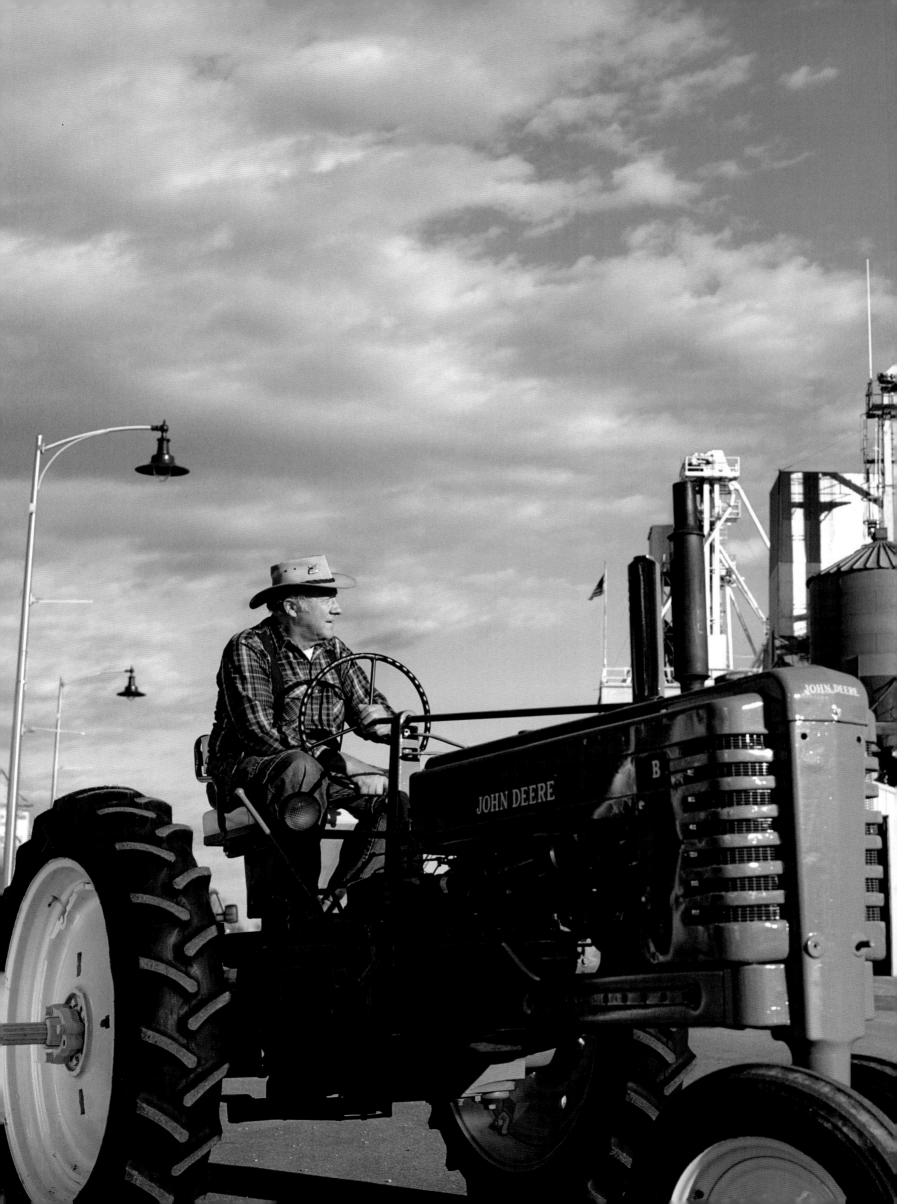

TONY SPELTZ

LEWISTON

"You'll love the one I have at home."

Tony is a little perplexed at my choice to take his picture in front of an old tractor, so he volunteers to run down to his house. It only takes him a few minutes, and when he returns I understand what he meant. "This is a vintage John Deere," he says enthusiastically. "This tractor is a true beauty—it has been in our family all my life."

Born and raised in Lewiston, Tony runs an agricultural supply store. "Farming is really strong around here," he says.

Tony's words don't take me by surprise, after driving for hours across endless fields punctuated by farms and silos. It's harvest season and the fields are invaded by flocks of thousands of birds that feed off the leftover grains.

"I grew up on my father's farm, with cows and pigs and chickens," says Tony, describing his upbringing. "We were farming and we started this business at the same time. My brother and I worked together and then we decided to go our separate ways. He got the farm and I took over the store."

His parents have both passed away, but his mother's is the really heartbreaking story. "It was a life dream of hers to go to Hawaii. As a surprise, Dad arranged to take her there. The first night of the trip was a stay over in Las Vegas and then the next day they were going to fly to Honolulu." Tony's tone changes. "She died in Vegas on the steps of the Riviera Casino. Massive coronary. She never did make it to Hawaii."

Tony is a hardworking man, always looking to keep busy. "I bought a couple of houses down in Arizona. I rent them out. I manage them myself. I like to head down there in the winter. I play a lot of golf. I usually go after Christmas so I can spend the holidays back here, with my family."

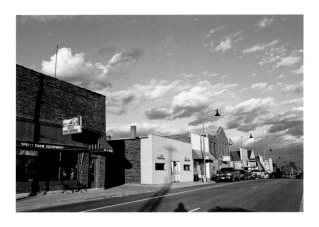

The yearly celebration is a chance to reunite with his three daughters and ten grandchildren.

"It takes a pretty big room to accommodate everybody for dinner," he says happily. "We usually get together at one of the kids' houses. I am not too handy at cooking. That's not my speciality!"

His forte is sales. "I sell a lot of corn-burning stoves. Just about everybody has a stove around here," he says. "I enjoy traveling, talking to people at farm shows. I take a few stoves to demonstrate, stick a pipe up in the air, even if we are indoors. When these stoves burn there is almost no smoke at all. And when they are finished burning they leave only a little clinker, real hard, almost rock-like because of the sugars and the starches in the corn."

The business takes a lot of his time but Tony manages to stay in touch with his daughters. "They all still live in Minnesota but spread out around the state. Only one is in Lewiston. She is a La Crosse University laureate; now she runs her own assisted-living center. The other one married a dairy farmer not far from town," he says, smiling. "Her husband is also a Speltz and I tease her all the time about that; she didn't even have to change the name on her driver's license." The youngest daughter instead moved to the big city, Minneapolis. "She had a harder time accepting her mother's loss." Tony lost his wife to breast cancer. "It's been twenty years already. It was challenging raising my girls after she passed away. I was so thankful that the girls were grown-ups. Deb was one year out of high school, Shelly just graduated that summer and Nicky had two years left. We made it through together."

Tony always found refuge in work. "Corn stove sales have been struggling because ethanol is making the price of corn skyrocket," he says, not very happy about it. He had to slow down a few years ago anyway. "I have a heart condition. They wanted to put me on the table and open me up." Luckily he got a second opinion and was told to lower his blood pressure and cholesterol, exercise and lose some weight.

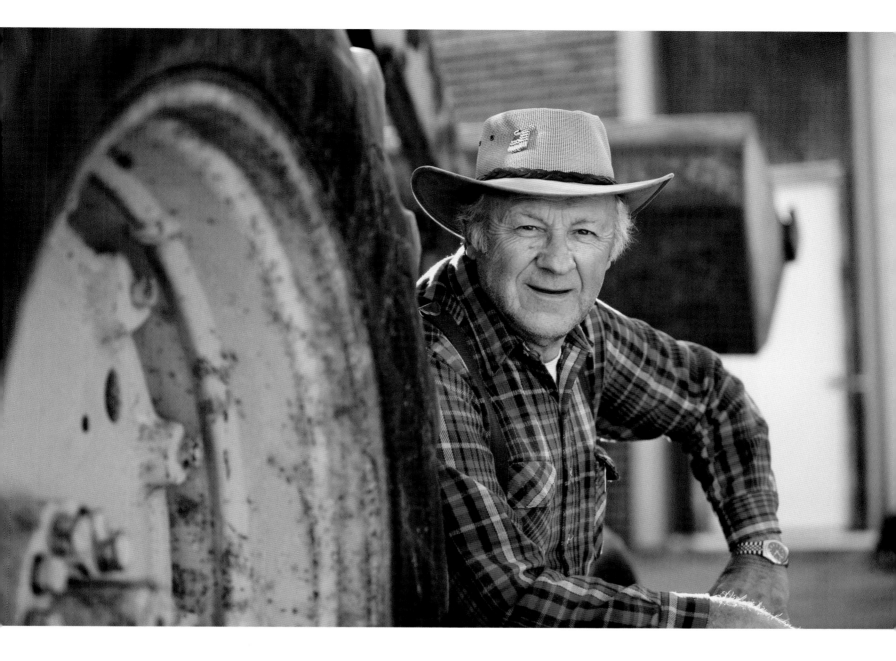

"I went to the Mayo Clinic in Rochester; it's one of the most renowned medical facilities in the world." I have to tell him a funny story involving my friend Pierpaolo, an Italian surgeon, going to a symposium at the Mayo Clinic. He called me from the Newark airport in desperation because they had mistakenly sent him to Rochester, New York. I had to spend the whole evening trying to set him up with a flight for the next morning! Tony gets a kick out of the story and goes back to talk about his tractor and his teenage years.

"I remember working endless days on this John Deere. It's one of the few ever made that you can drive standing up." His eyes light up and I can almost smell the air of those days. "I was eighteen years old and I loved to sing my favorite song while I was going up and down, plowing the fields." Of course I get curious and I have to ask what song that was. I still smile every time I think of his answer. "It was a Nat King Cole song: 'Mona Lisa.' I loved to sing 'Mona Lisa.'"

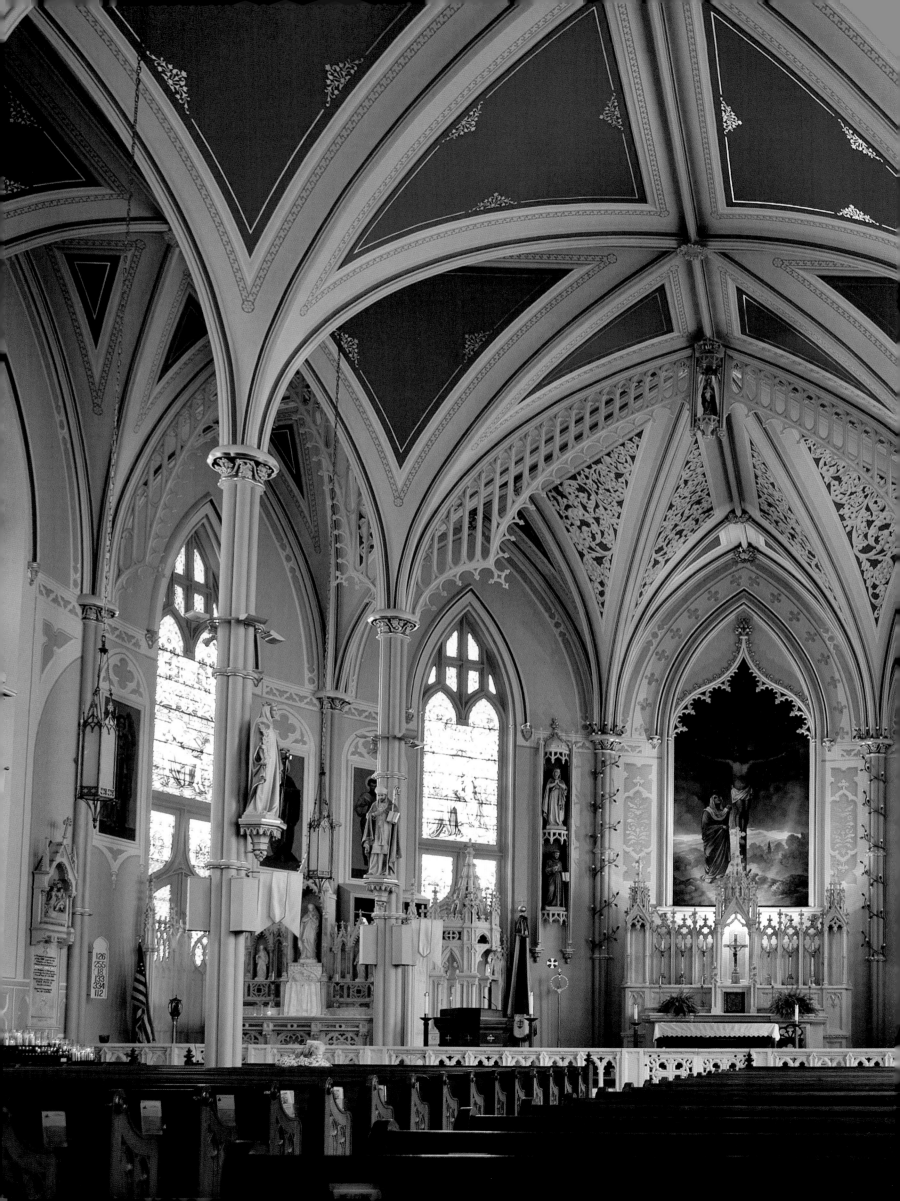

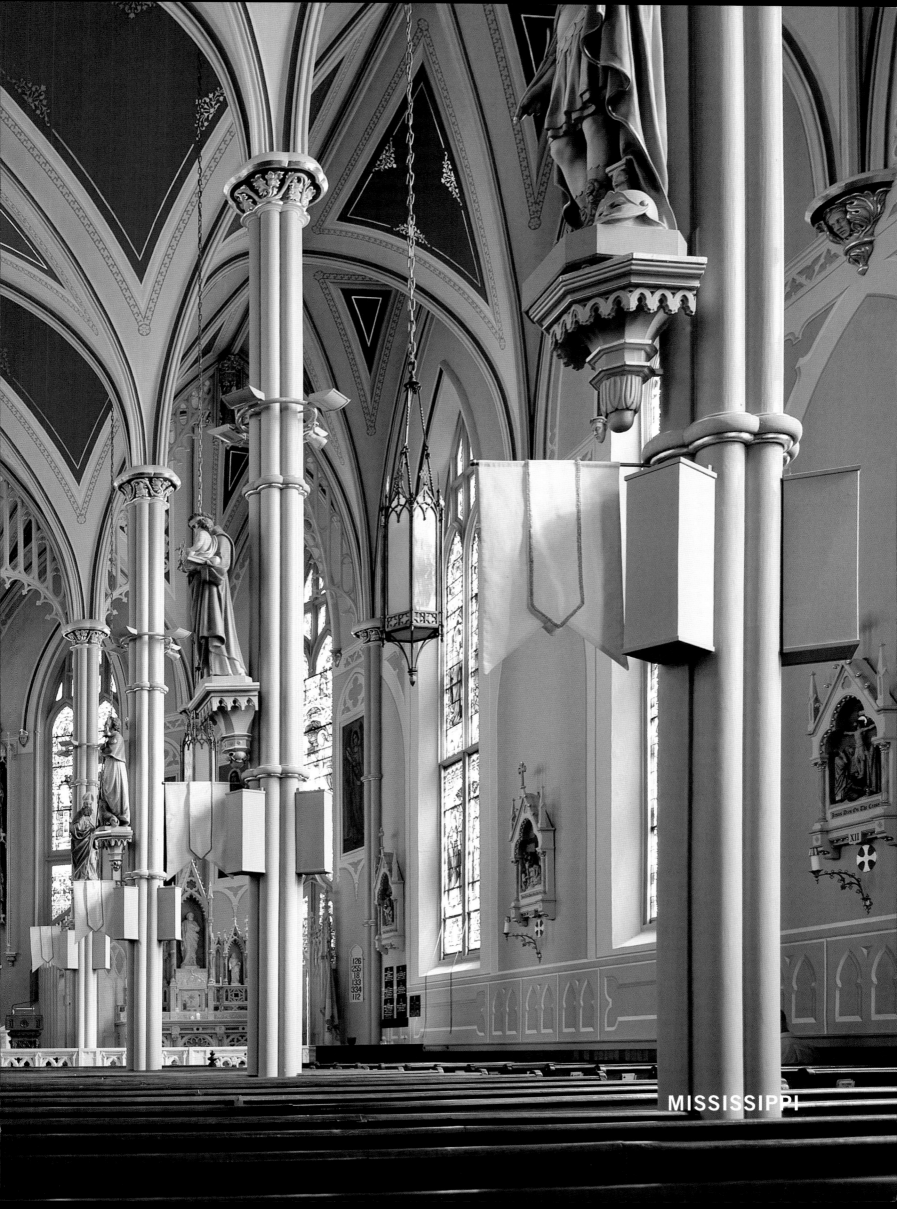

MISSISSIPPI

BERTHA BRIDGES

GRENADA ✈

Bertha still has pink rollers in her hair
when I arrive at 50 Main Street in Grenada, af-
ter a four-hour drive from Natchez, where I shot
a wedding at the St. Mary's Basilica. I am very
tempted but too tired to go look for the legendary
crossroads where the devil taught Robert John-
son how to play the blues.

"I didn't think you would come," says Bertha, a
little embarrassed. I sent her a letter and made
follow-up calls, the last one just a day earlier,
before arriving at her house, and yet she is still
skeptical about being chosen to be in a book.

It's a hot Sunday afternoon and Bertha hasn't
gone to church today. "I had a stroke a few
months ago. I can't attend the service at my
Baptist church. I get seizures. Every time I go to
church, I thank God if I make it home," she says
with her deep Southern accent and a light lisp.

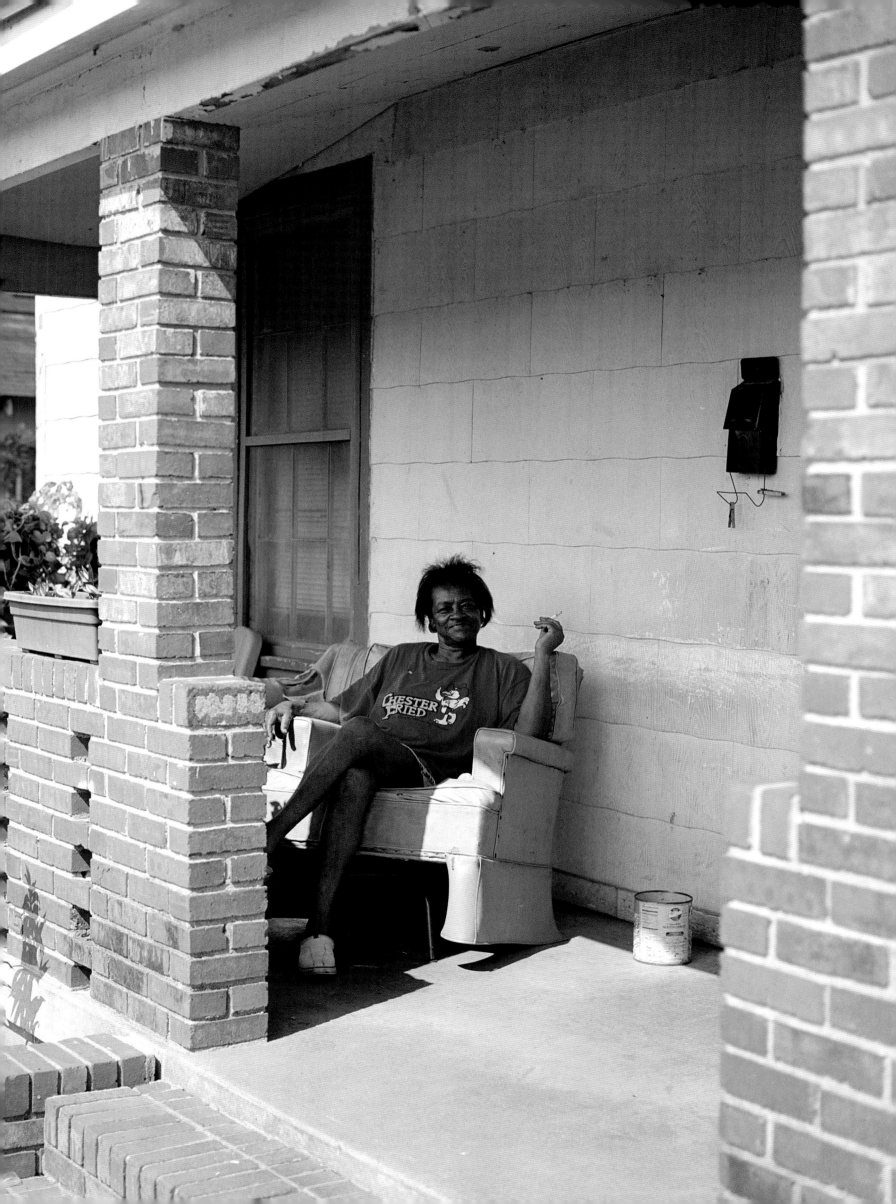

"The singing and the loud music make me crazy. The doctor told me to watch the service on television instead." She seems happy about the new arrangement. "Sometimes it is a black pastor and some other time it is a white one. I don't care, as long as I get to hear the gospel."

During our conversation I refer to her as Nollia a couple of times, because of her striking resemblance to my mother-in-law. I excuse myself but Bertha gets a kick out of it. Just like my mom-in-law, Bertha grew up during segregation. "When I was young the white children would be with white children and black children with black children. We had separate schools. We weren't allowed to mix. It didn't bother me. In any kind of public place we would have separate bathrooms, even in the courthouse. We were used to it, so it didn't bother me." She accepted the way things were in those days but appreciated when things changed. "After desegregation I went to work as a cook in a school. We had blacks and whites at the cafeteria, that was nice."

She remembers her childhood with happiness. "I was a tomboy," she says, smiling, "I liked to play football and wrestle with the boys. I was considered one of the guys. I played baseball but I wasn't good. They would always put me out in the outfield because I couldn't catch the ball."

She smiles talking about those days. "I liked being a child. We were young and wild. We would go up to the dam where kids could swim." She shows her sense of humor now. "I didn't swim though and I always told them," she says with a heavy twang, "'I ain't no fish, I don't swim.'"

She followed her group of friends anyway, twelve, fifteen of them. "I had to be with the rest of the guys," she says with a smirk on her face. "We had our routine on Sundays as well. We would run around all day after church, as long as we got back home before it got dark." They might have been wild, but they were respectful of their parents. "We would get back home on time because Mama said so. You didn't want to cross Mama. I loved her. Unfortunately she passed away a few years ago because of heart failure."

Bertha grew up in a divided household, last of seven children from an abusive father. "My father left us when I was four years old. He wanted to be a player. He didn't treat Mama well," she says briefly. Still her childhood memories are mostly positive. "I would play marbles or jump rope with Mama," she says with a smile. "She also taught me how to cook. The first thing she taught me was making homemade biscuits, hush puppies and then fried pie." I've never heard of fried pie before so Bertha volunteers the recipe. "You get peaches and you cook them, just like you would make sweet potatoes. You fry them in a skillet, and then you roll out the dough. You take the peaches, roll them in the dough and put them in the frying pan, like you would cook some fish, until it is brown, and you turn it over."

I am not sure I will ever make a fried pie, and Bertha is not going to make one any time soon either. "I don't like to make them anymore. I have made too many at work."

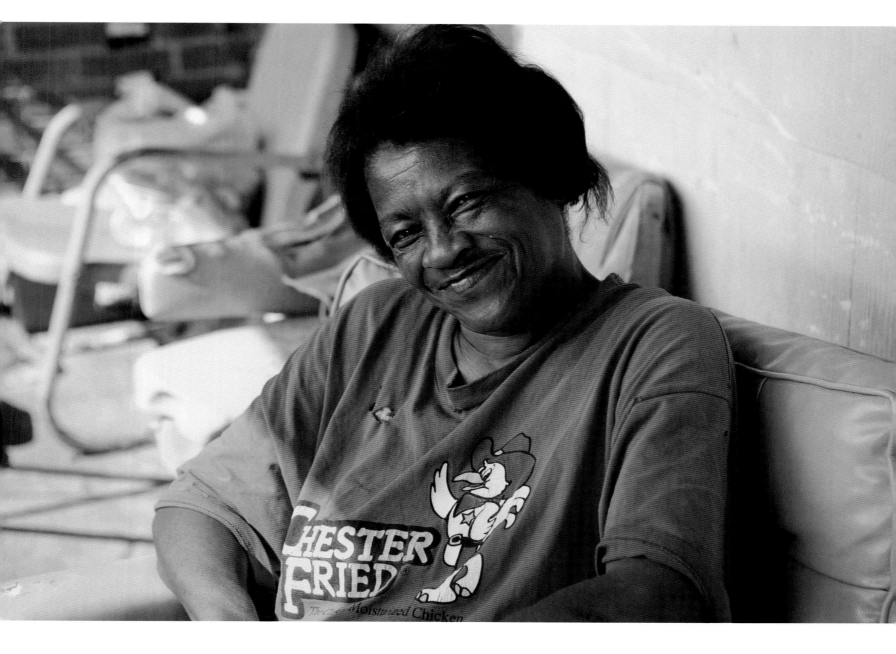

She started working in a kitchen at a young age, moving from place to place, often working two jobs to make ends meet, but always cooking. "That's all I know," she says. "Now that I can't work anymore I do the cooking at home for my daughter, Lacheryl, and the three grandchildren that live with us, Otoria, Maurice, and Pierre." Bertha is following strict doctor's orders these days. "I can't eat pork meat anymore—that was my favorite. We like pork in the South but now I have to eat more vegetables," she complains.

She has slowed down a lot since the stroke and she spends most of her days exchanging visits with her next-door neighbor, Ms. Thelma. "We look after each other. If she doesn't see me she comes over to check on me, and if I am doing all right she goes back home. And I do the same." Bertha's home is modest but nevertheless it is her pride. "I love having my own house. They gave me a thirty-year mortgage. I am making all my payments. I feel very good about it. One day it may be mine."

MISSOURI

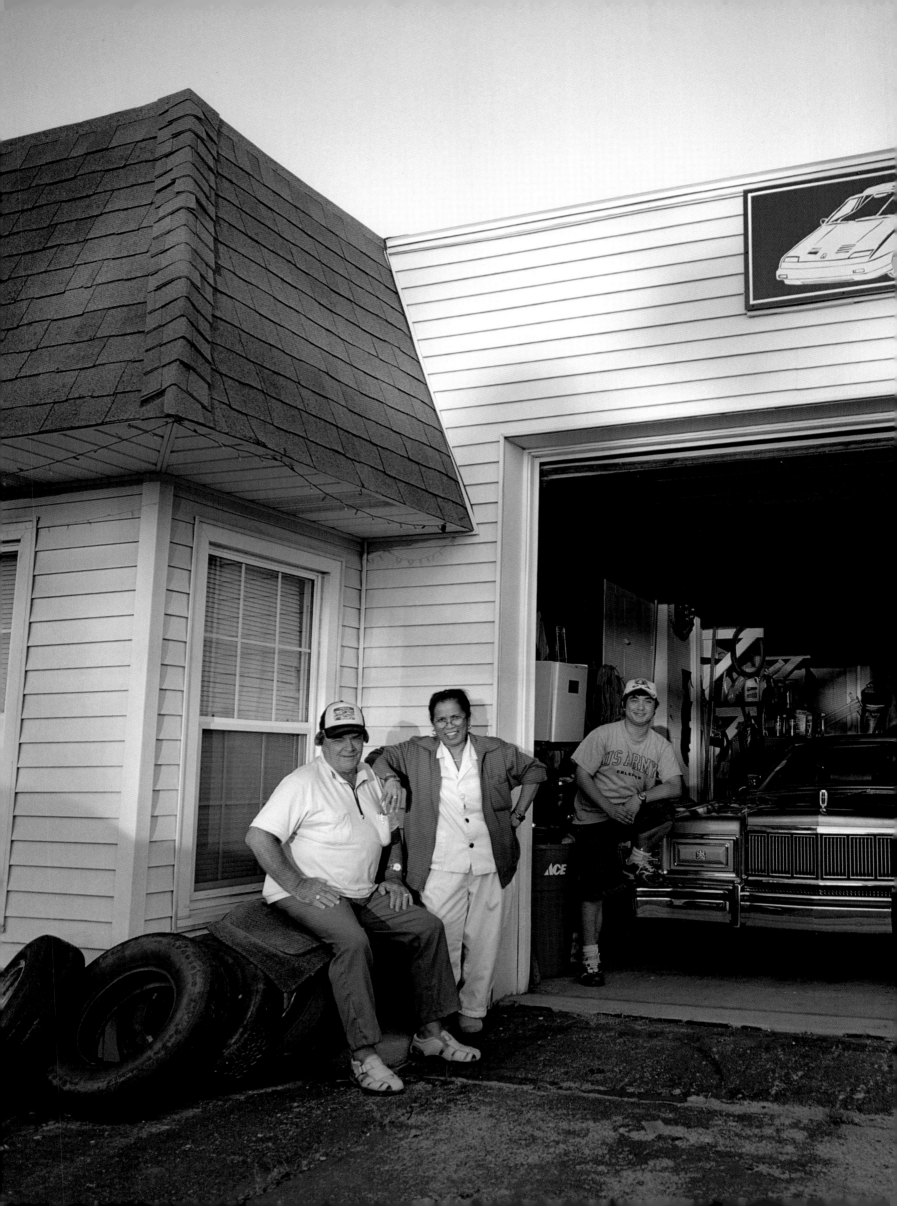

JIM TOWNSEND

ST. CLAIR ✛

The drive from Northern Kansas through Missouri is punctuated by surprising wine vineyards, the occasional cemetery, and a stop at Nostalgia Ville, USA, an incredible memorabilia store, right off of Highway 70. I park in a spot reserved for Stooges fans and I start humming "Lust for Life," my favorite Iggy Pop song. I am totally embarrassed and amused at the same time when I realize that the sign actually refers to Larry, Curly, and Moe.

Jim Townsend is sitting at his desk and doesn't move an inch when I enter his office. "I sell used cars—they call them pre-owned now," he says, laughing. "I've been here for twelve years. I was across the street for twenty years before that."

A loud train passes on the tracks just behind the building that hosts not only the business but the garage and the family residence as well. "It's the coal train. We got used to it. It only goes by every twenty minutes or so," says Jim patiently.

"I have to take my wife to Wal-mart first. She'll divorce me if I don't," says David, half joking, when I ask to take his picture. "It's Sunday afternoon, man. The family routine has been the same for years. Paulita, my wife, needs to go grocery shopping for the week. It's her only day off." They return kind of late, the sun quickly moving behind the building across the street. "We had to stop at Kentucky Fried Chicken," says Jim, excusing himself. "Jeffrey had to eat, you know. He is thirteen years old; he is always hungry."

I start hurrying around with my camera in search of the perfect spot and, when I find it, I start giving directions to Jim, with my Italian accent. "Queek, queek, the sun is going down. The car looks beautiful. Jeem, seet on those tires…"

It's now Jim's turn to order his wife and son around. "Queek Paulita, queek Jeffrey, the photographer says queek, queek!" I notice that he is making fun of my accent and I look at him. He responds with a satirical smile and our eyes meet. We have bonded already.

"I grew up in Alabama, Green Hill they call it. My dad died in a automobile accident when I was four years old so I was sent to live with my grandparents," he says, opening up. "My mother moved first to Detroit looking for work and then she came down to work at the Chrysler factory in Fenton, back in the '60s." He followed soon after. "I came here to visit my mom, I found a job and I stayed. I worked at the same Chrysler factory where she worked, for twenty-five years. I worked the assembly line, the forklift, all sort of jobs over the years. It was a huge factory; thousands of people worked there. It has closed down now." For a moment his age shows with other sad memories. "Mom passed away a few years ago. She had emphysema. She smoked for forty-five years. It finally got to her. I am glad I quit 'em thirty years ago," he says, cheering up. He never picked up the local accent. "They pronounce it Missoura over here. I call it Misery," he jokes. He mentions the city motto with a little irony as well—We're Open for Business—and references Route 66 as the highlight of his new hometown. He gets nostalgic like most people talking about the historic thoroughfare. "They called it The Mother Road. It was just a two-lane highway, but everybody came through these little towns. I worked at the gas station. Gas was fifteen cents a gallon, I still remember that. Cars would line up to get the cheap gas." Jim has always loved American cars. "I drive a 1996 Cadillac Seville but my prized possession these days is my 1978 Mercury Grand Marquis, the only car that I keep in the garage." I am obviously impressed by the car, as I choose it as the co-subject for the picture of the family. "Business is not going so well these days," he says. "I love that car but I'll sell it to anybody that might be interested. I need the money." I sense a hint of sadness in his voice at the idea of selling the car. His spirit gets better immediately as he starts talking about his son, Jeffrey. "I love my kid. He is the joy of my life. He is the thing that keeps me going. We had him right after I married Paulita, fourteen years ago."

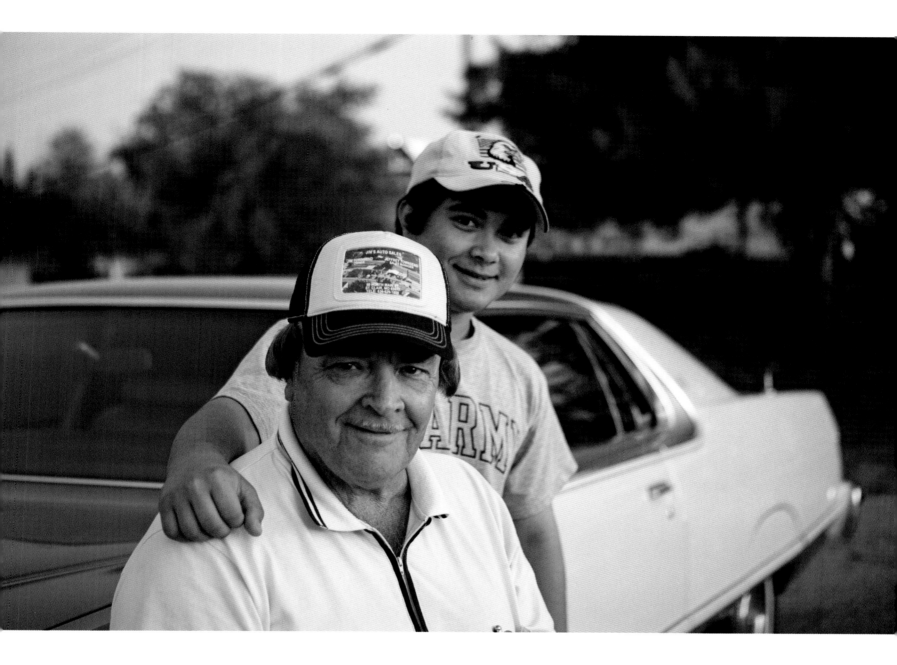

Jim was married twice before. "The first time, I got married at seventeen. I divorced the second wife after six months. I went ten years without dating. I was tired of American women." I can never tell whether he is serious or joking.

"I found an agency that put me in touch with Paulita in the Philippines. We wrote as pen pals for a while and then I went over there. We liked each other and we got married. She is a good wife; she works in a t-shirt factory and takes care of the house. She is raising Jeffrey well."

Jeffrey likes cars as well. "He is helping out with the business already, when he doesn't have school. He goes to public school here in town, good school. He helps me with the computer, he comes to auctions with me. I can't wait for him to take over the business in a few years." Jeffrey wears a USA baseball cap. "He hates it when I tell people that he his half Filipino. I think he should be proud of his heritage." The boy looks at his dad with a mix of affection and typical teenage impatience. "I am proud; I am American!"

MONTANA

JIM HEAPHY

ANACONDA ✈

Four snowstorms make my twelve-hour drive from Seattle, going across the Rocky Mountains, hazardous and miserable. I drive through the much-acclaimed Snoqualmie Pass with a visibility of about ten feet; I almost miss the sign for the Continental Divide, the legendary, invisible line that determines which direction rainwater will flow. I finally leave Highway 90 and take the Pinkler Scenic Route. I feel fortunate to spot a couple of Bald Eagles, the ultimate American symbol, and I get a sense of the magnificence of the famous valleys of Montana. I vow to return on a fly-fishing expedition some day.

When I arrive in Anaconda, I only have energy for a quick dinner and to check in at a local motel, where I hear about the decline of the copper industry that fueled the economy for the past century. I'm too tired to pay attention.

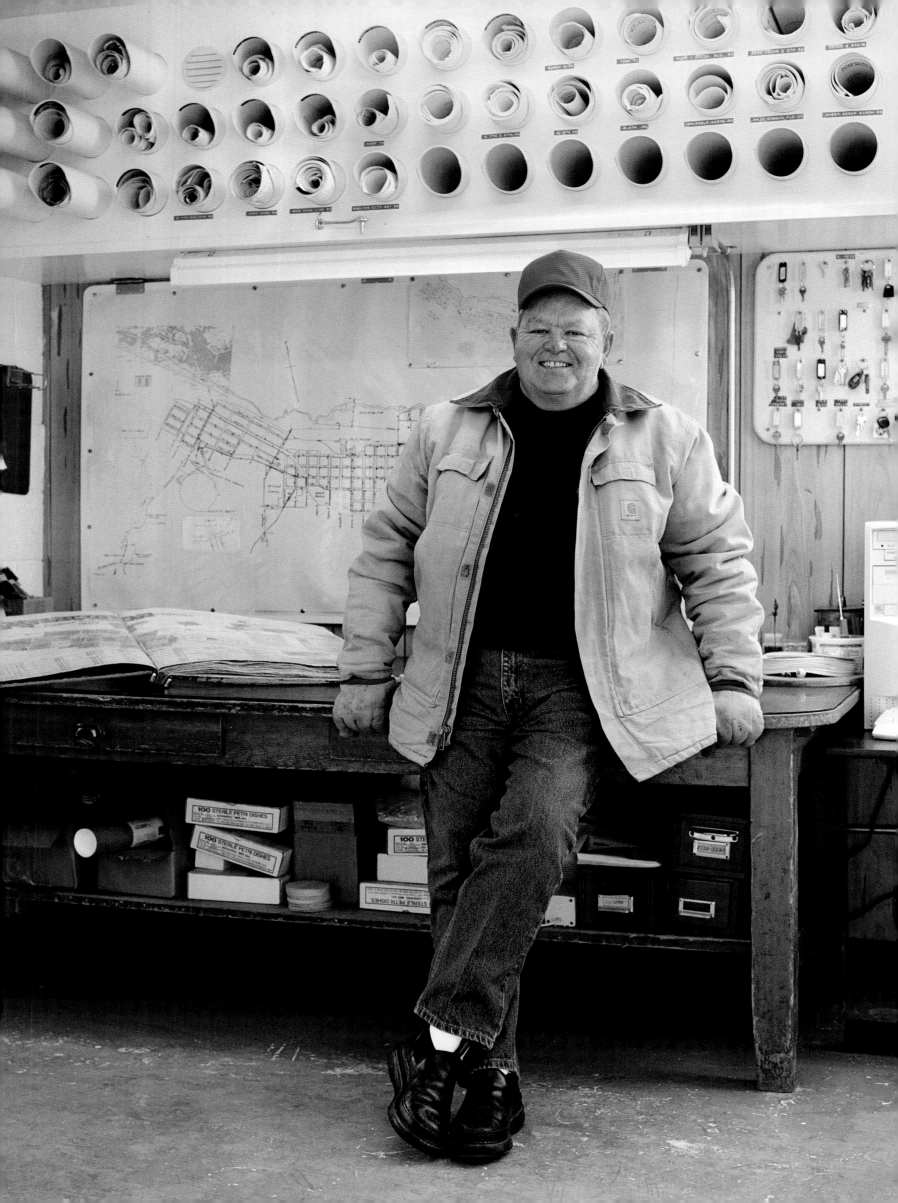

"Welcome Pierre." I smile at the misspelled sign in the window when I arrive at 50 Main Street the following morning. "I made some brownies for you last night, would you like some tea with them?" asks Cheryl, the office manager. "It's a frigid day and nobody is going out on the field; everybody is in the back taking care of the tools." Jim is the supervisor—the whole team loves him and they convince him to be my subject. "I have worked at the Water Department for thirty-seven years," he says humbly. "I started at the bottom and I ended up at the top. I've done every job there was in the department." He is going to retire in a few months. "Paul is going to take over for me. He's very good. I am not worried." Jim is looking forward to having more personal time. "I have a lot of work to do. I live on a farm. It belonged to my grandfather and then to my uncle. He grew potatoes. He went broke in 1953 so we had to sell most of it. I kept one acre where the house is, just trying to keep it in the family."

Jim enjoys his privacy. "My closest neighbor is almost a mile away," he says. "I only go to town for work or to see my aunt. She is ninety-one years old and needs assistance." He never really traveled much. "The first time I left town was when I went to the service—that gave me a little view of the world outside of Deer Lodge Valley."

His stint in the military came a little late. "I tried to study to become a teacher in a couple of different schools, without success. I couldn't cut it. I don't like book work." He eventually got drafted in 1966. "I was sent for training in Fort Lewis, WA, shipped off to Vietnam for a year, and then transferred to Germany for my third year."

He is still very proud of his contribution to the country but had some upsetting experiences. "It was disappointing and depressing when we came home from Vietnam. All the protests in California. We really got our eyes opened when we got off the airplane in Sacramento. We didn't understand, we didn't know what was going on in the United States much, because we didn't get much home news, and then all of a sudden there were all of these protests. We thought we were doing the right thing. And the people that we thought we were helping were against what we were doing." He still feels the pain. "There were some incidents that I hate to even talk about; they were spitting at us and treating us real crappy. That was hard to accept because we thought we were doing the right thing." His three years in the military were made better by his girlfriend, Sherry. "We went together for seven years before we got married," he says. "She wanted to go with me to the service but I wouldn't get married—not because I didn't love her," he clarifies, "but because I didn't know where I was going to be sent. I didn't have any ranks. She was better off being at home than being with me. I didn't want that responsibility, not enough money. I was lucky to take care of myself, never mind a wife." Sherry stuck by her man, though. "We wrote all the time, letters. It was harder to call, when we were on different continents—it was so expensive—but we wrote back and forth all the time."

Sherry and Jim have been together for forty-six years now, proud parents of Jim, Jr. "He is named after his father, like me. All my five sisters and my brother, they all had daughters, so he is the only one left to carry on the family name." Their story is from another era, very different from modern online dating. "We met at a fish fry." I smile when Jim tells me about their first encounter and he smiles back. "It's where a bunch of men," he tries to explain, "they go out and catch a bunch of fish out of the creek, and then everybody puts on baked beans and fry potatoes and onions, and they just make a big picnic. They cook a lot of bacon off, and keep the grease, and then fry the fish in it." Jim is still excited remembering the good old days. "I was eighteen. Funny enough, I worked with her dad in the summertime. I was working on the lawn crew. I couldn't do any driving or anything like that because I wasn't a Teamster. I just moved the water hose and watered all the grass."

I guess Jim was destined to work with water.

NEBRASKA

RALPH BOTTENFIELD

NELSON +

"The last time I had a whiskey was in 1926, when I graduated high school." Ralph is not kidding; I just have a hard time realizing that the spunky little man standing in front of me is one hundred years old.

I meet Ralph and his friends, Bonnie and Les, at the church next to 50 Main Street in Nelson. The little pink house immediately brings to my mind the classic John Mellencamp song.

Nobody is home today. "The guy that lived here was a friend of mine. He used to take care of the golf course," says Ralph, recollecting.

"I was born and raised right here in Nelson, just like my father, Forrester. I did move away once, for twenty years, to run a dry-cleaning business in Idaho Springs, Colorado." He's clear about his choices. "I liked it there," he says, "but then the hippies started to move into town and that told me that it was time to come back home."

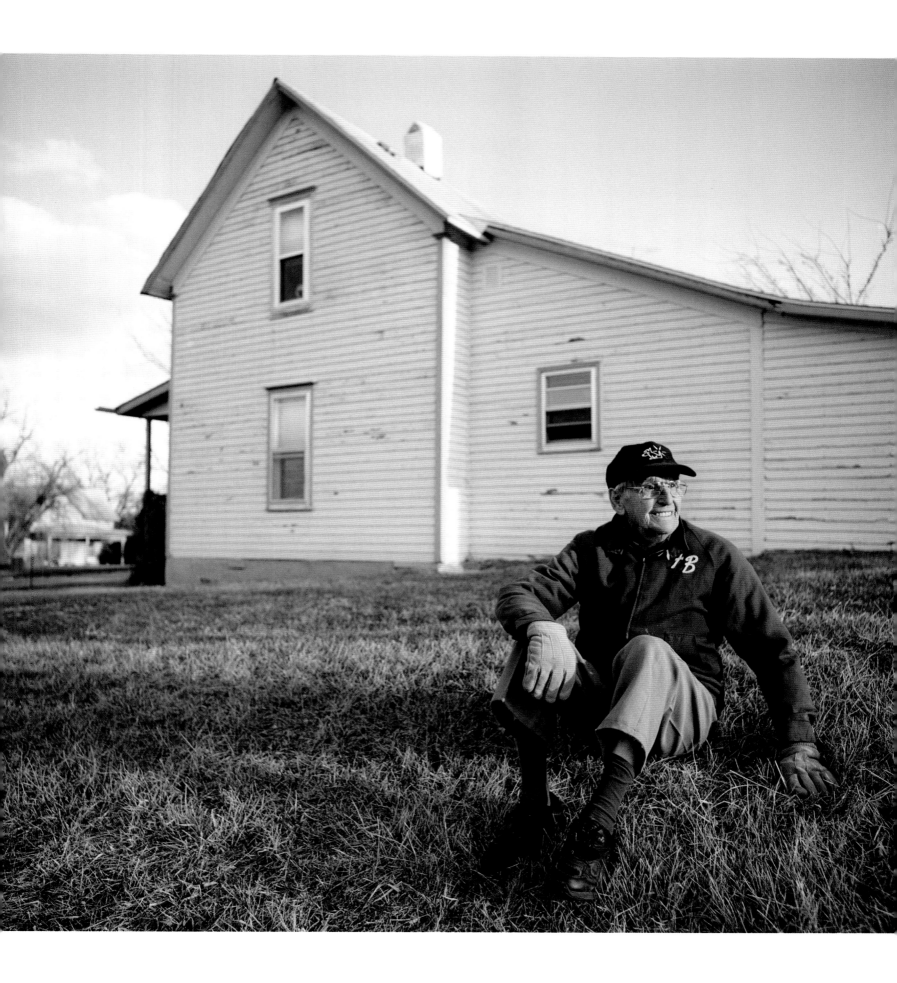

I get to snap a few pictures of Ralph and take advantage of Les, asking him to take a photo of myself with the only centenarian I've ever met. Ralph gets tired quickly so we head to Tucker's, the local restaurant, for a quick bite to eat, and he shows his sense of humor once again. "I have no ID, no beer for me!"

Ralph has his favorite meal, a charred cheeseburger, and I ask about his life. "I paid my dues," he tells me humbly. "There were a few farm depressions before we had the Great Depression, you know?" I actually didn't know so I show interest. "If you had a dollar you had a dollar, if you didn't you didn't—just like everybody else. Everybody was in the same boat." He brushes off the subject quickly. His mind is somewhere else. "I lost my luck," he says all of the sudden. His thoughts go to his wife, Helen. "She passed away a year and a half ago," he says, still upset. "We were married seventy-five years."

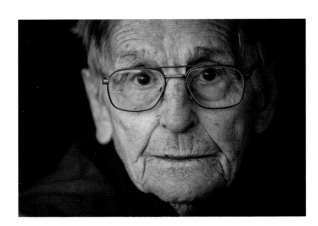

He loves remembering his Helen. "I first saw her at a dance when I played saxophone in a little dance band. Dancing was very popular; towns had dances most days of the week but generally on Fridays and Saturdays. One evening two girls danced by and I thought that they looked pretty good. The second time they danced by, I said to myself: 'That's the girl I am going to marry!'"

He didn't get to talk to her that night and it took three months of asking around to finally find her. "We courted for a couple of years until we decided to get married," he recalls. "We went down to Mankato, in Kansas, in the evening after the dance; we rousted out a judge—this was night, late—and he married us right there, in his house. She was twenty-two and I was twenty-four."

Ralph worked a number of jobs through the '30s. "I would go down to Texas to pick up cars for the dealers, worked in the grain elevators, I was a fireman for a little while. I even worked for an oil company in Iowa, but that was too cold for me." He never gave up. "Times were tough back then, jobs were hard to find and short. You had to change jobs often." He finally got a good job as a county clerk. "It was a godsend; it was good and steady money." He remembers being the third person in town to get a TV set, back in the '50s. "Before that we used to sit and look at each other," he laughs, "or listen to the radio."

Helen took care of the house and helped in the store. "When we had the dry-cleaning business she worked the front counter and did alterations, you know, shortening trousers or if they needed to get the waist expanded or contracted. Usually expanded," he says jokingly.

He was sixty-five when he retired in 1968 and moved back from Colorado. "It was a mistake to retire. You should keep working; it makes life more interesting." I get a few more words of advice from him. "You better do what I didn't do. I should have stood in the kitchen and watched Helen cook." He shares his secret for a successful marriage. "Never go to bed angry."

Life without Helen is not the same for Ralph; he now has TV dinners twice a week and watches newscasts and baseball, football and basketball.

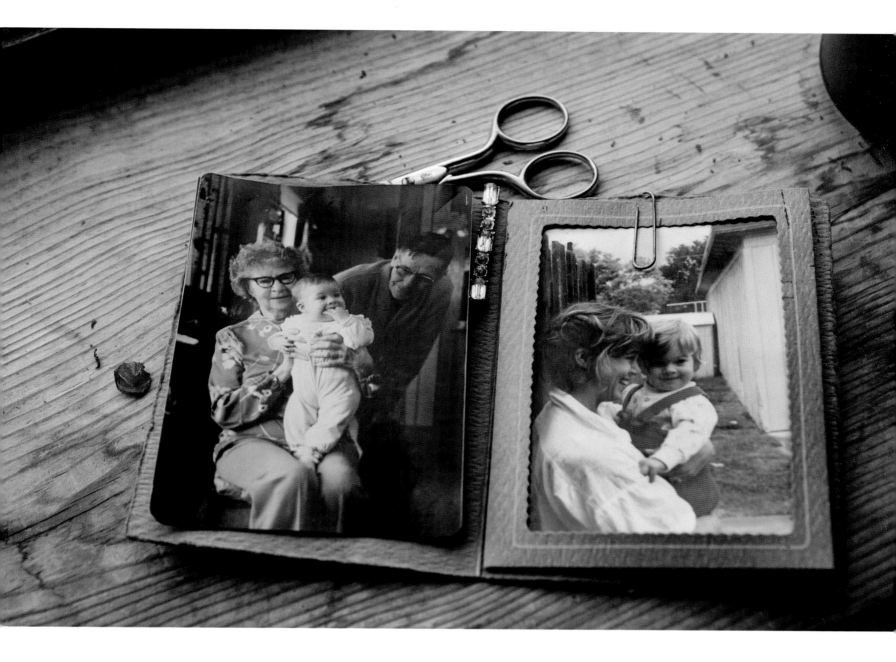

Sports make him think of his son. "We called him Bud. He was in the Air Force; for our vacations I would take Helen and Marilyn, our daughter, to visit him wherever he was stationed. He passed away eight years ago, cancer." Ralph is still heartbroken over the loss of his son. "You really do not expect to outlive your children."

Last year, age ninety-nine, he drove to visit his daughter in Washington State, 1,700 miles away. He impresses me as an old man, but he amazes me with a story of himself as a young boy.

"When I was twelve years old, my father sent me to Omaha to pick up a car. He put me on the train, I got the car and I drove it back."

That's almost two hundred miles away, and I am stunned at the magnitude of the task bestowed upon such a young boy. "They didn't have highways back then," he says, "just country roads, not even paved. I would go by post lines and followed my instinct." When in doubt he would ask for directions, but never lost his confidence. "That's what I was sent out to do, so I did it."

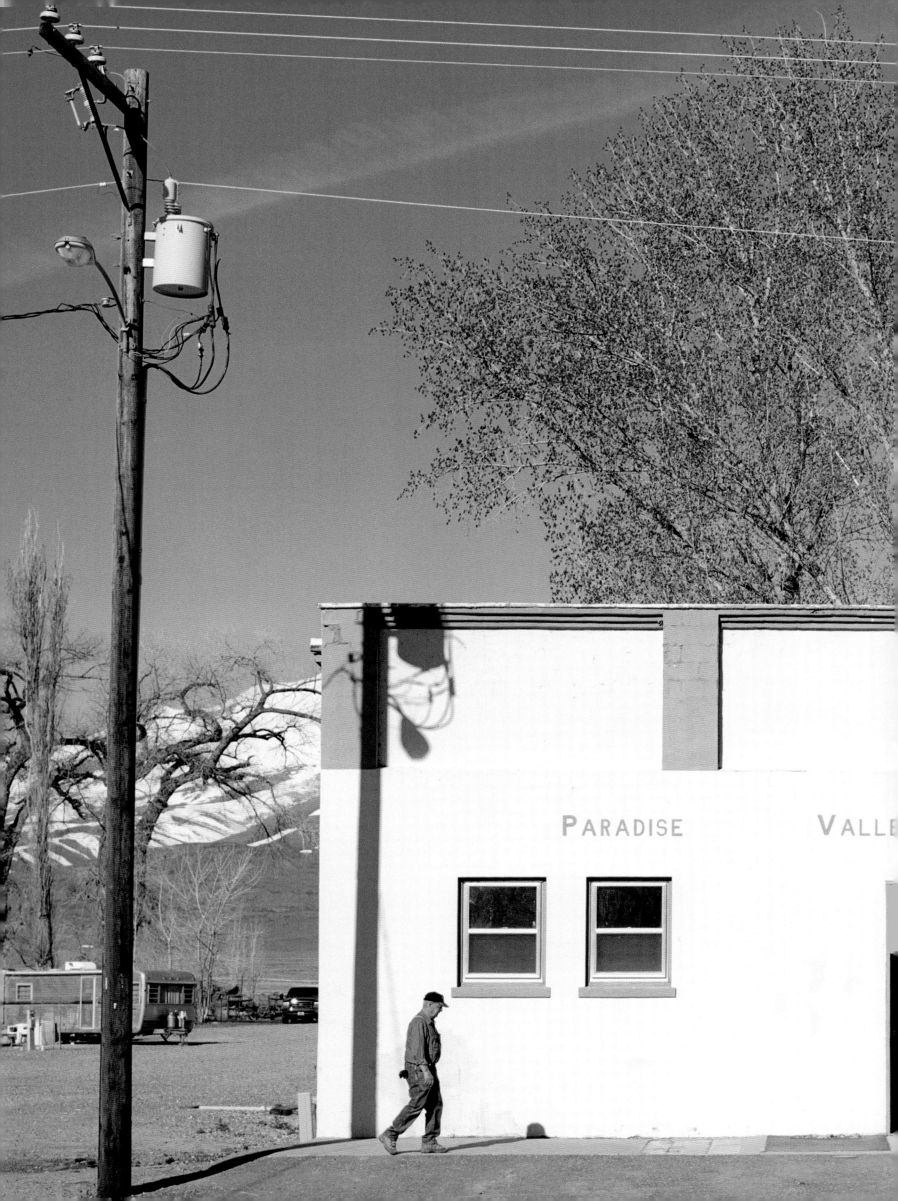

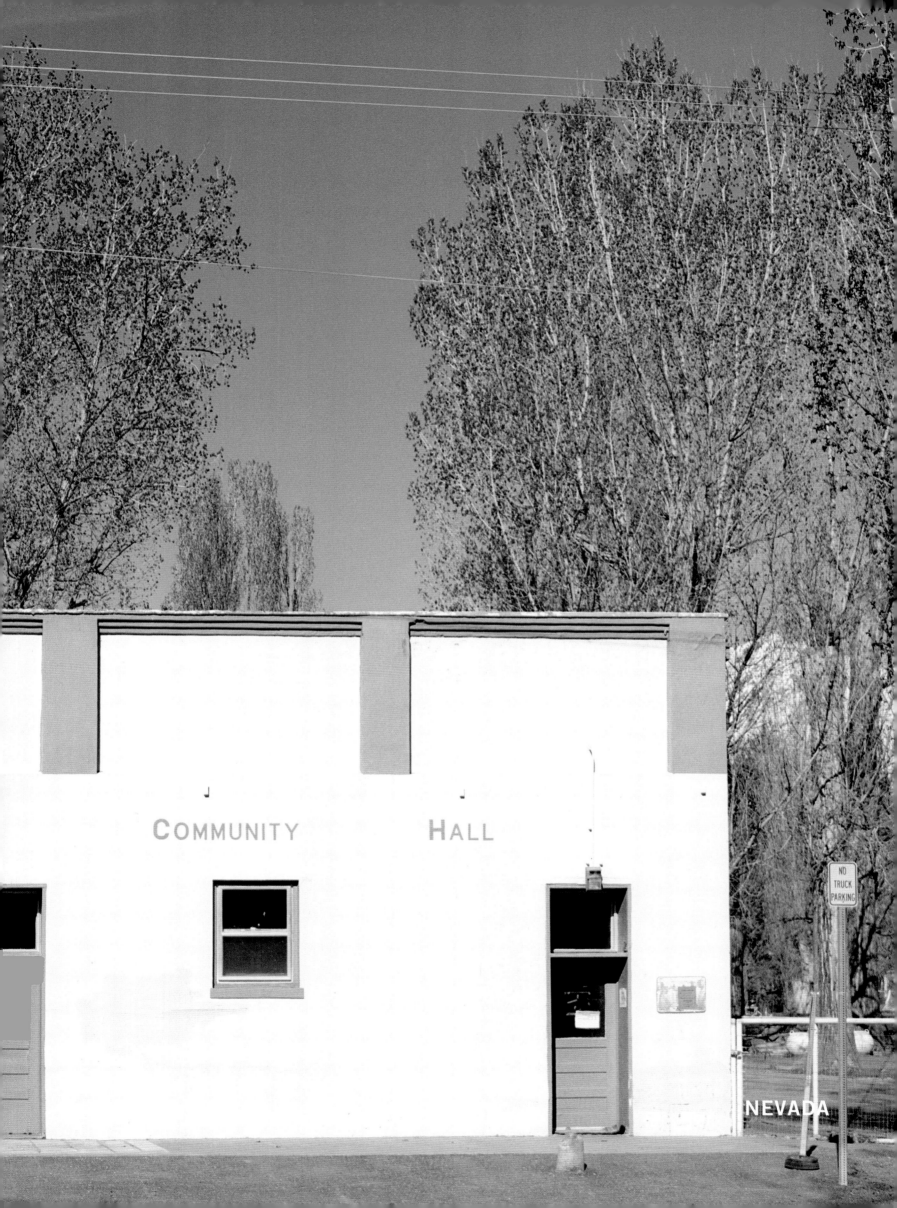

COMMUNITY HALL

NO
TRUCK
PARKING

NEVADA

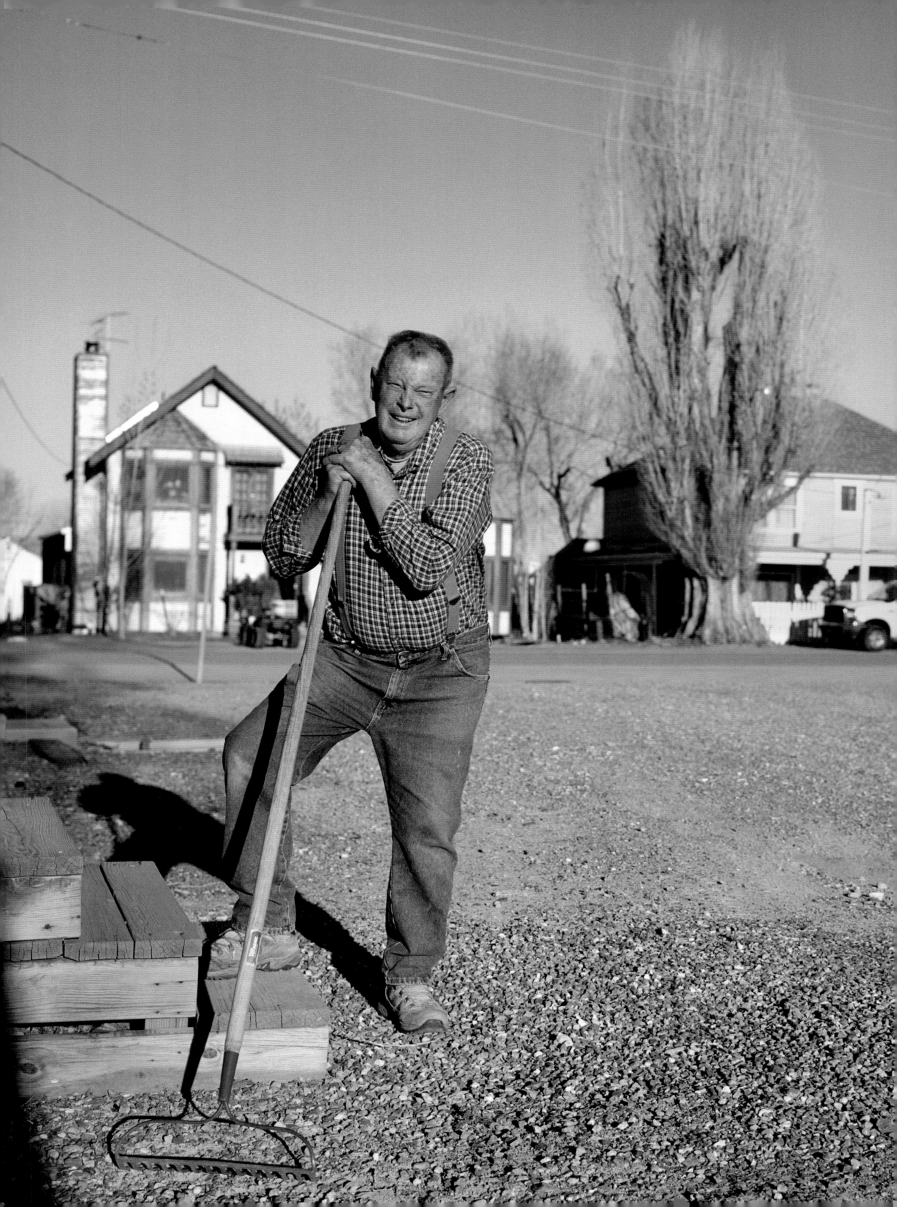

LYN MELODY

PARADISE VALLEY ✦

"Let me see what I have listed, up in Paradise." The county clerk in Winnemucca on the other side of the phone is trying to help me locate the person at 50 Main Street in Paradise Valley. The town is forty miles north of her but she seems very familiar with the small village, the community hall and its caretaker, Lyn Melody.

The trip down from Idaho is a smooth, almost straight highway drive through the high desert of northern Nevada. As soon as one crosses the border into Nevada there are reminders that this is a unique state: casinos and slot machines everywhere, even at gas stations.

I am curious to visit such a remote place and amused when, a sand vortex to my left and snow-capped mountains to my right, the radio plays an old Springsteen song: "Trouble in Paradise."

"How was your trip, honey?" Rachel's very first words and her smile melt my heart and Lyn's warm eyes and strong handshake make me feel welcome. Rachel's Italian roots bring her to offer me something to eat; we soon find out that her ancestors are from my neck of the woods and I am flabbergasted to realize that we might even be distantly related, her last name differing only by the final vowel from my cousin Vittorio's!

"We flush thirty-five toilets in Paradise," is Lyn's observation about the sixty inhabitants of the town. "I take care of the Center and the adjacent trailer park, you bet!" He shows me around the grounds. "We had our fiftieth wedding anniversary party in here. For the fifty-fifth anniversary we just stayed home and watched TV," he says, amused. We are both equally surprised when we find out that we got married on the same day of the year, February 12. Only forty-six years apart.

"It was love at first sight," says Rachel, in typical romantic, Italian style. "I was too slow going uphill," is Lyn's humorous version of their love story. "We met in Tonopah. The town is on a mountain; everything is uphill or downhill, you bet." He seems to like that idiom. "Rachel was born and raised there. I couldn't run fast enough and she caught me!" He was working for First National Bank of Nevada. "I started when I was

fifteen years old and moved all around the state, Carson, Winnemucca, Reno, Las Vegas. I was twenty-two when I met Rachel; she was twenty years old. We married eight months after we met. You bet."

The tour of the town takes us to a street intersection with a handful of abandoned buildings reminiscent of the Old West. We eventually arrive at the cemetery; Lyn is the volunteer groundskeeper here as well. "These are my two sons." His voice is only slightly different when he introduces me to two adjacent graves with his sons' names on them. "Ray passed away in 1995 and Tony in 2007. I come see them almost every day." I have no words. "Tony was a tremendous athlete," says Lyn proudly. "He was taking first place all the time, you bet." He is serene when telling about his oldest son Ray, who passed away from pancreatic cancer, and Tony, the second son, who decided to take his own life after two years of living with Epstein-Barr. "It's a disease that destroys your body. He would go for an hour and then lay down for two hours… He couldn't take it anymore. He shot himself." For a few minutes the wind is the only sound in the cemetery.

Lyn senses my mood and changes the subject, to happier memories of his kids. "Ray used to think he was a great white hunter because he could shoot a B.B. gun when he was two years old," he says. "My father started me hunting when I was a little bitty tyke and I did the same with my boys, you bet." I am always happy to hear good father-and-son stories, as I lost my own dad at a young age and missed out on a lot of that. "Tony got himself a big mountain lion once when we were out deer hunting, you bet." That was before Lyn had the heart attack that forced him to slow down and give up stressful activities.

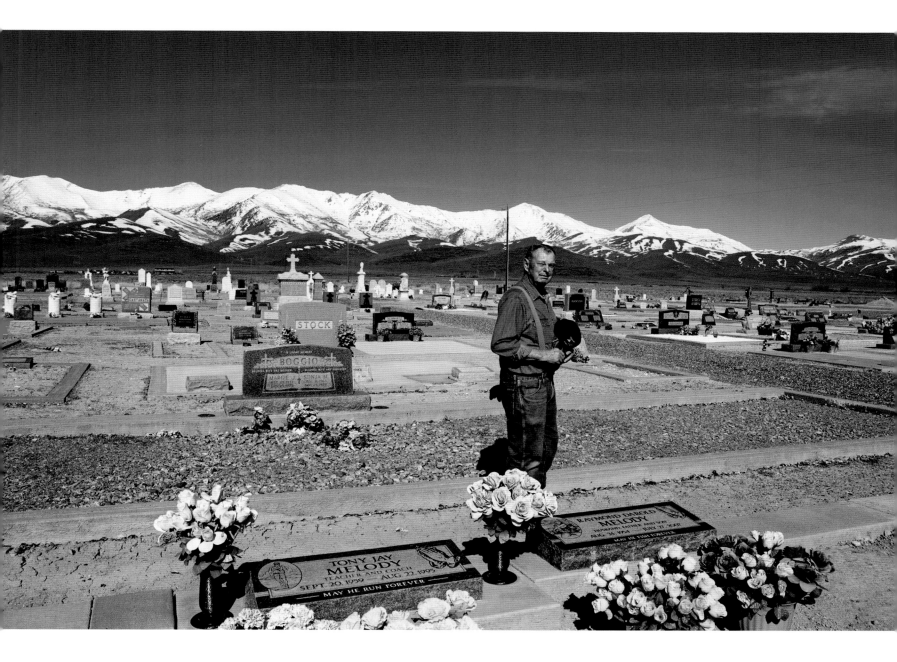

"The doctor told me I should have gotten out of the banking business twenty years earlier." His tone is still upbeat despite the subject. "We just got back from the hospital in Reno yesterday," he says calmly. "I have been getting chemotherapy treatment for prostate cancer for the last five years. This time I feel fine—sometimes it puts me out for two or three days." I don't have time to express my surprise when he starts telling me about his years on the bookmobile. "I didn't like being too idle when I retired so I got a job with the public library delivering books around the county. I loved going to the various ranches. I knew all the people, I grew up with most of them. One time I would have to go in for coffee, another time I would have to join them for lunch, you bet." I invite Rachel and Lyn to come visit me in New York. They laugh at the proposition. "You know what they say here in Nevada: 'What happens in Vegas stays in Vegas?' Well, for us, if it doesn't have mountains and if it is not flat with sagebrush, we don't go there." You bet!

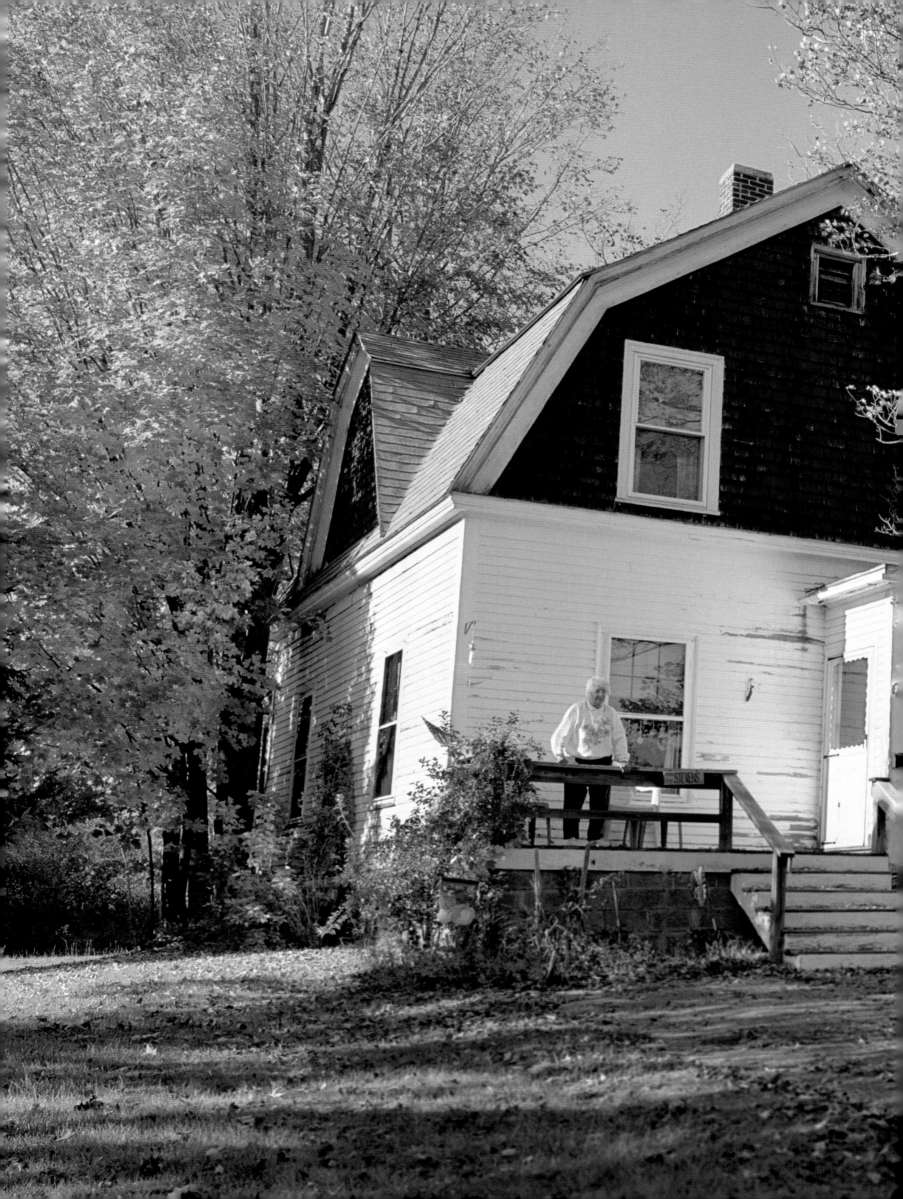

NEW HAMPSHIRE

AVIS STEVENS

Foliage season is magnificent in New England. Coming from Vermont, the landscape is an ever-changing palette of colors on the endless trees that cover the mountains around the highways. The transition into New Hampshire is seamless. I soak in the beauty and take my time to enjoy my favorite American breakfast, blueberry pancakes and real maple syrup.

When I arrive at 50 Main Street I have a hard time finding the entrance of the house. "I don't use the front entrance anymore—too much traffic on Main Street these days." Avis greets me on her front porch and directs me to the back of the house where I can park my car.

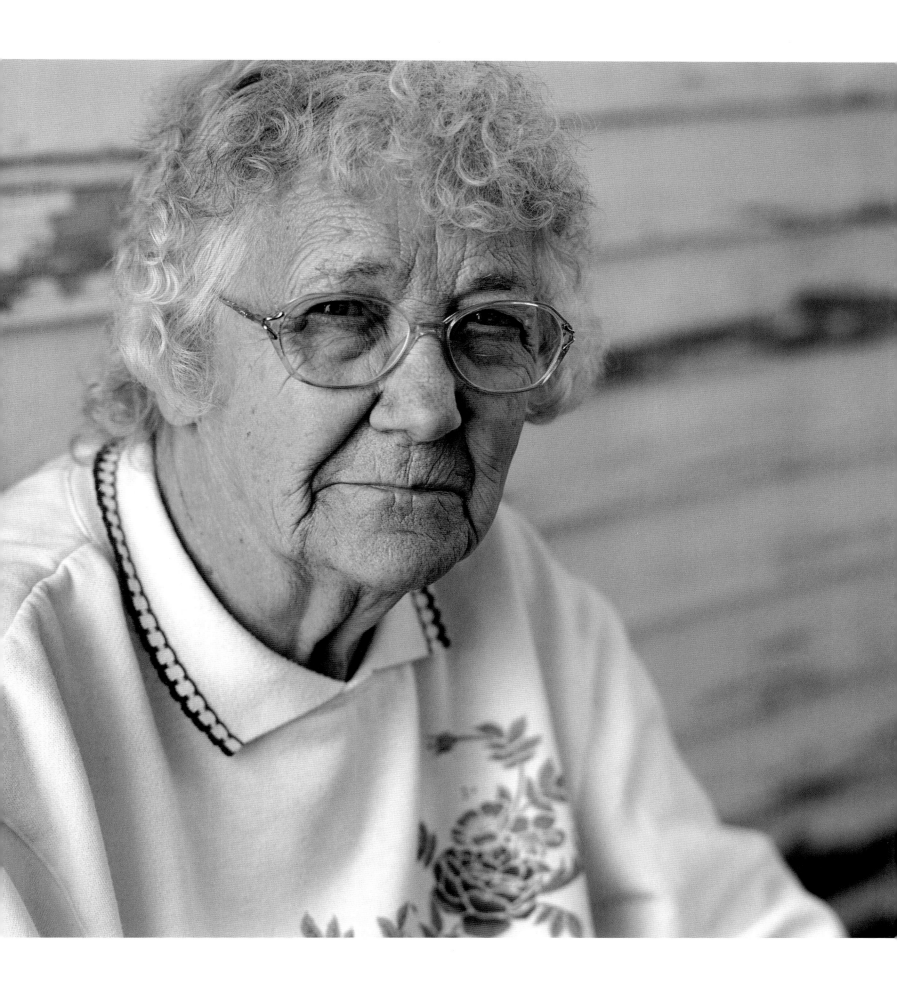

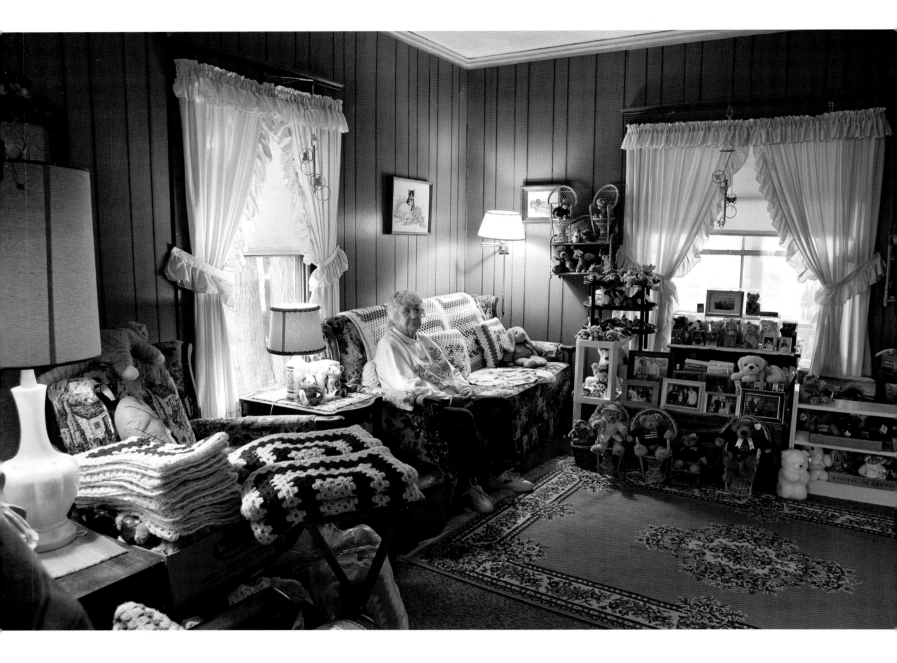

As we get acquainted, she recounts losing first her father when she was six years old and then her mother when she was nineteen. "I got married by the age of twenty. The first of our six children came just one year later," she says. "Charlie was a nice man, good-looking man." She recalls her late husband with serenity and then adds with a chuckle that betrays her sense of humor: "He was a nice man, he didn't beat me up!"

Now eighty-six years old, Avis grew up in the northern part of the state. "I was born in Warren, that's where I met Charlie. We bought this house in 1952; we paid $5,000. We had to cash out on our life insurance to pay for it." It quickly became the center of their world, with huge gatherings for the holidays. "Until the family became too large," she says, "so we started renting a recreation hall for our celebrations. It was hard in the winter to have fifty-plus people in here."

Avis and Charlie were active in the Methodist church and enjoyed the outdoors. "We would go brook trout fishing and dancing at the town hall,

but my favorite outdoor activity was deer hunting. I liked the meat." I am amused and surprised by the notion of Avis shooting a rifle; she notices it and adds with pride, "I was a pretty good shot."

"Once all six children were in school, I went to work on the hot lunch program at the local high school," she continues. "Charlie worked a series of various jobs, including one at the local sawmill, and then eventually went to work for the state." She gets sad for a moment. "He was on night patrol when he died. He was seventy-three. He was still working. There are not many nowadays, collecting the old paycheck at that age."

She lives alone these days, but her children visit often and she maintains a fairly social schedule too. "Wednesday night is weight-loss group and on Thursdays and Fridays I meet friends at the recreation center in Northville. They have a good senior's luncheon for two bucks!"

She recently attended her seventieth high school class reunion. She can't miss the opportunity to crack a joke. "Nine people came... needless to say, we won't be having any reunions anymore."

Avis is a bit of a collector as well: stuffed animals and magnets, as souvenirs of her travels. "I used to travel with a couple of friends. We went all over the United States, from the Rockies to California, and even on a cruise to the Caribbean. Never made it to Alaska though; I would like to visit Alaska one day." It reminds her of when her husband and the kids used to run on dog sleds. "We had a kennel at one point. The boys and the girls would race the dogs. My son Tommy was a one-dog champion one year." I am almost surprised that she didn't run the dogs herself. "But I had to do all the work," she says grudgingly. "The dogs belonged to me in the summer—I was the one in charge of feeding them, every day."

Avis spends most of her days in the house, keeping busy crocheting. I am a sucker for crochet, as it was my mother's favorite activity. "I get many special requests," she says, "from relatives and friends, either for the holidays or special occasions—especially newborns. I crochet almost every day. I don't have much house work. My daughter stops by regularly and takes care of the laundry and other chores, and James rides his bike over almost every day." The young neighbor helps with taking out the garbage and other chores. "He is a nice boy; he would do just about anything for a quarter," she giggles.

Avis is diligent with her diet and eats routinely the same exact healthy foods. "I have a banana every morning, cereal and strawberries every evening. And my diabetes pills."

She likes to watch *Jeopardy* and the news before retiring at night so it's easy for me to make the assumption that TV keeps her company.

"No," she says promptly, "he does." She points at Boots, the cat. "He even sleeps with me in the same bed. He seems to like this old lady."

As I leave I ask Avis about her family ancestry. She has no hesitation. "I am a Yankee." Given her last name, I guess she might be of English or Irish descent. All I get is another firm answer: "I am a Yankee, just a damn Yankee."

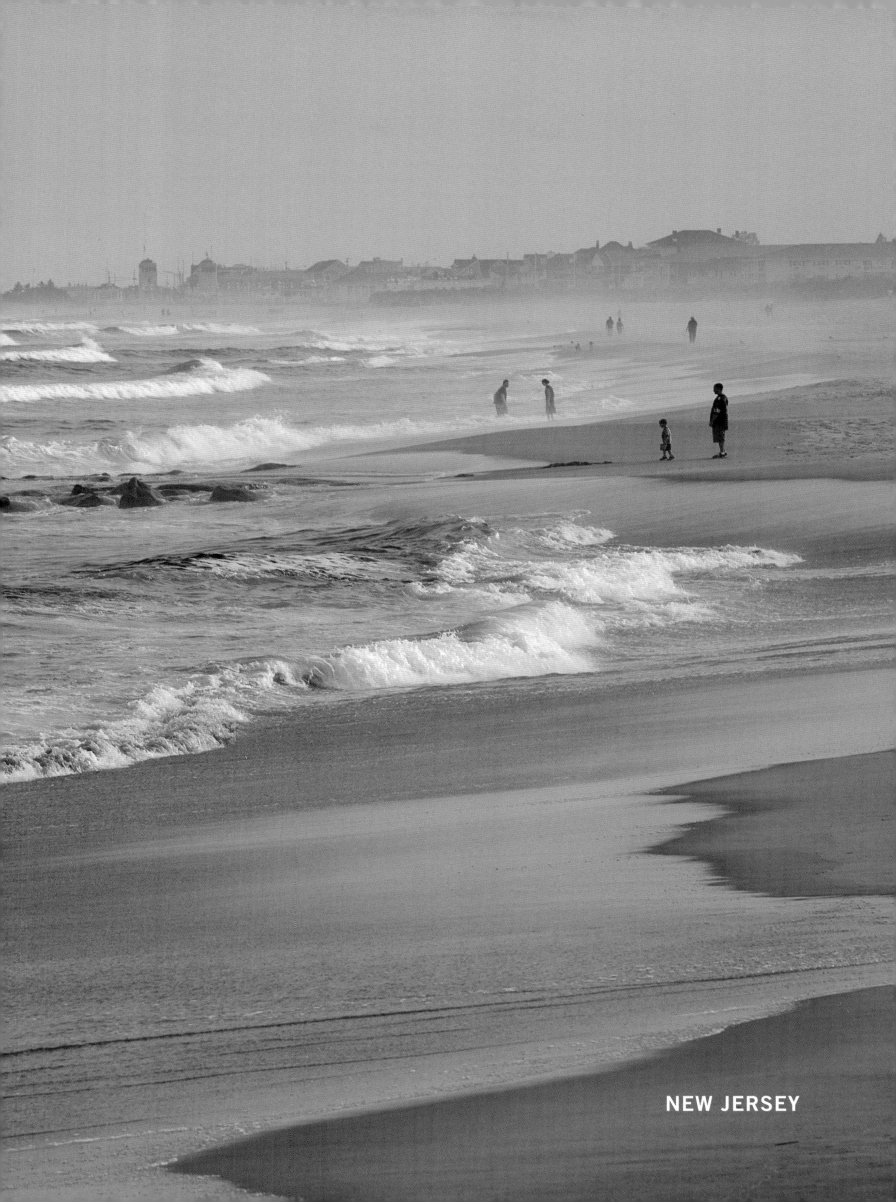

NEW JERSEY

PRASOP & SAOWALUCK KIEWDARA

SOUTH RIVER

Saowaluck is very friendly when she welcomes me to River Thai, the restaurant she and her husband own and operate at 50 Main Street in South River. First she serves me lunch and then, when all of the customers have left, she convinces the whole family to pose for me. Both Prasop and Saowaluck are from Bangkok, Thailand, but they met in Queens, New York, at the restaurant where Saowaluck was working.

"He very nice guy. Never complain about people, never talk behind people. I feel like I find friend." Her English is still a work in progress but that doesn't prevent her from talking up a storm. She appreciated the attention that Prasop paid her in many ways. "He pick me up at work. He even buy a car to take me home at night. He take me to restaurants and shopping, you know—girls like shopping."

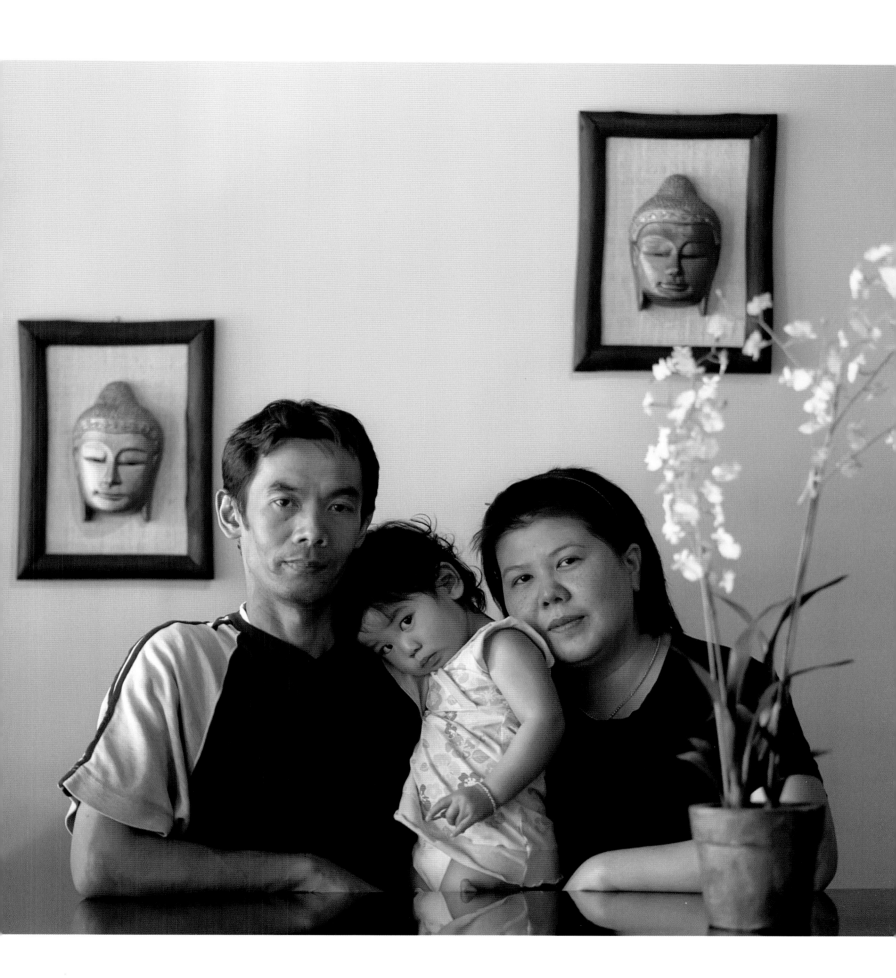

She laughs shyly when sharing these details about their relationship and she focuses on a particular one. "He honest, he never lie to me." They married after two years of courting.

Just like myself, Prasop came to America in the mid-'80s, to follow his best friend. "I worked in my family's farm back in Thailand. We grew lemongrass and basil, you know, for cooking Thai food." He left to look for more opportunities. "Here you have a lot of chances if you want to work," he says, "it's only a matter of hard work." Saowaluck has praises for her new country as well. "I like that people here, rich or poor, is the same. And they take good care, when you have green card, like when you have to go to hospital." America may afford immigrants more opportunities, but it is difficult to adjust to cultural differences. The Kiewdaras have maintained their traditional Buddhist faith so they make regular trips into New York City to visit the Buddhist temple. "We love to visit there. Every April they have the New Year Songkran, like in Chiang Mai," she says with a slight sense of melancholy.

"Chiang Mai is city in Northern Thailand," she says, recalling her younger days, "that where they have beautiful Songkran festival, every April. People splash each other with water, lot of water, let birds out of cages and set fish free in ponds."

In New Jersey they found a new oasis, not only do they own the restaurant but they also bought a house in suburbia, where they are planning to raise their only daughter, Anisa.

"I love the peace and quiet, the backyard, the barbeque. We don't even have to lock the doors at night." Prasop is happy about his new life but I am puzzled by his work schedule. "I work 4 a.m. to 11 a.m. in a hotel in Manhattan four days a week and then I work at the restaurant." I add up the working hours and the commuting time and I am left wondering how much sleep he manages to get. "I still have time to play with Anisa in the morning some days and in the afternoon other days." He tries his best, but Saowaluck still finds reasons to complain. "He spoil her too much— he buy her things all the time and give her candy, too much!"

The restaurant is doing well and they pride themselves on cooking traditional Thai cuisine. They don't have any secret recipe but Prasop sums up their philosophy in a few words: "To make good food you have to use fresh ingredients and put your heart in the cooking." Simple enough.

He still misses the foods from his own country. "I like longan, a round white-fleshed sweet fruit, similar to the lychee. And durian, a strong-smelling mango-like orange fruit." He smiles at my expression of astonishment: I've never even heard of such fruits. "My mother cooked kaidao on top of rice with soy or fish sauce," he says, recalling his childhood lunch box. His memories of the motherland are not only about food. "When I was a kid, we would go visit the Emerald Buddha," Prasop recollects, referring to Bangkok's famous icon found in the Royal Temple. "I would run around in the park—hundreds of people riding bicycles, flying colorful kites. It was great fun."

He only went back home once in twenty-four years. "Bangkok is not the same now. There were all farms where I used to live at the edge of the city. Now the city has expanded and they have buildings and townhouses everywhere." His only trip back was after his mother passed away, a pain that I deeply share with him. "I was very close to my mother; it's not the same without her," he says, still sad about it. I realize how similar our experiences have been, losing a mother while abroad and a father as a teenager.

Prasop and I share another immigrant detail: we both don't have any relatives in our new country. He also is the only one of his family in America. But he jokes, "I am the youngest one, so no one worries about me. They all know I will be OK." Prasop and Saowaluck are happy in America but they both long for a visit home. "Maybe one day when Anisa is old enough," Saowaluck says, "we'll be able to take her to visit our families and share all the memories with her."

ELEVATION
7,275 FT.

NDPAINTING POTTERY

GREAT
DIVIDE
GIFTS
ST HWY 122 #01

Souvenirs

master charge
THE INTERBANK CARD

HISTORIC
NEW MEXICO
66
ROUTE

NEW MEXICO

SHERRY ANAYA & JOSEPH ARGUELLO

MOSQUERO ✦

A smiling woman waves at me from the distance when I arrive in Mosquero. "We have just about 120 people living in town; I spotted your car right away," says Sherry, introducing herself. We have time for a beer at the only bar in town before Joseph joins us a few minutes later. "We should go to Dennis Hill, our favorite place— it's just down the canyon. There's a spot with beautiful Native American drawings on the walls where we love to go meditate."

I just drove in a flat desert environment for the last four hours, but when we start driving down the hill, I suddenly realize that Mosquero is on a high plateau, the unique geography of the West known as high plains.

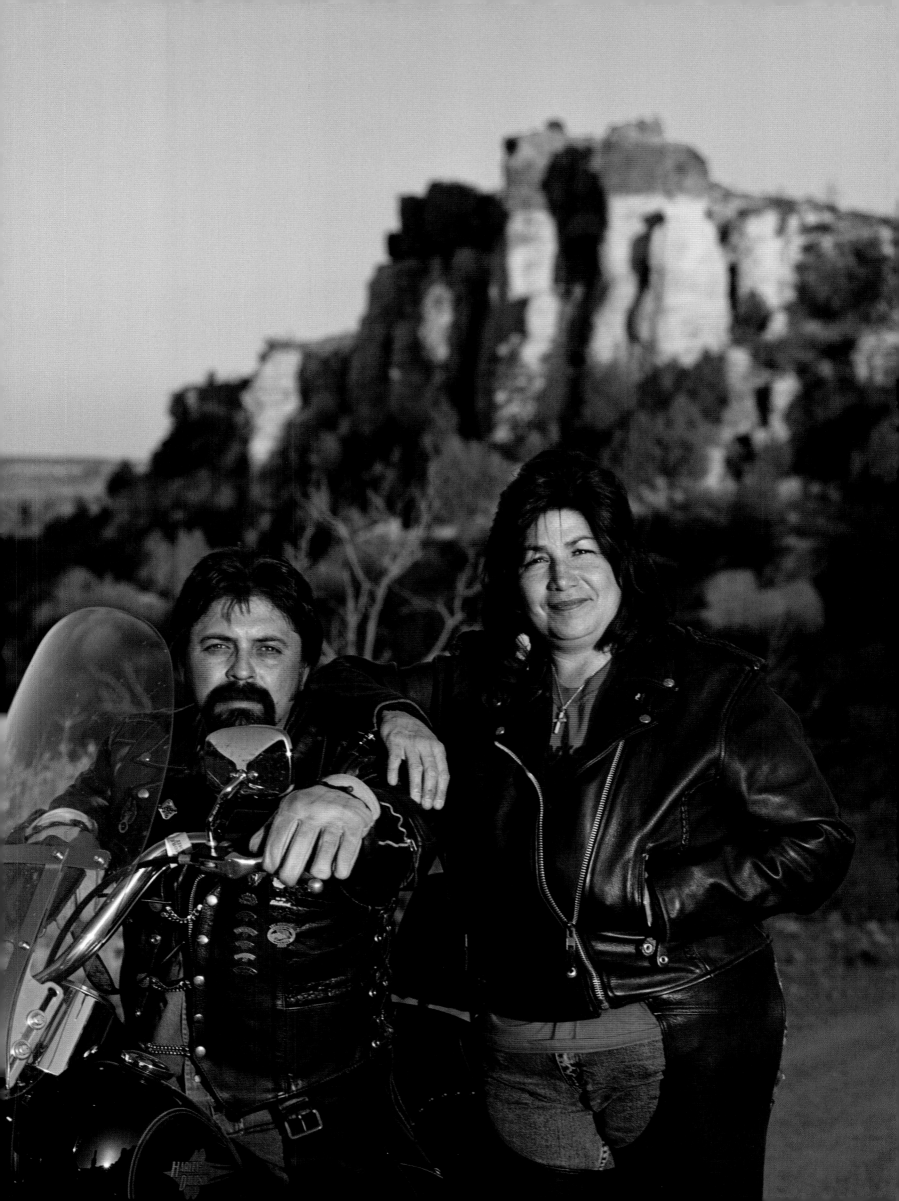

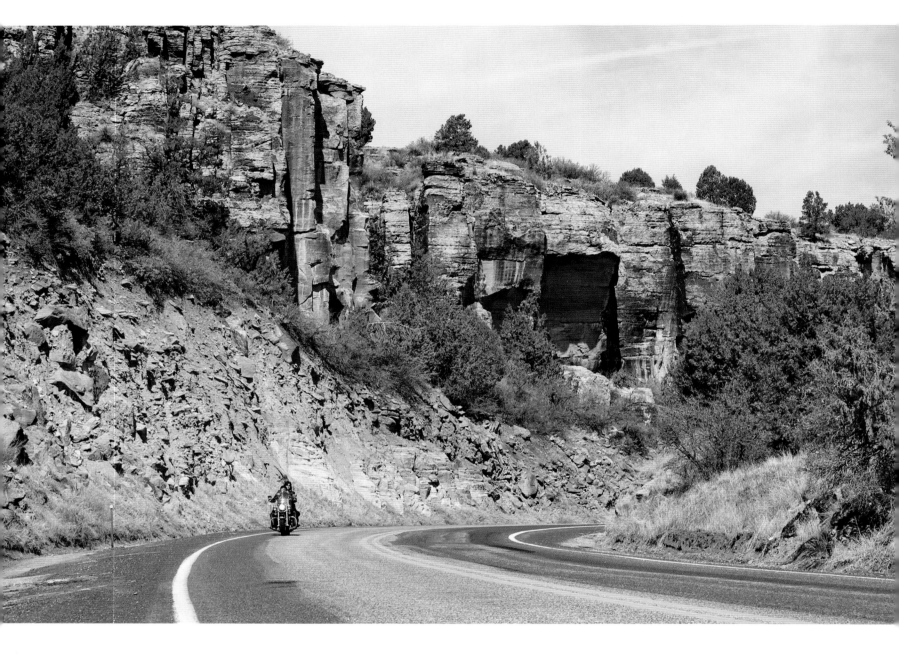

Sherry is an open book. "I love Joseph because he is a gentleman; he shares his emotions, he opens up, he cries with me. He shows me a side that most people don't get to see." She was skeptical when they first met. "My friend Shelly introduced us. I thought he was too handsome so I was very tentative. I was still recovering from a divorce that took a lot of energy out of me." Eleven years later, Sherry is still grateful to Shelly. "He is my soulmate, my best friend; I don't know what I would do without him," she says seriously.

They share a love of motorcycles. "Our best trips have been to Sturgis, SD, for the Motorcycle Rally." I've heard of the infamous gatherings so I want to hear stories. "We make a vacation out of it; it takes us two days to get there. We camp for a week and just ride around with thousands of other motorcycles, mostly Harleys." I have to press her for details. "Some people want to be naturalistic," she laughs, "so they have a naked parade. It's a big party, kind of like Mardi Gras. I love the diversity of the people and the freedom."

Sherry is originally from California. "My father's best friend lived in Tucumcari, seventy-five miles away from here. He saved my dad's life in the war and they bonded like brothers, so we would come visit every year from San Francisco," she says. "We eventually moved there for good when I was seventeen. A couple of years later I met my husband and we had Richard and Amanda." The husband is gone but the kids are her jewels. "I love my kids. I am so glad I had a chance to raise them here. It's comfortable, peaceful and relaxed; when I wake up and there is a buck outside my window or when I see a bobcat mother crossing the street with her baby, I wonder how many people get to enjoy that."

Sherry has been running a part-time hairdressing business at the small shop that Joseph built for her. "I moved it from the gas station that closed down across the street—now we can't even buy gas in Mosquero anymore," he says, laughing.

Sherry loves doing hair but she decided to go back to school. "My dream is to become a hospice nurse and to reach people in their most vulnerable time in life." A few people inspired her. "When my mom became ill with a stroke and bedridden, she asked me not to put her into a nursing home, to allow her to die in her own bed. My sister and I did all we could, you know, the changing, feeding, bathing, but I will never forget the nurse that supported us. Her name is Diana Beck. She helped us deal with the emotional part of saying goodbye."

A few years later she had another inspiring moment. "Joseph's mother was dying of ovarian cancer. One night she asked me to take her outside in her wheelchair. It was snowing, snowflakes the size of a silver dollar. We just sat there, she put her hand out and she opened her mouth, try-ing to catch snowflakes. With only a few days left in her life, that's all she wanted to do. It was an awe-striking moment with somebody that I loved, full of power and emotion. I decided that I wanted to give that to somebody else some day."

Joseph listens quietly. "My grandma, Maria, was Apache Indian and my grandfathers were from Spain and France; they came to New Mexico to work for the railroad. I grew up right around here, in Bueyeros—a very little town," he says. "My parents moved to Mosquero because that's where the public school was." He's more reserved than Sherry but appreciates the same aspects of life in New Mexico. "I love the clear skies; after a long day at work, I love sitting out back and looking at the sunset and the stars. They are closer up here," he says calmly. "I still remember the one time when we saw a comet. It had a green tail. That was special."

The closest hotel is in Tucumcari so they invite me to have dinner and stay the night with them. I get to show off some of my cooking skills and am touched when my name is mentioned during grace. Before going to sleep I want to experience the view that Joseph loves so much. The night is dark, not one sound in the small town. I look up at the sky and I must agree with him: the stars are indeed closer in Mosquero. 5,600 feet closer.

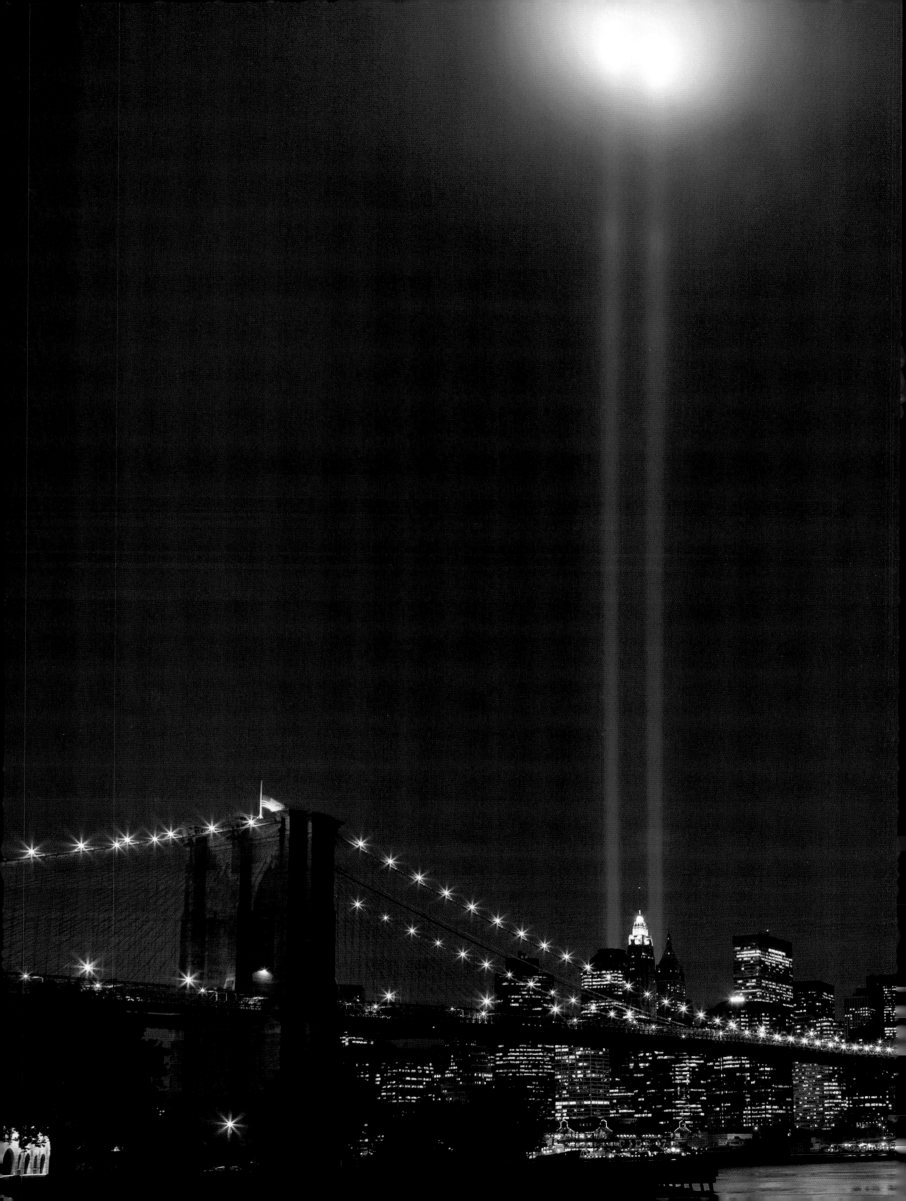

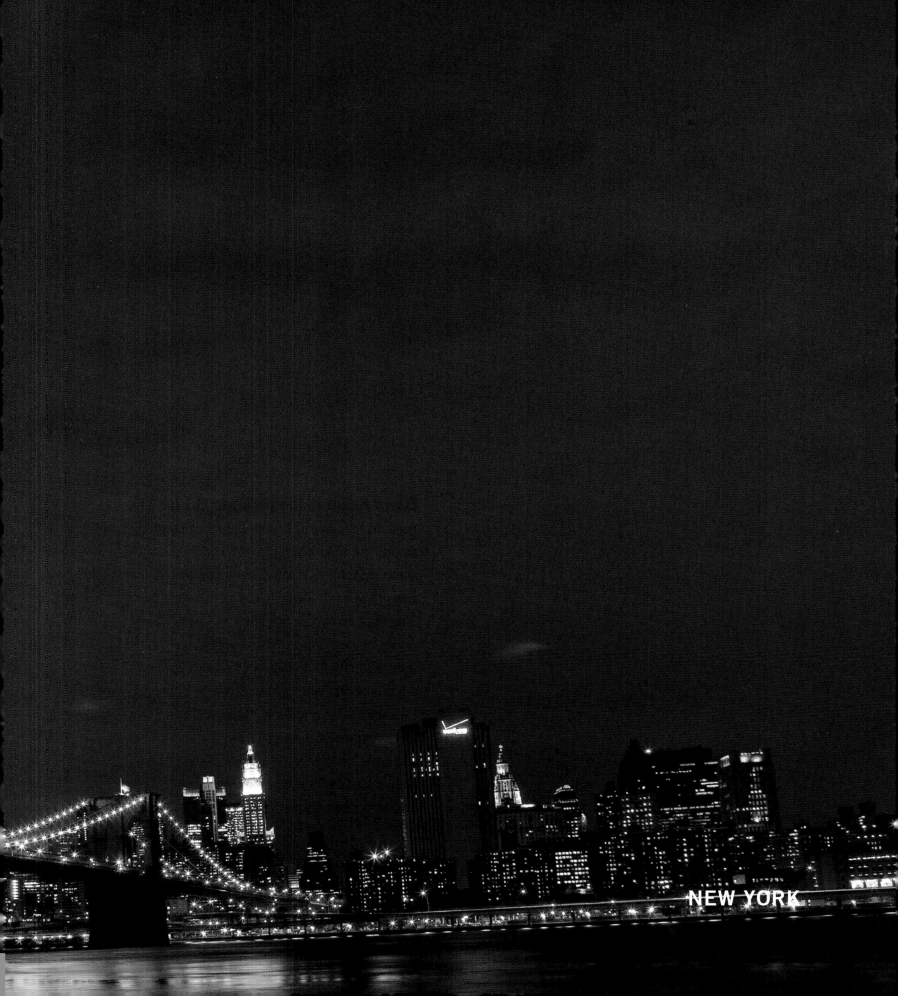
NEW YORK

DAVID KELLER

WASHINGTONVILLE ✦

David Keller is the first subject for the book. In my naiveté, I started the project driving around the state looking for somebody to photograph at 50 Main Street, not considering that not every town has a Main Street and not every Main Street has a number 50. In some towns I found empty houses and in others people that didn't want anything to do with a wandering guy with a heavy accent who wanted to take their photo. I will always be grateful to David and his family for being the first to welcome me into their home and allow me to start the project. "A long journey always starts with a first step," he says when I explain my tribulations finding him.

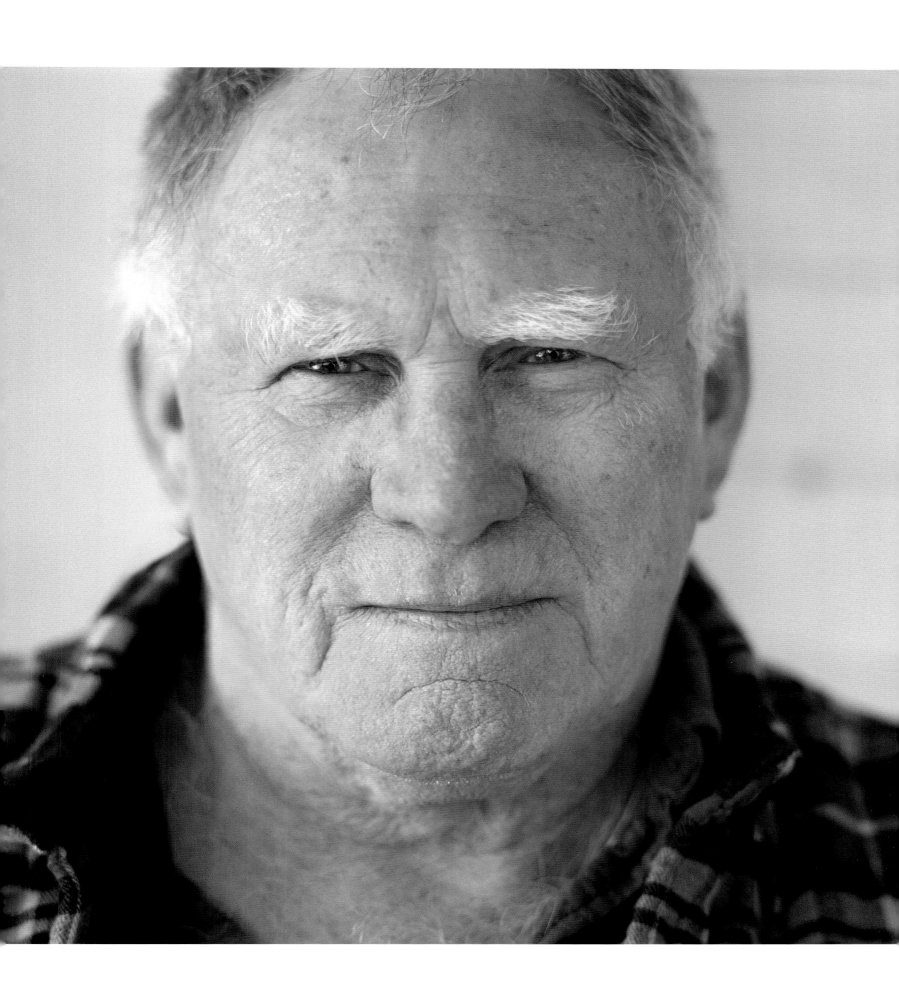

David is the right person to remind me of that old saying, as he has driven trucks most of his life, until the accident. "I don't remember much about it," he says, dismissing the episode. He has been told most of the details by his wife, Margaret. "He was picking up milk on a farm in Upper Red Hook, he hit black ice or something and turned over the tractor trailer. He had 80,000 pounds of milk in it," she recalls.

"She had just gotten to Florida and she had to come right back because of me." He seems more sorry for interrupting her vacation than anything else. "He was pretty banged up," says Margaret. "He was unconscious for a few minutes; he can't remember anything of the accident. He was really out of it for quite a while."

David also repaired oil burners for a few years, and his skills come in handy since he retired. "I now do work around the house when needed—just put in a new water heater last month. You have to do the work yourself these days, unless you are rich and can afford to pay people."

Money is always a concern for the Kellers. "We bought an RV a few years ago so we don't have to spend money in restaurants and hotels when we go visit family." They took the RV across the country last year for their fiftieth wedding anniversary. "That was fun! We went to Oregon to visit friends. We went to see the Badlands, Mount Rushmore and the Crazy Horse monument. It's beautiful there, but it was hard—too many turns for a twenty-four-foot vehicle in the Black Hills!"

The RV is also convenient when they go see David's family down in Tennessee, where he is from. "I am a mongrel," he says, talking about his ancestry. "I have a lot of German and other European in me, but we found out a few years ago that my great-grandmother was Cherokee." He seems proud of it. "We even have pictures of hers from the Civil War times." David has family all over the country, from Arizona to Louisiana and Arkansas, so they are planning more traveling soon. "Not interested in Las Vegas, though," Margaret says promptly, thinking ahead. "Not too much money to throw away."

David is a local guy and remembers the old days around here. "We used to know everybody and wave at people when they drove by. Now, we hardly know anybody." Washingtonville has changed, like many other communities close to a big city. "A lot more city folks are moving in. We now have a shopping mall, a new high school." Nevertheless he is still proud of his town, especially the winery. "We have the oldest winery in the country, The Brotherhood Winery. It goes back to the 1800s."

They made 50 Main Street their home forty-five years ago and they raised all their children here. "We had five children but we lost a daughter when she was only eight months old," says David. The four remaining children all live around the area. "We see each other often; the kids come by to check on us almost every day," he continues. "We have a lot of memories in this house. We are fortunate to own it." They are particularly fond of their traditional Thanksgiving family gatherings.

"Nothing fancy—we like to fix a turkey, some stuffing, sweet potatoes and pies. That's what everybody comes for. Apple pie, pumpkin pie; Betty Anne makes a killer coconut custard."

Eric and Thomas, their teenage grandchildren, stop by the house and join in the conversation. The boys are shy, not intrigued by my life in New York City but very curious about my whereabouts on September 11, 2001. They were very affected by the tragic events of that day and they are both interested in pursuing security and police work.

It is getting late and I am ready to head back home. I ask them about a place where I could get an oil change for my car. I immediately see a sparkle in the kids' eyes. They know what to do and they spring into action. Thomas heads to the garage to get the tools while Eric opens up the trunk. In no time the car is up on cones, the oil dripping out of the engine and replaced with new oil. David stands back, supervising, and the kids occasionally look at him with questioning eyes; he nods silently and smiles in approval.

NORTH CAROLINA

NANCY BEASLEY

WAYNESVILLE ✦

It's always hard to keep up with time, but traveling between time zones adds a little more confusion. I am driving East on Interstate 40 in Tennessee when, in an uncanny coincidence, I actually see the time jump an hour ahead the exact moment I pick up the phone to call Nancy. All of a sudden I am an hour late.
She has to leave the store so we decide to meet the following morning. When I eventually arrive in Waynesville, I feel like a celebrity. Nancy has called the local newspaper and a photographer is waiting to take my picture. She also arranged the windows of her store and got all dressed up for the occasion. "I'm not dressed up," she says with Southern flair. "I always dress nicely."

"I love clothes, and I love shoes. I have about one hundred pairs of shoes." She reminds me of my own wife. "You can never have enough shoes." Main Street is dressed up as well, decorated with flags and flowers. "Every July we have a big celebration here," she says. "We are getting ready for the Folkmoot Festival. It's a big folk music and dance festival. People and performers come from all over the world."

Nancy is not originally from here. "I was born in South Georgia, moved to Alabama, graduated from college in Florida, and then went back to Georgia." I look at her dress and listen to her Southern drawl and I dare to refer to her as the quintessential Southern belle. She loves the compliment and her response is immediate, firm and amused. "Absolutely!"

"My husband and I used to come visit the Great Smoky Mountains region for decades," she says. "We had a vacation house here and we used to come as much as we could. Ben was still working at the bank and I was a director at a United Way office in Valdosta, Georgia. I was a fundraiser, raising money for different charities. We really liked it here so when we retired we decided to make it our home."

Helping others runs in the family. "Ben was always a strong believer in volunteering," she says

with pride. "He did it for many years in a golf tournament when we lived in Florida, and our son, David, still does it in Orlando; our daughter-in-law also volunteers, for the Arnold Palmer Golf Invitational. We always loved golf and tried to stay involved as much as possible. Mr. Palmer is a great person and we appreciate his work with his charities for children and women."

Waynesville is a tourist destination. "People come from all over. We have white-water rafting, you can go kayaking, there is great hiking; we are surrounded by forest, lakes and rivers. And people come skiing in the winter." She sounds like a tour guide. "Well, I did use to be a docent on a plantation in Georgia," she says, laughing. She returns to her life in Waynesville. "My favorite is the rooftop movie theatre. We don't have a drive-in anymore so, in the summer, they put up a big screen on top of the parking garage. People just bring their lawn chairs, blankets, coolers. It's very charming. And then there is Art After Dark—all the art galleries are encouraged to stay open late on the first Friday of the month." The town seems very organized. "We have an excellent Downtown Waynesville Association; they always have something going, pretty much all year round. All the different businesses get involved in it. They help each other out. If somebody needs help, somebody would come and help them out. You know, that type of thing." She started her business by chance. "I helped a friend achieve her dream," says Nancy. "She dreamed of selling fine linen, so we opened our own store." The partner since retired and Nancy took over the store. "We carry items for babies and adults. The store is the reflection of my taste." Even the name: "We chose to call it The White Orchid because it's sort of classic, timeless."

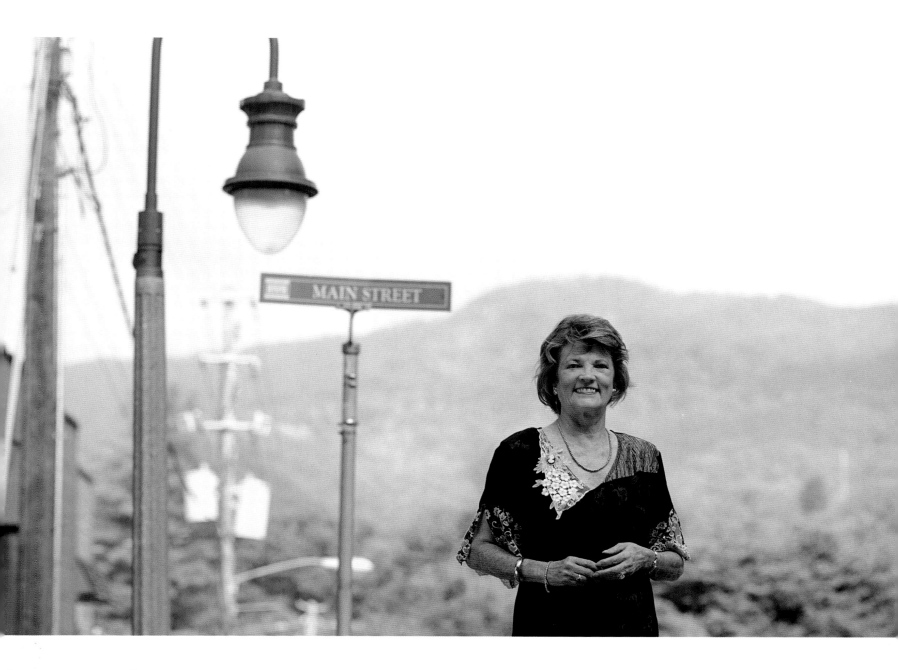

Business has taken a bit too much of her life. "You get into retail and it becomes all-consuming," she says. "We always wished we could travel more and then all this stuff happened with my husband..." Four years earlier Ben started having health problems. "He went in for some test, they found a subtle hematoma that he'd had for a while. He was in surgery for the next three hours. It was one of those things that happen so fast that you don't even have time to worry about it. And that was just the beginning," she continues.

"Ben had to undergo four more brain surgeries. He suffered a couple of strokes and then started having seizures. We never know what kind of day it's going to be." She chooses to look on the bright side. "He has made a lot of progress. They let him have a golf cart. Now he can go up and down the street and visit the neighbors. He'll never be able to drive again, so anywhere he wants to go or needs to be, I'm it." Nancy hasn't lost her spirit. "Well, now I am volunteering, only for my husband!"

IVAN JOHNSON

MAYVILLE ✛

Tears form in my eyes and I get all choked up when I am told the story of Lloyd Nelson. His picture is hanging on the wall at the Veterans of Foreign Wars hall, where I meet Ivan Johnson. "He was the first boy from Mayville to die in World War II. We named our post after him," he says. Maybe the tears are just my spontaneous way of thanking him for the ultimate sacrifice, as I still remember my mother's stories and her happiness of greeting American soldiers coming to liberate the country from dictatorship. Ivan Johnson is a soft-spoken, Army veteran himself. "I was in Japan and Korea. Looking back, it was a real good experience; at the time, not so good!" He has a hard time understanding me; he wears a hearing aid and my accent doesn't help either. But he has no problem recollecting some of his favorite memories.

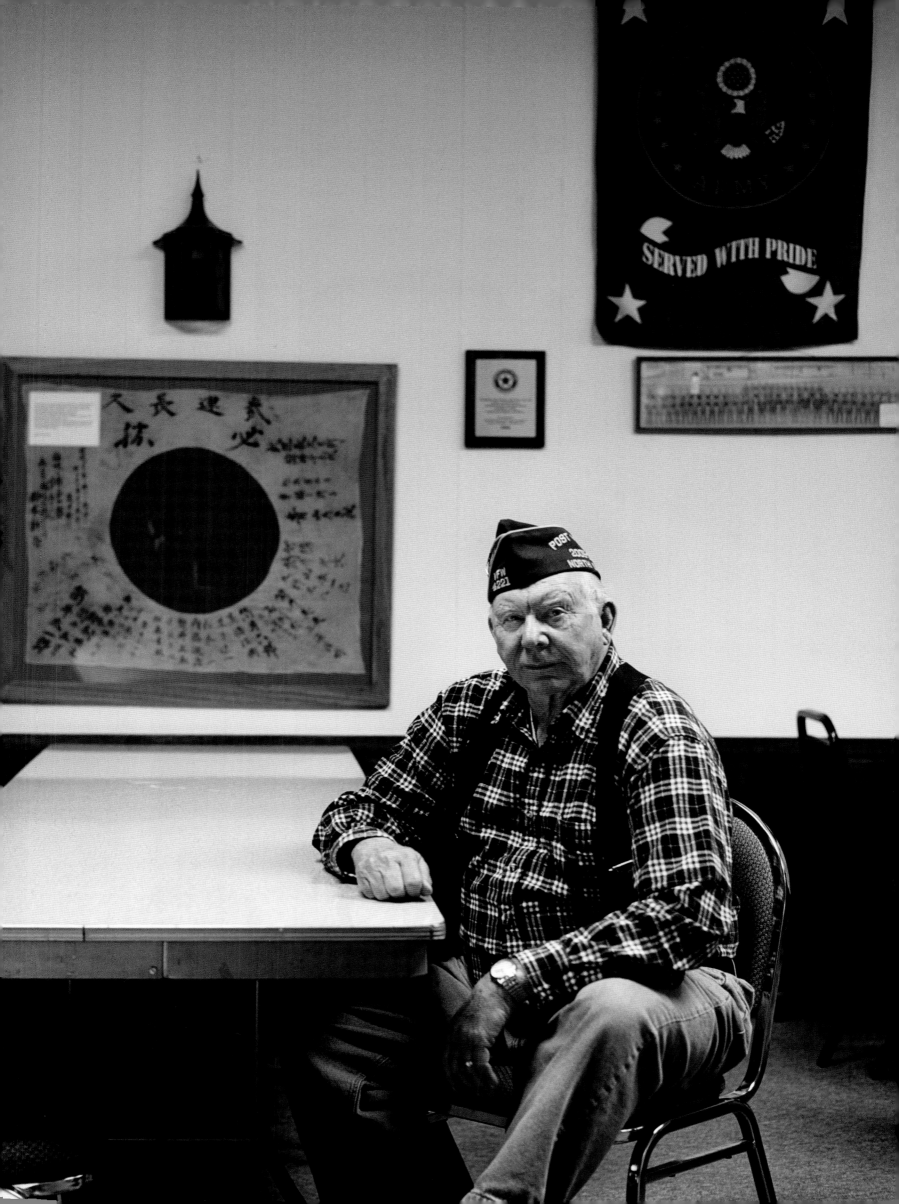

"I was in Korea when they signed the ceasefire. I was overseas for eighteen months." He chuckles recounting one particular detail. "If you took the bus, full of men and women, and when bathroom time came, they would just stop on the side of the road and women would get out on one side and the men on the other." He enjoyed the chance to visit foreign lands. "Seeing two different countries and how people live, learning about their culture, that part was interesting." Other than that he has always been a local boy.

"I worked for my dad until I went into the Army. He raised livestock and grew wheat, barley, oats, flax, and potatoes. When I got back home I went to work for the telephone company. I worked there for thirty-seven and a half years. They offered me an office job but I didn't like the idea of working inside. I'd rather work outside," he says, "well, in the summertime, that is. Some winters I had to work outside when it was 30° below zero." Ivan met his wife, Dolores, when he returned home from the service. "We met at a park dinner.

I went with two buddies of mine. They went to meet some friends and I tagged along. We liked each other right away. We got married shortly after that." Ivan was twenty-three and Dolores was eighteen years old. "I didn't want her to get away." Ivan smiles, realizing how young she was. "We are Norwegians around here," he says about his roots. "We love winter sports. Back then almost every town would build a ski jump, a scaffolding maybe fifty feet high, and they would put snow on it. You would go down and jump off to the river. Of course the river was frozen." He can sense my astonishment at the idea.

"We are both retired now, but we try to keep busy. Dolores carries the flag for the Auxiliary and I carry the rifle for the VFW. She also has the kids singing some songs. I am in the color guard—we present the color to the games and for Relay of Life. They raise money for people with cancer." Ivan and Dolores raised three children and got all of them through college. "Well, Harlen didn't quite finish, but he was under the G.I. Bill when he got out of the Navy; we helped Randy and Kathy as much as we could. They stayed home. Then they got student loans. I don't believe in giving the kids too much. It's better to earn their own, somewhat." The kids have moved on. "Harlen works for Crystal Sugar; they grow a lot of sugar beets. They are still processing them. They dig them in the fall. They freeze outside in the wintertime. That preserves them." His farm experience kicks in. "Randy runs his own company in Louisiana, and Kathy is a music teacher in Lake of the Woods, as far north as you can get without entering Canada." Music has been in the Johnson family forever. "Kathy sings and plays piano and clarinet, my brother played accordion, my father played violin and my mother the piano.

They played at dances, in people's houses. They would roll up the linoleum off the floor in the living room and they would dance."

The memories keep on coming. "Julebukking is another Norwegian custom that we used to love. It means 'Christmas fool.' We would put on a mask and heavy clothes so people would not recognize us and we would go to different houses; they were supposed to guess who it was. Then the couple you visited would get dressed up and go with you. By the time we were done we would have two or three full cars. It involved drinking, dandelion wine or whiskey and 7-Up. It was a lot of fun! Except the next day it wasn't so much fun, the hangover from all the too much drinking..."

The cold is always a good excuse to drink. "It does get very cold around here," he says. "The day we got married, it was 20° below zero. My car would not start that morning. My dad had a team of horses that he used for tourists. He suited that team of horses and pulled the car until we got it started." I assume he was late for the ceremony. "Well, the preacher wasn't there either," he says, thinking back. "We had to go over to his house and get him." I smile at all the hardship he had to endure on his wedding day. He smiles back at me. "I really didn't want her to get away."

OHIO

MIKE WIRES

UTICA

I decide to drive to Utica at the end of a five-day assignment at Nationwide Children's Hospital in Columbus. My mood is somber; it's hard to shake the sadness of meeting innocent little patients in such critical conditions. The goodness of heart of all the people helping them makes me feel better and a bit more optimistic.

The landscape outside of the busy metropolitan area of Columbus quickly changes to peaceful cultivated fields. I have always thought of Ohio as a grey, desolate state, mainly because of the impressions left by one of my old favorite bands, Devo: their costumes, their videos and their songs about industrial alienation.

I arrive at the Village Inn at high noon, totally un-announced; only a few patrons are at the bar. The owner is not available so Mike Wires agrees to be my subject for the book. He is very excited at the premise of the project and proud of being able to represent Ohio.

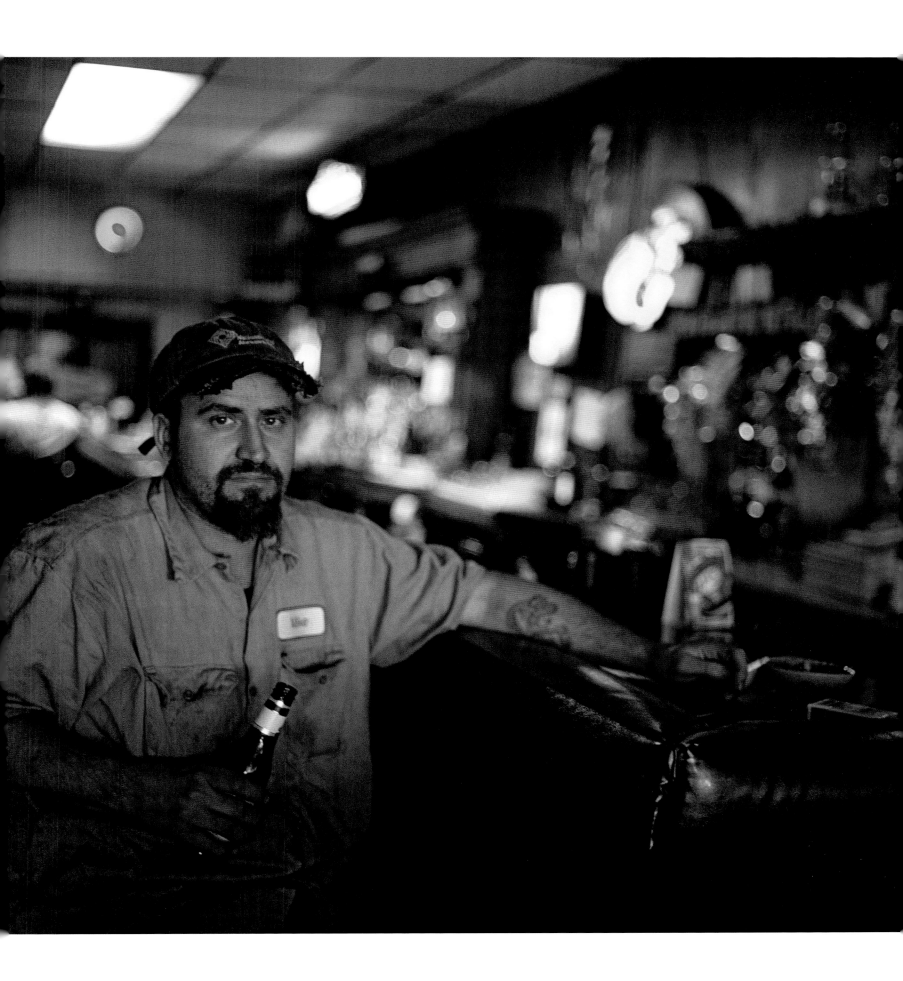

"Devo are from Akron," he says, laughing at my memory. "That was the rubber capital of the world. Utica is the ice cream capital of Ohio." Mike likes to talk about his state, maybe helped by the couple of beers he's already had.

"I just got off my graveyard shift at the foundry; we forge cast-iron casings for mechanical pumps." He excuses himself for the way he looks. "I am supervisor of my shift. We ground the extra metal off the parts; we use a machine called the Wheelabrator. It has a table on it, and as the table turns, there's a thing up above that looks like a water wheel on a mill. It spins real fast, and it shoots real tiny pellets down the blast of a fan, and cleans off the parts and makes them look shiny." It reminds me of my first summer job, age fourteen, working with tractor parts bigger than I was. "Yeah," he agrees, "sometimes the parts are so heavy that we have to use a crane to put them on the machine. You know, you couldn't do that today in America. We have child labor laws—you'd have to be eighteen."

Mike grew up in a town even smaller than mine. "I still live in Martinsburg," he says, "only a couple of hundred people, you know, only one stoplight kind of town. The only thing we had back when I was a kid was the feed mill, the gas station, very small post office and a little general store."

He still knows the owner. "Don Ryan, he used to have the old Coke machine, the one that you put money in and push a button and then you have to pull the bottle out through the metal thing that keeps it locked in." Mike's parents divorced when he was very young. "They've been divorced from first grade," he says. "Mom and I are like best friends, even too much—I get on her case all the time." She had him at a young age. "She just turned nineteen six days after I was born. I was at her graduation, when she graduated high school. We have a picture of Mom holding me in her cap and gown. So when I graduated high school, I tried to pick her up and hold her like she held me, and got a picture taken. It was in good fun." It's a bit more complicated with his father. "Dad went to the service three years after the divorce. He used to have a drinking problem— that's why him and Mom split up." Mike doesn't mind sharing his family's struggles. "I do have some good memories. Sometimes he would take me with him to the bar and I would always get a Mountain Dew. The old bottles had a hillbilly walking up to an outhouse on them. I've been trying to find one of those for years. It would be fun to have." It's been a long time. "We get along better these days. He drives a truck now. He was in the National Guard a couple of years ago and he was sent to Iraq. That was stressful." Mike's father made an effort to reconnect with him. "He calls me a couple of times a week. We just have all these conversations about my childhood and his drinking problem. What I remember, what I went through with it. He apologizes every time." Mike is at peace. "He lives in Oklahoma now so I don't see him that often. He remarried; his wife is an Iowa Indian. They have a fourteen-year-old boy. He is four inches taller than me," he laughs.

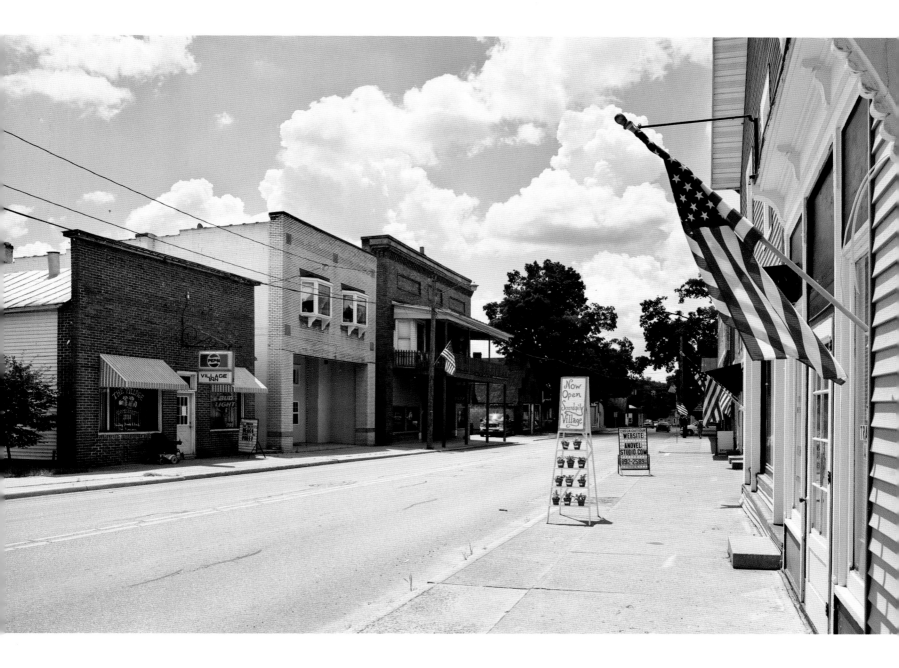

"I was outside of Ohio only a couple of times. The first time I was nineteen. My dad took me to Alabama to fetch his stepson that had run away from home—he was only fifteen. I only went out of the state one time for an actual vacation. I was in eighth grade. My grandparents took me and my cousin to Lookout Mountain, on the border of Tennessee and Georgia. We just went sightseeing. They fought a Civil War battle there. On a clear day you can see seven states from the top of the peak," he says, enthusiastically.

Mike was a little rascal. "I bought cigarette loads—they are almost like firecrackers. I stuck one in my grandpa's cigarette. It blew up when he lit it. The fireball went all over the bed. My poor grandpa jumped up and tried to put it out." Mike himself started smoking very young. "I was fifteen," he says, "but I think I am going to quit." I look at him quizzically. "I did quit two years ago." We laugh together when I share one of my favorite Mark Twain quotes: "It's easy to quit smoking; I've done it hundreds of times."

OKLAHOMA

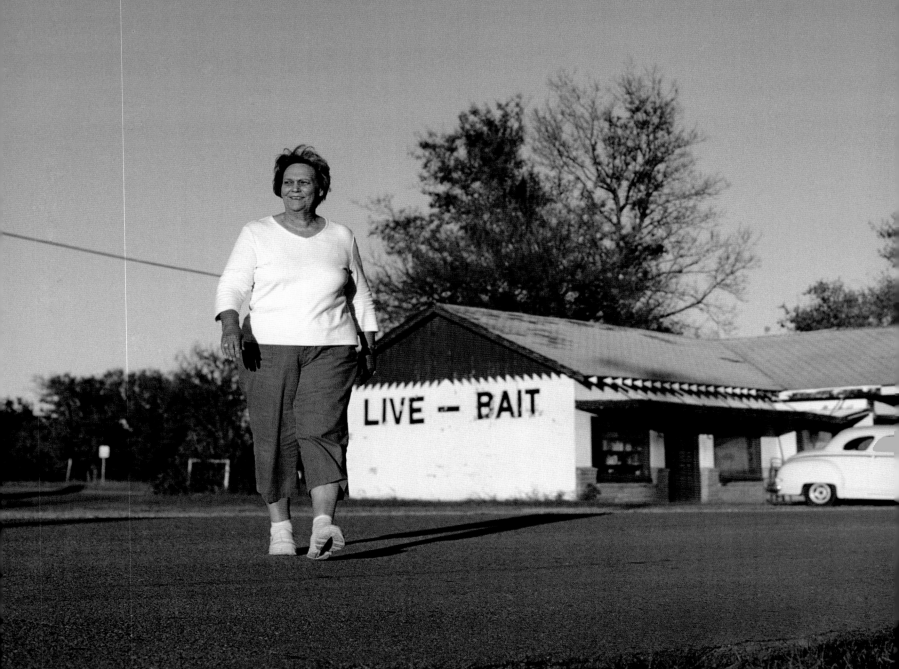

JEANNE NEUGIN

CHOUTEAU ✦

The green rolling hills of southeastern
Oklahoma remind me of old cowboy movies and
I find myself whistling the Bonanza theme, one
of the defining tunes of my childhood. It's hard
to imagine that I am in the same state described
by Megan, my only Okie friend, when recounting
her grandmother's experiences during the tragic
years of the Dust Bowl.

I meet Jeanne at Let's Talk, her store at 50 East
Main Street, where she sells cellular telephones.
"My son played football in high school," she says
when I tell her about my Friday Night Lights en-
counter the night before. "We used to work in
the concession stand selling drinks, coffee and
hot chocolate, popcorn, candy bars and stuff like
that at the games; we did it to raise money to buy
footballs and uniforms for the team."

"I went to work at the Chouteau Telephone Company in the early '80s, when cellular started," she says. "Of course we didn't sell many because it was so new and expensive." She has seen the business grow and change. "Way back then, we used to mount them in cars. Then came bag phones; now they are like small computers in your pocket. I've seen them all." She is very proud of her loyalty. "Me and one other guy in Claremore are the only two of the original agents left that started with the company. Twenty-five years with the same company. We're two loyal folks." The number twenty-five returns when she talks about her ex-husband, the father of her son and daughter. "He ran off with another woman. We were fixing to celebrate our twenty-fifth wedding anniversary and I didn't have a clue." She seems at peace with it. "It's been fifteen years. He is happy and I am happy that he is happy."

Jeanne takes me to the banks of the Grand River, her quiet spot. "We're blessed with lots of water in this area. We go to the river and lakes to camp, boating and fishing, as far as entertainment. This is where I raised my two children." They are still in the area. "Our family is real close. I have grandchildren now and they all keep a check on me. They come over often and we go to church together every Sunday," she says with a smile.

"I just went to Branson with my daughter last week for fall break. It's a neat place to go. If you like hillbilly music!" I laugh, as my friend Peter used to jokingly call me an Italian hillbilly. "They have country and comedy shows, lots of arts and crafts. It's just a quick place to go to get away from town and the phones." I laugh at the idea of getting away from cellular phones. "Yeah," she agrees, "you can't really get away from cell phones—I just get away from the office, I guess. If I go home, customers call me at home." I am surprised and she smiles. "I know everybody in town. Of course they call me at home."

Her grandson, Derrick, stops by to visit while I am taking Jeannie's photos. "I told you that they keep an eye on me," she says lovingly. "He is such a nice kid; he's a job coach for the mentally handicapped. He works for Gateway, a company in Tulsa. They mow yards for the federal building and all of the city buildings that have lawns. They landscape, they have riding lawn mowers, edge trimmers and things; they do all kinds of work. They have to have one job coach to oversee five people, so Derrick helps them load the equipment and takes them from one job to another."

She is proud of her grandson and worried at the same time. "Sometimes they have to really be careful because there are hypodermic needles out there, so he has to go scan the area before they can start mowing. If he finds packets of drugs and stuff, then they have to clean the place up. He has to deal with homeless people and drug addicts. It's pitiful but it's a learning experience for him, I tell you—to see how some people have to live. It teaches you not to take things for granted." I am reminded of the urban issues that plague so many other cities, but Jeanne takes me immediately back to her life in Oklahoma.

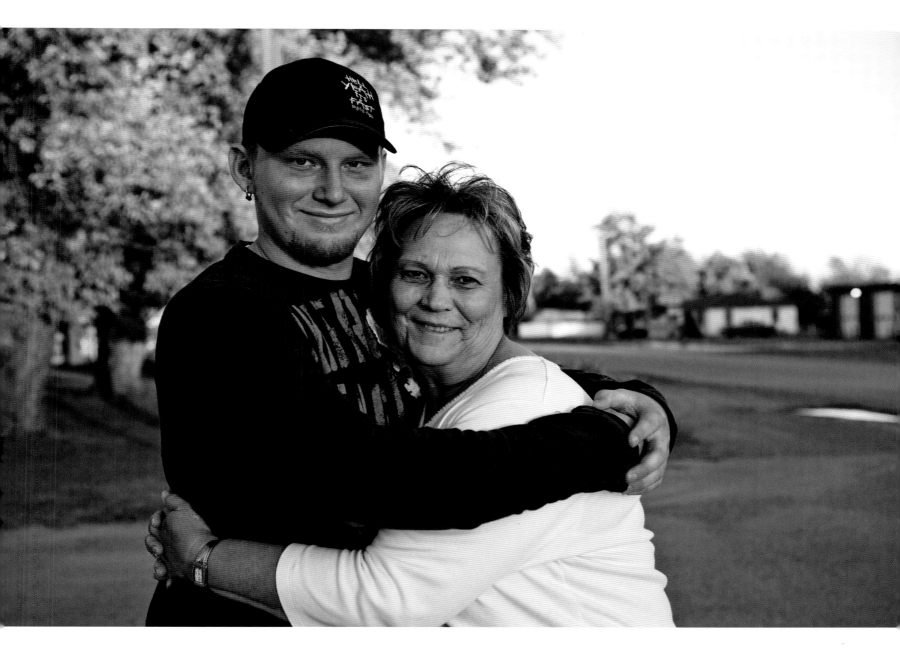

"My granddaughter, Hannah, has a pig at school that she shows, so we go to the pig shows, usually on Saturday afternoons." I am amused at the idea. "She owns Cadillac, that's the pig's name, but they have barns at the school so she keeps her there. Last Saturday my son, his wife and the baby came down and we all went to the show." Another opportunity to spend time together. "There usually are five or six schools at the shows and they each bring about twenty pigs, so there are over one hundred pigs at these events. They're divided into weight classes. Cadillac is 210 pounds. They walk them around the pen to get judged." I try to imagine the size of a 210-pound pig. "They're farm pigs. Hannah's is a Duroc. When she gets through showing her, then they'll have a premium sale. She'll use the money she makes off of Cadillac to buy another one for next year." I wonder aloud about the pig's fate. Jeanne gets a kick out of my city-slicker reaction. "We don't eat her, of course. Somebody else does, but not us. We couldn't do that!"

OREGON

KILMENY HALL

ASHLAND

"Those woods were like my backyard.

I spent every free minute I had there." Kilmeny gets excited when I describe to her the hike I took on my previous visit to Oregon, while helping my friend Justin move from New York to Eugene. "The Columbia River Gorge is my favorite place in the world," she continues. "I love hiking and you can't beat that place. The trails, the forest, the animals, the fresh air, the waterfalls, the views of the river."

I have to agree as I ask for help pronouncing her unique name. "Just think of 'kill me knee,'" she says, amused. "My mother is Canadian; she got it from a character in a novel she loved, *Kilmeny of the Orchard.* I grew up in Portland but I just graduated from Southern Oregon State University here in Ashland; majored in anthropology and Native American studies."

"I am the manager of the wine store," she tells me. "What started as a part-time job became my career. I kind of fell into it, really. I used to live in Bend and I worked in a fine dining restaurant there. They had a really great wine program. They offered wine classes for the employees so I started to get into it that way. I really liked it. I've always liked wine but, you know, I started to expand my palette and get into the intellectual part of it. When I moved to Ashland, I was still in school; I was looking for a weekend job in the newspaper classifieds. I found a job at a winery, working in the tasting room at the Valley View Winery, out in the Applegate Valley. It's becoming a really popular valley. It is within the more famous Rogue Valley. You know, very quaint, really cozy wineries. The warmer climate allows them to grow good varietals. They make Syrah and Viognier really well. Now I am in the wine business professionally, and I think I've found my career."

We are sitting at Chateaulin, the restaurant at 50 Main Street, next door to the wine store. "It's a French restaurant, very good food," she says. "It caters to locals and many visitors. Ashland gets a lot of tourism because of the Shakespeare Festival. It's a great event; it brings in thousands of people between February and October. It kind of put Ashland on the map." She likes the arts.

"That's one of the reasons I decided to come to SOU. Ashland is a wonderful little town and the school is great. I wanted to live in a smaller place with a strong community. I found all these beautiful aspects here. It's an artistic and eccentric town. I guess I have hippie tendencies," she says, laughing at herself. "I love nature and around here I am able to access very beautiful wilderness areas." She is even more enthusiastic now. "We are sort of nestled in between the Cascades and the Siskiyou mountains region. Not too far from the Redwoods and the coast; and I love surfing." Her love for nature has a long history. "I was always drawn to, not only Native American culture and philosophy, but spiritual teachings in general—Buddhist teachings, you know. Just looking at life from a more spiritual, non-scientific viewpoint." She pauses. "I lost my best friend; she was my closet friend from when we were six years old. She died in a plane crash when we were twenty. That was one of the worst moments of my life. It made me grow up in a really short amount of time. When you go through those tragic, tragic moments, and you're just completely raw, you find ways to be strong, to dig deep, to be vulnerable, to expose yourself. To really have self-awareness. That was a major moment for me: when I had to decide whether I was going to close up and build walls, and you know, be bitter, be sad, feel like life was unfair, or going to try and make sense of it. Have more purpose and meaning in my life."

She finds solace in writing her feelings down. "I have always kept a journal and writing was my saving grace. That and my community—my friends and family really rallied around me. And being outside. Those were my little trio of medicine. Writing, community and nature."

The outdoors is so important for Kilmeny. "Well, I'm a pretty nature-centered person. So my church is nature. And I think that's really the piece of it that draws me to Native culture. That philosophy, that paradigm, being so close in contact with nature, and that everything is connected. I love to hike peaks and mountains and get up to a viewpoint. I love endless views. When I get to the top I just sit there and soak in the view. I take pictures and just sit there for awhile, just soak it in, recharge my batteries," she continues.

"I pack a little lunch, bring a book and my journal and write about how I'm feeling. I like to put on a dress and heels every now and then, but I'm much more comfortable in jeans and a t-shirt." I assume she must love her hiking boots. "Actually, I love flip-flops," she says. I wonder how she can hike in flip-flops. "I don't wear them hiking. I carry them with me," she answers, laughing, "but I always wear them before and after, so my toes can be free."

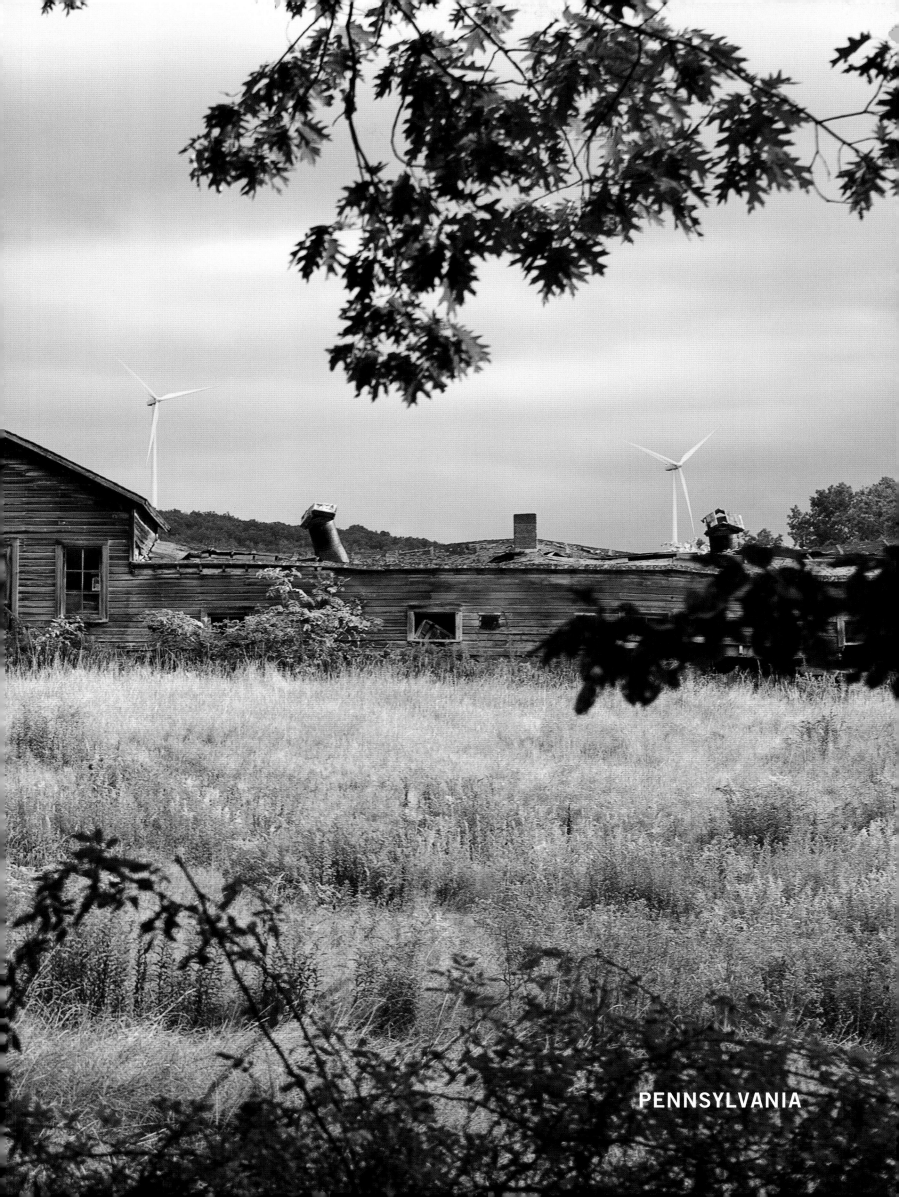

PENNSYLVANIA

LEVI & SETH
FREEBURN

LEOLA

Seth and a couple of his colleagues
welcome me at the firehouse where they volun-
teer at 50 W Main Street in Leola, in the mid-
dle of Lancaster County. I am coming from the
Pocono Mountains, on my way to visit the historic
Civic War battlefield in Gettysburg, and I am fas-
cinated by all the horse carriages the Amish of
the region still drive around the roads.

After getting a tour from Larry, the fire chief, I
take some time to look for a location and set
my camera on its tripod in front of the shiny fire
truck. I turn around and I see a baby in Seth's
arms. He smiles when I express my surprise. "I
am not Seth. I am Levi, his twin bother." He no-
tices my embarrassment. "It's OK, it happens all
the time, all our life." Twins are always hard to
resist for a photographer, and the two brothers
become the subjects for the book.

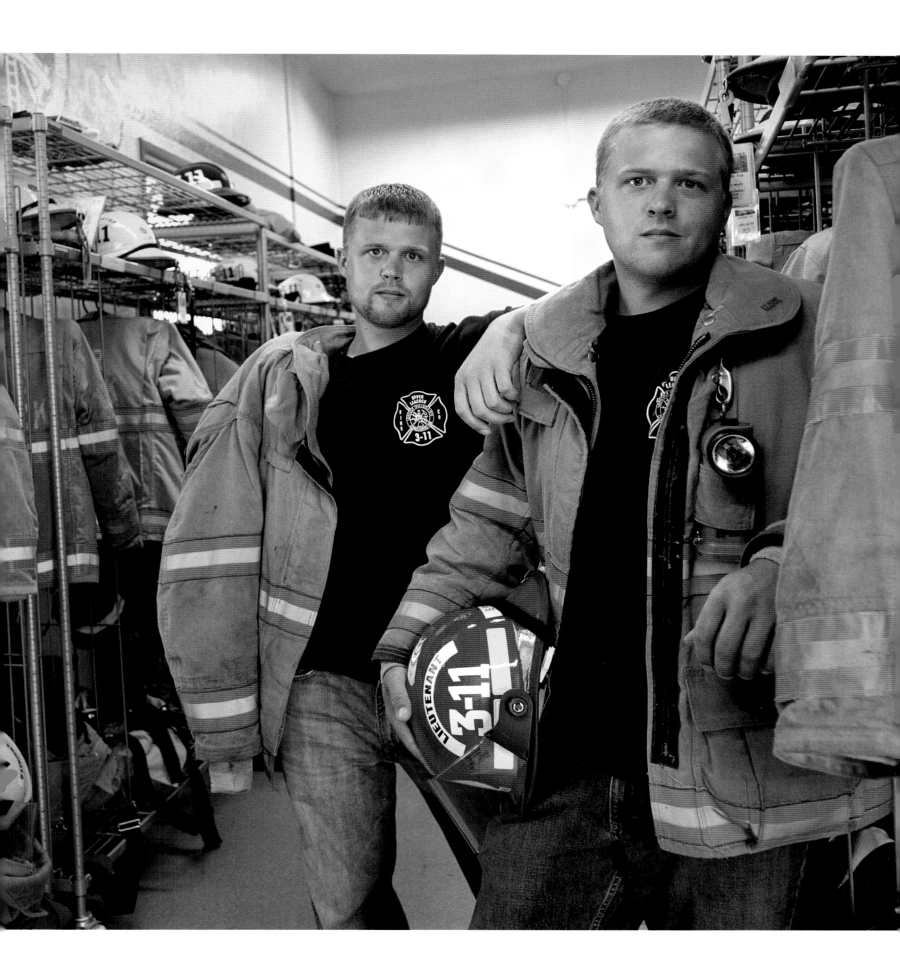

"This is home away from home for us." The twins speak in unison. "We've been here ten years now." The atmosphere is friendly and relaxed despite the stress of the job. "We get about six hundred calls a year, between fires, medical calls and car accidents." They are very humble in their young attitude. "Just helping people is a big thing. That's what I like to do. But going into burning buildings is also thrilling; talk about an adrenaline rush. It's hot, you know, fire." Levi is the first to share his excitement but quickly becomes serious. "We'll go through the house first and make sure no one is in there; when you are in that fire and if somebody is in there, you are their lifeline, you know? If you don't find them, they don't have a chance. It's a lot of responsibility, but I'm good at it." He sounds very confident, and he has reason to be. "You join as a junior and train for a couple of years. When you turn eighteen you become a firefighter—that's a defining moment and you get to use all the tools."

"I still remember my first fire. It was scary! You can train for it but it is not quite the same as the real thing." Seth was there as well. "You'll never forget your first fire; that's something that sticks with you. We'd just turned eighteen, we were finally allowed to go in. It was an old Amish house, I remember the ceiling collapsed and fell down on some of the guys, right in front of me. But they were unhurt and we put the fire out and everybody went home." Levi is honest about it. "I was scared but, you know, I wanted to do it again. Just to help out again."

The job is serious but there is a light side to it. "We get to brag about it with our friends and the other guys at the firehouse; you come back and your hair smells like smoke, it's all dirty. Your helmet's a little black. We kind of brag, 'Hey we got to go and fight a fire and help out.' It's all in good fun." They are all friends but the fire chief is also the boss. "We're really good friends, but in an emergency scene you have to listen, you have to follow his lead. Ain't no joking around at that time. You have to know your boundaries, you have to have respect."

One fire that turned into a funny story still sticks out in Seth's memory. "We were in the middle of another Amish house fire, you know—we have a lot of Amish farms around here. Bullets started popping. The guy had a box of bullets on top of a furnace and that caught fire. We heard these loud pops and everything; there are so many sounds in a fire and we didn't know what they were until we saw bullets sticking in the rafters and the walls. We went out and checked that nobody got hit by one." He tells the story with a smile on his face. "We still talk about that call, and laugh out loud to this day."

But sometimes there is no happy ending, and fatal accidents still have an effect. "You don't get used to it—anytime you can't save that person, that sticks with you." Seth's tone is serene but serious now. "The first time was a motorcycle accident, a drunk guy speeding. Some were even worse. Bad crashes, people seriously hurt. They don't look like humans anymore."

These experiences leave a mark and everybody copes their own way. "This job is not cut out for everybody. You have to be able to put the bad stuff past you, right away. You still have a job to do and keep helping people. I am lucky that I get to go home, talk to my wife and I am all right. I don't know what I would do without her." Levi makes his point clear. "We have to keep doing our job. Somebody is having the worst day of their life and we are there to help—that's what it's all about. That's what we love to do."

Like many twins, their interests have always been very similar, and even now they both work in construction—hopefully not for long. "I applied for a full time position with the Fire Department in Washington D.C.," says Seth. "That's the only thing I would really love to do. That would be a dream come true."

Being married to a twin myself, I have to ask the classic question. "I am." Levi is prompt in his response. "I am five minutes older."

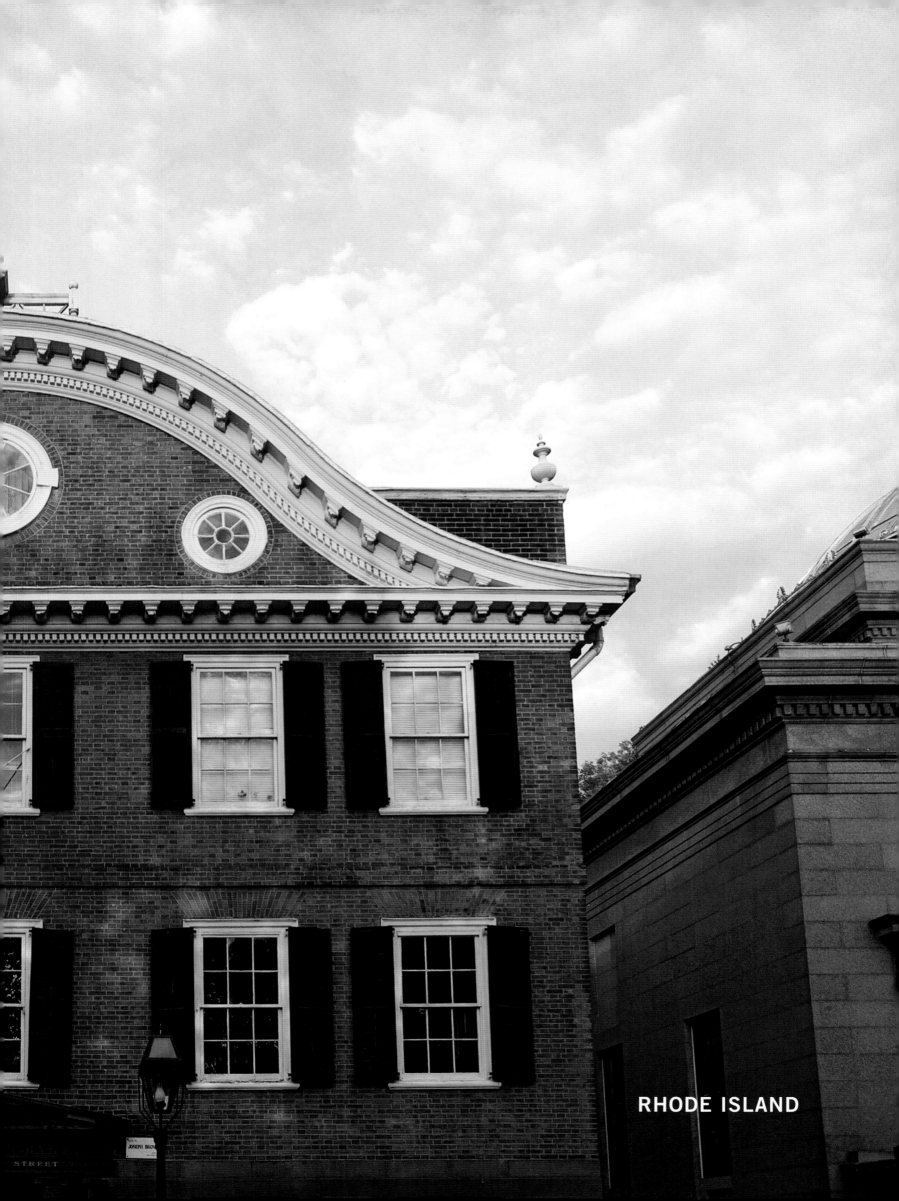

RHODE ISLAND

ANGELA FISCHER BROWN

PROVIDENCE ✦

"Built in 1774 by Donald Brown," states
the plaque at the entrance to the building in
Providence. "He was an ancestor of mine," says
Angela. "He lived upstairs and had the business
downstairs. He was in the shipping business; it
was very convenient, being so close to the river. I
have an office in here now." I marvel at the beau-
ty and history of the building. "My cousins own it
now. We all feel very nice about it. Historically, in
America, it's so unusual to have one family still in
the same place for so long."

The building's address has a peculiar story be-
hind it, as number 50 is located between num-
bers 74 and 121. Angela seems used to explain-
ing how that came to be.

"The city was building new courthouses and wanted to tear down my father's building at 50 South Main Street. He moved his offices here; he liked the number and didn't want to change the stationery, so he obtained to keep the address." He must have been an important man in town. Angela is not as impressed as I am. "They just weren't as bureaucratic as they are nowadays." My assumption doesn't seem so baseless after I hear about the relationship between Angela's family and Brown University, the great Providence institution. "My great-great-grandfather, Nicholas Brown, donated $5,000 to the school back in 1804 so they decided to name the school after him." Angela is a well-educated and well-traveled lady and we find a common denominator almost immediately when she asks about my accent. "I love Italy. I studied there in 1958," she replies.

I am blown away by the notion that she was in my country right around the time when I was born!

Life has been busy for Angela between school, raising three children, work and volunteering. The school part is particularly interesting to me. "I went to an all-girls boarding school in Virginia, where my mother was from. She thought the Southern ladies were a bit more charming. Very strict school—besides the holidays, we were allowed to go home only one weekend a year, and only if we had straight A's. It was a military school; we had to march, with rifles." Angela and rifles somehow don't seem to match in my mind. She went on to attend Harvard University. "It was called Radcliffe College back then." She likes to be precise. "It was for girls only, one of the Seven Sisters; now they put boys and girls together."

We find another common factor in our spouses, both from Brooklyn, NY. "I met my husband, Edwin, in New York, when I went to study at the Parson's School of Design. He was in medical school at Columbia. He became a neurosurgeon." Even though he was a Harvard graduate himself, they had never met in Cambridge. A mutual friend introduced them; they connected immediately and married soon after. "After forty-five years of marriage, I think I deserve the medal," she responds to my comment about putting up with the hours that a surgeon works.

Angela majored in Fine Arts, the history of art, and has shared her passion with many family members, including her daughter Olivia, a portrait painter and her late brother, J. Carter Brown, former director of the National Gallery in Washington, D.C. "He was very passionate about art. I was very close to him. Unfortunately he passed away young. He had multiple myeloma, a terrible blood disease. He was only sixty-eight years old." Angela and her husband spend time in Boston, where he still sees patients and she runs a lecture series at the Boston Museum. "We keep this place in Providence, where I have my office representing a few different businesses and we live in Newport. I am the vice president of the Preservation Society there and volunteer for many fundraising events." Their home overlooks the harbor, walking distance to their sailboat.

"Edwin loves sailing. He took his boat five times across the Atlantic. We even went to Russia one year." I admire her audacious traveling spirit, but she corrects me quickly. "Oh no—I flew and met him over there. That has no appeal for me at all. Three weeks sitting on a boat in the Atlantic. No thanks." I laugh at her honesty and she continues telling me about other adventures she experienced with her husband, this time more romantic, even during the dark times of the Vietnam War. "He was a surgeon in the Navy. I met him several times in the Far East. I remember one time flying to meet him in Bangkok; it was 1965. We stayed at one of those Grand Hotels with louvered windows and large ceiling fans. I thought it was one of the most fascinating places." I picture a younger Angela all dressed up, holding the arm of Navy Medical Officer Fischer, walking the halls of exotic hotels around the world. I make my obvious comment about how handsome her husband must have been in uniform. I love her response. "Oh, he still is!"

SOUTH CAROLINA

HANK BRIDGES

JACKSON✈

I have to admit that before arriving in Jackson, my knowledge of South Carolina was limited to Charleston. I had visited the charming city many years earlier on a photo assignment, during which I enjoyed the unique architecture of the downtown area and learned about its history, including its claim to the first Tea Party, a couple of weeks before the more famous one in Boston. I've also heard my mother-in-law's recollections of growing up on a farm just outside of Columbia. Her stories of milking the cows, picking cotton, and digging out potatoes remind me of my own mother's childhood, but with the added tragic aspects of life during segregation as a "colored woman," as Nollia Pearl still calls herself.

After a long struggle to find a subject for the book, the headquarters of Lafarge kindly grant me permission to photograph at their location at 50 Main Street.

I am a little surprised to find large cement silos on Main Street. Hank is the manager of the plant. The gorgeous sunny day and the industrial structure make the scene picture perfect, and I spring into action. "How do y'all like the heat?" says Hank when he sees me struggling to keep the sweat from dripping on my camera. "That's the South for you," he says, almost apologizing. "We have a very long summer—it's going to be this hot for another two months at least."

Hank lives just across the border in Augusta, and has lived in the South all his life. "I can't imagine living anywhere else. I traveled a bit, went out West and up to Canada, but I love it down here." He remembers where I live and tries to make me feel better. "I like it when I go visit a friend of mine that moved up to New York City, but after three or four days, I look forward to coming home."

He has family in this area—actually two families. "I have two daughters, Jamie and Allie, from my first marriage; they are in college now," he says, trying to explain, "and three kids that came with my third wife, Kelly." He likes to tell how they met. "We were both in the same supper club," he says, smiling. "We would get together once a month at a different house and whoever's house it was, they had to cook. We were both single so we decided to team up and do it at her house."

He still remembers what they cooked. "We made a Mediterranean-style chicken with olives, herbs and stuff. It was goood..." He asked her out a few days later and the rest is history. "We love family life. My mother-in-law has a house in Fripp Island so we all get to spend a few weekends a year by the beach. We love fishing there."

Life with children makes him reminisce. "I came in right at the beginning of the integration period. They were bussing kids all over to go to different schools. The parents were really the ones that had most of the issues with it, taking kids out of public schools and putting them in private schools. The kids seemed to get along fine and handled everything very well." He smiles at the thought. "I was brought up non-racially. My parents taught me to treat everybody the same." He pauses. "In a way, it was much simpler growing up back then. We could be children; nowadays you have to watch for everything. It is criminal if you let a child ride a bike without a helmet..."

He always tries to find time for his kids. "My dad was a doctor, an orthopedic surgeon," he says with a hint of sadness. "I was in the hospital many weekend nights with him. We would go out to do something together and then he would get called in for an emergency. He was on call all the time. He was too busy for me." His mother was busy as well. "Mom was a registered nurse and, after working in many hospitals, she helped Dad when he opened his own practice. She ran the office for him, so they had a lady watching all of us." Hank is the oldest of five siblings, three sisters and two brothers. They all live close by. "Mom and Dad are both retired. They're home all the time now. The bad thing is, we're not. We're working, we have our own lives, but we do try to see them as much as we can."

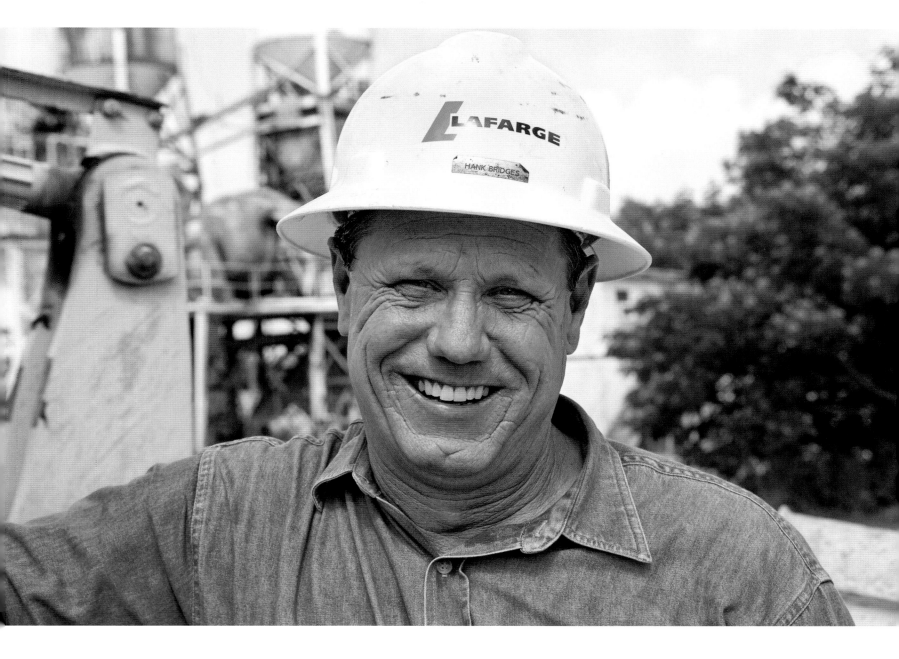

Hank loves working at Lafarge. "It's a fast-paced job; we have been very busy with the Savannah River Site, just a few miles from here. It was built during the Cold War, a lot of people worked there. They used to make some of the elements that went into the nuclear weapons. Now they are mainly in the clean-up stage. There are no more functioning reactors." The plant still keeps them busy. "They are now building a new plant where they will be converting weapons-grade plutonium into fuel for commercial power reactors."

He is optimistic about the future. "Life hasn't changed much in the South in the last thirty years, but I think things have gotten better in our society. There's a lot more opportunities for minorities, for the impoverished."

Hank has clear ideas of himself. "I guess you could call me a conservative," he says in his usual humble tone, "someone who works hard for what he has, cares about family and friends, and does not expect handouts from anyone; someone who feels in control of his own life."

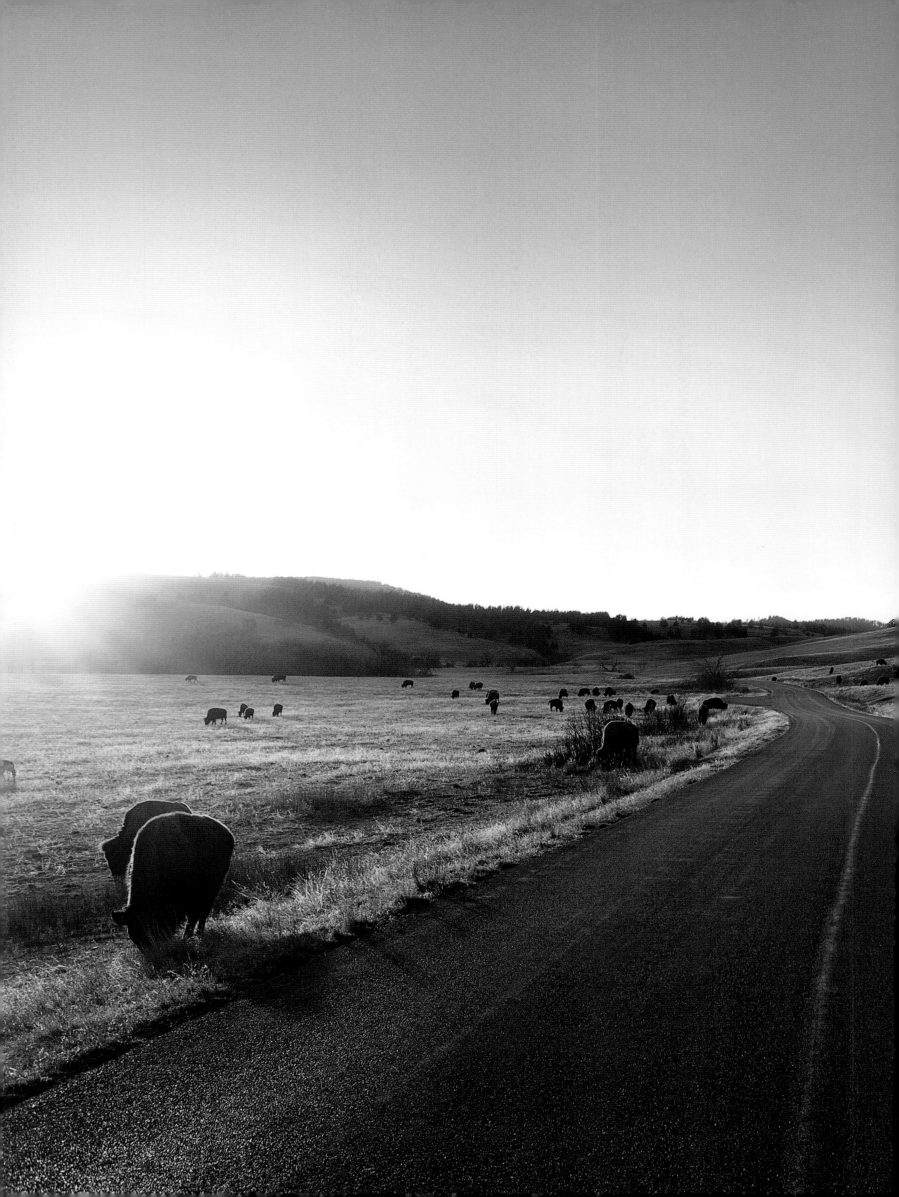

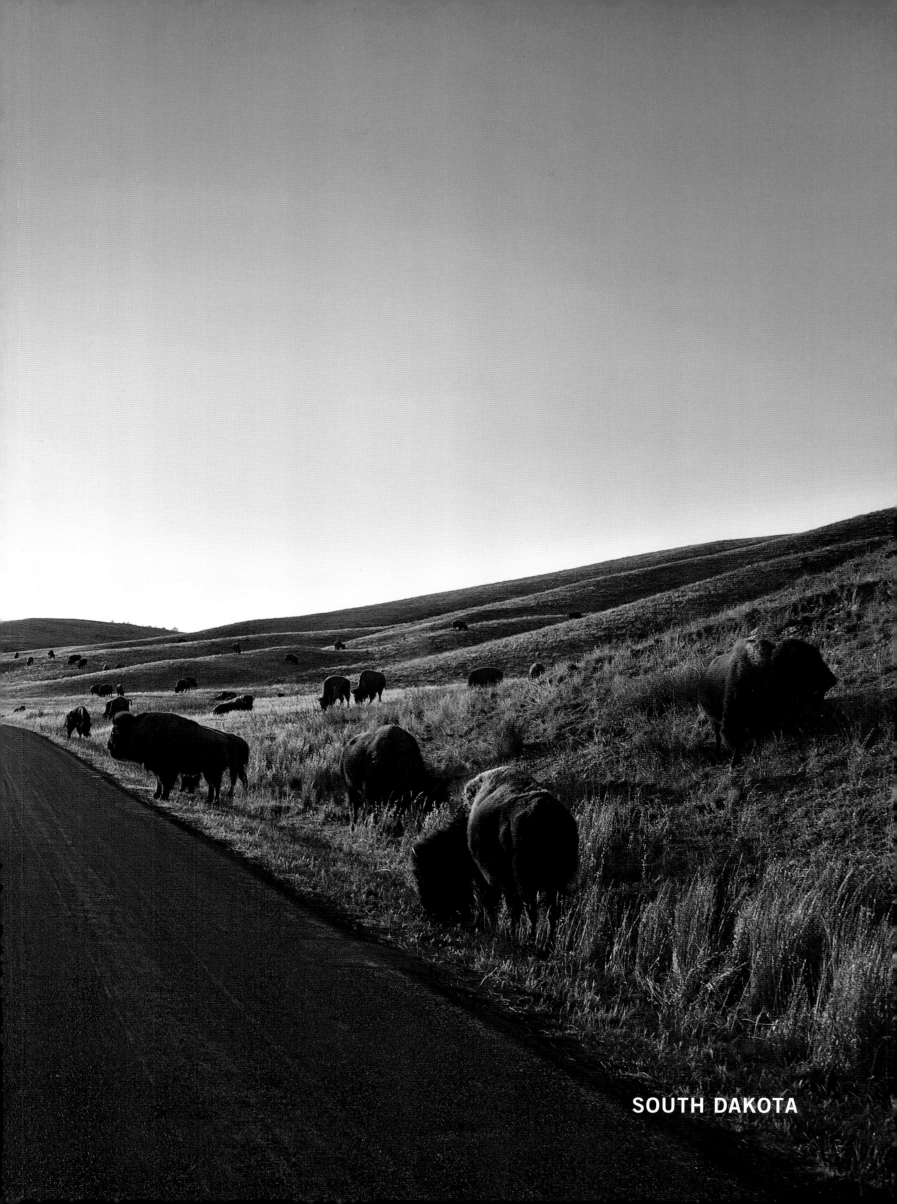

SOUTH DAKOTA

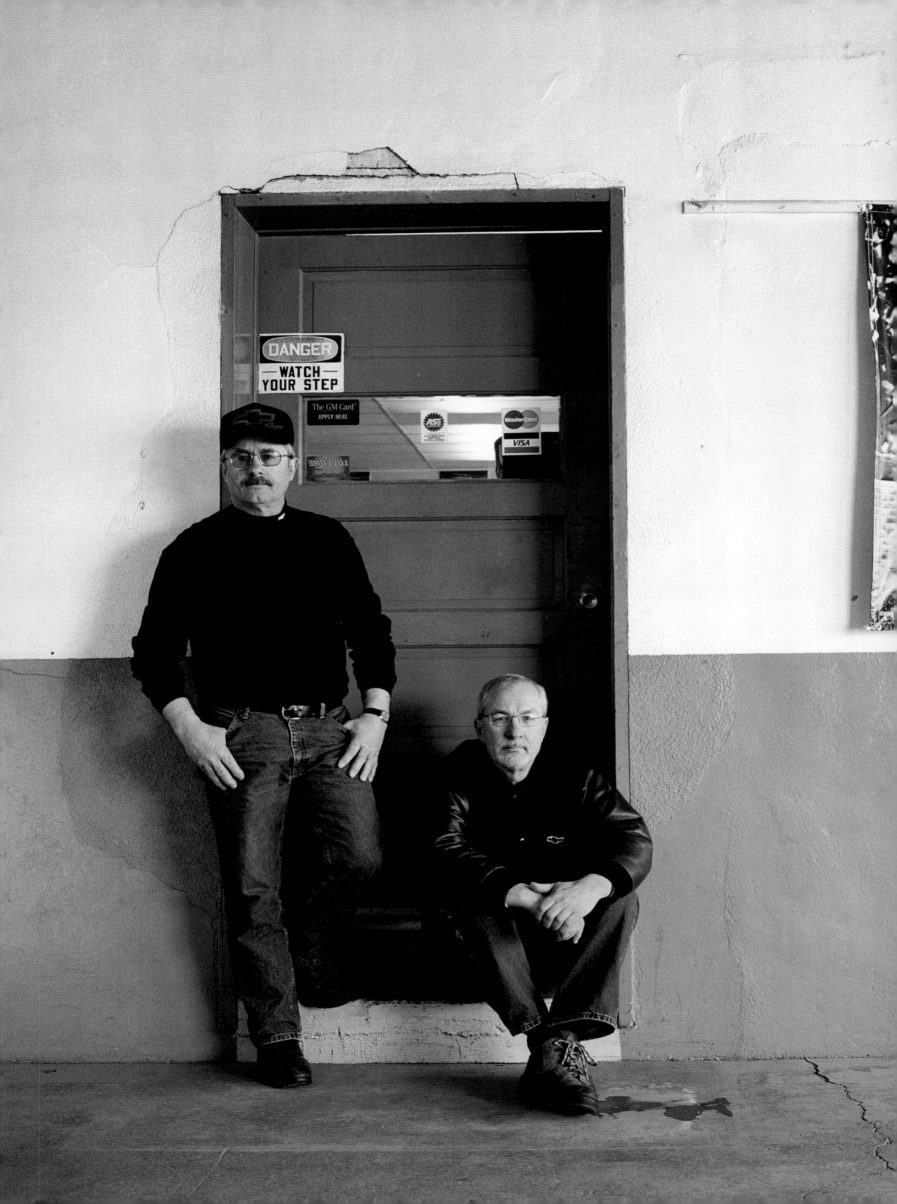

DENNIS & DON FECHNER

WAGNER ✛

"You were in the middle of nowhere, that's where you were!" Don laughs at my description of the drive down from North Dakota through snow blowing horizontally across the highway. In the middle of April!

I've just spent a couple of days with my friends Leonard and Oonagh in the Black Hills, traveled to North Dakota first and then down to Wagner. The long drive allows me to take in the beauty of the varied landscape and ponder the tragic history of this part of the United States. The excitement of seeing wild buffalo up close, the majesty of Mount Rushmore, and the stunning colors of the Badlands are contrasted by a somber visit to Sitting Bull's monument and the sorrow of the memories of Wounded Knee.

"I'm good, very good. But that's my opinion!" Dennis shows his funny side as soon as we meet. The two brothers have been working together for a remarkable thirty-seven years. "We always got along," says Dennis. "We grew up here. I worked with my dad in the shop, in the mechanic side of it. He taught me what I learned, the right way and the wrong way. Don learned bodywork so we complement each other. It is hard to find good help out here in rural America—young kids want to get out of here, go to bigger and better places."

A couple of Native American customers enter the brothers' Chevrolet dealership. "Wagner is in the middle of the Yankton Indian Reservation," says Dennis, explaining. "We do a lot of business with them, especially selling used cars." Don jumps into the conversation. "He's older but I am better looking!" he says, laughing, while Dennis takes care of the new customers. "We are only one year apart from each other. We are best friends, you know; we always did things together. We even married and raised families at the same time."

Doing things around Wagner seems to revolve around the Mississippi River, just a dozen miles south. "That's where we would always go on vacation with our families. Just camping, fishing, hanging out. Our kids loved it."

Dennis has been divorced for a few years now. "Failure to communicate" is his quick analysis. Don is still married so now they don't do as many things together as they used to. "I have been married forty years. We have two boys and five grandchildren." Don is very pleased with his family. Dennis instead is a little bitter about the divorce and sad about the loss of his second daughter. "She was in a single car accident, in the springtime, just a goofy thing, you know. Bad deal! We took it terrible—her kids were only two and four years old." His constant smile goes away for a moment but quickly comes back when mentioning his six grandchildren, four of them from his first daughter.

Despite that accident, cars are still their life's passion. "Each one of us probably had fifty hot rods over the years. We start with old bones and fix them up." Dennis introduces me to his 1967 all-white Plymouth. I admire all the details and the chrome but he is particularly proud of the sound it makes. "Half of the fun is listening to the car revving up. I changed three sets of mufflers before settling for these," he gloats.

The one time they went separate ways was during the service, in the '60s. Dennis went to Germany. "I trained and worked as a radar operator in Hawk missile systems. I think it was good for Dennis Fechner as far as becoming more of a man, so to speak. I had to grow up."

Don, instead, went to Vietnam. He is still bitter about it. "It was a political war. It was not good!" I ask him if he was actually in combat situations.

"Oh yeah," he answers somberly, "never went home for twelve months." I fail to understand his discomfort so I continue asking questions about those days. "They are not good memories and I am not going to talk about them," he states firmly.

Changing the subject, Don takes me to see his own hot rod. "The '69 Camaro is sort of a collector car—it's a hot number, so to speak." He has more numbers for me. "It's got a big block HEMI V8 engine, 496 cubic inch, 813 horsepower, 20" wide tires." Not sure what all that means, but it sure sounds quite impressive to me. "I am still working on it. I won first prize at a few car shows. I even got Best Engine at the Canton Car Show last year—it's the biggest show in the state." His wife goes along to keep him company. "She could care less about the cars," he says with affection, "she just sits and reads her books."

Dennis is enjoying being single. "I like to run around too much, so when I want to go I don't have to ask anybody," he says. "I went down to Automania two years ago. This year I am going to Devil's Run, in North Dakota." I guess he likes to show off his vehicle. "Oh yes, that's what the car is all about!" Between work and their hobby, the two brothers don't seem to have time for any other interest. As usual, Dennis is honest and funny. "Well, I guess I am just a car nut!"

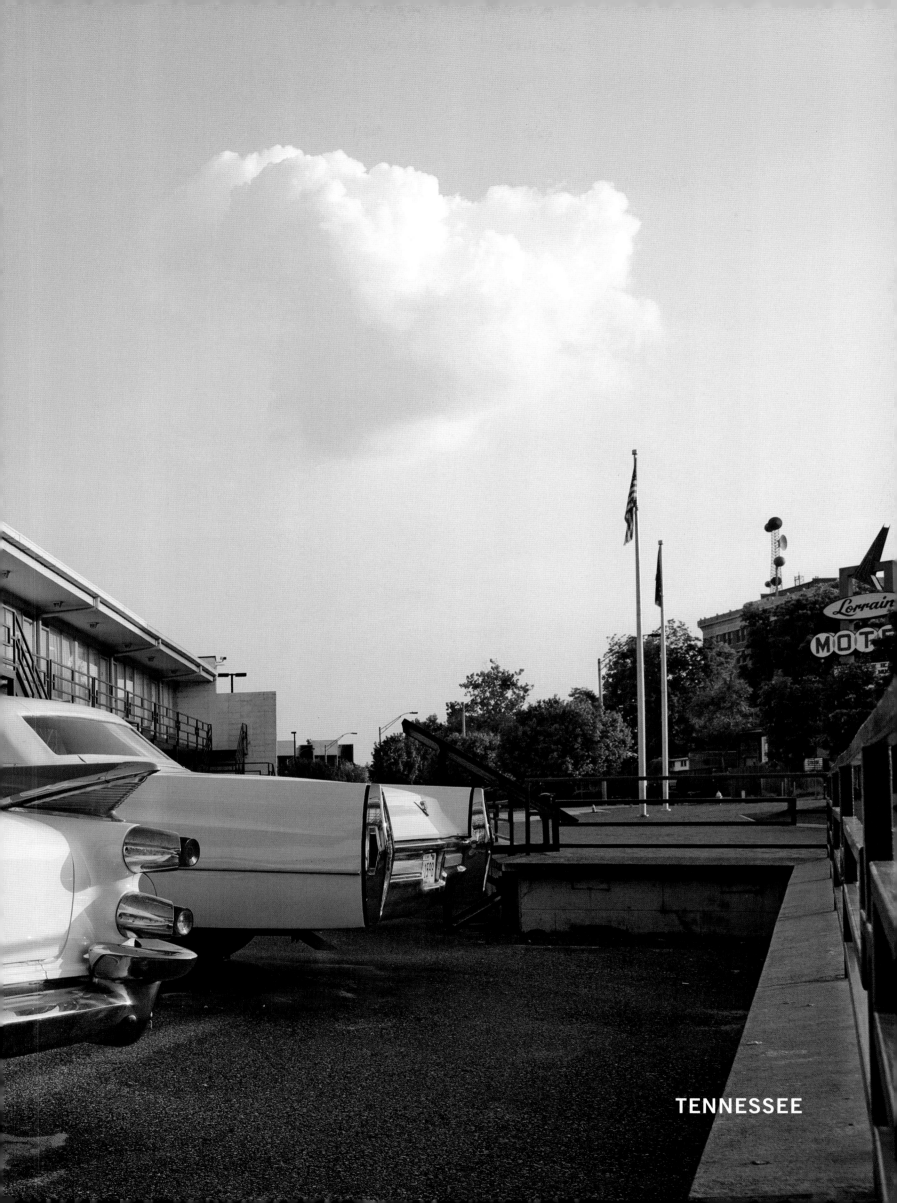

TENNESSEE

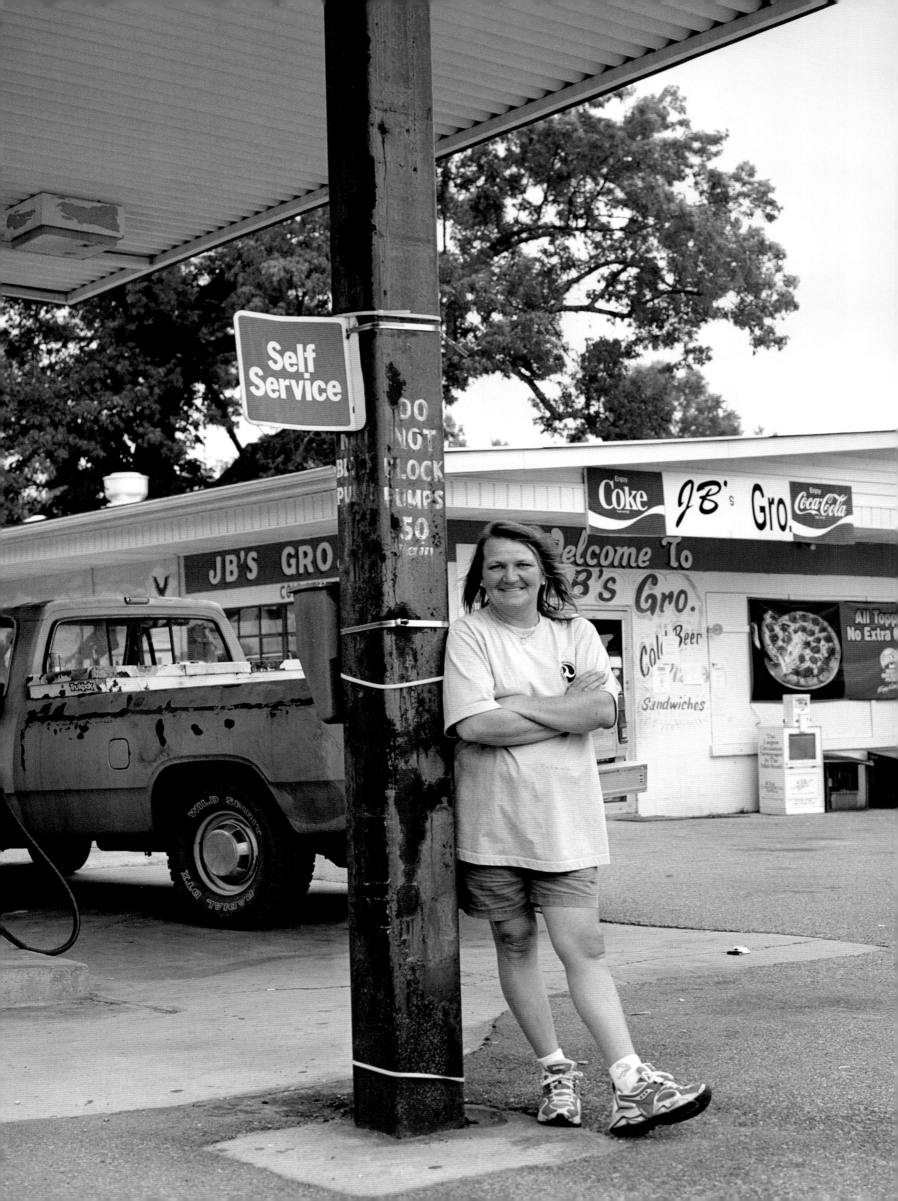

LYNNE SCOTT

SALTILLO ✦

America has always been a beacon in my life. I grew up loving rock and roll and blues music and I am very excited when I arrive in Memphis. The Mississippi River, Sun Studios, Graceland and the clubs of Beale Street revive mystical images and stir my imagination, but when I visit the Lorraine Motel, I am reminded of another event that made a big impression on me as a ten-year-old child. The assassination of Dr. Martin Luther King Jr. is certainly a dark moment in American history and a strong reminder of the enormous strides that this nation has undergone. I say a prayer for the inspiring American hero and drive out to Saltillo.

Lynne welcomes me with a big smile and I feel an immediate connection with her, because of our physical resemblance and, as I soon find out, our mutual love for Dolly Parton, one of Tennessee's favorite daughters.

"I only work here at the gas station in between construction jobs," she says. "A tornado hit about ten miles down the river. We went down there and helped them rebuild, pouring concrete, driveways, boat trails; everything the tornado took away that was ruined we built back, this time in concrete. We just finished up the week before last. We are not working construction anywhere else anymore, we are staying around here." I notice she uses the plural when she speaks so I ask who she is referring to. "My husband Larry. We used to move around; wherever the job was, we would go together, rented an apartment or a house and stayed until the job was done and come back this way, waiting for the next job."

Larry just happens to come by the station and we get to meet. He seems to always hold a cigarette. "I wished he'd quit that habit," says Lynne when he leaves. I ask whether she would ever be able to convince him to quit. "Are you kidding?" she says, bursting out in a loud laugh.

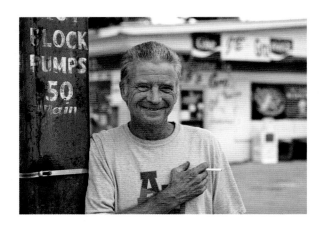

They met on a job. "I was operating a UM Levelling Machine at the steel plant. I was the first woman to ever be trained for it." She sounds proud. "It levelled; it kept the camber out of the roller steels. Take the camber out, cut it to length, a flat sheet, whatever it was for. The mother plant was in Brooklyn, Ohio. I took my training in 1997 and I stayed there until 2001, when the industry started going down." She eventually got to move closer to home. "They built a plant down here. They put out an ad in the paper. Out of 27,000 applications, I was one of the 1,500 finalists and then I made it down to the last eighteen, so I got hired." She is humble but self-confident. "They were looking at our work history, and what we were capable of and, you know, if you could handle giving other people the knowledge that they needed, telling people what to do, and carry on with your job without having somebody over you all the time." Other factories in the area, the jeans manufacturing plant and the sawmill, either closed down or cut back, leaving hundreds of people out of work. "It doesn't take much to put a small town out of business," she says sadly. She felt bad when the steel plant closed and let her go. "I would have liked to stay," she says honestly. "The money was good. But you know, if it's not there, it's just not there—but there were still four-lane highways and stuff to build, so I moved into construction. I liked the steel mill, though. I mean, it was a hard job, but it was a good job." She is still proud of it as well. "It was the first steel mill of its kind to ever be built in the South."

She likes surprising me with information like that. "We go fishing down to the river, the Tennessee River—it's the only one in the United States that runs backwards." She laughs out loud at my perplexed look. "Yes, it runs South to North, up until around Knoxville. It's kind of funny when you are sitting there looking at the river and it's going right backwards." The river is only a couple of miles away from her house, but that's where Lynne and her family spend their vacations, like many others. "Lord have mercy, it gets crowded in the summertime," she says in frustration.

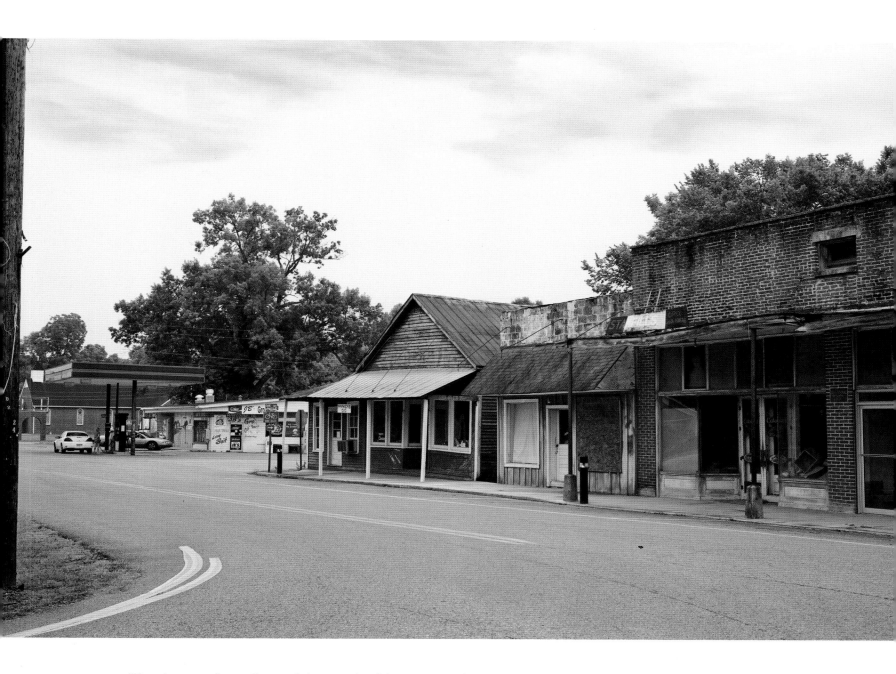

"People come from all over, Arkansas, Louisiana, Texas—they all come on the holidays. I guess you can call Saltillo a recreational town because in the wintertime it's really, really dead, but in the spring and summer, it's just absolutely bursting at the seams with people having fun."

Lynne has practical reasons for enjoying the river. "We have boats but we don't go out riding in the river just for fun. We go out fishing. Groceries have become so expensive," she says, "you can't get much with $100 these days. You have to use coupons and shop in three or four different stores if you want to make ends meet. Fishing helps us. We catch catfish, stripe, that's mainly it—I don't care much about the bass."

All the talk about fishing reminds her of the son and husband waiting for her at home. "I have to go home to cook dinner," she says while I am packing up my cameras. I ask her if any of the guys at home can get dinner started before she gets home. She bursts out in the laugh that I've gotten to know by now. "Are you kidding?"

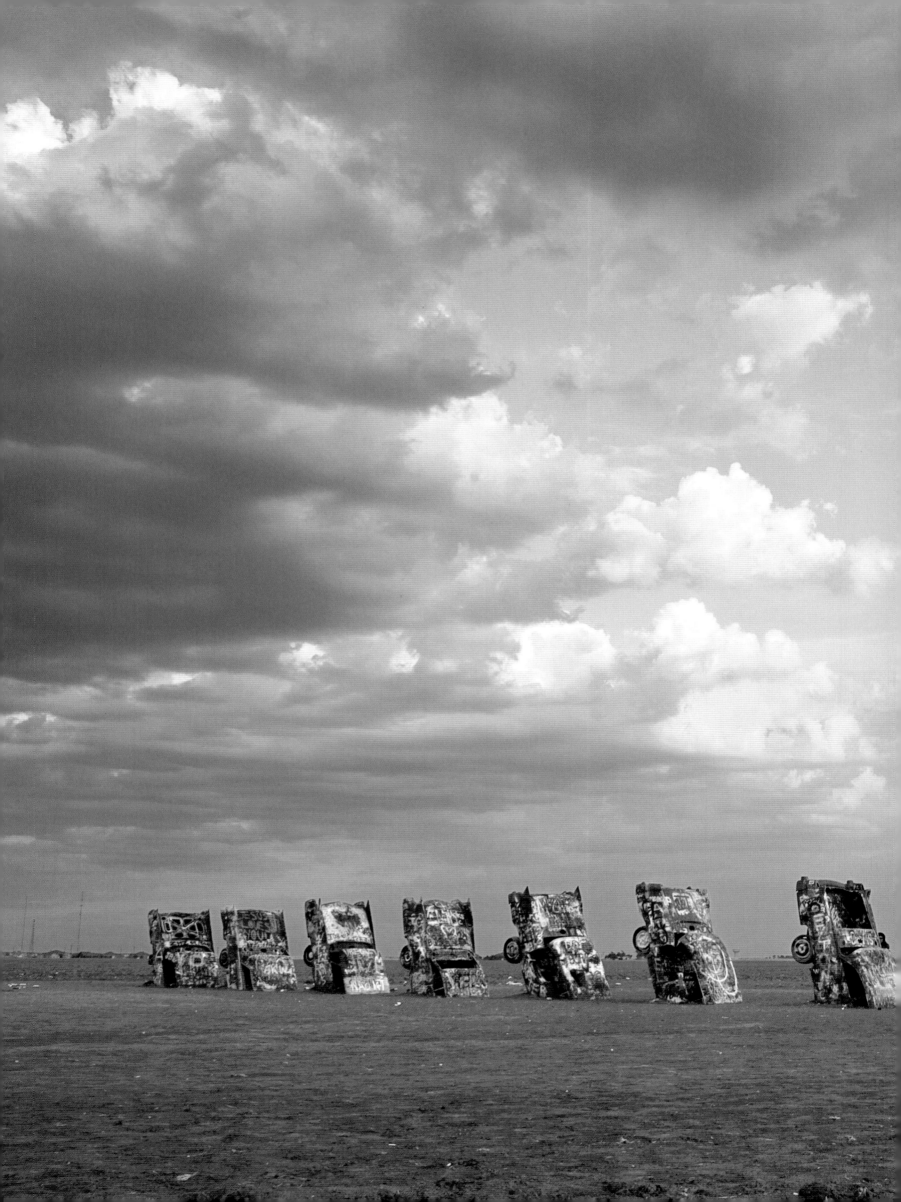

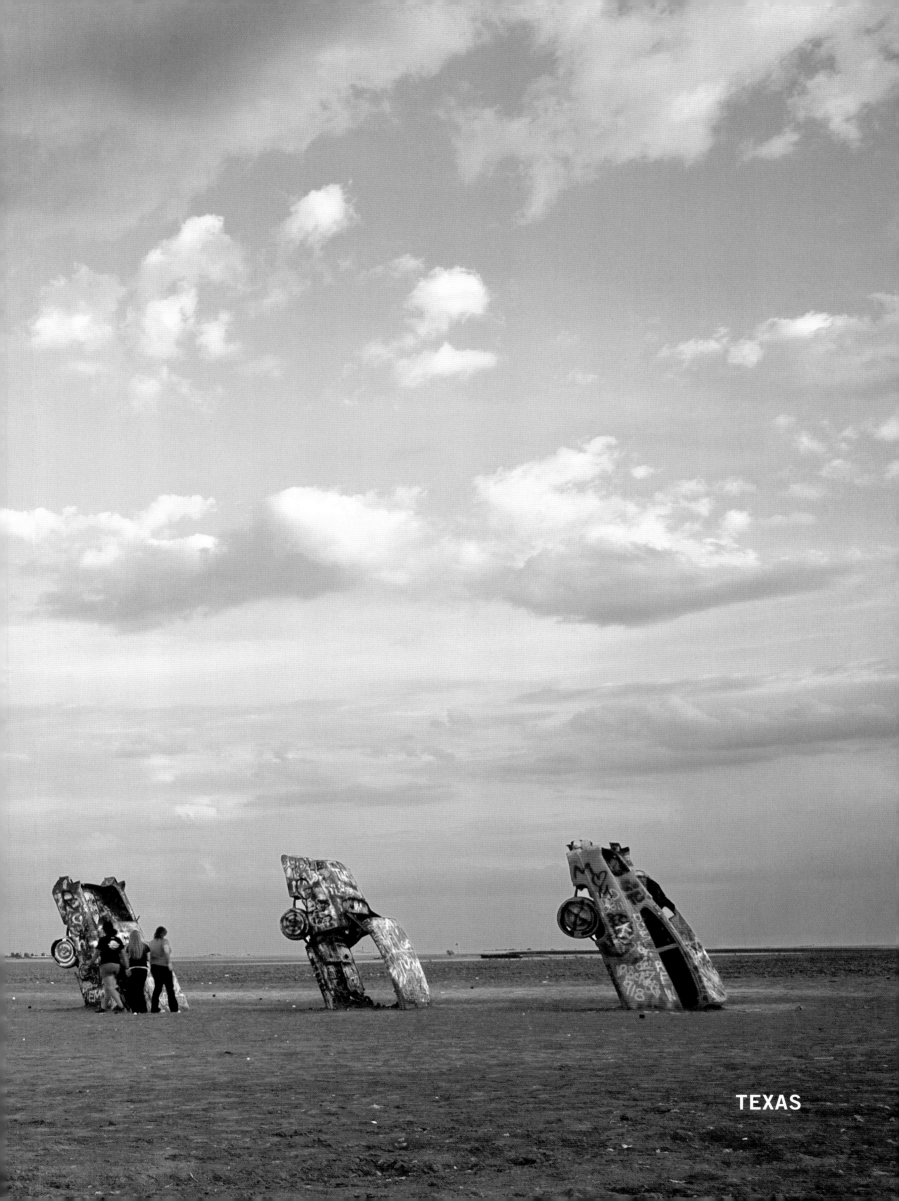

TEXAS

HELEN & MIKE MOSHER

PARIS ✦

Texas holds a particular place in my heart since the summer of 1985, when I joined my friend Peter in Dallas and we drove back to New York together. I remember having a very hard time understanding the locals' Southern drawl, but we nevertheless had a great time, and I still hold in my wallet a coin that I won playing a game at Billy Bob's Honky Tonk in Forth Worth, my first taste of cowboy country.

More than twenty years later, when I first meet Helen at her favourite lunch place in Paris, I am very pleased with my understanding of her accent. "I am actually from Upstate New York, near Ithaca, in the Finger Lakes region," she says, laughing at my early assumption.

"Actually, a fortune teller had told me that I was going to marry in Texas," she says, explaining her journey. "I met my husband, Mike, in New York. He is in a mediation meeting now, who knows when he'll be done..." Waiting for Mike gives us a chance to explore the city. "Paris is small," she says while driving around town. "We don't have a rush hour here, we have a rush ten minutes!" Helen smiles and a couple of tiny wrinkles appear on her face. I am shocked when she tells me that she is fifty years old. The tour of the town starts from Mike's law office at 50 South Main Street, where Helen works part-time. She shows me the old part of town and the cemetery. "Strangely enough, I love this spot," she says, showing me some very decorated headstones. "I love the one with Jesus in cowboy boots." And then she takes me to the Tower of Paris, a miniature version of the Eiffel Tower in France. "They built the tower first, and only years later they added the hat," she says, pointing at the red cowboy hat perched on the top. She got used to her new hometown.

"We love to ride our bicycles on these long, straight roads. I love the wide open spaces, but the one thing I miss is the church. I grew up in a traditional family so I always went to the Greek Orthodox Church, and Paris doesn't have one."

We finally meet up with Mike. "We are going for a ride!" he says, establishing his personality. I convince him to take some photos in the main square not far from the office. "I performed in a few plays in that theater," says Mike, disclosing his passion for literature and the arts.

Mike is serious about their routine ride, so we head home where they change into their bicycle gear; I follow them for a while until the sun is about to set, and I take some more pictures.

"You have to stay for dinner—I would be remiss if we didn't show some Southern hospitality," Helen says ironically. I am thrilled to join them for a homemade dinner.

Their interaction in the kitchen is interesting. Mike's bursting energy and Helen's polite style are such a sweet combination. "'How far are you running?' That was Mike's pick-up line when we first met," says Helen, reminiscing. "We met jogging in a park in Queens, NY," says Mike, taking command of the conversation. "I was working in a corporate law office in the city." He alternates between his story and a sip at his glass of wine, which seems always full and never empty. "I got an English degree and taught at the University of Texas in El Paso. I left the teaching and went up to New York to write the Great American Novel. I couldn't get it finished because I didn't have enough self-discipline. No one to blame but myself. But I'm still writing one now," he says, bursting out in a raspy laugh. "I try to find time to write while running the law office and managing my six-hundred-acre ranch outside of town."

It sounds like his private playground. "I like to hunt for deer, ducks and rabbits. I keep busy at the ranch; I build and fix the fence. I brand cow…" Helen interrupts him laughing. "He likes to drive around in his SUV with satellite radio and the air-conditioning blasting."

A big, blue-eyed Akita dog bursts into the room. "Koda is the only child we have left with us in the house. Our two sons are now studying at University of Texas in Austin. That's my alma mater," says Mike proudly. "I miss them, especially the time when they were in Little League—they played baseball, soccer, ran track," says Helen. She likes the athletic side of her men. "I played football, baseball and basketball myself," boasts Mike. "I had a football scholarship and then I busted up my knee. I had to give it up."

Helen is more humble, as usual. "I didn't have time for anything athletic when I was young. My father had a Greek diner so I had to help out, like everybody else in the family." She made up for it. "But I ran five marathons in my forties, though!"

Mike is now in the middle of the kitchen, looking around for utensils. "Why can I never find what I need?" he says in frustration. "Because you are a man!" is Helen's immediate response. This time Mike looks at me with a big smile on his face. "She may be right about that!"

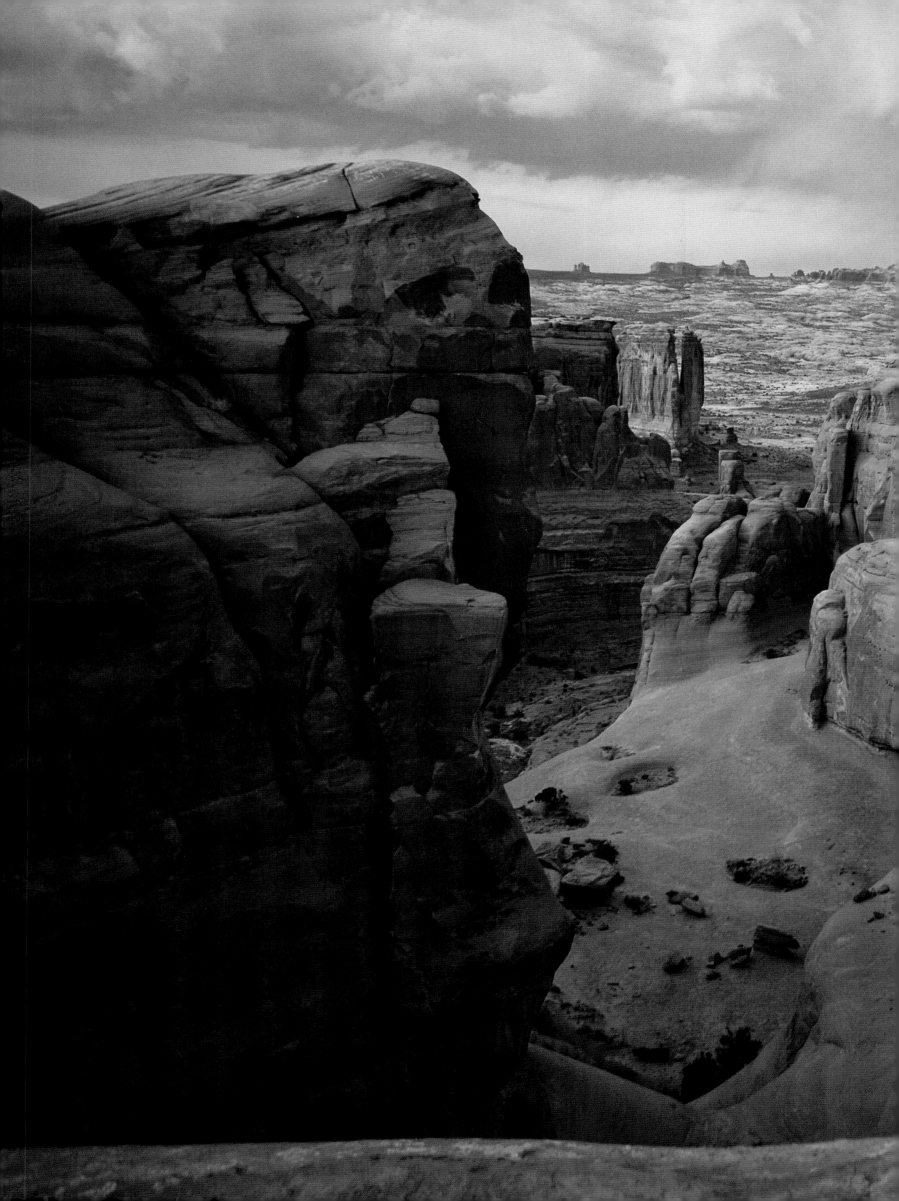

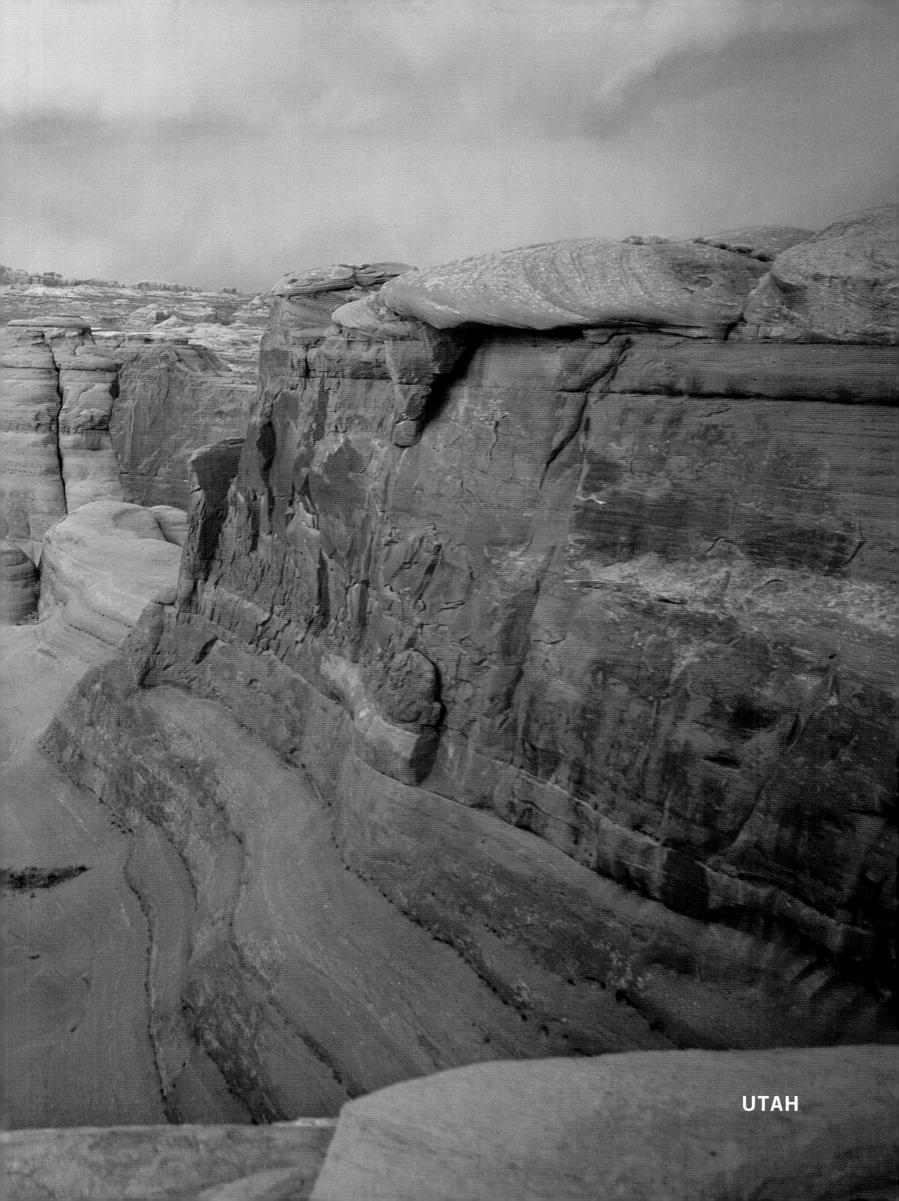

UTAH

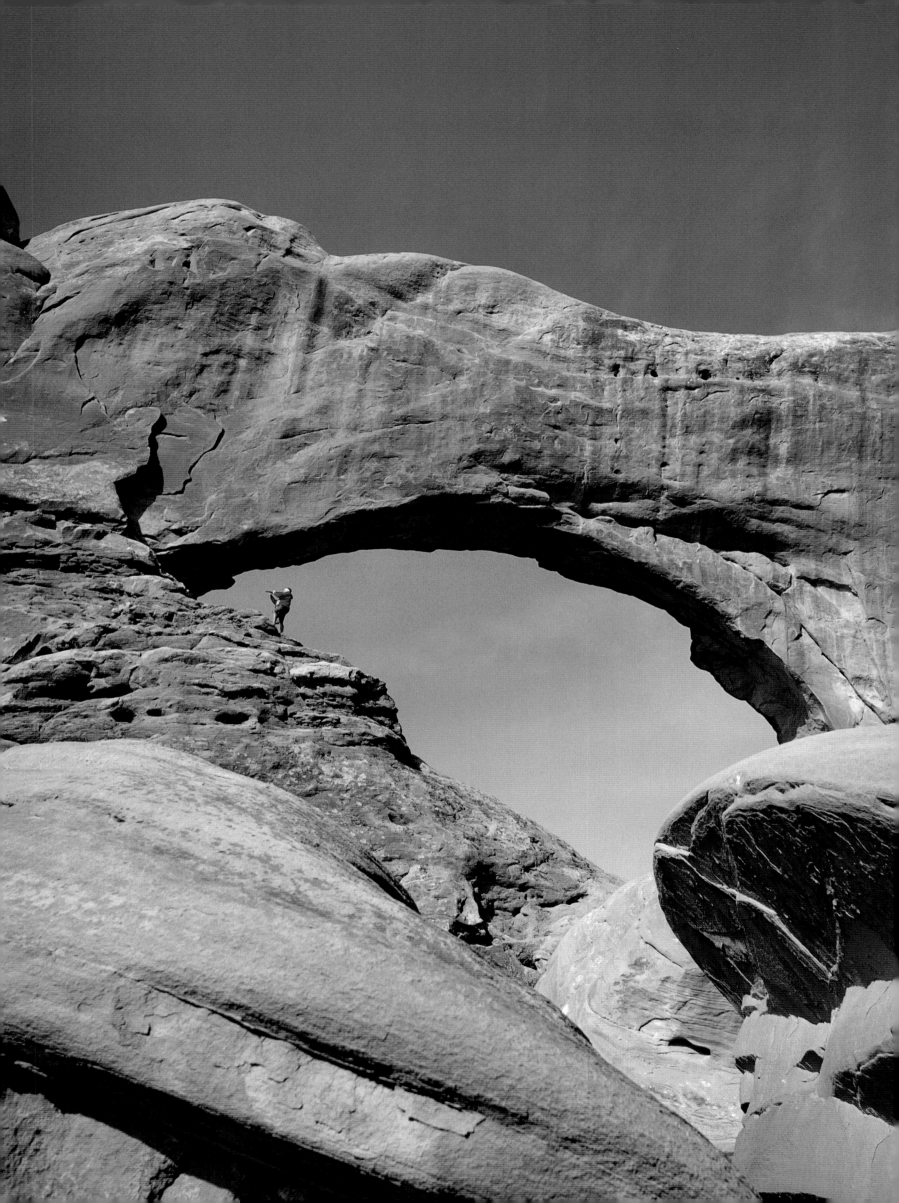

KEVIN FITZGERALD

MOAB ✦

You might have seen or heard Kevin already, if you ever visited Arches National Park in the early morning. "I come up here a few times a week," he says while walking to one of his meditation spots. "I play the shakuhachi here, at sunrise." Kevin is an unusual real estate agent; I missed him at his office the night before, so we agreed to meet first thing in the morning, in the environment he prefers: nature.

"I grew up on a big dairy farm and worked on it for thirty years. I was always in nature, always planting, always living with the moon cycles, the sun cycles, the equinox, the solstice—it was all based on the seasons, you know. So I was always interested in the fact that that's how we exist, through nature, through life. Life is only here because of Mother Earth."

After I take some pictures at the North Window, Kevin convinces me to go on a hike to another of his favorite spots. "I have a secret place where I play the flute at sunset. For my birthday I like to go up there and do a dance, in my birthday suit." I get the first glimpse of his personality.

We spend the day taking care of some real estate business at Angel Rock, at 50 N Main Street. When Kevin is done with his chores we head to the secret spot and I get to learn more about him. "I was an only child but I had Navajo brothers when I grew up. My family is Mormon; they were part of an organization that took in boys in need from Native American tribes, and that gave me the opportunity to get exposed to their culture." All of a sudden Kevin lets out a loud scream. I look at him, startled. "We have to warn the spirits that we are coming," he says seriously.

What Kevin calls a hike starts to feel more like a climb to me, the path as steep as a wall at times. I have a hard time keeping up with Kevin, who is busy telling me more stories from his early days.

"When my Navajo brothers' father died, we went to his funeral. It started out as a Mormon funeral, but right in the middle of it, the Navajo shaman and the medicine man came up and took over the ceremony." He laughs at the thought. "They started singing, and chanting and crying, lit up some sage, eagle feathers. When it was over, putting the dirt on the casket, then there was a celebration. We had a very good meal; we all sat around and swapped stories about him. I was seventeen. It was very, very influential on me. I had a whole different look at how to respect life, and how to respect death." I am fascinated by the story but also worried about myself, as I have never been on such a steep hike.

"Thank you, Great Mystery!" Kevin manages to startle me once again with another loud announcement. "The Native American tradition believes in Great Mystery," he explains, "the mystery of life. The great mystery of creator is here on Earth with us, and his spirit is everywhere, and that's basically how we exist, through his spirit. There's no real form to it, we can't really define it because it is a mystery, but we know that it exists because we, ourselves, exist."

When we finally reach the top, the rocks around us glow in the sunlight, carved by millions of years of erosion. "Water always overcomes rock." Of course Kevin has something to say about it. "Softness always overcomes hardness, with time. It is so clear here in the Moab area, because of all the arches. It's a very powerful statement of how softness overcomes the hard."

The sun is setting. I take many, many pictures and Kevin starts playing the flute. "The first time I played it, I sat down for an hour and I didn't get any sound out of it. Then I realized that I was fighting it too much. I needed to intend that the sound come out the flute, and immediately I got a sound. It was one of those meditative instants, where you go, it's not about forcing the issue, it's about letting the issue happen with you. Come from your spirit of intention, and God, all of a sudden, I had music. It was a great moment!"

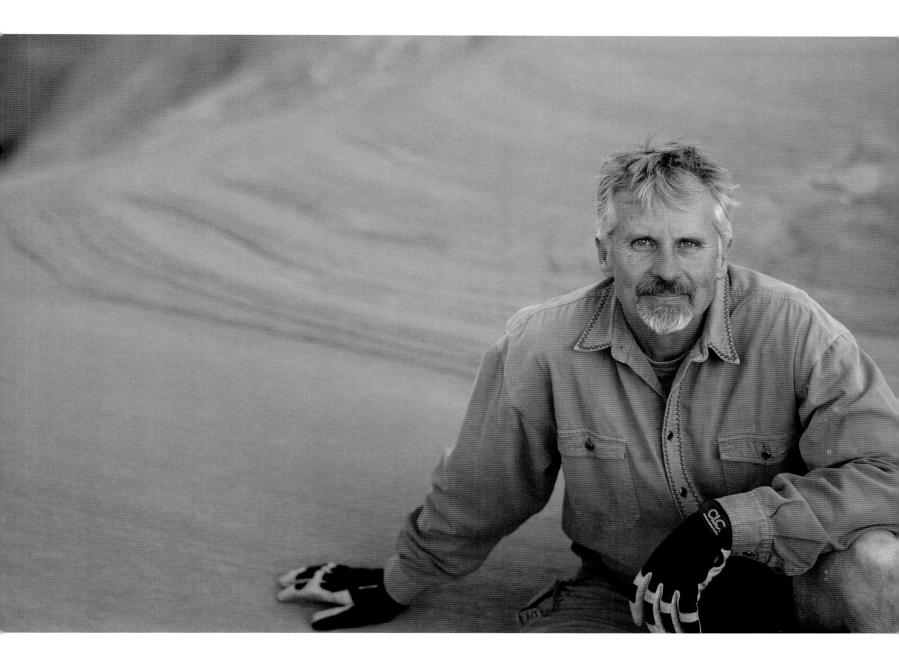

By the time I am done taking pictures, the sun has gone down completely—and we still have to hike back, down the steep rocks.

Kevin offers to take my backpack with all the cameras and we head down, in the moonlight.

I am actually afraid for my life, but we safely make it back to flat ground. Emotionally drained, I embrace the side of a large rock. I close my eyes and the clear image of my father comes to me, thirty-five years after his death. "He must have been an adventurer" is Kevin's explanation.

"The rocks are the memory of the earth," he says, "every sunrise, sunset, moonrise, moonset, the weather—the rocks store that information. If you walk into a sacred space with those rocks that are there, that space is there, remembers who you are. Out of your presence, your essence for that moment is radiated into the rock."

I am not following Kevin's thoughts, still flabbergasted and overwhelmed by the vivid image of my dad, and only one response comes to my mind. "Thank you, Great Mystery!"

VERMONT

DENISE SMITH

ST. ALBANS ✦

The yoga studio at 50 Main Street

in St. Albans is a quiet oasis on the top floor of a building busy with election headquarters and various shops in the center of town. "I just opened the studio," says Denise, smiling and touching her belly when we first meet, "just before I found out that I was expecting." The sense of serenity in the place is palpable. "I picked up yoga because I had a bad back," she tells me with a giggle. "I am very pragmatic about it. I love Bikram yoga because it's very structured: always the same ninety minutes and the same twenty-six postures. You always know what you are going to get. We practice it in a heated room, very hot and humid. It relaxes the muscles and makes them more malleable, improves blood circulation, and it helps with detoxing the body."

"The discipline is not so much spiritual but rather about the physical, the postures—we call them asanas—and the healing of the body, considered the house of the soul." Denise is very passionate about it and has enormous reverence for her guru, Bikram Choudhury. "I look at him as a master. He took his own form of Hatha yoga from India to this country. He has done a really good, good thing." She mentions one of his quotes as a life-changing factor for her. "'What you do with your days is what you do with your life.' It was a revelation for me; I was always swamped in my daily business routine that never left me any time for myself. I think I was open to hear it at that moment; it struck me that I needed to change what to do with my days, so I quit my office job and started my own business." Her husband helped Denise through the difficulties starting out. "It wasn't always easy financially, but I guess that happiness has a price. I am so glad I had a chance to become a yoga teacher and for the opportunity to change lives."

Denise has always liked doing good for others. "Right after college I joined the Peace Corps and spent two years in Mali, West Africa. It was a life lesson. You learn quickly that you have to pick your battles." Her tone changes, thinking about her experiences in one of the poorest countries in the world. "Even after all the training I went through, it was hard to deal with that level of poverty. But I came to realize that they were very happy people inside, even though they had next to nothing." She gained a new appreciation for life. "I knew I was going into a community that was two thousand years old," she says with a lot of respect. "I don't think the Peace Corps is about changing the way people farm or the way people live their lives, nor would I want it to be that. I think the Peace Corps is really about having a cultural experience; you are meeting people and they are meeting you and you get an exchange of ideas." She pauses. "It's like what you want to do with your book; these experiences make you realize how much we have in common." She found strength as well. "The experience taught me the value of problem-solving, being resourceful, and trusting my instincts. It made me determined to make my world a better place—and by my world, I mean the whole world. I have an all encompassing vision," she says with compassion. At her return to Vermont, Denise met her husband. "When I came back from Africa I went to work for the local Chamber of Commerce and then for the State of Vermont. That's where I met Tim. Not a very exciting story," she says with her soft laugh. "We were colleagues and friends for two months before he actually kissed me. I remember it was the Fourth of July." Just a few months later he surprised her with a romantic weekend in Paris. "We were there only for four days and then, on top of the Eiffel Tower, he proposed!" Onyx, their German Shepherd-Husky dog, has been with them for the last five years. "He has been a faithful companion but also a good way to practice for our own family," she says, caressing the dog.

Denise is going through all the feelings common to expecting moms. "I have all these doubts about not being able to provide for the baby, but the excitement of bringing a new person to this world..." She pauses. "There's nothing like it."

I am touched by the depth of her love for Tim. "It's unfortunate that he can't feel what I am feeling inside of me. It's very special, you know." She seems out of words to describe her feelings. "This embryonic thing—and then all of the sudden it's going to be a person. It's crazy!"

They don't want to know whether it's going to be a baby boy or girl in advance. "We don't want to find out until when the day comes. There are so few surprises in life," she says with a hint of naughtiness, "at least let us enjoy this one."

Tim loves to play hockey and I suggest maybe he would welcome a boy over a girl so he could teach him the game. Denise defies that notion vehemently; "Girls can play hockey too!"

VIRGINIA

GLORIA, EMILY & JAKE DIAMOND

NEWPORT NEWS ✈

"This address was always special to me," says Gloria when I meet her at 50 Main Street in Newport News. "Even my ex-mother-in-law told me not to ever leave."

Born and raised in the suburbs of Philadelphia, Gloria moved here fifteen years earlier following her husband, stationed at Langley Air Force Base. "I love it here. It's really a special place. It's an old town, in suburbia." She stumbles, trying to find the right words. "The neighborhood is called Historic Hilton Village; our house was built in 1918. The older style of the houses reminded me of home. There's a church on each corner. The kids actually play outside. We've got a river down the road where we can go watch the sunset. The neighbors are all friendly and talk to each other. It's just a nice, close-knit community."

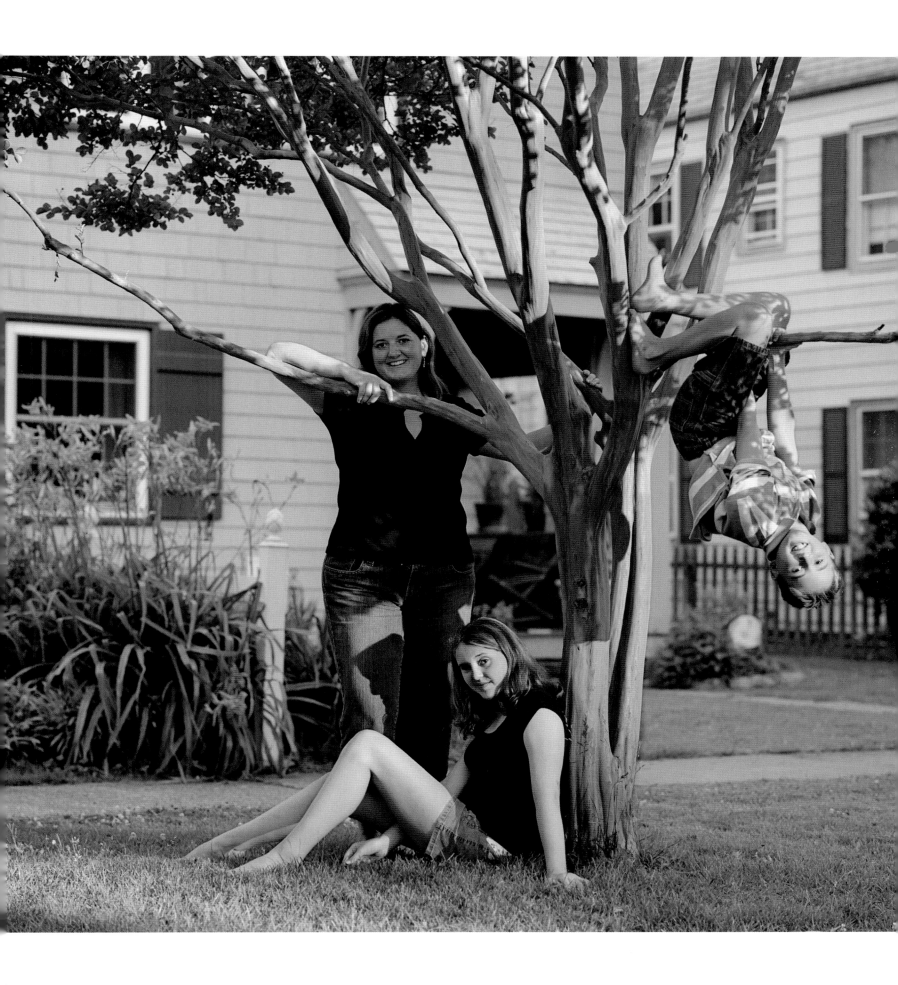

"We have sidewalks here." She laughs saying it, realizing it might sound strange to me. "I grew up with sidewalks," she continues. "I didn't realize there were so many places that don't have them, until we started looking for houses. That was one of the things we loved when we came to look at this house. There's an elementary school at the bottom of the street; we saw mothers pushing the strollers and the kids riding their bicycles, people walking their dogs, the trees lining the streets—it was just nice and we loved it right away."

And it is on Main Street. "On any government holiday they hang the flags from the street posts; it's a very old town kind of charm. We have the Fourth of July parade every year!" She gets excited at the idea. "The kids decorate their bikes and the fire department comes out; everybody claps for them alongside the road. My kids have been decorating their bikes for years in the past. Now they're decorating their cousins', my sister's twins." Her mother and sister moved down the street a few years ago, after Gloria's divorce.

"We make a better unit together," says Gloria, referring to her relationship with Emily and Jake after the divorce. "The kids were pretty upset about it at first. But then we learned to work together. We are very close and considerate of each other." Gloria has a remarkable relationship with her children and has been able to maintain a positive outlook on life even through tough times. "Emily needed twenty-one surgeries before she was three years old. We were lucky to find the doctors at the Children's Hospital of the King's Daughters. We were beneficiaries of the Exceptional Family Member program; it helped us stay close to where our doctors were so we didn't have to move around like other military families." A roller coaster of emotions. "It was really difficult. You know, you have your first baby and you are counting fingers and toes, and wanting everything to be just right. The day Emily was born the doctor told me that she might not make it past three or four. She had her first surgery when she was two weeks old, and the last one a few weeks before her third birthday."

Gloria had to adapt to life as a single mother. "I was a stay-at-home mom when I was married so after the divorce I went back to school for four years and became a nurse." Her priorities are very clear. "Emily and Jake are the most important things in my life," she says without hesitation. "I only have them for a few more years—I want to make the most of it. We try to go on different adventures. We went rock climbing in New York and Jake and I got to fly a small airplane last spring." Gloria enjoys being a hands-on mom. "I got to be the Girl Scout leader; I help coordinate with Bible School and with the swim team; I try to be there for my children through all of their activities. I went camping with Emily and her friends.

I helped them sell Girl Scout cookies, even took belly-dancing classes with them, to show them something new." I try to imagine Jake's face when looking at Gloria and Emily practicing belly dancing together. "It was lots of fun. I like that the kids didn't mind having me around at that point."

The children have gregarious personalities. "There usually is a group of kids at my house, whether it's girls having a sleepover or the boys skateboarding outside."

Emily is interested in going to film school. "She wants to write movies, and will often take a script and try to rewrite it or come up with a different scene. Her bedroom walls are covered with movie stars." Jake's room, instead, is a boy's room. "There's a lot of Speed Racer on his walls and some skateboarding; he's got an Abbey Road and a Woodstock poster. He's a really neat kid."

Gloria is happy the kids didn't get too involved with computers and video games but embraced the new Beatles Rock Band they just purchased. "Sometimes I join in and play, but mostly I like listening to them. I think it's fun. I'd be in the kitchen baking cookies while they're playing; the sound of them laughing is just music to my ears." Her approach is very simple. "As long as they are happy, I am happy!"

WASHINGTON

PAT WEEKLEY

COUPEVILLE ✛

"Fifty people, all living at 50 N Main Street, and all of them over fifty years old." Pat laughs, responding to my explanation of the book. "I live and work here at Cam-Bey," she says in her gentle tone. "Senior Services of Island County owns this apartment complex for seniors."

She just turned seventy years of age, but she keeps busy with work. "One of the hats I wear here is that of the assistant manager for the apartments, so part of the job is dealing with maintenance issues during the day and then, since I live on site, if something comes up at night, they call me. I am also the director of the Volunteer CHORE program for Senior Services. The island's transportation logistics are difficult for people that can no longer drive," she explains.

"We provide services for the people who need help getting to medical appointments, which might be here in Coupeville or it might be as far away as Seattle. We did 1,283 trips last year and drove 61,000 miles," she says proudly. "That's a lot of driving and a lot of people we are helping on the Island."

Pat has been working at Cam-Bey for ten years. She really cares about her fellow seniors' issues and puts her heart and soul into it. "We are upset these days. The state wants to cut funding for these programs. I think it's a horrible thing to do." She loves the island as much as her job. "The quietness, the absolutely stunning beauty that there is all around here. It's just the most marvelous place. As you're going down the highway you can see Mount Baker, you can see the Cascades, and the sun coming down on the mountaintop and glistening on the snow, and it is so breathtaking; you look in another direction and you are looking out into the Pacific Ocean." She has more praises. "The water is clean. The air is so clean. We don't have traffic jams, we don't have much crime. It's just so, so nice."

Pat moved to Coupeville from Florida to follow her daughter Linda; the serenity of the island helped her stay sane when Linda developed lung cancer and passed away a couple of years later.

"It was tough," she says, "it's something you never really get over. But you learn to live with it. What other choices do you have, really?"

Pat got through those tough times with the same attitude she always had. "I try to focus on the positive. I don't think I could survive otherwise— I would drown in all the sadness." Her voice changes now. "There's been a great deal of sadness in my life. I lost touch with my son many years ago. I lost my daughter Susan in a car accident back in the '80s, and then, of course, Linda in 2004." Pat tries to keep things in perspective. "These things happen to other people as well. I think we should try to get up above whatever happens in our life and go on, do something good and constructive out of it."

She finds help in her newfound Jewish faith. "My maiden name is Goodman, very Jewish. My great-grandparents on my father's side of the family came from the Lorraine region of Germany on the French border. They came over to the United States and they tried to assimilate as much as possible, so by the time I was born my family didn't have any of the Jewish culture left," she says. "My mother was English and Scotch of the Christian faith, and that side took over my life. I've probably attended every known Christian church in existence," she says, laughing. "My grandmother actually met Mary Baker Eddy at one point in her life, and the family became very involved in the Christian Science Church. Then my dad had to move to Florida and he broke away from all of that. They kept changing churches, trying to find the place that felt right for them." She eventually found a connection to her Jewish heritage. "As I became older, I started searching out my roots. I always had this really strong interest in reading about World War II.

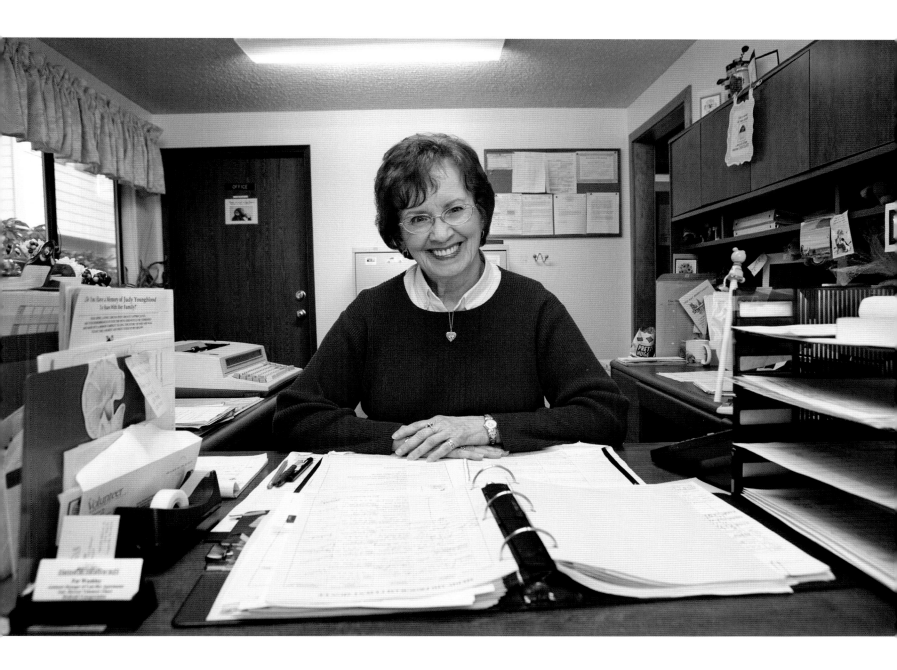

The Holocaust appalled me and I felt an affinity, a connection to the struggles of the Jewish people and all those tragic events." For the last fifteen years she's followed her new religious beliefs. "I do embrace my Jewish heritage and culture. I think it's very important; the Jewish people have given a great deal to the world and I'm proud of that." Her personal journey helps Pat keep a unique perspective on things. "Sure, the past is very important, because that's where our history is, but you can't let the history be your whole life. You have to put it where it belongs; somehow you have to go on. Reading so much about the Holocaust and our history taught me that the Jewish people had to go through so much, and yet they still picked up the pieces and went on and began again and began again. It teaches me that we weren't meant to give in to whatever the grief or hurt it is that life has given us."

Crossing the waters on the ferry boat back to the mainland, I promise myself to make her words a lesson in my own life.

WEST VIRGINIA

JOHN LITTLE

WHITE SULPHUR SPRINGS ✈

"A river runs through it." John refers to Norman Maclean's famous novel to describe the area surrounding White Sulphur Springs, where I meet him at his office at 50 Main Street. "This past Sunday, my daughter and I took our bikes and got on the Greenbrier River Trail; we wore our bathing suits, rode about two miles up the trail, went to the swimming hole, parked our bikes, went swimming for about an hour, got back on the bikes, and rode back down the trail." He is excited. "That's one of the really nice things you can do around here."

John is originally from North Carolina. "I followed the woman," he says, amused. "Her name is Kris. She wanted to be near her family, so I sort of stopped what I was doing, and picked up and moved. It was a pretty crazy thing to do at the time, but it was worth it."

They moved from Charlotte, NC, where Kris and John met in college. "It was a big change, moving from a city of almost two million people. It's only 3,500 of us in my hometown now," he says without regrets, "but we love raising our children in this environment."

The first daughter, McKenzie, is nine years old, and the younger boy just turned five. "Cameron is also my father's and my own name—he is John Little Cameron III. My father passed away when I was very young, so I wanted to carry on his name." I am startled for a second and I relive the feeling of emptiness from losing my father as a teenager. "I know," he says sharing my feelings. "I felt the same way: at a loss. He just went away. It takes a lifetime to sort of understand it."

John changes the subject quickly. "I love this lifestyle, the close-knit community; the same people you work with, the same people your kids play with, they're the same people. I guess that it might be bad in some ways, but in terms of making a child's life really good, or making your life really comfortable, it's nice to be closer and more connected to all those people. You become more involved in their success and their failures and their interests. It makes for a community versus, well, just a place to live."

I get a taste of what he means when we go for a quick lunch at Vicky's Diner, down the road on Main Street, and he is welcomed like an old friend. "I come here for lunch almost every day. We do hotel and resort furnishings and some apparel and accessories for the spa world. Our base clients are at the Sporting Club at the Greenbrier." I am not familiar with the place, so John explains patiently. "We have therapeutic springs here; people have been coming up from all over to use them. The Greenbrier Hotel is one of the oldest, most historic hotels in the nation. A lot of presidents stayed there, since the 1700s."

Business has been slowing down lately, so John and his father-in-law are already planning a new adventure. "We want to open a distillery," he says, excited, "to take advantage of the purity of our water. We already have a name for it: Smooth Ambler Spirits. It signifies what we like about living here. It's a certain gait," he explains, "when a horse ambles, is neither walking nor running. Well, people think we are a bunch of slow folks in West Virginia, but the reality is that we just choose to live our lives at a slower pace."

When Kris and John moved to the Greenbrier Valley, they bought a new house in Lewisburg, a few miles from his office. "It is an older house. We continually update it. We need to put in a new roof now. We try to do as much as we can ourselves, you know, knock shelves out and put new carpet in, new air conditioning. In the last eight years we spent a lot of time and money and effort on it, to make it nice. All in a day's work."

John is very proud of his wife. "Kris works two jobs. She's a full-time ER nurse and she is also a flight nurse." He notices my blank stare. "She flies on a helicopter," he explains. "When you live in a little town like this, you can't always get to a hospital that's close by. But if you get in a really bad accident, they'll stabilize you, and then fly you to a big city, which would be an hour and a half away by ambulance. There is a helicopter that serves the area; they'll pick you up and fly you there in about twenty minutes." he says.

"It's like a flying ambulance. She had to go through extensive paramedic flight nurse training, so she knows how to read heart monitors and give medications, and basically put people in and out of a helicopter. It's pretty cool."

The children keep John and Kris very busy so, once again, they are glad to be in West Virginia. "We get a lot of help from relatives and friends, and they are in after-school programs. You know the expression, 'It takes a village to raise a child,'" he laughs at his own cliché. "Well, it does."

WISCONSIN

KARL HURLEBUSCH

"Where are they?" I am focused on taking Karl's picture on his porch when I hear the familiar sound of Canada Geese. I expect them to be roaming around in some field. "They are going home," he responds, smiling at me and pointing to the sky, filled with geese in flying formation. "They are heading to their home, the Horicon Marsh State Wildlife Area, just a few miles west from here."

It's a beautiful, sunny fall day and Karl is lucky enough to live right on the west bank of the small Rock River that cuts through Kekoskee, a village of 169 people in southeastern Wisconsin. "The name means Friendly Village in the old native Winnebago language," he likes to point out.

Karl lives here with his girlfriend, Lisa. "We met in Milwaukee on the lakefront, where people park, look at the water and hang out. We lived in the inner city—not a nice part of town." Karl has conflicting memories. "We loved living in a mixed environment; my friends were from all different races. But one day we got held up at gunpoint," he says with a hint of glee in his voice. "I thought it was a friend of mine joking around so I grabbed the gun; well, it wasn't my friend. It was a little punky kid—he must have been twelve or so." Luckily things didn't turn out for the worse, and the only thing lost was Lisa's purse. "She was scared after the incident and realized that life in the city wasn't for her anymore. We found our love nest here in Kekoskee, at 50 Main Street."

After a couple of years commuting to the big city, Karl decided to start his own business. "I was always fascinated by forensic science and a lot of stain-removing has to do with figuring out what it is, from the color, the smell, and the look."

His passion for his trade is remarkable, and Karl is not shy either. "I do an exceptionally good job. I am certified by the Institute of Inspection Cleaning Restoration Certification for all the services I provide. I love the name I chose for my business. The Spot Doctor—All the oops, eewww, and ohmygawd that gets on your carpet." He laughs.

"I had a pretty happy family growing up," he says, changing the subject. "My dad was a blue-collar worker, car frames—he was very big on the unions." Karl is proud of his working-class roots. "As an independent contractor, I can see things from both perspectives; I don't like unions telling me what to do, but my father raised me with an awareness of all the rights that unions obtained for the country with great sacrifice in the past. Child labor laws, the forty-hour work week, the time-and-a-half. Unions were a big factor in obtaining the wages that created the middle class that made the economic fortune of our country." He is an opinionated guy. "I have different views," he says. "Last winter the state wanted to define the marriage between a man and a woman. There is already a statute that says that, but they wanted to deny any other substantial legal status to anyone else. So if you are a same-sex couple, you would be screwed—no civil union or nothing like that. I believe that's discrimination." He is not done surprising me. "I am kind of liberal when it comes to the marriage thing, but I am very conservative when it comes to the divorce thing. I don't think divorce should be legal."

The subject makes him think of his parents. "They both passed away," he says. "My mom went first. When she lost her mother she took it very badly and started drinking. She eventually had a stroke. She was only sixty-two years old." His father outlasted his mother a few years before losing the battle to throat cancer. "My dad was the kind of guy that thought he would show love by providing for you. He worked double shifts, extra shifts, took all the hardship. We never got to spend much time together. Only at the end I would come down to visit and we were able to sit around, have some beers and talk."

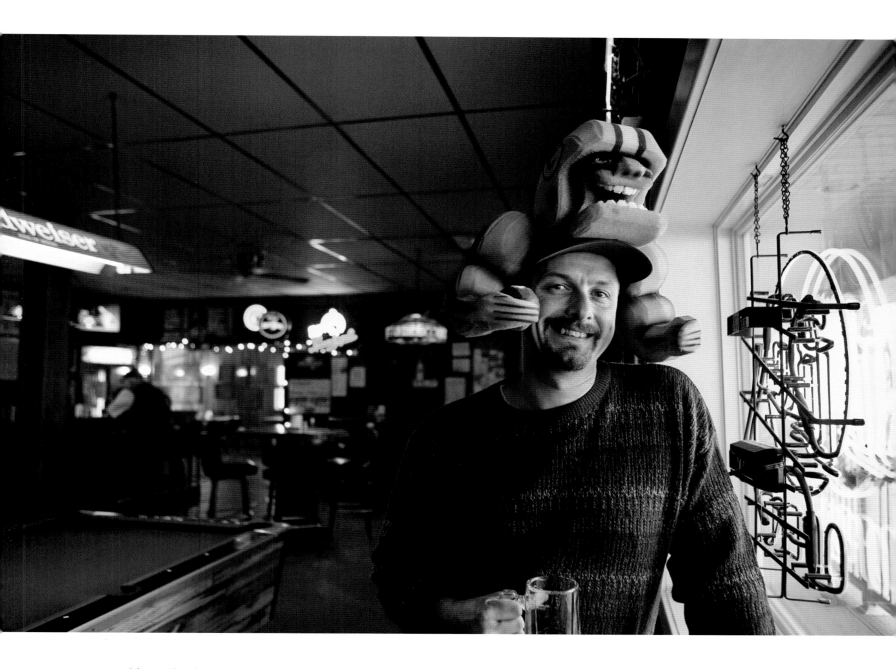

It's getting hotter in the house so Karl takes me for a drive around the area. "You know they call us Cheeseheads, right?" he says when we drive by a large cheese factory. I am aware of the humorous nickname and the connection with football fans all over Wisconsin, so he takes me for a beer at the Marsh Inn Tavern, where we take some pictures of him in his game-day hat.

"The Packers are a religion in this part of the country. They are the only team in the NFL publicly held by the fans," he says enthusiastically.

"And their games are still broadcast on basic television. They tried to put them on cable at one point but people threatened a revolt, so they didn't go ahead with those plans. A lot of people out in the country don't get cable, you know," he says seriously.

I look around the deserted streets of the small town and ask Karl if he ever considered leaving Wisconsin to try his fortune somewhere else. He doesn't hesitate. "Not really—I wouldn't want to miss my Packers games!"

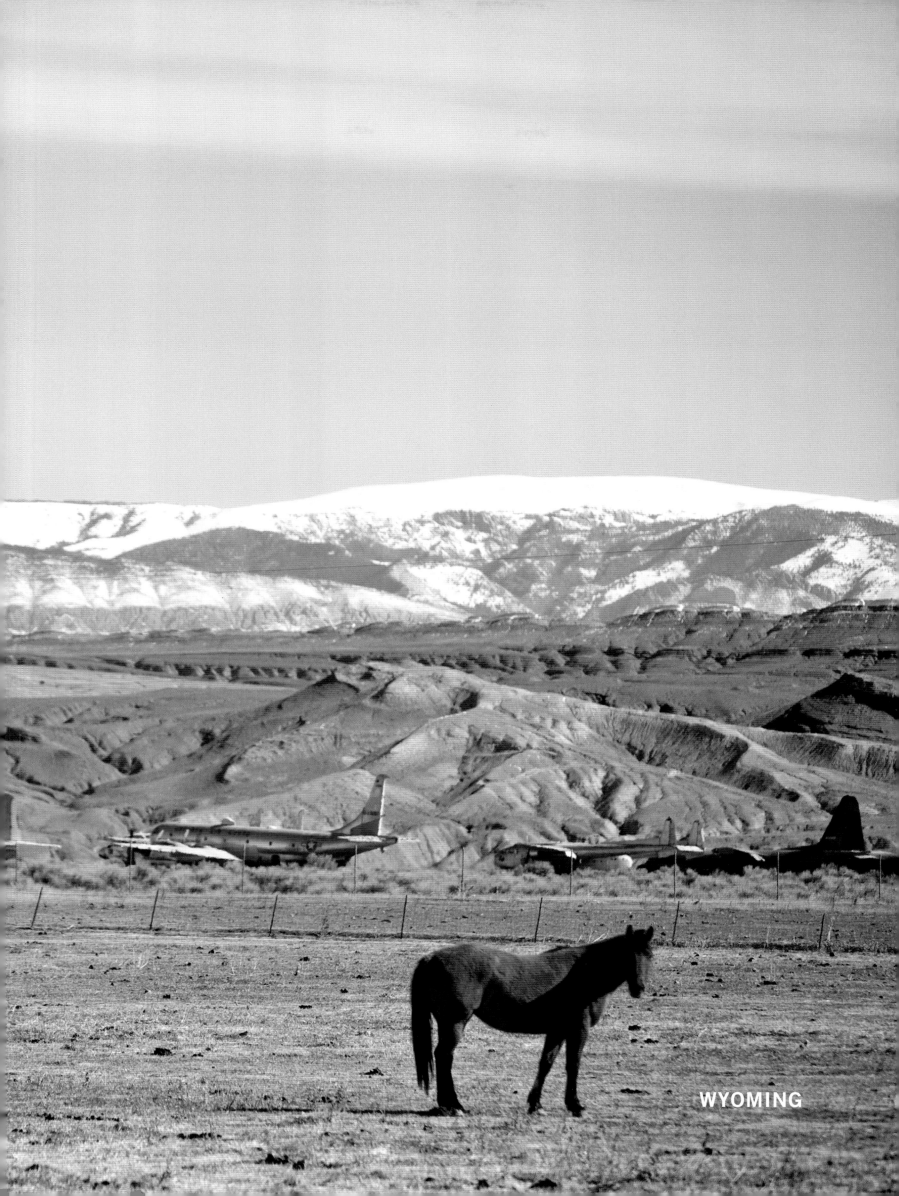

WYOMING

THERESA
HOEBELHEINRICH

SHERIDAN ✦

"You must have driven through Shell
Canyon. I love it up there. I used to snowboard up in Antelope Butte, right on that pass," says Theresa when I tell her about the gorgeous mountains I just crossed coming from Montana. "My grandpa lives in Basin. When I was a girl, he would drive around and point out the house where he grew up, just a big square box."

She seems to enjoy old stories. "I remember my grandma telling me how her and her three sisters all slept in the same bed, and how they used to play Annie Annie Over. Everybody had to stand on one side of the house, they'd throw a ball over the roof, and everybody had to run around the house to try to catch the ball before it hit the ground. Whoever caught the ball got to throw it over the house next, you know?"

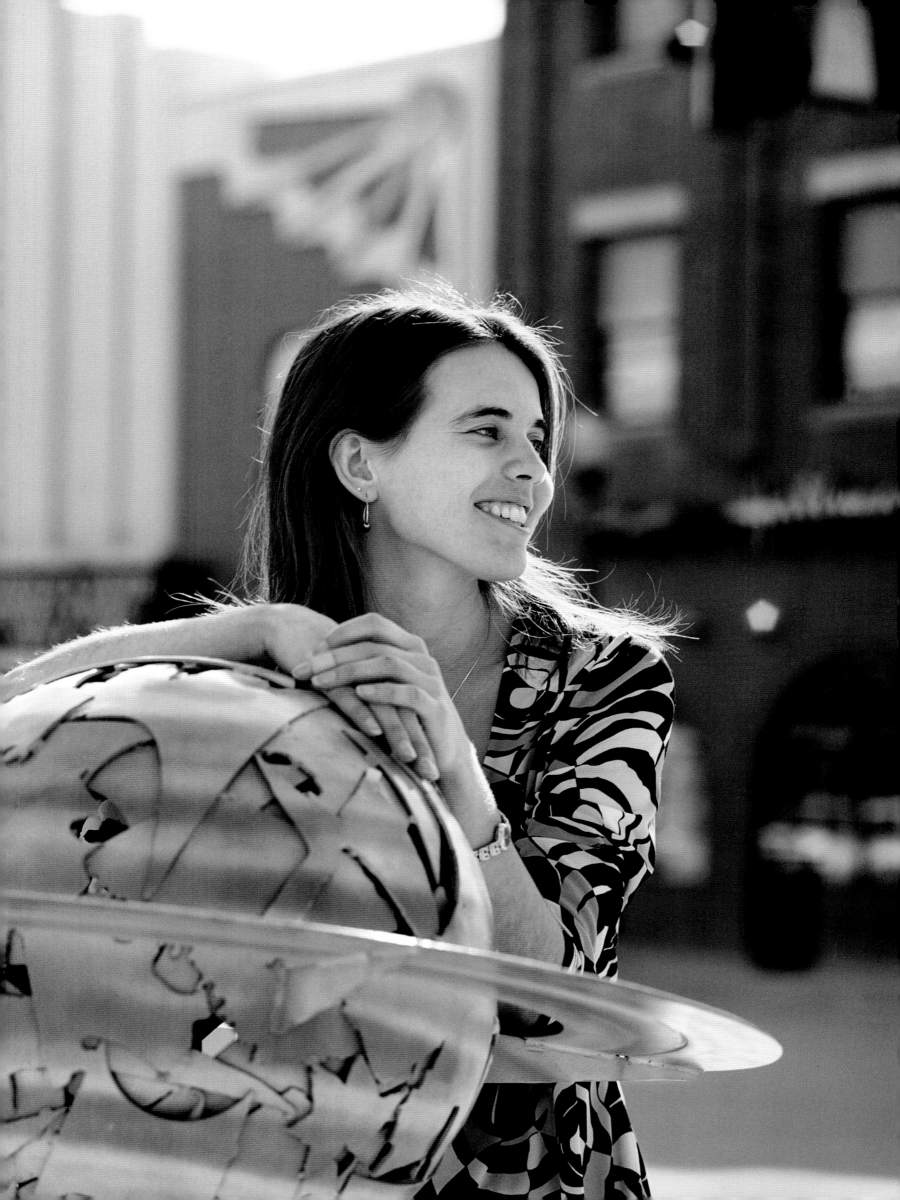

I meet Theresa at the local Hallmark store that she manages. "I work a lot," she says. "Thirty-five to forty hours a week." Those seem like pretty normal hours to me. "I wish I had more time for prayer," she replies. She is only twenty-six years old and I am surprised to hear words that could have come out of my mother's mouth. "I pretty much grew up in church," she says. "I remember when I was a little girl, my mom took me to meet the pastor of the church, and he explained the gospel message and how Jesus died for my sins, and led me in a prayer to invite me to save my heart. I don't really remember it very clearly, but I remember praying something with him and somehow I knew that I asked the Lord into my heart. I've known the Lord from that point on. There he was, you know?"

Following her faith, she went to Wesleyan College in Bartlesville, Oklahoma, where she received a degree in Biblical studies.

"At first I did not know what degree to get. Some of our general classes were Bible classes; I just noticed the more Bible classes I took, the more I wanted and the more I loved them. I just couldn't get enough of studying the Bible," she recounts. "The principles of the Word of God are very effective, you know, in whatever you do. I use it in business every day. For example, one principle is when Jesus preached about the one who wants to be the greatest of all becomes the least of all the servants. So I just like to paraphrase that, like, 'Leadership is servanthood,'" she says. "I am a manager but I am there for my people—I'm not there to be bossy, you know? To teach them, to encourage them, help them grow into the best that they could be."

Theresa likes to crochet, paint, sing, and play the piano. "Everything is about Jesus," she says, smiling. "Everything I do has Him in it, it's for Him. My painting, my singing, it's for Him. It's not like I do it to please God, but everything is His spirit, my spirit—it's one inside of me. There is this union, you know? Like a marriage. We do everything together. There is a unity with the Holy Spirit; stuff just bursts out of you. When I paint something, it's like, I stare at a blank piece of paper and then I see; the Holy Spirit brings out blue so I got blue, and then He speaks to me, He gives me a word and then... the picture. I wouldn't be painting if it wasn't for this passion inside of me that has to come out, you know?"

We take a short drive to visit her church. "I don't go by any denomination; I feel God is doing a new thing in the Earth right now. God is so way past denominations," she says, laughing. "He just loves every single person He ever made on the face of the planet. It's like, He wants them, He loves them all, all His children." She gets very excited and I wonder whether she tries to convert anybody she gets to meet. Her answer is very enthusiastic. "Yeah?" she says with that ironic tone so common in young people. "If you knew something that was so good and you knew life would be better with it than without it, wouldn't you want people to have it? It's not like I want to convert people to an ideology or convince people

that they have to think like me. God is so creative; He doesn't do the same thing twice. God can speak to you different than He can speak to me." Now I feel like she is talking directly to me. "But I can tell you that there have been times in your life when you felt God and you felt that spark and you felt that light, the hope. Whether you hear me right now and believe or just God reveals Himself to you, there is something in you already, and I can say that about every single person I've ever met. They want the real thing; they don't want lies. They don't want a life of false myths and false joy and stuff that only lasts but so long, you know?" She is relentless. "People are crying out in desperation for something that is real, like... I have it! How can I hold it in, you know? When the power of God touches you, there is something so different!" I obviously agree with her final point. "I am not different from you; I am not different from anybody around me. We are all humans. We are all loved by Jesus, he died for every single one of us, you know?"

THOMAS JEFFE

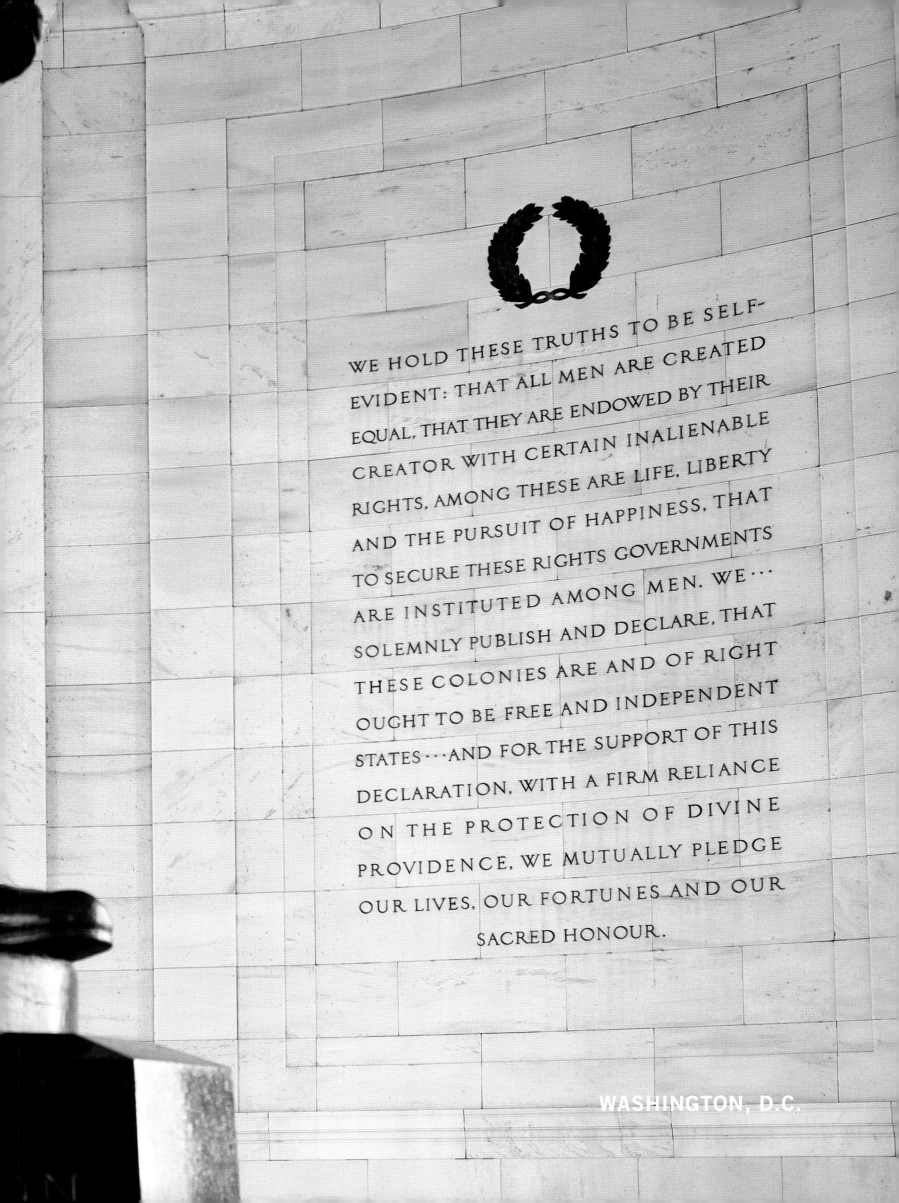

WE HOLD THESE TRUTHS TO BE SELF-
EVIDENT: THAT ALL MEN ARE CREATED
EQUAL, THAT THEY ARE ENDOWED BY THEIR
CREATOR WITH CERTAIN INALIENABLE
RIGHTS, AMONG THESE ARE LIFE, LIBERTY
AND THE PURSUIT OF HAPPINESS, THAT
TO SECURE THESE RIGHTS GOVERNMENTS
ARE INSTITUTED AMONG MEN. WE ···
SOLEMNLY PUBLISH AND DECLARE, THAT
THESE COLONIES ARE AND OF RIGHT
OUGHT TO BE FREE AND INDEPENDENT
STATES ··· AND FOR THE SUPPORT OF THIS
DECLARATION, WITH A FIRM RELIANCE
ON THE PROTECTION OF DIVINE
PROVIDENCE, WE MUTUALLY PLEDGE
OUR LIVES, OUR FORTUNES AND OUR
SACRED HONOUR.

WASHINGTON, D.C.

It took seven years to complete this project.
I first started visiting towns in the Tri-State area,
hoping to find someone at 50 Main Street. I
learned my lesson after spending countless
hours driving around from town to town, only to
find nobody at home or no number 50 on Main
Street. I started consulting the phone listings and
sent letters of inquiry, accepting the first answer
as my subject for that state.

I ended up shooting 370 rolls of film and 325
gigabytes of digital images. I flew 31,000 miles,
drove another 16,000 miles and rode on trains
and ferryboats to reach all the people featured
in this book, throughout our magnificent country.

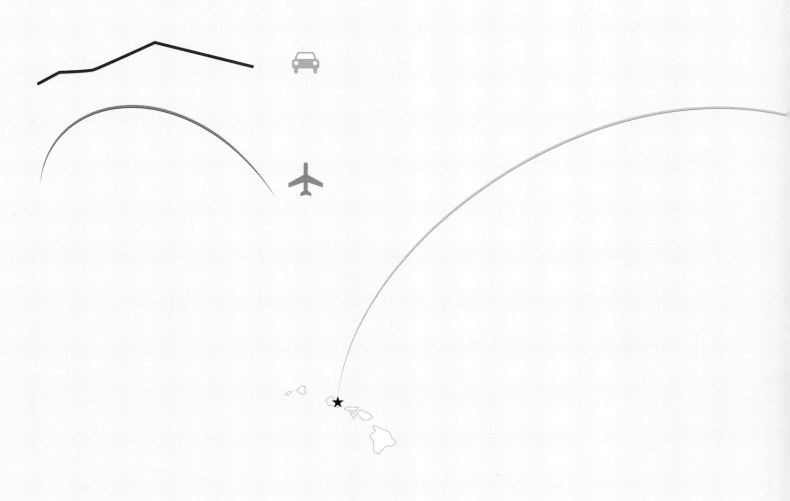

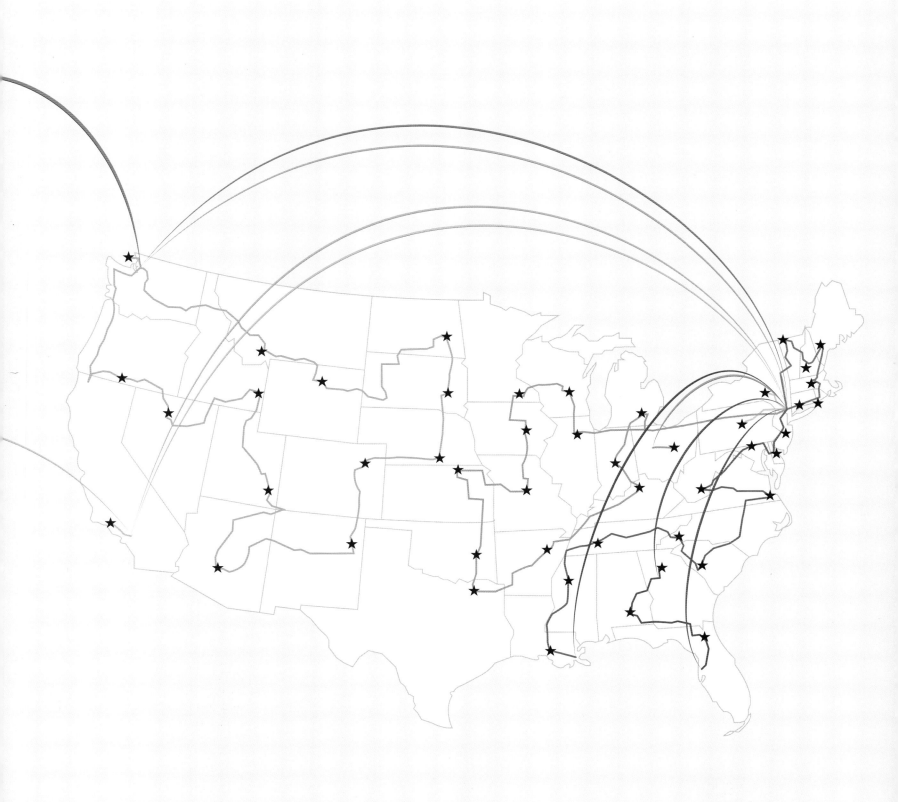

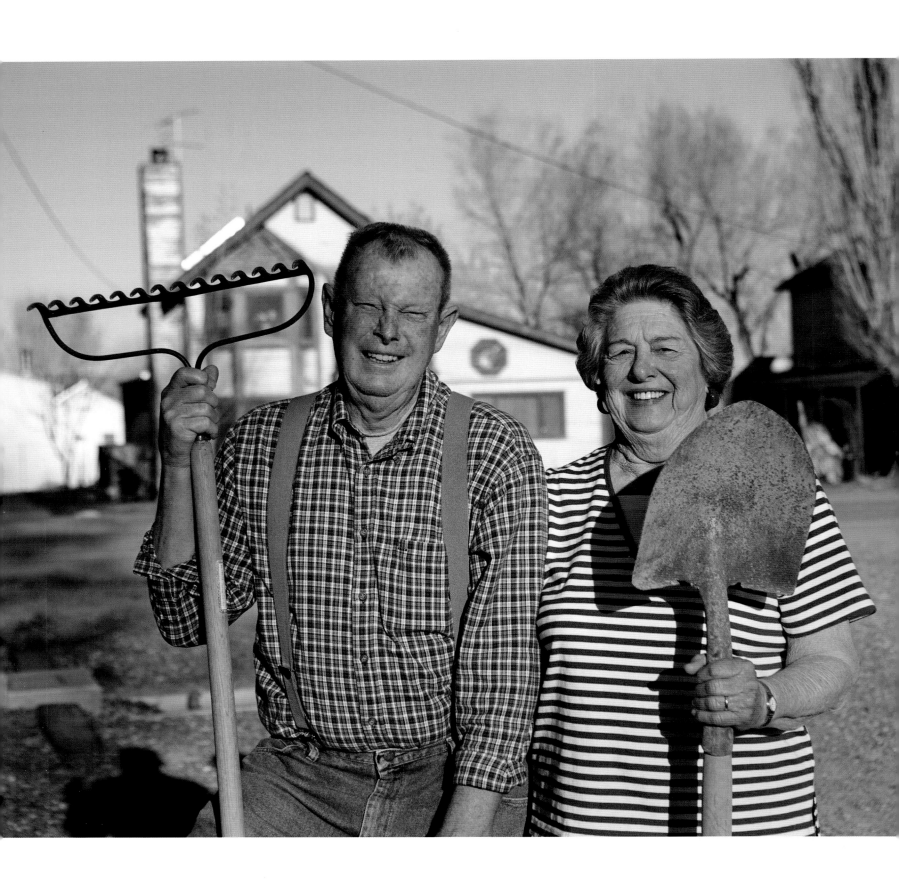

AFTERWORD

As a rule, I don't set goals. Especially in public. I find them fraught with potential embarrassment and a serious threat to leisure time.

Back in 2004 however, when *Dirty Jobs* was in its first season, I made an exception. On one of the late night talk shows, I casually mentioned that I would like to work a dirty job in all fifty states before I turned fifty years old.

It was really just a passing comment, but viewers, God bless 'em, tend to remember such things. Within weeks, I was quickly overwhelmed with thousands of invitations to get dirty from sea to shining sea. How could I say no?

That was eight years ago, and now, as my long and smelly odyssey finally comes to an end (one month before my fiftieth birthday), I can't help but wonder how Piero Ribelli managed to complete a similar quest. Like me, Piero wanted to visit every state before he turned fifty and celebrate regular Americans in a way that was unique to him. Unlike me, Piero didn't have at his disposal a well-heeled production company, or the vast resources of The Discovery Channel. Nor did he have the financial support of multiple advertisers or a stubborn group of loyal fans forcing him to make good on an offhand comment. All Piero had was a single camera, a simple idea, and the good sense to keep his personal goals to himself. The result is a completely authentic snapshot of who we are as Americans.

A quick word about "authentic." In my business, "authenticity" is the term of the decade. Networks and advertisers are desperate to deliver an authentic experience for the simple reason that viewers and consumers are desperate to have one. TV producers fall over themselves to "keep it real," and the result is a genre of television that has come to guarantee the precise opposite. From what I've seen, the same is true in publishing. So when a show or a book comes along that actually delivers on the promise of authenticity, I get excited. That's why, even though I don't personally know Piero Ribelli, I'm honored to brag about what he's done.

50 Main Street matters not because it'll make you smile and not because it's filled with pretty pictures. It matters because it's genuinely, thoroughly, and relentlessly authentic. Look again at the guy on the cover. He's the real deal, just like everyone inside. No models. No actors. No sets. Just people. Anonymous, average, ordinary Americans. Except somehow, they're not. Between these covers, they become something else. Something special. This is a story of strangers you've always known, and old friends you've not yet met. It's a journey back home, and a reminder that no matter where you come from, we all share the same address.

The only flaw I can find with *50 Main Street* is that I didn't write it. I'm prepared to forgive Piero for that if he keeps his promise to watch reruns of *Dirty Jobs* for the next twenty-five years. In the meantime, I'll be holding onto his book for a lot longer than that. I suspect you will, too.

Mike Rowe
Founder, mikeroweWORKS Foundation
Creator and Host, *Dirty Jobs*

Acknowledgments

Sincerest thank-you to all the friends who have helped in small or big ways.

Fabrizio La Rocca, Brian Stanton, Alison Lew, Siobhan O'Hare, Matteo Bologna, William Scalia, Leila Moghimzadeh, Ombretta and Benito Rial, Justin Novak, Aelish Patane', Rita and Glenn Ahner, Gustavo Asman, Maria Teresa Ribelli, Marcella Smith, Josh Marwell, Chitra Boparticar, Jayne Wexler, Oonagh and Leonard Wood, Nicola Verlato, Kaveri Marathe, Noel Mignott, Joanne LaMarca, David Auerbach, Rich and Dina Duva, Roseann Lentin, Russell Perreault, Magali Laguerre, Havilah Clark, Ted Kawalerski, Ellen To, Kristine Szabo, Wendy Newton and Peter Ferko, Alessandra Cozzolino, Jennifer Robbins, Kate Peila, Joseph Overbey, Virgilio Sacchini, Ubaldo Holguin, Andrea Vecchietti, Giampi and Tiziana Branchi, Tony Garino, Sonya and Mike Gaffney, Brian and Patty Hughes, Laverne and Mike Ploom, Anna and Pierpaolo Borelli, Jennifer and Bart Kasten, Anne and Enrico Brivio, Mike Gaffney, Sr., Korentha and Junia Farrell, Jeffrey Fites, Bonnie and John McCallum, Dionne Jacques, Robert Buckley, Holly Wexler, Michael Courto, Lindsey Nelson, Mary and Caroline Peila, Jill Chatfield, Dragon London and the Ketchikan Visitors Bureau, Black Bear Inn-Ketchikan, Anaconda Water Department crew, Farrell Fleming, Terry Allen, Amber Deters, James Dooley, Jill and Bonnie at SpoonSisters.com, Deb's on Mane-Mayville-ND, Megan and Francesco Leone, Kevin Wilson, Francesca Mor, Andy Rourke, Mark Gordon and Hilary Stauffer at G10 Capture, Chiara Montalto, David Waitz, Jim Mairs, Sondra Nolan, Bonnie and Les Jensen, Sthu Zungu, Susan Raihoffer, Rick Carey, Laura Neilson, Vadim Rizov, Chris Stanton, Jason O'Neal, Brian Delaney, Deb Millk, Erica Leone, Nora Federici, Francesco Mosto, Larry Samuel, Cora and Wayne Wang, Michelle Dotter, Elle Carriere, Ken Burns, Blythe Nelson, Michael Franti, Merr Tingle, John Mellencamp, Larry Fink, Teresa Hughes, Dolly Parton, Tina White, Mike Rowe, Virginia Northington, Douglas Brinkley, Chris Gruener.

Photography: Hasselblad film cameras, Canon digital cameras, Gitzo tripods, Kodak Supra film, Imacon scanners, My Own Color Lab - NYC.